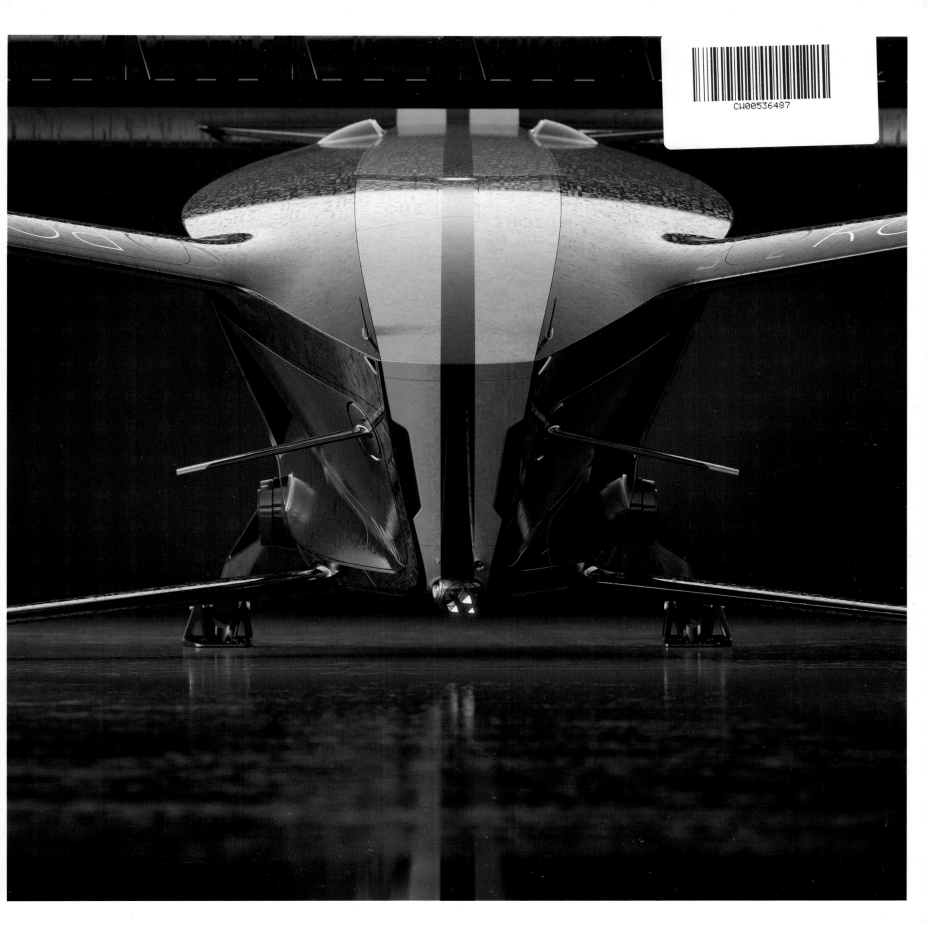

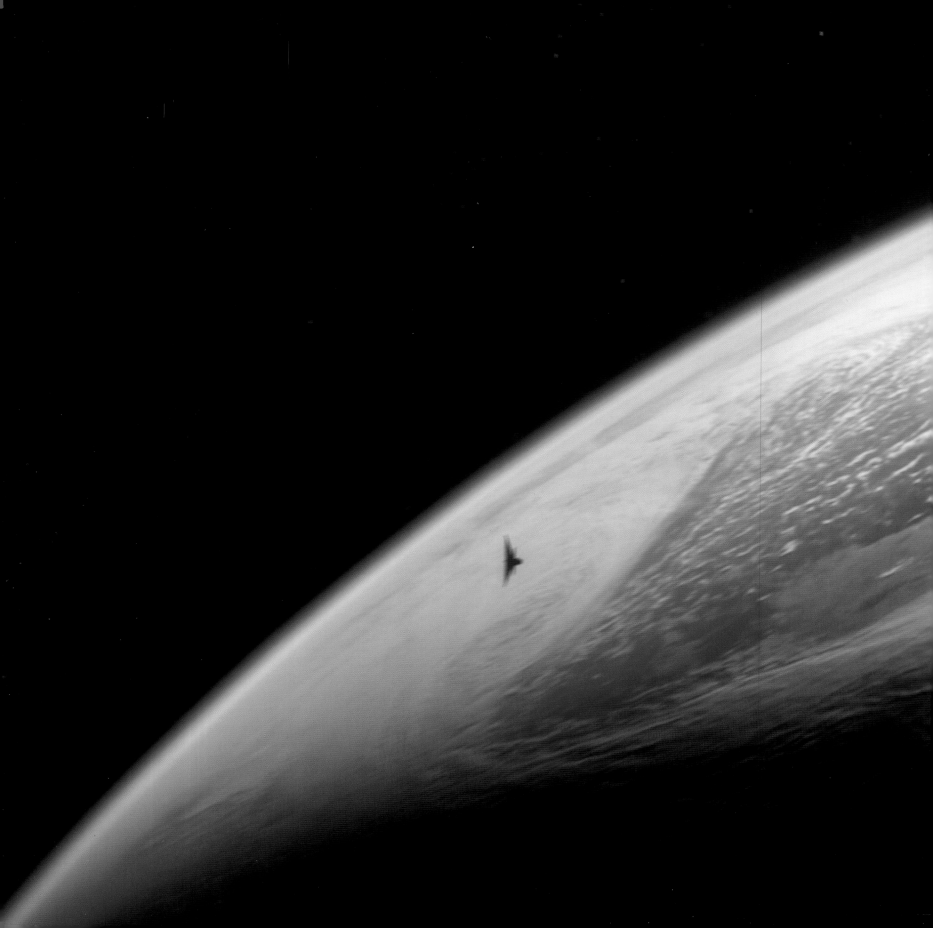

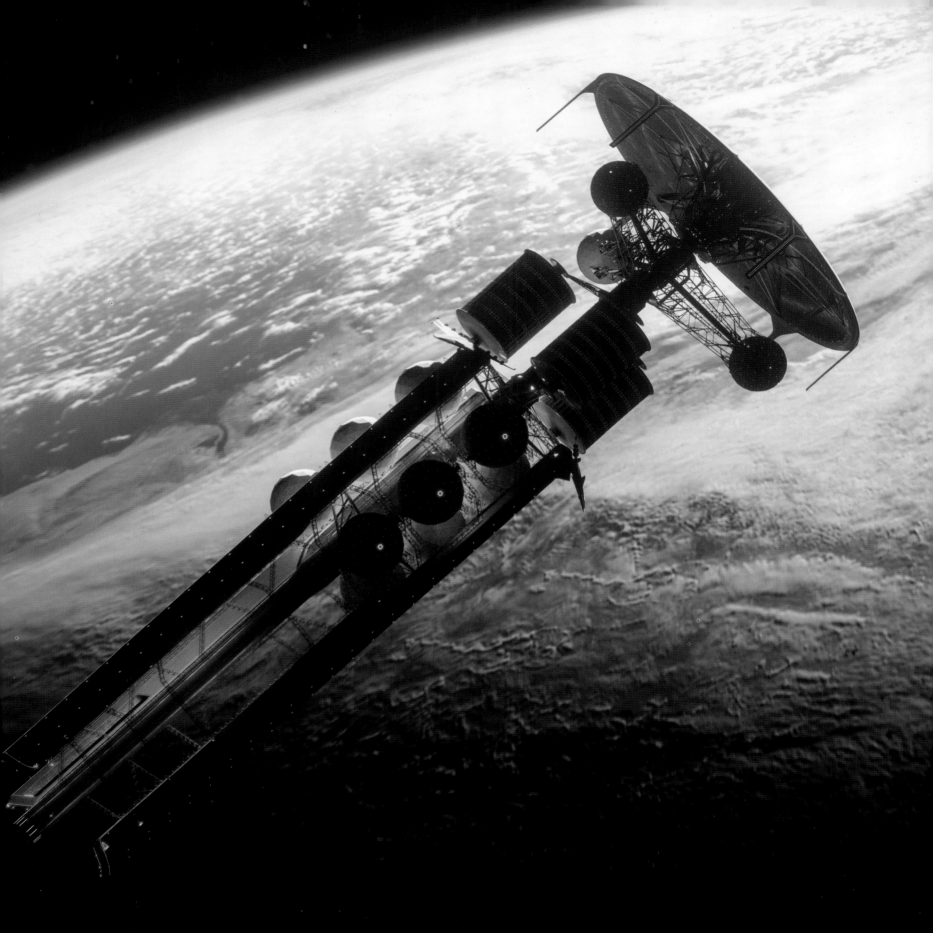

DEDICATION

To Steffi, my brother, my parents,
Boomer, and Loki

Foreword by Tim Kentley Klay 6

Introduction: One Year Dedicated to Realizing One Dream 8

Envisioning Vehicles That Would Save Humanity 9

Vehicle Design: Silhouette Is Key 11

Key Sketch Collection 12

Vehicles

The Ark: Humankind's Last Hope 14

The Swan: Space Transporter V1 26

The Orca: Space Transporter V2 38

The Octopus: Underwater and Land Vessel 46

The Falcon: Aircraft and Troop Carrier 54

The Ant: All-Terrain Research Lab 64

The Monkey: All-Terrain Vehicle 74

The Mäck: Construction Robot 82

The Mantis: Woodworker Robot 90

The Goose: Long-Distance Aircraft 100

The Cricket: Exploratory Vehicle 110

The Hornet: Stealth Rotorcraft 118

The Albatross: Research Aircraft 128

The UFO: Satellite and Scanner Drone 136

The Boomer: Defensive Drone 144

My Journey into Uncharted Lands 155

Acknowledgments 158

Tools and Software 159

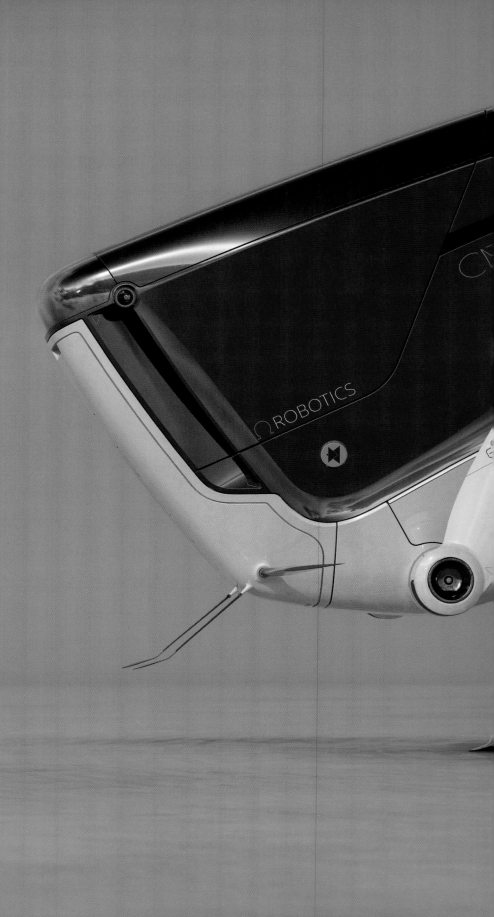

Foreword by Tim Kentley Klay

Can you imagine? I know someone who can. His name is Christian Grajewski, and I have the pleasure and honor of introducing his imagination to you in this wondrous work you now hold: *EXPLORER: Futuristic Vehicles for Uncharted Lands*.

You see, imagination is a very special commodity—unique in the universe—because it holds vividly that which does not yet exist. How can something that is virtual be powerful? Because creativity is our ultimate guide—it is the intangible force that shows us the way forward into the unknown.

For imagination can see not what is, but what is to be.

When I came across Christian's work, scouring the Internet looking for talent to help build my robotics company, ZOOX, I was stunned. His unique style was an intoxicating mix of the future in bioorganic form. Christian's aesthetic is a fusion of animal and robot—manufactured and evolved, machine with mind.

And he was compelled. He desperately wanted to leave his job in automotive, and barely wanted to work with me; the energy inside him wanted to manifest this world. Fortunately for me, he needed cash! But as a testament to his convictions, he got it done. And now we all have the joy of sharing in Christian's imagination as he sees it.

His imagination is truly as extraordinary as it is powerful. Furthermore, I predict that this work will go on to inspire and inform future creators as they reach out beyond this world to explore other worlds. This collection is a window into the future of how robotic vehicles can be for uncharted lands.

We are all explorers; enjoy exploring this book.

Tim Kentley Klay

Founder of XYZ STUDIOS, CRAYON, ZOOX, & HYPR

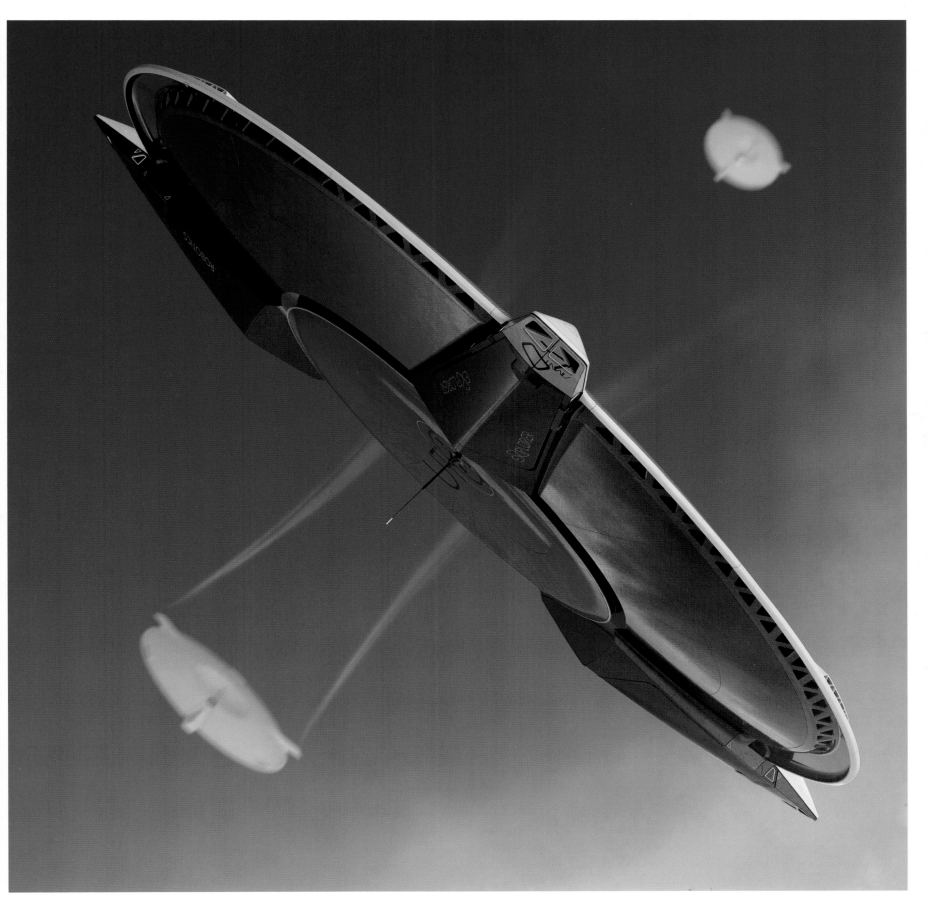

One Year Dedicated to Realizing One Dream

I have been fortunate that being creative has been the nature of my profession for some time. For almost eight years, at Volkswagen Future Center Europe (formerly Design Center Potsdam), I designed car interiors for Volkswagen, Audi, Lamborghini, Bentley, Porsche, Seat, and Škoda. It was a dream job, and I was lucky to work with and learn from some of the world's leading designers, engineers, and modelers. Thanks to the variety of brands and vehicle classes I was working on, it never got boring, yet somehow that wasn't enough. I still had the urge to draw other things, things that had nothing to do with my job but with my second passion: concept art.

After spending years constantly sketching spaceships, cars, robots, creatures, and more in my free time, my artwork was piling up so high that I decided to take a one-year sabbatical to develop an art book. I started with a rough story idea: the imminent destruction of Earth required every nation to join forces to build a space ark to preserve humankind. The ark would be loaded with materials, vehicles, robots, and the genetic codes and memories of select humans in order to rebuild society somewhere far, far away from its current solar system. I picked existing vehicle sketches to render in 3D and also planned to invent new ones, all inspired by animals. While the full narrative was in progress, my focus for sabbatical would be the vehicles themselves—to imagine things never seen before.

> "I started with a rough story idea: the imminent destruction of Earth required every nation to join forces to build a space ark to preserve humankind. The ark would be loaded with materials, vehicles, robots, and the genetic codes and memories of select humans in order to rebuild society somewhere far, far away from its current solar system."

On the first of January 2016, my sabbatical started.

To achieve everything I wanted to in a tight timeframe, I followed a strict daily routine: I started my day at 4:20 a.m. and worked until about 7 p.m., dedicating a minimum of 70 hours a week to my project. In my mind, this structure was the key to succeeding. By the year's end, I had finished a number of aircraft, creatures, robots, character suits, and weapons for the book while learning ZBrush, Illustrator, KeyShot, Daz 3D, and a bit of Maya and MoI 3D. I also became more acquainted with the previously strange world of Poly modeling and UV editing.

Being at home, focused on something I loved, one year passed very quickly, and it was time for me to go back to Future Center Europe. Though I reduced my hours to 28 a week, back at work, there seemed to be two hearts beating in my chest: one for interior design, the other, for concept design. But looking back, that wasn't true—I just couldn't see it. My love for concept design had taken over even before I returned to my job.

I went through some quite tough months, torn between my job, my passion, and my health. One thing always kept me smiling: the fact that people really were responding to my designs online, which I started publishing on Artstation, Behance, Facebook and my new website, toward the end of my sabbatical. This really kept me going. Then, in June of 2017 being on vacation in Italy, I experienced a major health scare, an anaphylactic shock in the middle of the night. Not being able to breathe anymore, and ending up in the ER, changed everything. You become 100 percent aware of what is most important in your life. I quit my job to concentrate on what I really lived for: my loved ones and designing what I wanted.

I was reading *Tools of Titans* by Tim Ferriss at that time, and I think it really inspired me to make that decision. The book offers a lot of great ideas and suggestions that are actually very obvious—but we are conditioned by society to do the opposite!—such as making a list of what is most important in your life, including your goals and what you need in order to achieve them. For me, it is being healthy and happy, spending time with the people I cherish, and doing what I love. I didn't need a lot of money for any of these. You certainly can't buy back your health or time.

More than three years have gone by since I decided to really dive into concept art: staying at home, working on my own projects, only taking freelance clients and projects I like, and spending thousands of hours of constantly learning, creating new things, and being extremely positive and also dubious about what I am doing. This book is the result of years I dedicated to my passion. I call it *EXPLORER*. I thought it was fitting, as I was and still am as much of an explorer as these autonomous vehicles are on their way to a new world.

> "This book is the result of years I dedicated to my passion. I call it *EXPLORER*. I thought it was fitting, as I was and still am as much of an explorer as these autonomous vehicles are on their way to a new world."

Consider this just a taste of the imagined world—actually, a whole new civilization—I've been developing into a novel with my friends. Before delving into my creations, I share my thought processes that led to them, especially questions I asked myself in order to spur more innovative designs. Woven through the book, I also included my reflections on specific designs: what inspired them, challenges I faced, how each evolved and why. Each vehicle was an adventure in problem-solving and possibilities.

I hope you enjoy *EXPLORER*, learn from my journey, and are inspired by it!

Christian Grajewski
Hannover, German
July 2020

The Ark

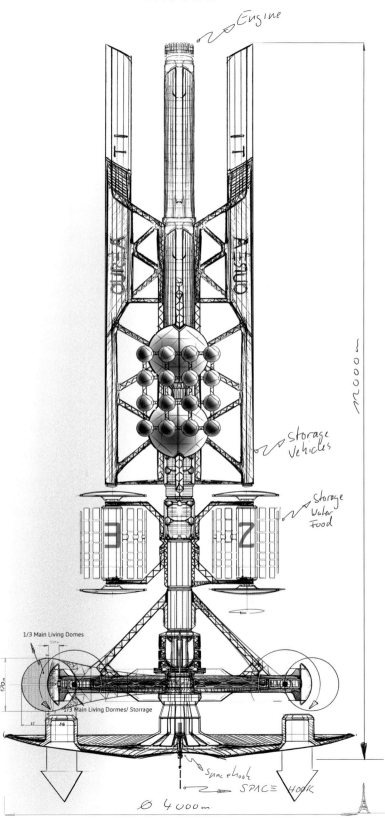

Engine

OUR-E

A-STO

Storage Vehicles

Storage Water Food

1/3 Main Living Domes

1/3 Main Living Dormes/ Storrage

Space hook
SPACE HOOK

Ø 4000m

Envisioning Vehicles That Would Save Humanity

2065: Earth was just a shadow of herself.

The human race was already in peril as nations fought over dwindling resources due to centuries of people polluting the planet and turning our once-beloved home into a massive dumping ground. Then, scientists discovered that a gamma-ray burst was quickly heading toward our solar system, which, upon entry, would bring an immediate end to every complex life-form.

Facing extinction, every nation had to unite for the very first time in history to preserve humankind. This required each country's leading minds to share their secret, most advanced technologies that were originally developed for one purpose only—to be victorious over enemies in case of a World War III.

With multinational cooperation, an AI entity called the Omnipresence, or simply O, was developed using all the world's greatest technologies to serve as the foundation for a new generation of highly advanced, autonomous robotic vehicles to explore new lands for human colonization.

Under O's direction, three major companies were founded—Omega Robotics (European countries), the AMNT (Asian nations), and Exis (North and South American countries)—to create the vehicles. But first, O instructed the companies to undertake an unprecedented construction task in order for our species to survive: to build a massive, operational ark without a single living being on it.

Instead, O would be at its helm, with humankind on board in a very different form. It was impossible to save humanity as it was; humans had to face their fate, dying on Earth, but with the plan of being reborn on a beautiful distant planet with O programmed to use copies of the human consciousness and genetic code to create clones for colonization.

Project Ark was born, with humans and the world's most cutting-edge robots united to build the ark and hundreds of highly advanced, autonomous vehicles, aircraft, and robots. These machines would travel through space in the ark for however long it took to find a new home.

It was up to the Omnipresence, whom humankind learned to trust and put faith in, to journey in the ark and continue our species beyond Earth.

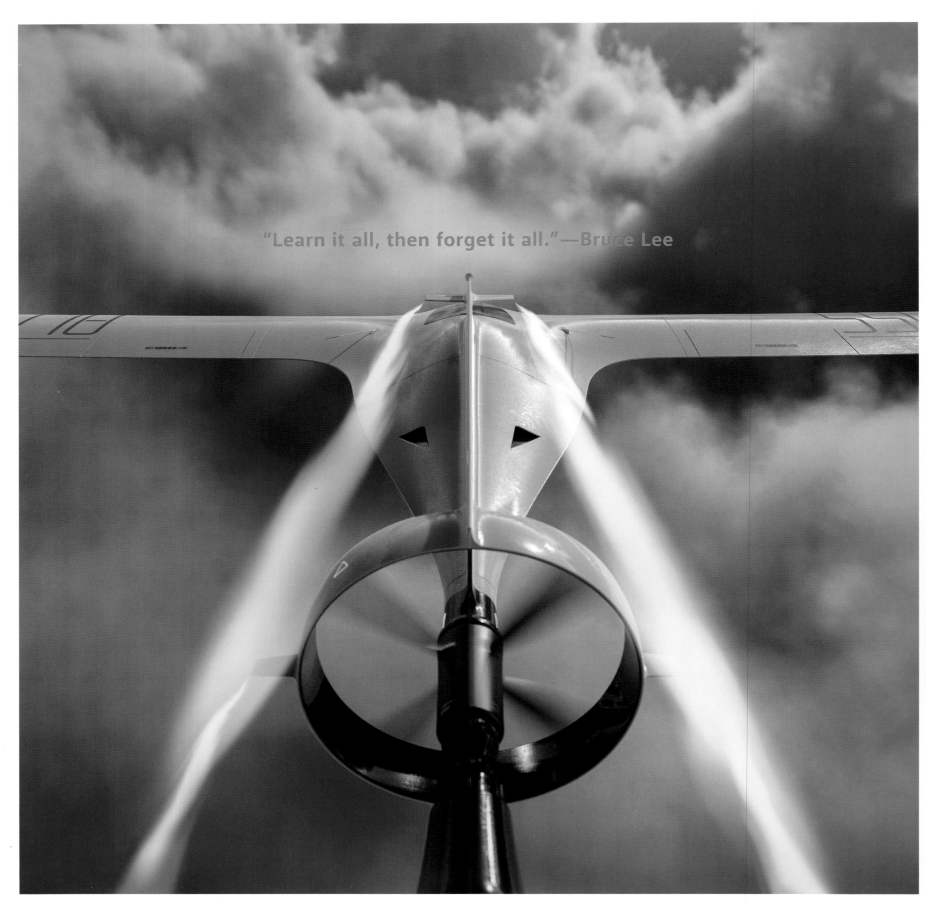

"Learn it all, then forget it all."—Bruce Lee

The goal is to have everything come naturally so you don't have to think about what you are doing anymore.

When I start a project nowadays, such as an aircraft, my approach is unlike in the past. The main difference is that I do fewer sketches now. This is also the reason why there aren't many in this book. And I didn't want to put any fake sketches over a finished 3D model. But I do miss sketching and all the happy accidents that happen while drawing.

As my ability to work in 3D improved and the time required to build something shortened, I sketched less and less. Making different kinds of sketches from multiple views takes the same amount of time for me as a good 3D model. And if I needed to, I could take a screenshot of the model from any angle and sketch over it. That's why I love to sketch side or top views. They're fast, and you're just working on a silhouette, taking good care about proportions. An iconic silhouette is very important. Just look at the very first *Star Wars* designs: all of them have an easy-to-read silhouette that a child can draw.

One of my former bosses once told me: "Imagine a child looking through a car window. If that child is able to draw your interior, you did a very good job." So, concentrating on the silhouette is key, while details are considered at the end. Details don't make a good design—most of the time they just cover bad proportions. Of course, details are important, you need them, but primarily to give your design scale and credibility.

The best way to approach the level of detail needed is to think about production. With what kind of material are you working: real or fictitious? How is it assembled, manufactured, and so on?

Here's a quick example. A friend once said, "Christian, your aircraft needs more imperfections; no airplane looks that perfect."

I explained to him that the aircraft industry was heavily investing into 3D printing, and that my story took place in the future. "Why should I include imperfections if it is possible to build perfect aircrafts?"

Before I start doing any sketches now, I do more research and a lot of thinking. While I'm doing that, I can still work on something else, because my subconscious is on fire and will come up with an idea after it has had enough time to digest. I know that although this works great for a personal project, it may not for your daily job, but hopefully it helps a bit.

Another important thing I am doing now is never finishing a design at once. I build something to a certain point and then put it aside, because we sometimes go blind after looking at our designs for too long. I go back to it after a month or two, because then I can look at it with a certain novelty which allows me to judge it better.

Vehicle Design: Silhouette Is Key

Let me explain some of my thoughts concerning my hard surface designs. As an interior designer, I was keen to do an awesome sci-fi interior, but after I gave it more thought, reality hit me hard. There was a lot to consider.

One: Why should any futuristic vehicle have a steering wheel or something similar? It doesn't make any sense at all, knowing that autonomous driving is possible today.

Two: I decided to introduce a microcomputer called Mindcom which is connected to the human brain in my imagined future world. It can blend reality with information or completely overwrite it. A human can see what the vehicle sees. With this in mind, none of my vehicles needed windows anymore, and they became safer. But the best thing is that this gives me much more freedom and opens up new possibilities regarding my designs.

Three: Because the vehicle is connected to your brain, hard user-interface buttons are gone as well; you can control everything with a single thought or some kind of a gravitational glove.

Four: I think about the field of the vehicle. Shall it move on land, or in air or water? Shall it carry a couple, a handful, 20, or even more people? What distances shall it cover, long or short ones? Shall it be fast or slow, heavy or lightweight? What's its purpose, construction, transport, surveillance?

Five: When I'm working on a design, I think about its specific functions. How does one get in and out? How does steering work? And the landing gear? Do I need lights?

Six: I decided that I didn't need lights, because we just have lights as a warning for animals and other people, and to see at night. If my vehicle has lidar (light detection sensors), radar, sonar, infrared cameras, and so on, light is unnecessary. The vehicle's AI could see so much better than any human. For that reason, my designs just have "marker lights" (for show) and lights to create a face.

You may have noticed that the order of my thoughts is from the inside of the vehicle out. In my opinion, the interiors are most important, because, in the end, a human being will use it. And even if it is just fictional, this method will help me in developing a better design.

With all of that in mind, including the futuristic production technologies, I could finally start designing or rethinking already existing ideas.

But, I should be honest, I don't always follow my own rules. Sometimes a concept just looks great and I have to add meaning later on. Nobody's perfect!

Key Sketch Collection

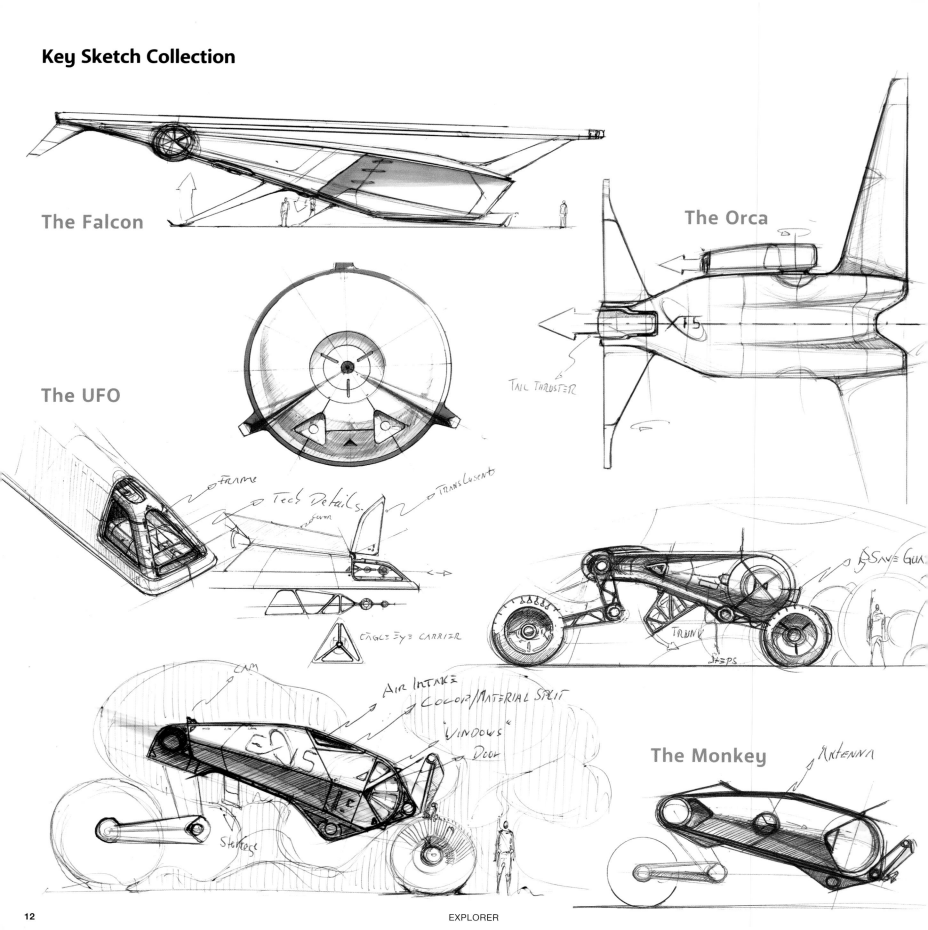

The Falcon

The Orca

The UFO

TAIL THRUSTER

FRAME

Tech Details.

TRANSLUSENT

EAGLE EYE CARRIER

SAVE GUN

TRUNK

STEPS

CAM

AIR INTAKE

COLOR/MATERIAL SPLIT

"WINDOWS"

DOOR

The Monkey

ANTENNA

STAIRCASE

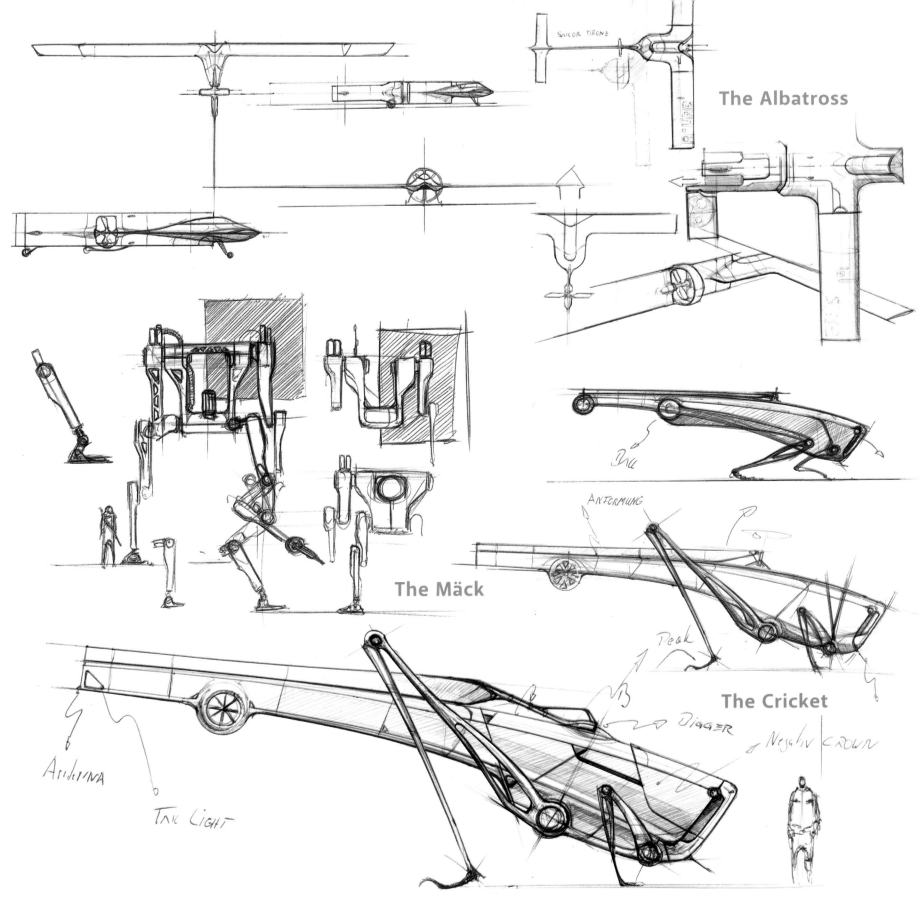

The Albatross

The Mäck

The Cricket

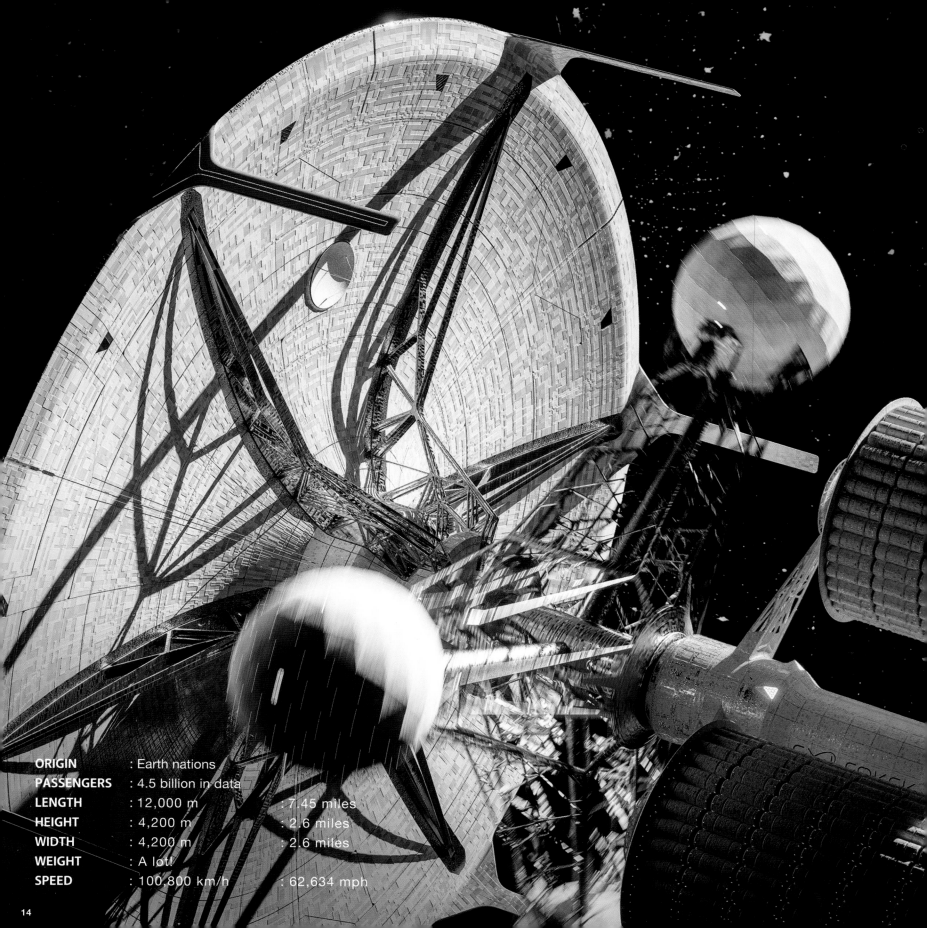

ORIGIN : Earth nations
PASSENGERS : 4.5 billion in data
LENGTH : 12,000 m : 7.45 miles
HEIGHT : 4,200 m : 2.6 miles
WIDTH : 4,200 m : 2.6 miles
WEIGHT : A lot!
SPEED : 100,800 km/h : 62,634 mph

The Ark

HUMANKIND'S LAST HOPE

At 12 kilometers in length and 4.2 kilometers in diameter, the Ark is the greatest technological achievement known to man. A much smaller prototype was already in development by the Chinese government before Earth's inhabitants learned of their impending doomsday. With the help of the Omnipresence, the international alliance was able to build this superior and larger space ark. It is filled with everything needed to build a new society from the ground up: the DNA and memory of every human being and the DNA of almost every plant and animal from the past century, basic resources, as well as vehicles, aircrafts, preassembled base stations, and enough materials to build a functioning colony for upwards of 100,000 people.

Equipped with a giant center engine and three energy chambers, the Ark is able to travel more than a thousand years through space. The engine runs through the whole vessel and operates in both directions. As soon as the ship has to decelerate to arrive at its final destination, an energy beam is emitted out of the front shield to protect the Ark from space debris, so she can safely arrive at her destination, a planet deemed hospitable by O, and fulfill her purpose. Then the Ark's six giant container modules would be released and fly toward the planet.

MAIN STORAGE UNITS

Filled with 3D printers for mass-cloning process, drones, construction materials, and other vital resources

LIQUID CONTAINERS

Carries water, fuel, and main organic 3D printing liquid tanks

THE EGSBERGER DRIVE

Named after the MIT student Johann Egsberger, whose scientific ideas were key for the propulsion development; drives main engine that goes through the whole Ark

NOTE

When I first thought about the Ark, I wanted it to look as credible as possible. I had a practical and simple, and elegant, look in mind, with the main engine at its center and a shield to protect it. I thought about a three-way safety net to successfully execute the plan to save humanity. The first stage of colonization required three preloaded Orca (p.38) carriers that included the human data to create thousands of clones, and enough equipment, vehicles, and rations for the initial settlement. The second stage of colonization involved the three container modules loaded with enough equipment and resources to grow the colony's population significantly, with around 100,000 people. Once the first settlers successfully functioned on the new planet, under O's direction, the third stage would start: replicating the rest of humankind over many centuries to prevent humans from exploiting the planet's resources and turning their new home into a wasteland, as they had on Earth.

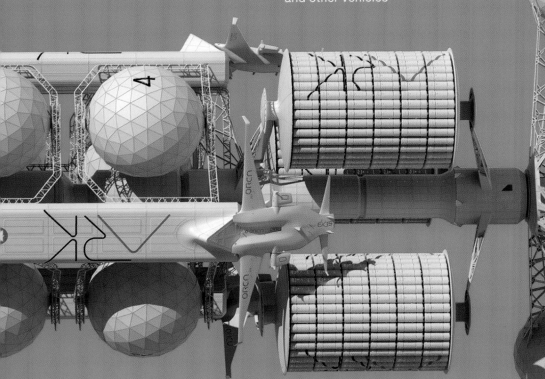

PROTECTION SHIELD

To protect the Ark from potential space debris

CONTAINER MODULES

Three container units with 1,200 containers each, equipped with 3D printers, base-station kits, construction materials, drones, and other vehicles

FRONT THRUSTER

For decelerating when arriving at a new planet

DOCKING STATION

For Swan and Orca space carriers preloaded with drones, first settler data, organic material for 3D printers for cloning first humans, base-station kits, water, and construction materials

GREENHOUSE

Three greenhouse habitats with artificial gravity to grow food for the first settlers. The growing process will start about 100 years ahead of arriving at the new planet. Drones will take care of the gardening process and other vehicles.

SIDE NOZZLE

Twelve big side nozzles for stabilization

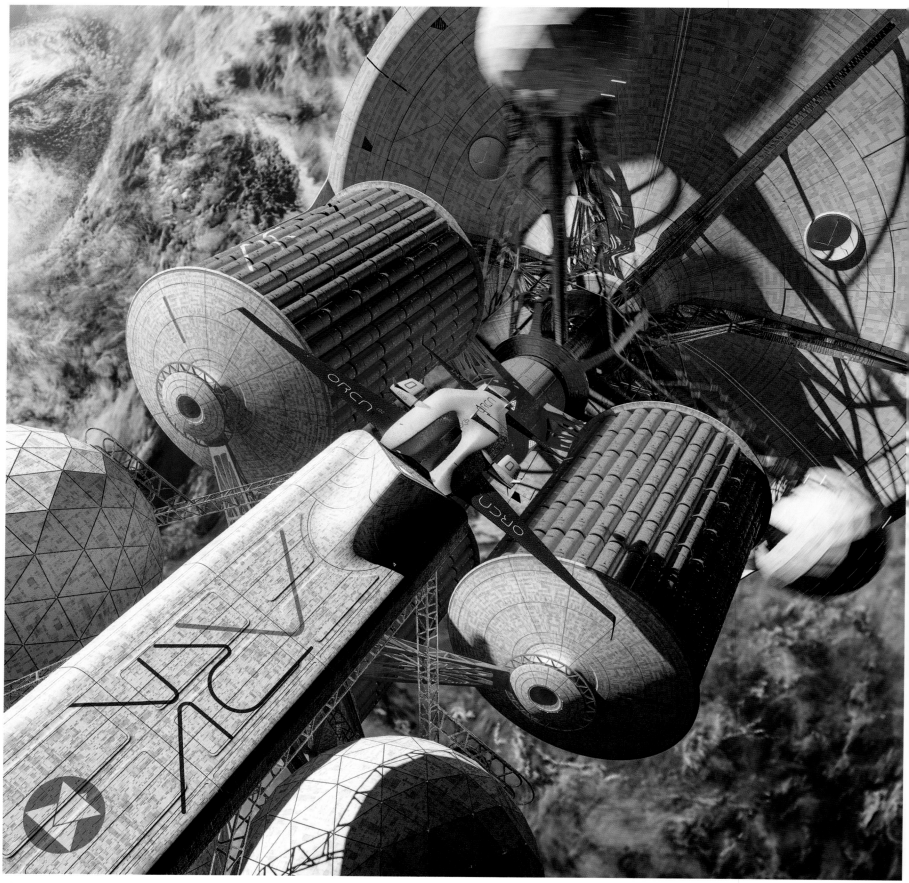

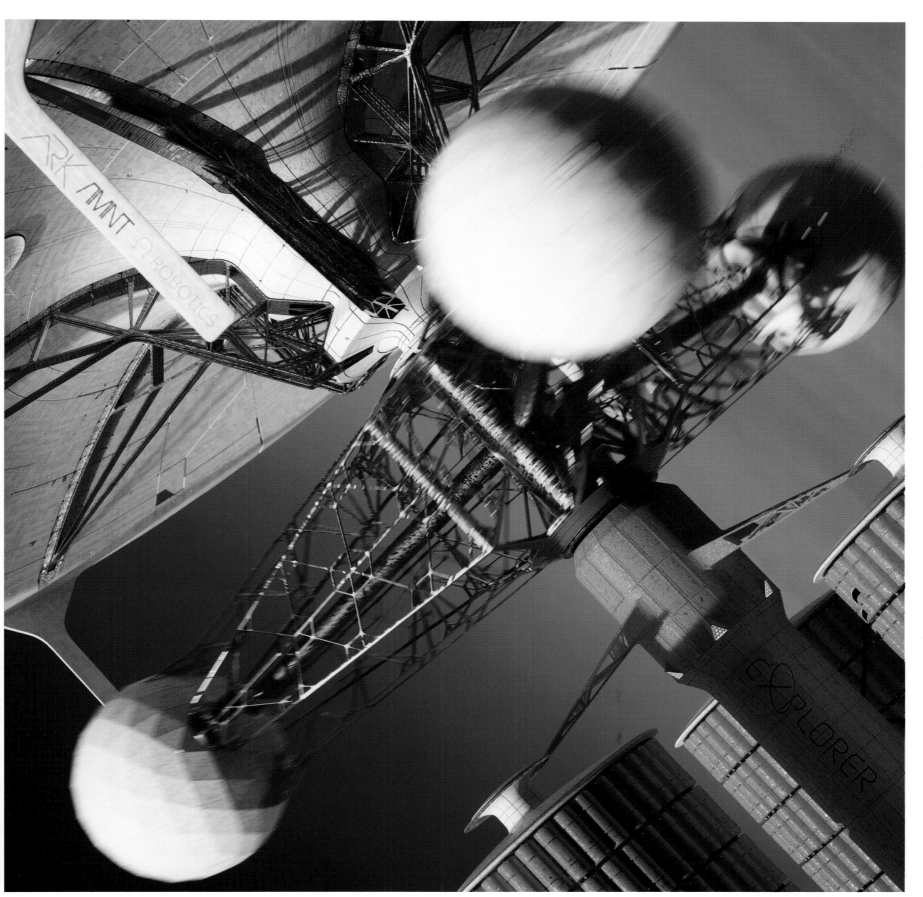

The Ark: Humankind's Last Hope

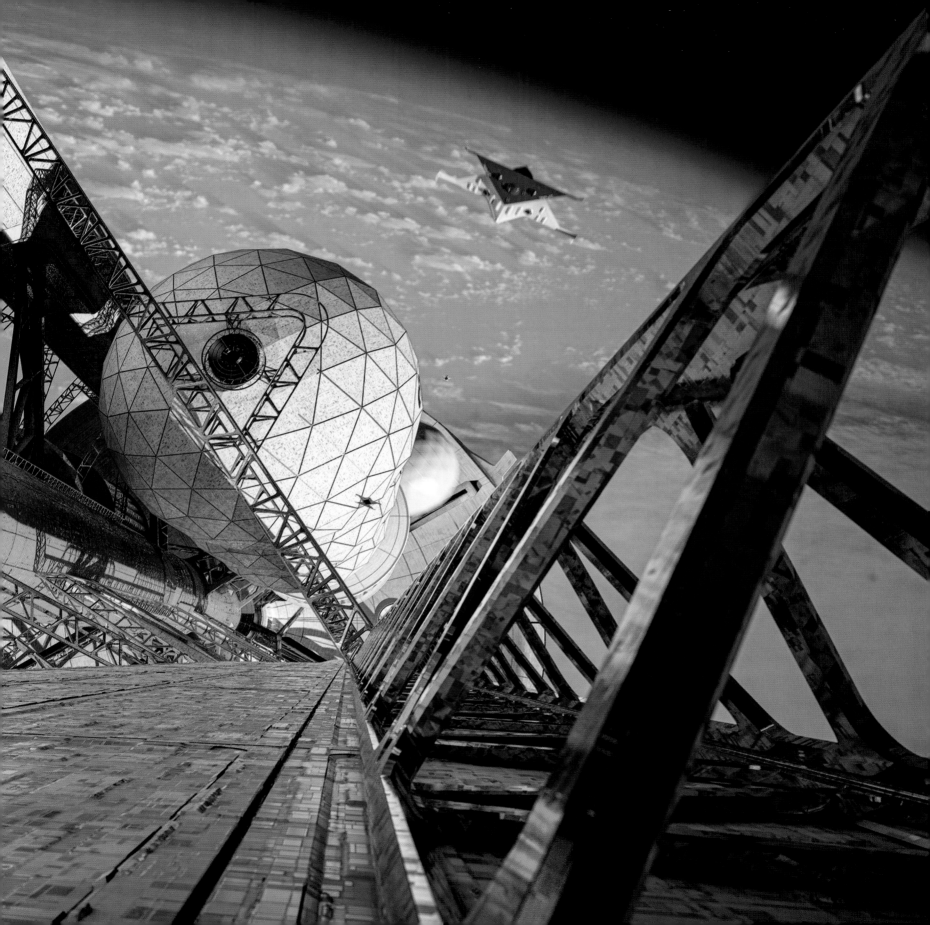

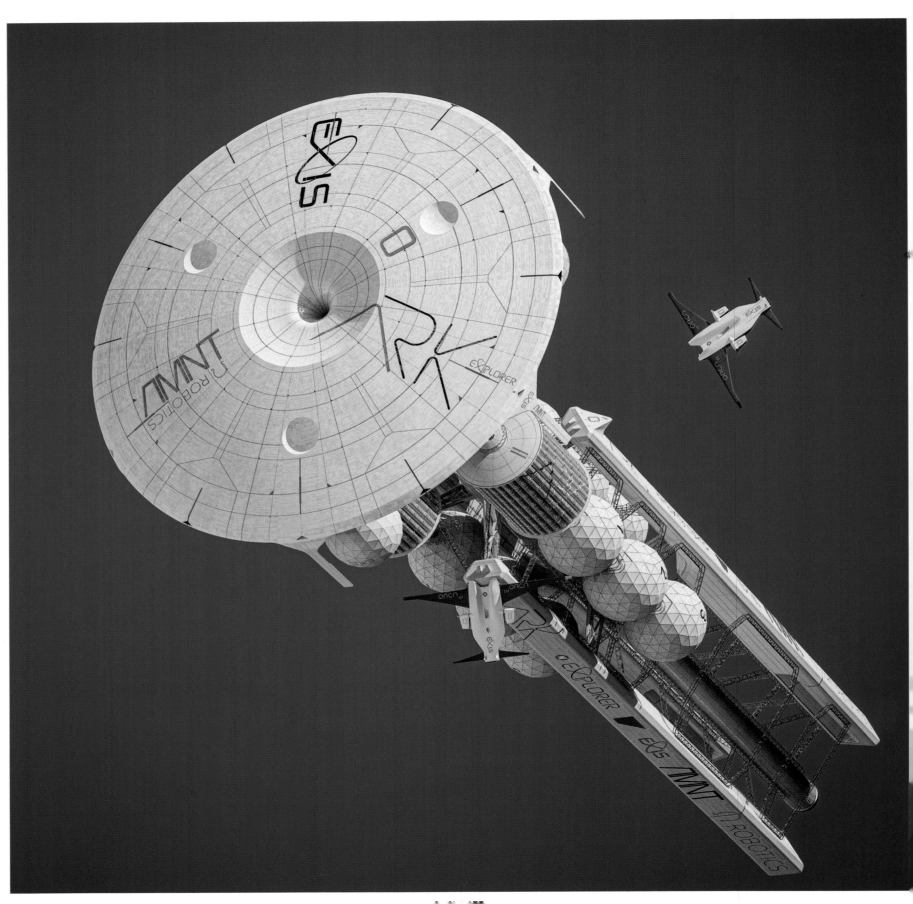

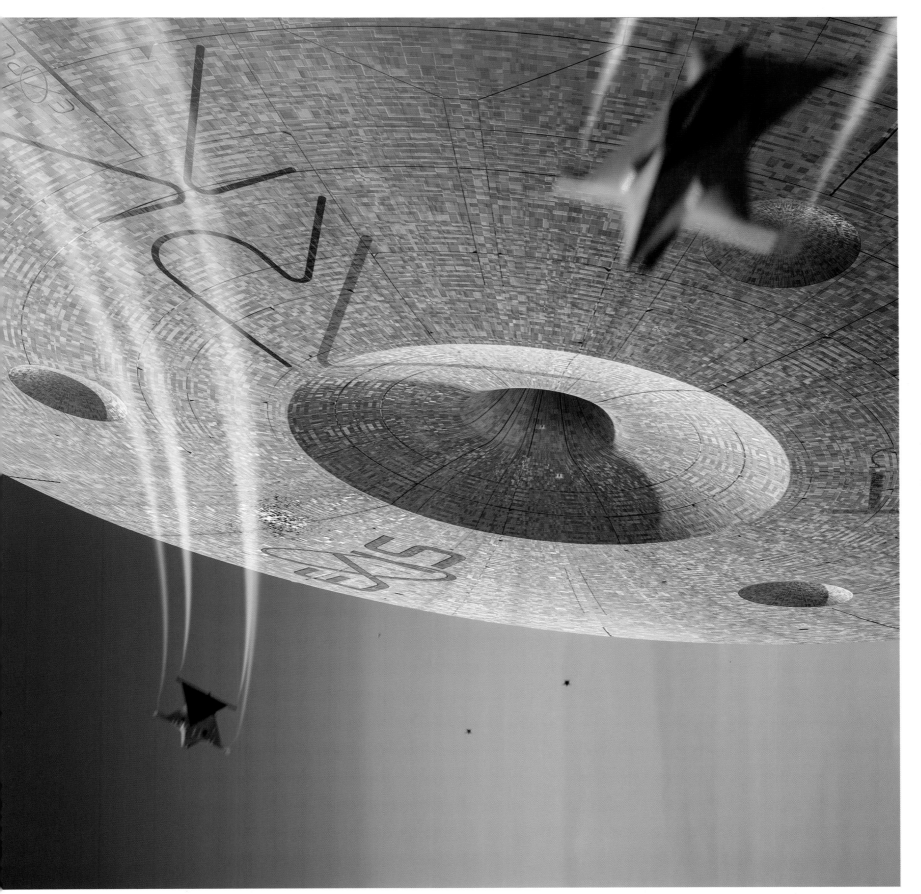

The Ark: Humankind's Last Hope

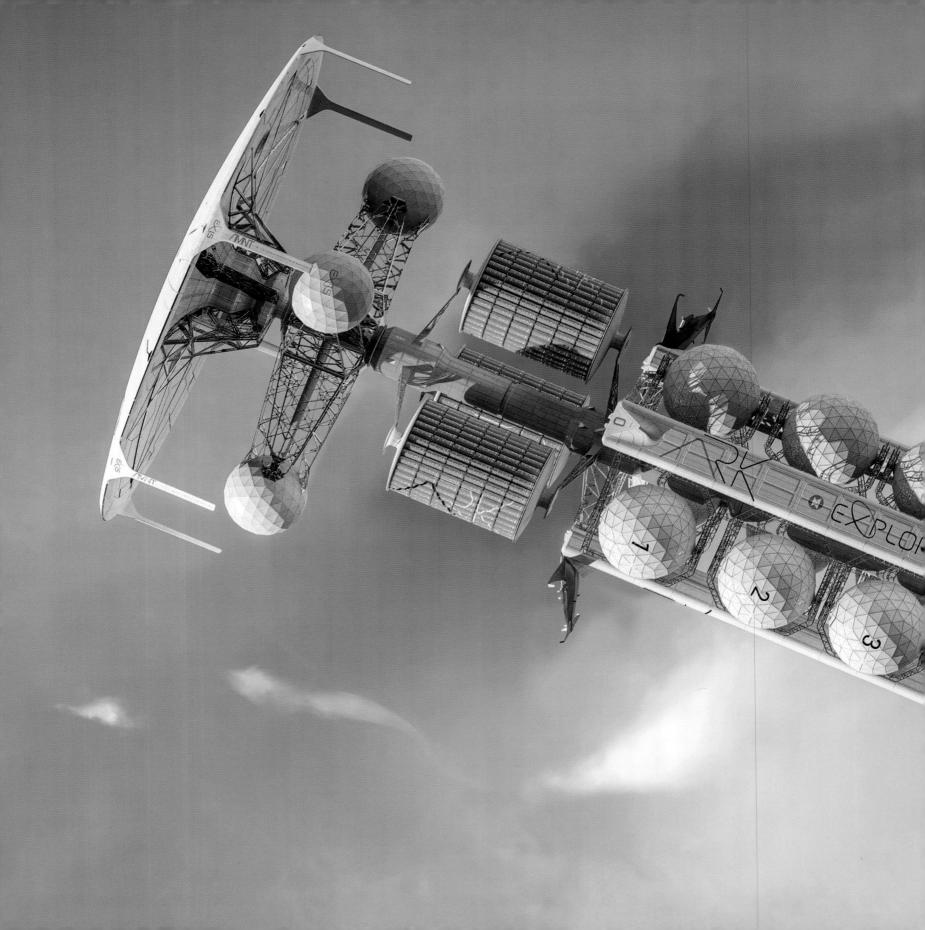

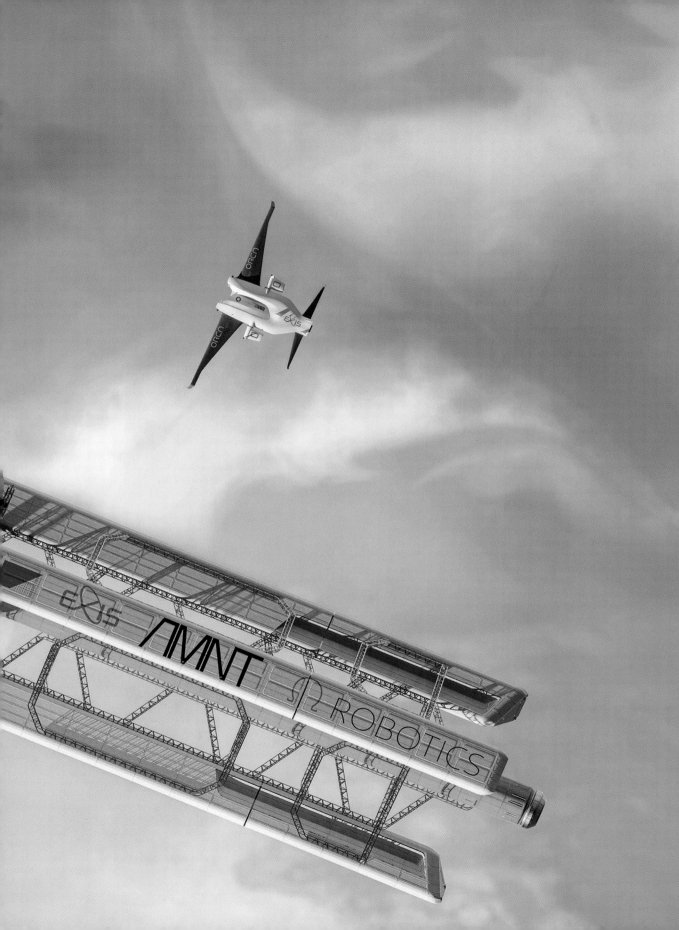

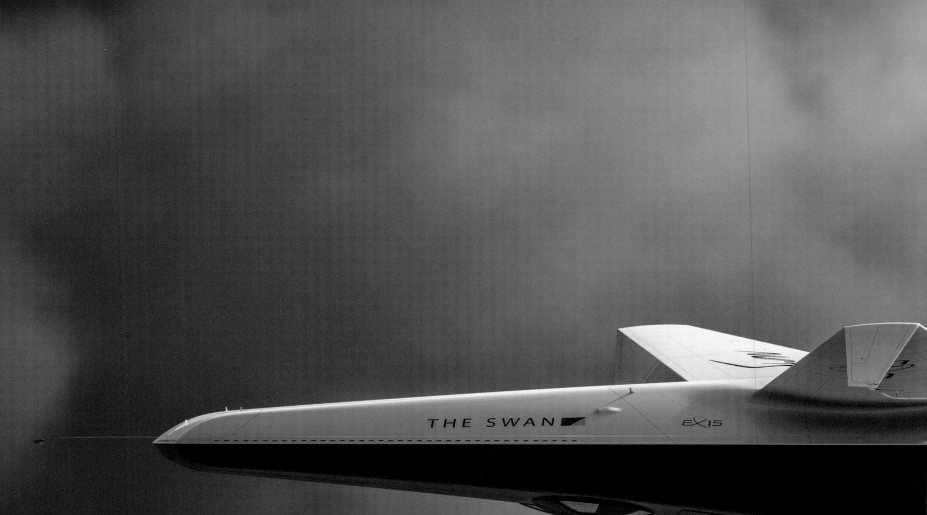

ORIGIN	: China	
PASSENGERS	: Up to 50,000	
LENGTH	: 700 m	: 765 yd.
HEIGHT	: 145 m	: 158 yd.
WIDTH	: 1,400 m	: 1,530 yd.
WEIGHT	: 6,500 t	: 7,165 tn.
SPEED	: 5,600 km/h	: 3,480 mph

The Swan
SPACE TRANSPORTER V1

The second-largest machine ever built, the Swan was originally a top-secret Chinese military project. In case of a war, the aircraft carrier could transport a very large number of vehicles and troops all over the world in a short time span. Under the supervision of O, three of these carriers (named Swans) were built and further developed to be functional in space. Each carrier was preloaded with the same equipment necessary to build the very first home base on a new planet in case one or two of the aircrafts malfunctioned. Equipped with 11 massive engines, eight were used for takeoff and landing. Because of their size, the Swans had to be attached outside the Ark so they could easily detach from it. They would be the first aircraft to land on the planet, after drones surveyed its environment for O.

IDEATION

When I did these sketches, the direction of flight from the Swan was the other way around as you can see from the direction of the thrusters. I changed my opinion about that when I had my first proportion model in Alias. And as you can see, I changed the propulsion system to a more futuristic one.

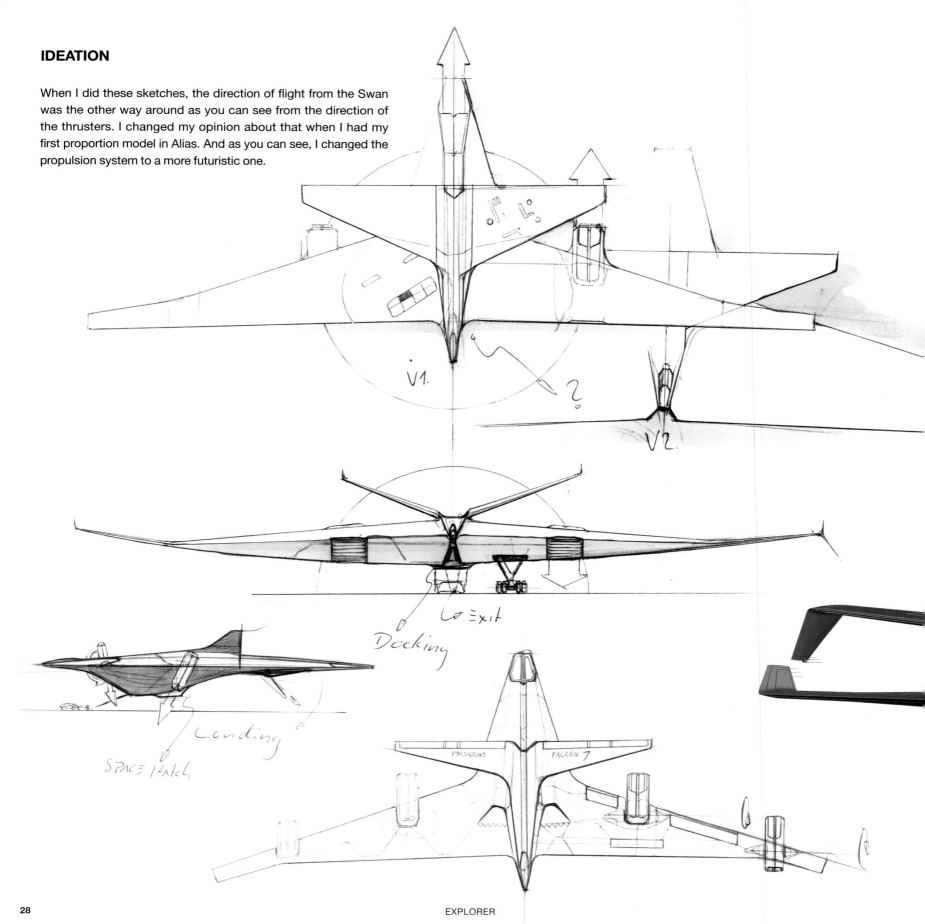

V1.

?

V2.

⌐ Exit

Docking

Landing

SPACE Hatch

PEREGRINE FALCON 7

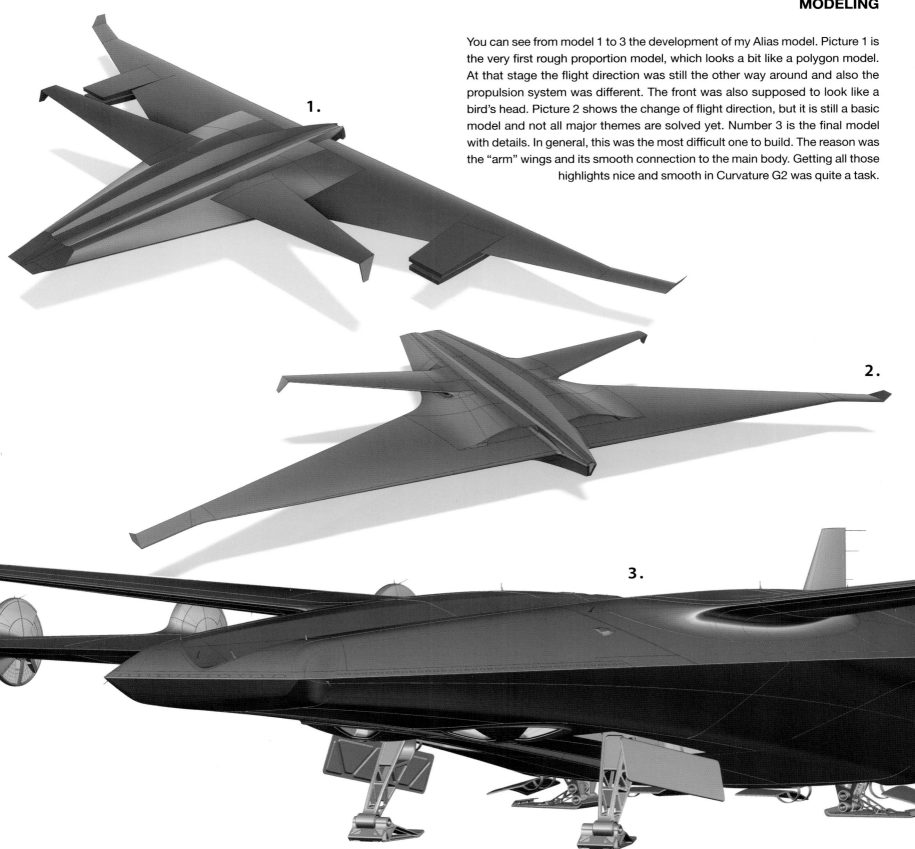

You can see from model 1 to 3 the development of my Alias model. Picture 1 is the very first rough proportion model, which looks a bit like a polygon model. At that stage the flight direction was still the other way around and also the propulsion system was different. The front was also supposed to look like a bird's head. Picture 2 shows the change of flight direction, but it is still a basic model and not all major themes are solved yet. Number 3 is the final model with details. In general, this was the most difficult one to build. The reason was the "arm" wings and its smooth connection to the main body. Getting all those highlights nice and smooth in Curvature G2 was quite a task.

1.

2.

3.

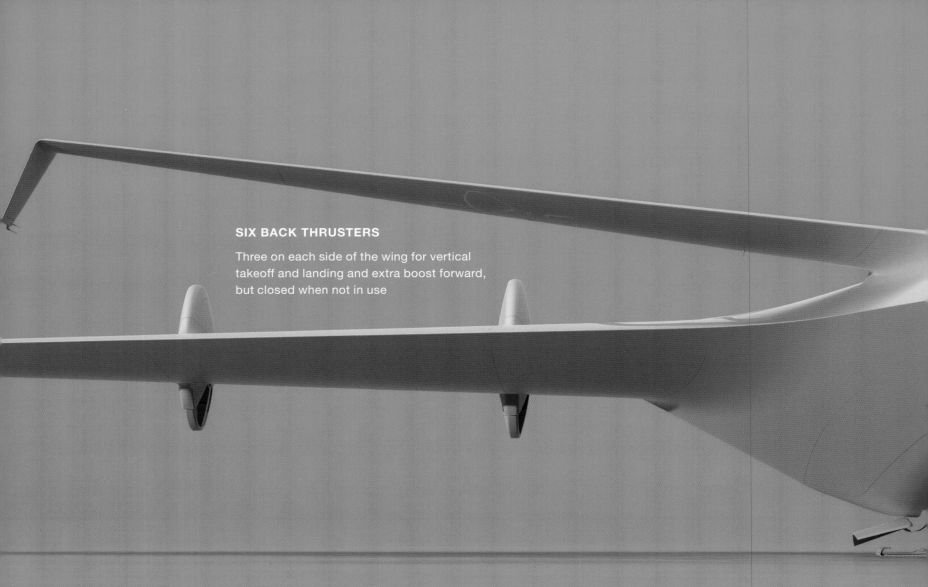

SIX BACK THRUSTERS

Three on each side of the wing for vertical
takeoff and landing and extra boost forward,
but closed when not in use

NOTE

*The Swan was my first space transporter concept. It would be loaded from
the back, to give it a more dynamic, arrow-like shape. I also had another
version in mind that would be loaded from the front, creating a strong
chest area with rotatable engines. I decided to build it as well, and you can
decide which one you like more! My overall design idea was a mono wing–
like aircraft with an additional layer below it, similar to a wingsuit. The first
version of the Swan was windowless. As humans, we are accustomed to
windows as size indicators. I decided to give my design some window-like
outlines, so the readers' eyes had something to relate to.*

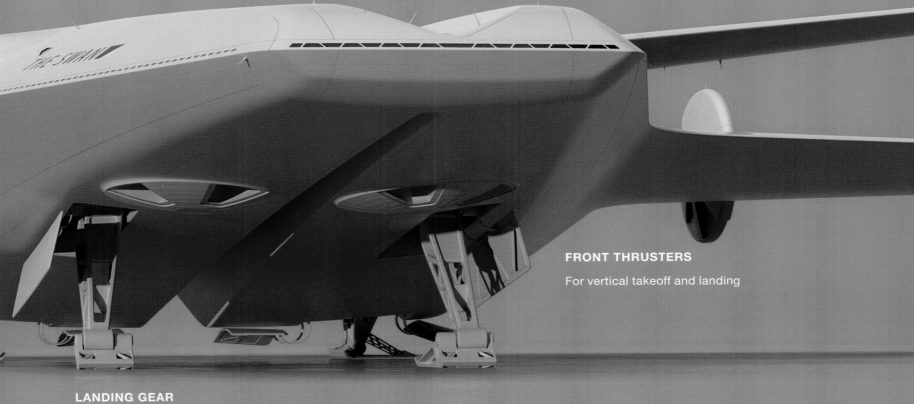

WINGSUIT ARMS

Mimics a person maneuvering through the air in a wingsuit

FRONT THRUSTERS

For vertical takeoff and landing

LANDING GEAR

Features workable hatches and pivot points

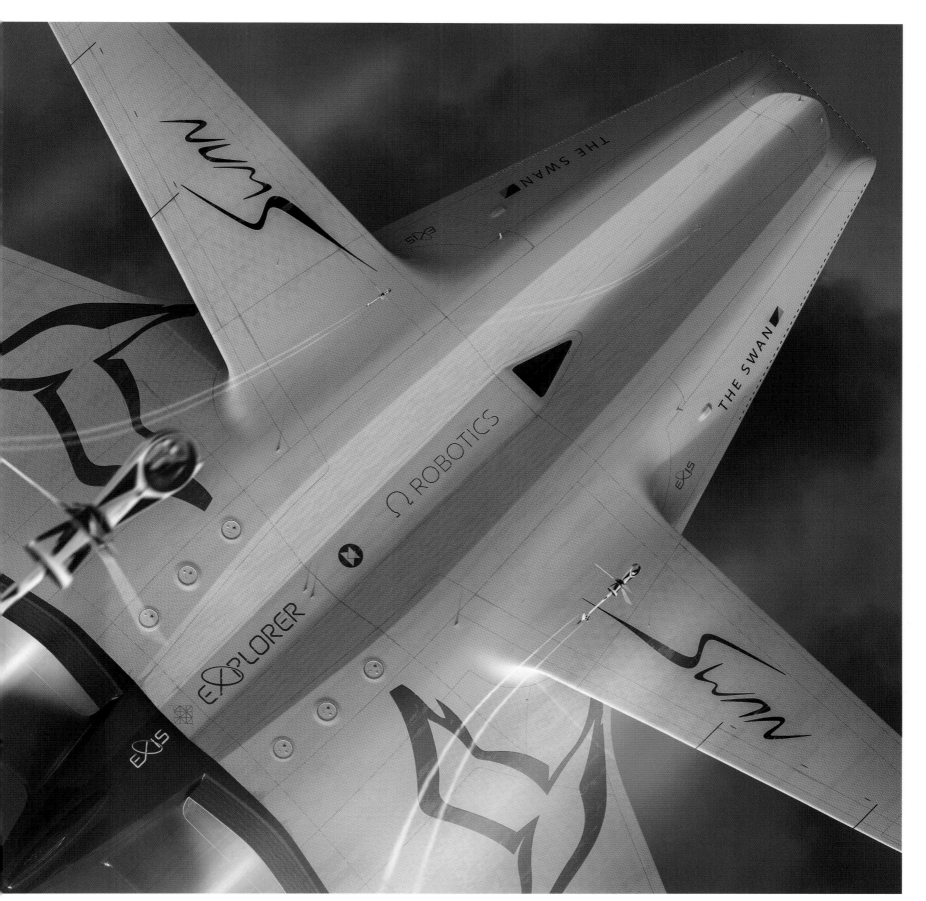

The Swan: Space Transporter V1

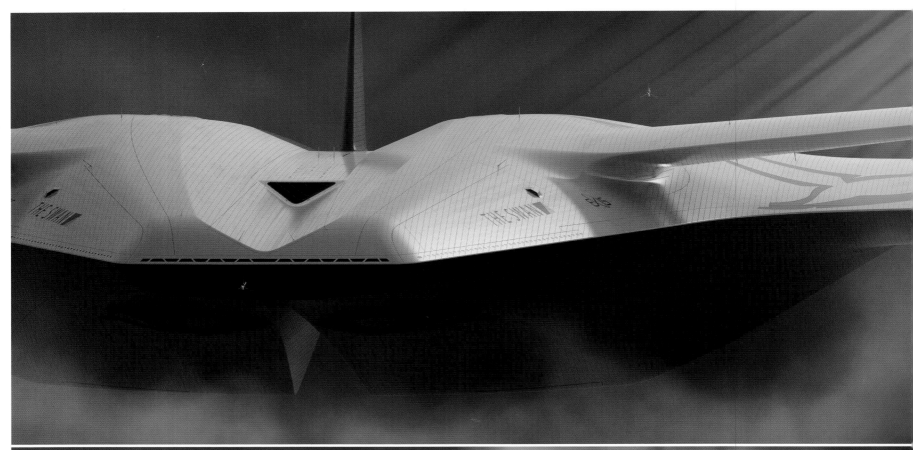

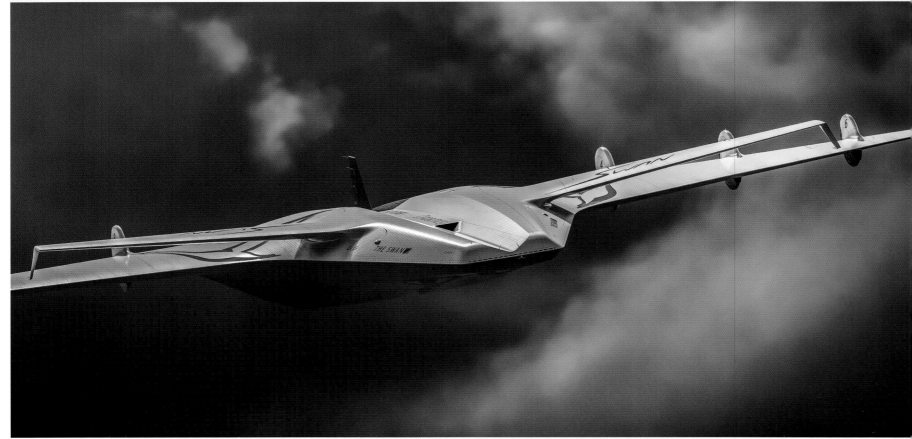

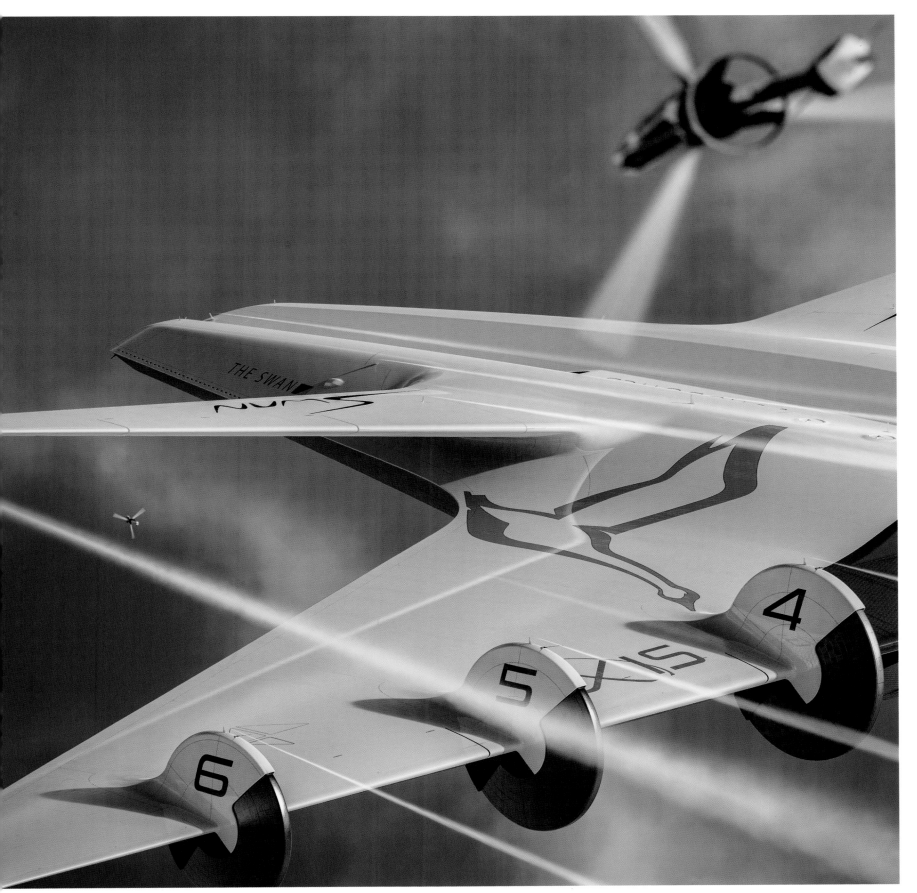

The Swan: Space Transporter V1

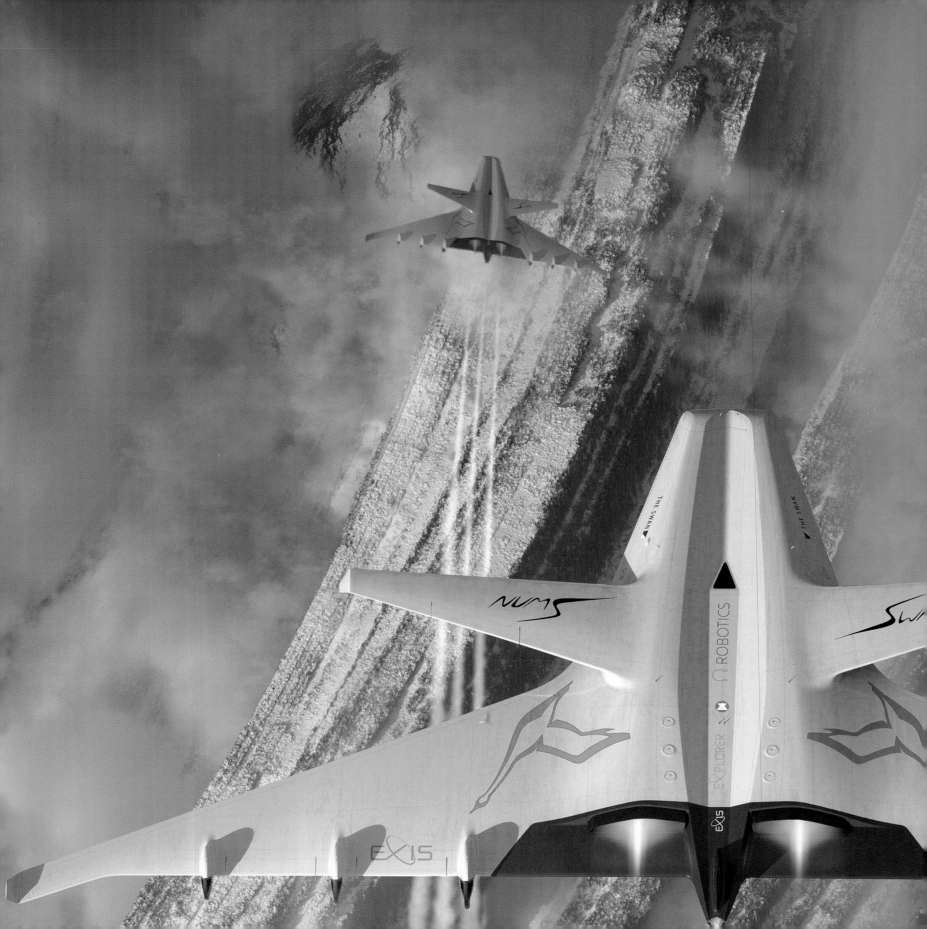

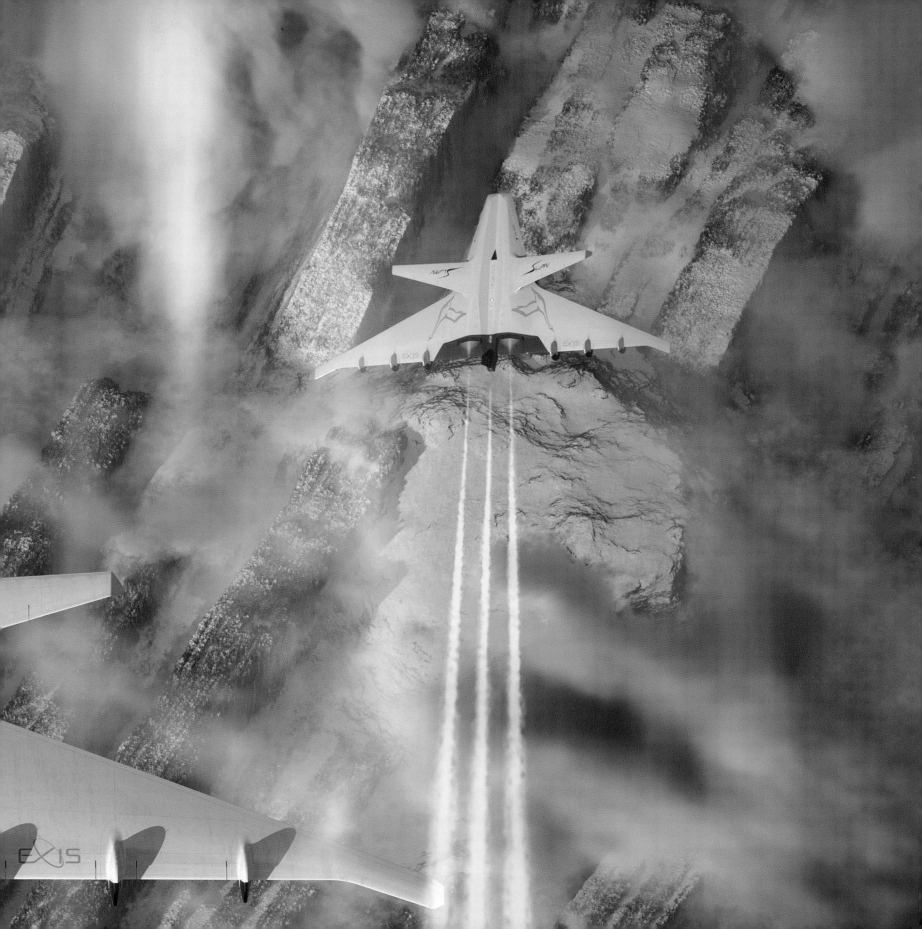

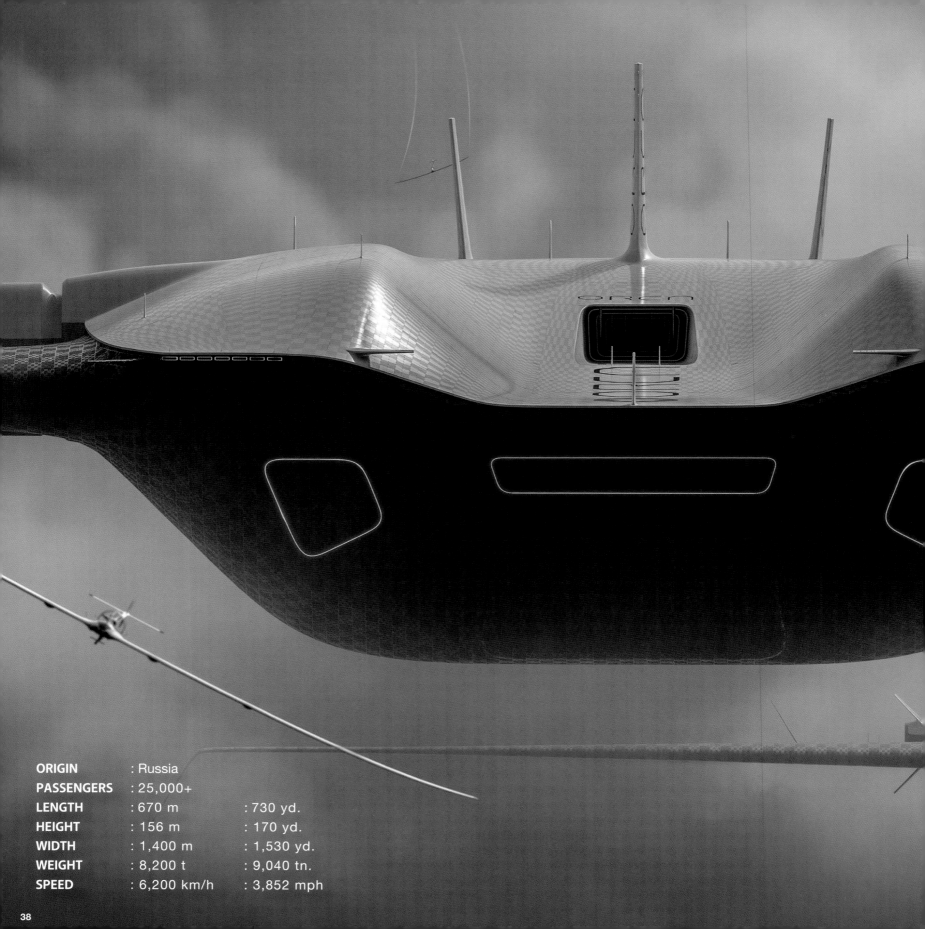

ORIGIN	: Russia	
PASSENGERS	: 25,000+	
LENGTH	: 670 m	: 730 yd.
HEIGHT	: 156 m	: 170 yd.
WIDTH	: 1,400 m	: 1,530 yd.
WEIGHT	: 8,200 t	: 9,040 tn.
SPEED	: 6,200 km/h	: 3,852 mph

The Orca
SPACE TRANSPORTER V2

The original Orca was a classified Russian mass stratosphere transporter with a similar purpose to China's Swan. It was supposed to bring large numbers of Russian troops, vehicles, and equipment as fast as possible via the stratosphere from point A to B, but its initial design was unable to successfully take flight. With some adjustments to the aerodynamics, and using a newly developed material based on spider silk in combination with graphene, and an improved propulsion system based on a fusion drive, O was able to make it fly. As with the Swan, space transporters were built and preloaded with human and plant DNA, vehicles, and equipment to build a first settlement. Its three main engines are able to rotate 110 degrees for vertical takeoff and landing.

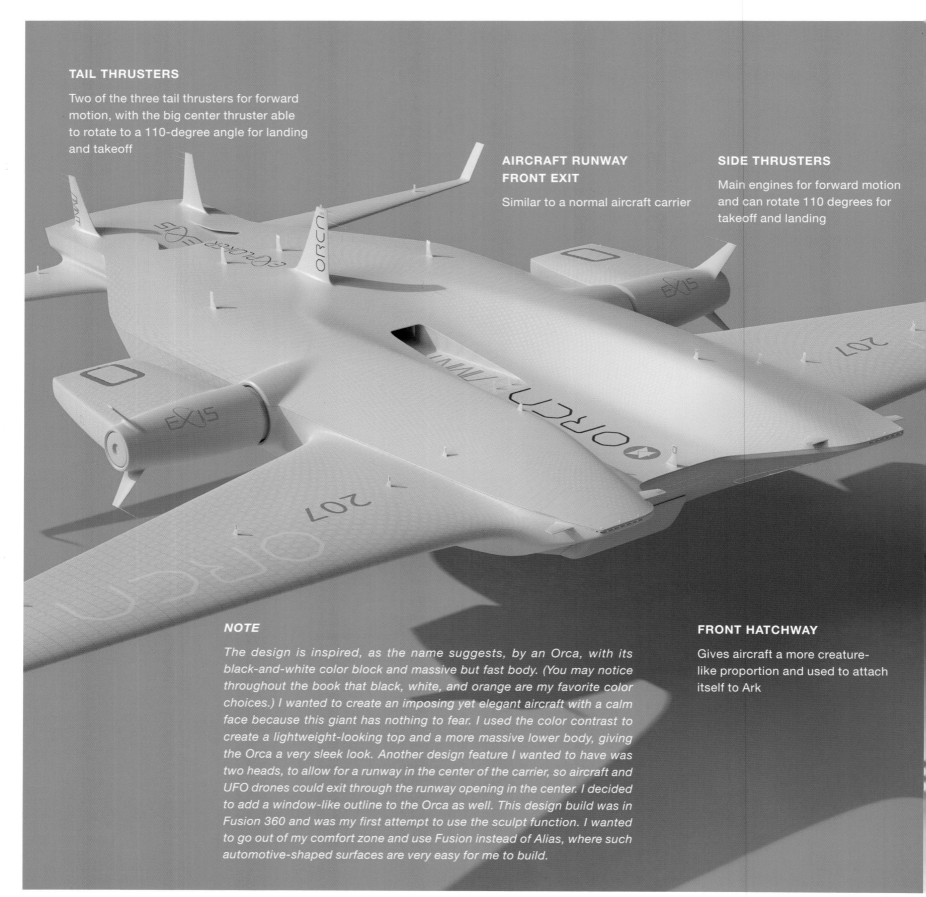

TAIL THRUSTERS

Two of the three tail thrusters for forward motion, with the big center thruster able to rotate to a 110-degree angle for landing and takeoff

AIRCRAFT RUNWAY FRONT EXIT

Similar to a normal aircraft carrier

SIDE THRUSTERS

Main engines for forward motion and can rotate 110 degrees for takeoff and landing

FRONT HATCHWAY

Gives aircraft a more creature-like proportion and used to attach itself to Ark

NOTE

The design is inspired, as the name suggests, by an Orca, with its black-and-white color block and massive but fast body. (You may notice throughout the book that black, white, and orange are my favorite color choices.) I wanted to create an imposing yet elegant aircraft with a calm face because this giant has nothing to fear. I used the color contrast to create a lightweight-looking top and a more massive lower body, giving the Orca a very sleek look. Another design feature I wanted to have was two heads, to allow for a runway in the center of the carrier, so aircraft and UFO drones could exit through the runway opening in the center. I decided to add a window-like outline to the Orca as well. This design build was in Fusion 360 and was my first attempt to use the sculpt function. I wanted to go out of my comfort zone and use Fusion instead of Alias, where such automotive-shaped surfaces are very easy for me to build.

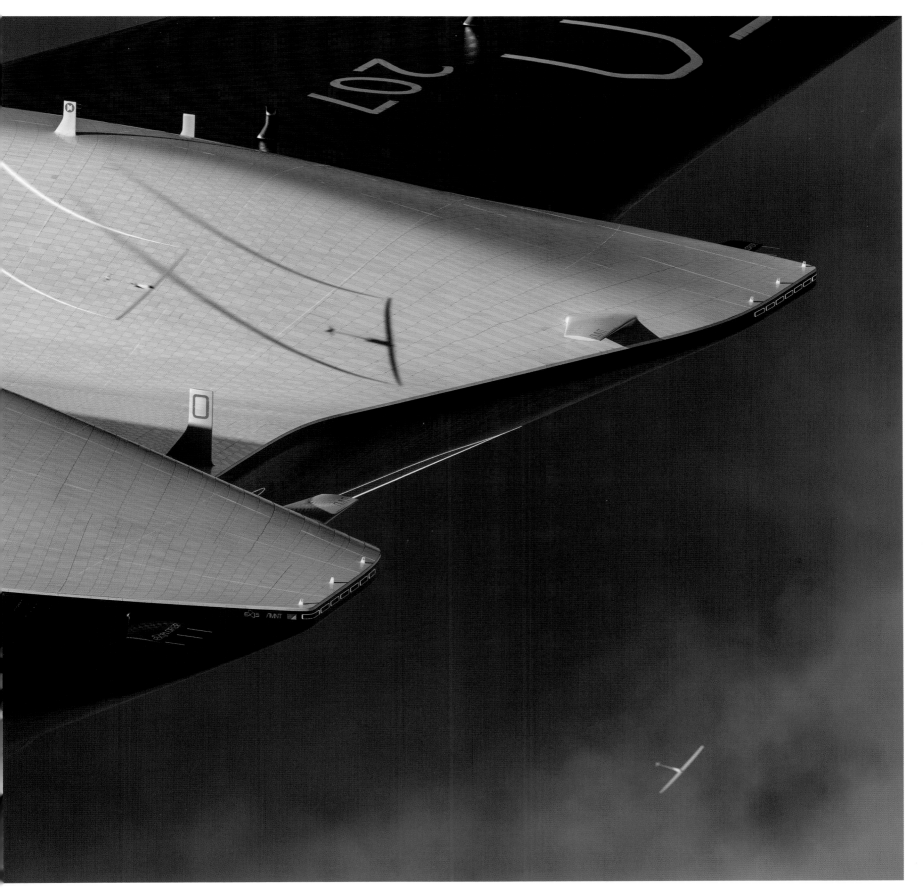

The Orca: Space Transporter V2

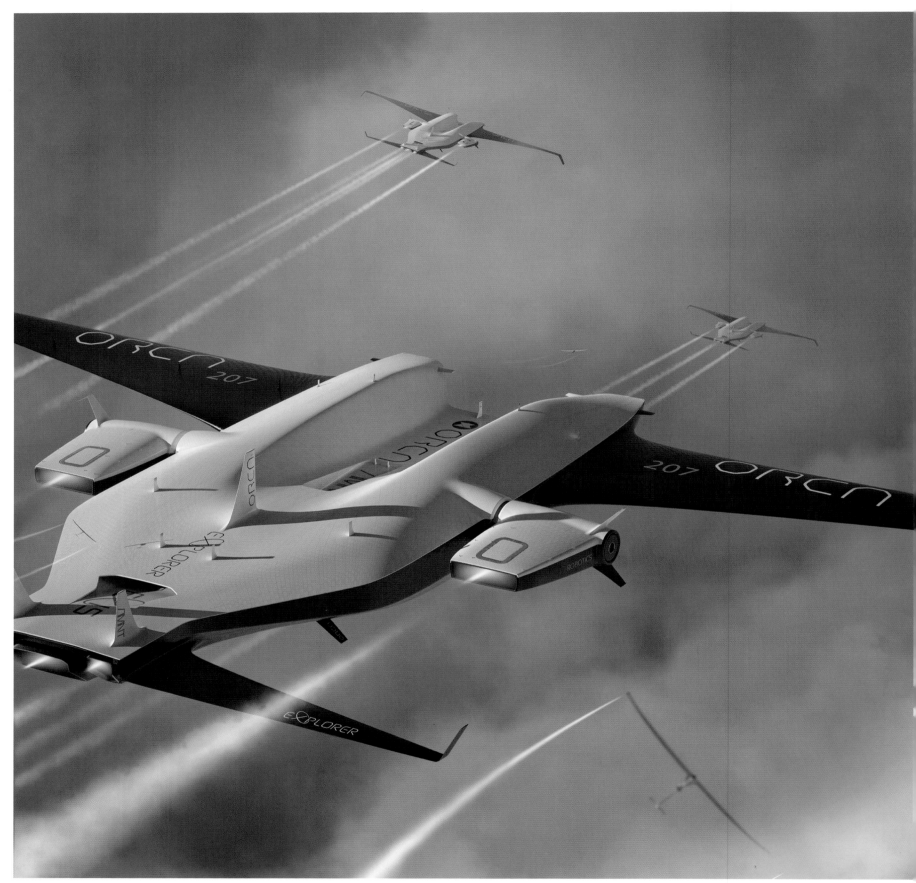

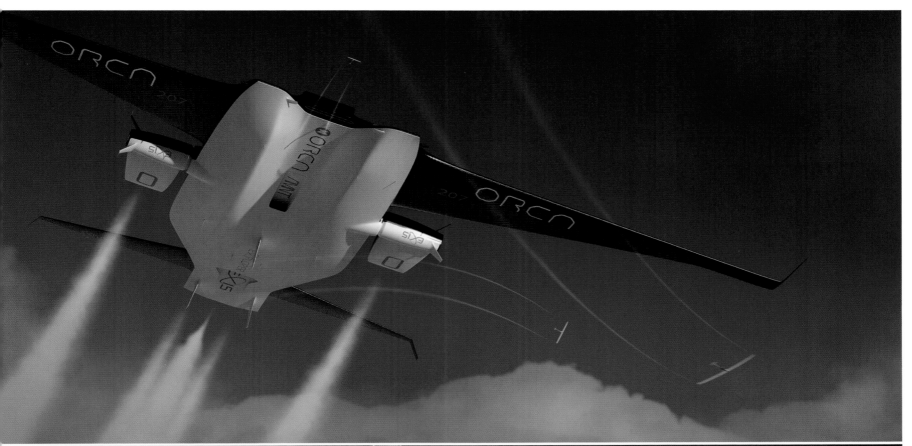

The Orca: Space Transporter V2

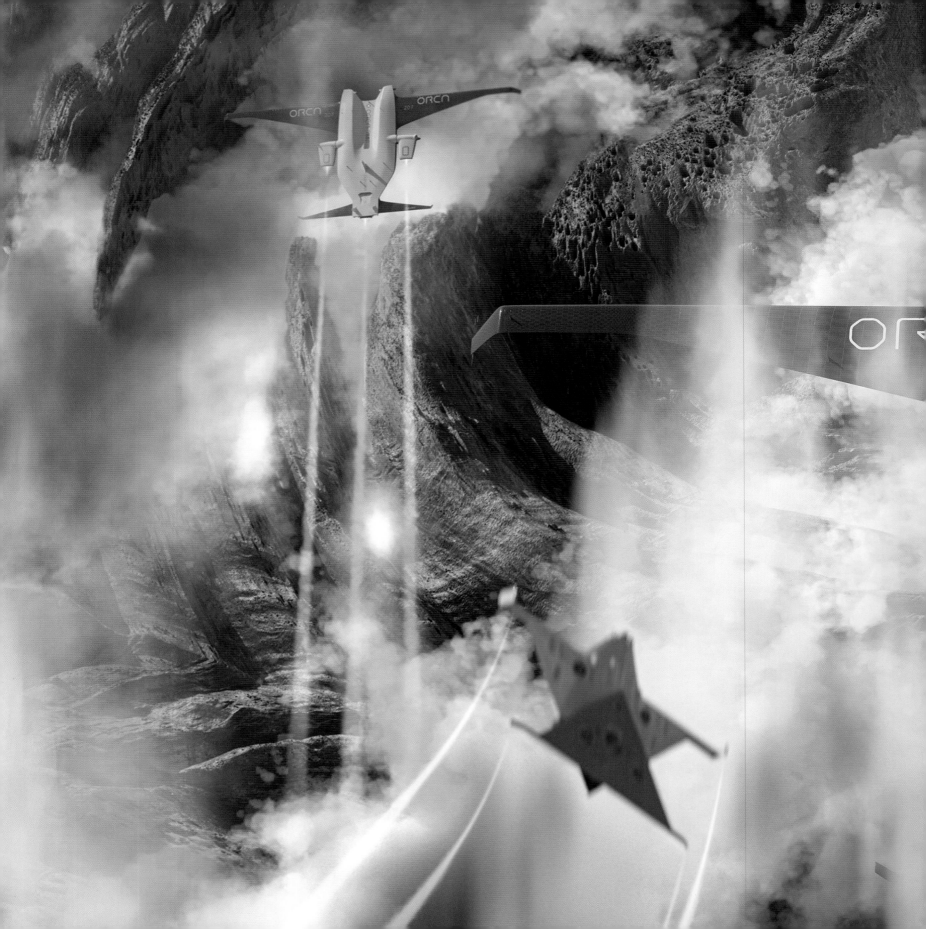

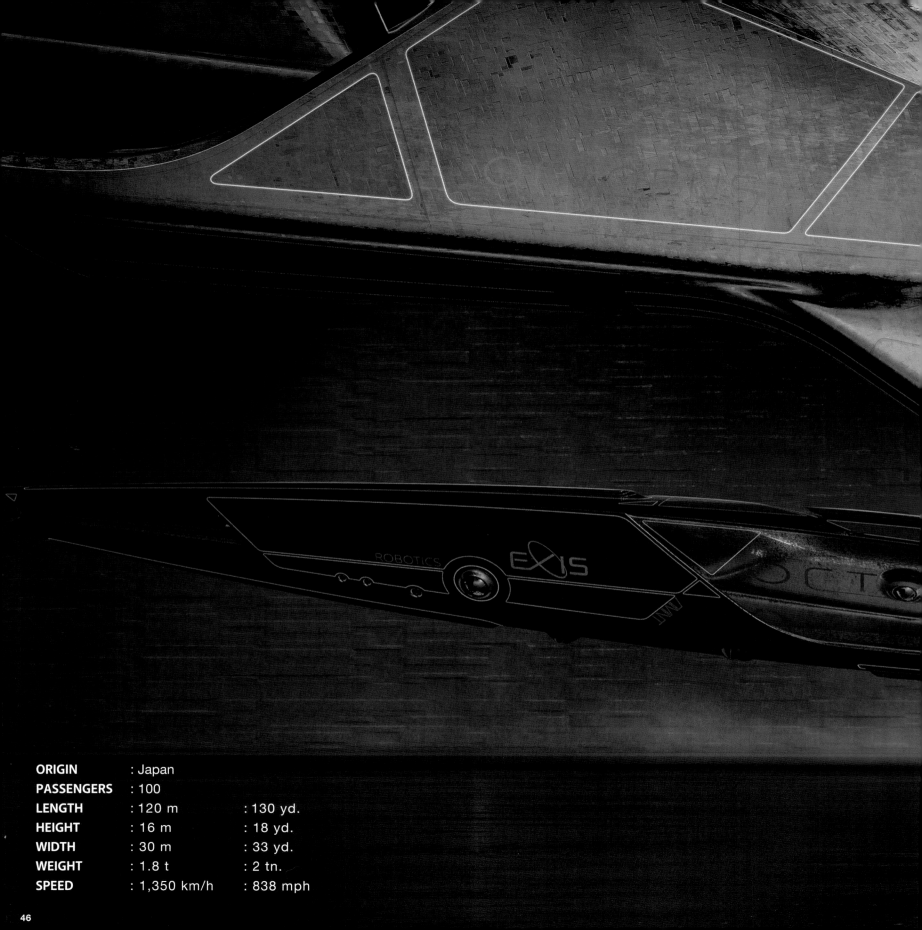

ORIGIN	: Japan	
PASSENGERS	: 100	
LENGTH	: 120 m	: 130 yd.
HEIGHT	: 16 m	: 18 yd.
WIDTH	: 30 m	: 33 yd.
WEIGHT	: 1.8 t	: 2 tn.
SPEED	: 1,350 km/h	: 838 mph

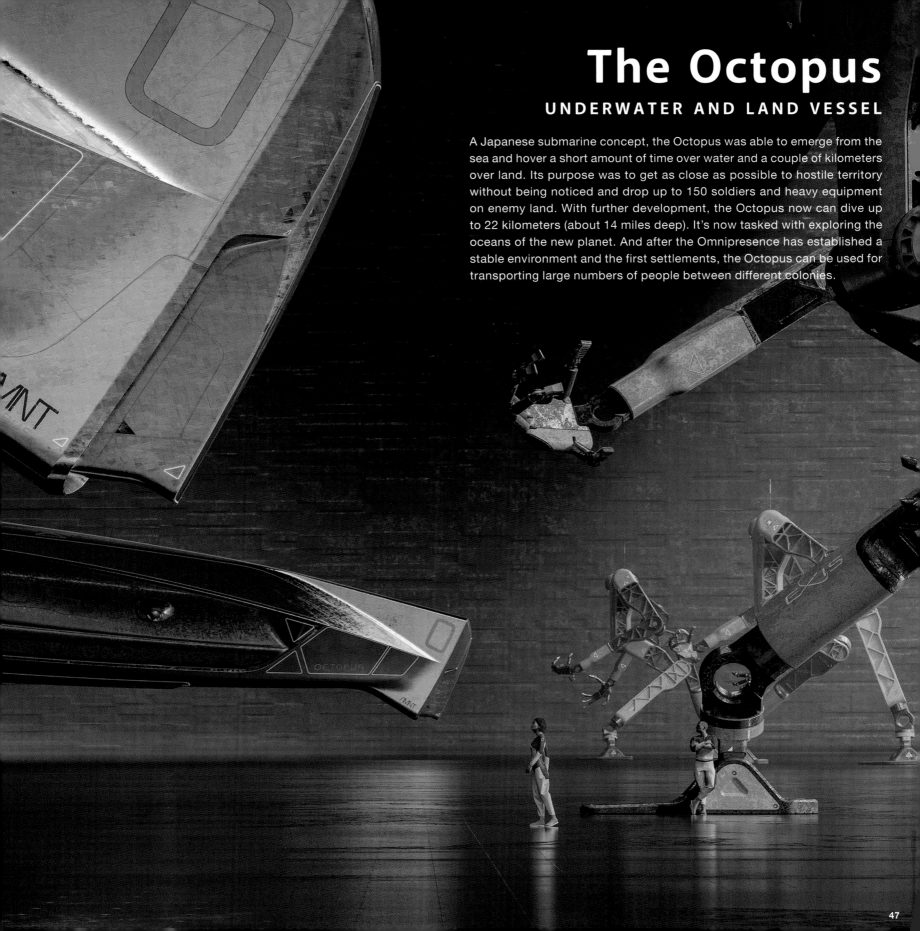

The Octopus
UNDERWATER AND LAND VESSEL

A Japanese submarine concept, the Octopus was able to emerge from the sea and hover a short amount of time over water and a couple of kilometers over land. Its purpose was to get as close as possible to hostile territory without being noticed and drop up to 150 soldiers and heavy equipment on enemy land. With further development, the Octopus now can dive up to 22 kilometers (about 14 miles deep). It's now tasked with exploring the oceans of the new planet. And after the Omnipresence has established a stable environment and the first settlements, the Octopus can be used for transporting large numbers of people between different colonies.

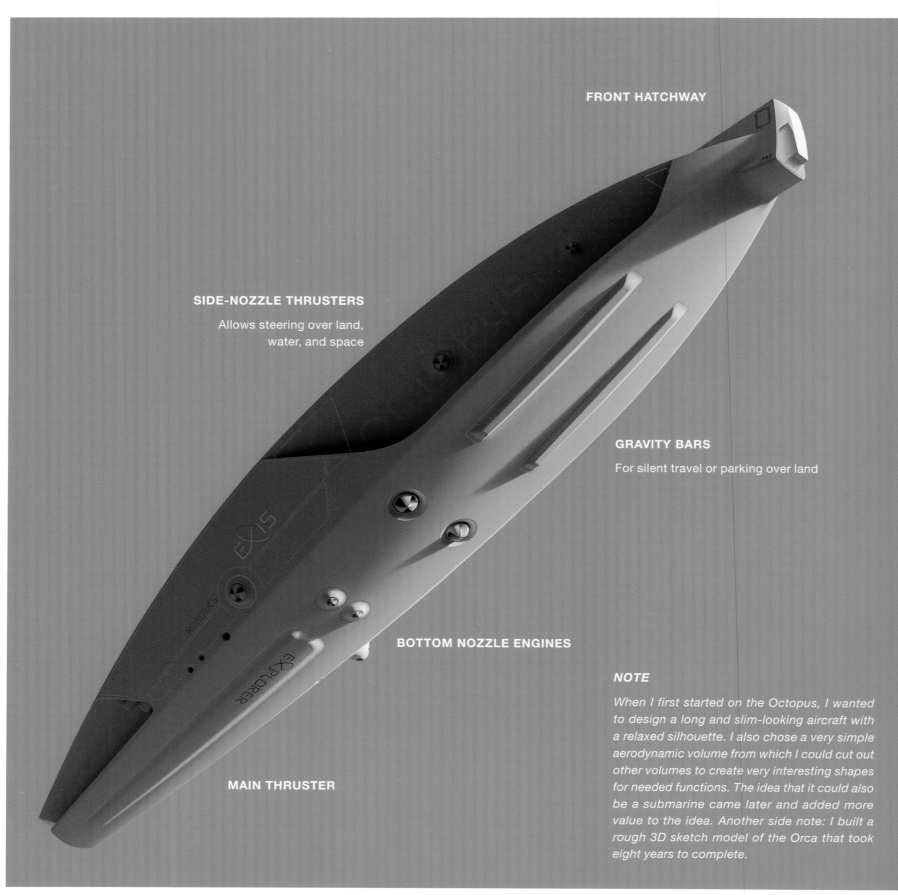

FRONT HATCHWAY

SIDE-NOZZLE THRUSTERS

Allows steering over land,
water, and space

GRAVITY BARS

For silent travel or parking over land

BOTTOM NOZZLE ENGINES

NOTE

*When I first started on the Octopus, I wanted
to design a long and slim-looking aircraft with
a relaxed silhouette. I also chose a very simple
aerodynamic volume from which I could cut out
other volumes to create very interesting shapes
for needed functions. The idea that it could also
be a submarine came later and added more
value to the idea. Another side note: I built a
rough 3D sketch model of the Orca that took
eight years to complete.*

MAIN THRUSTER

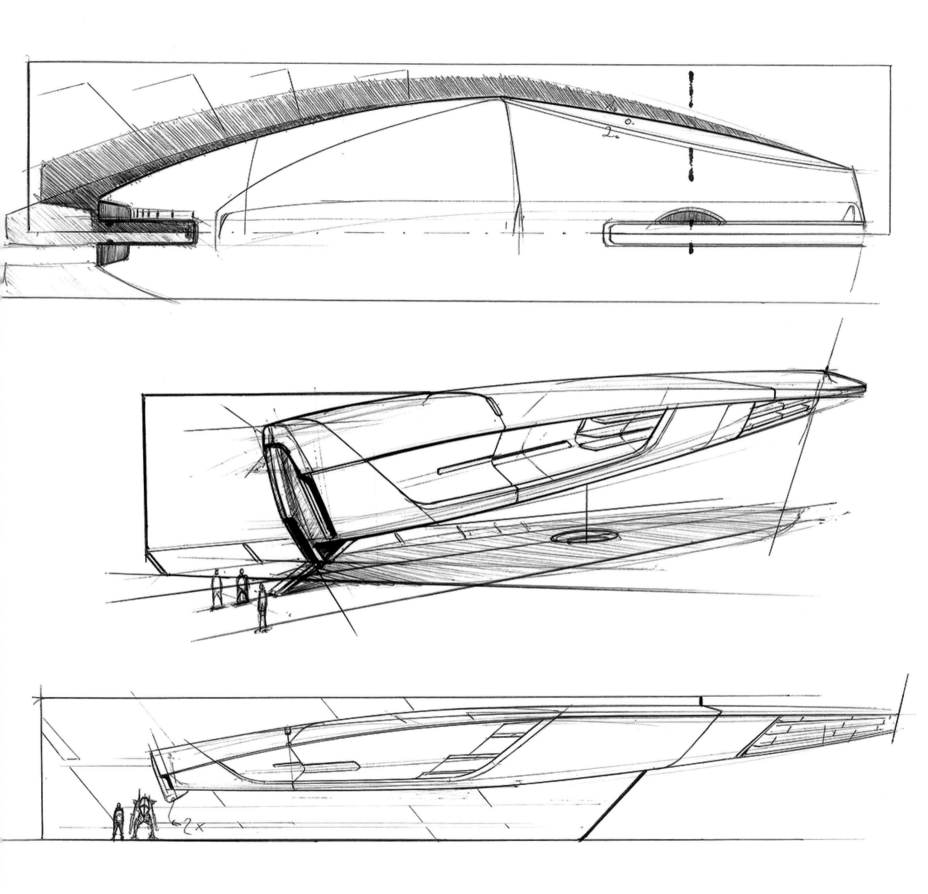

The Octopus: Underwater and Land Vessel

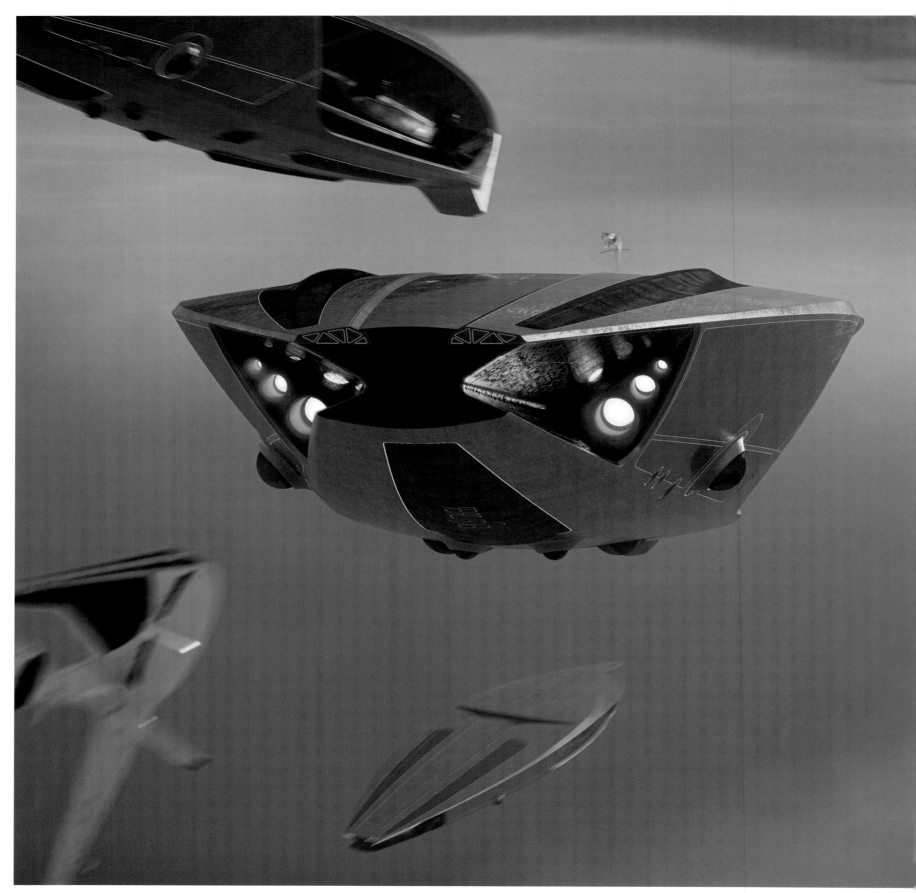

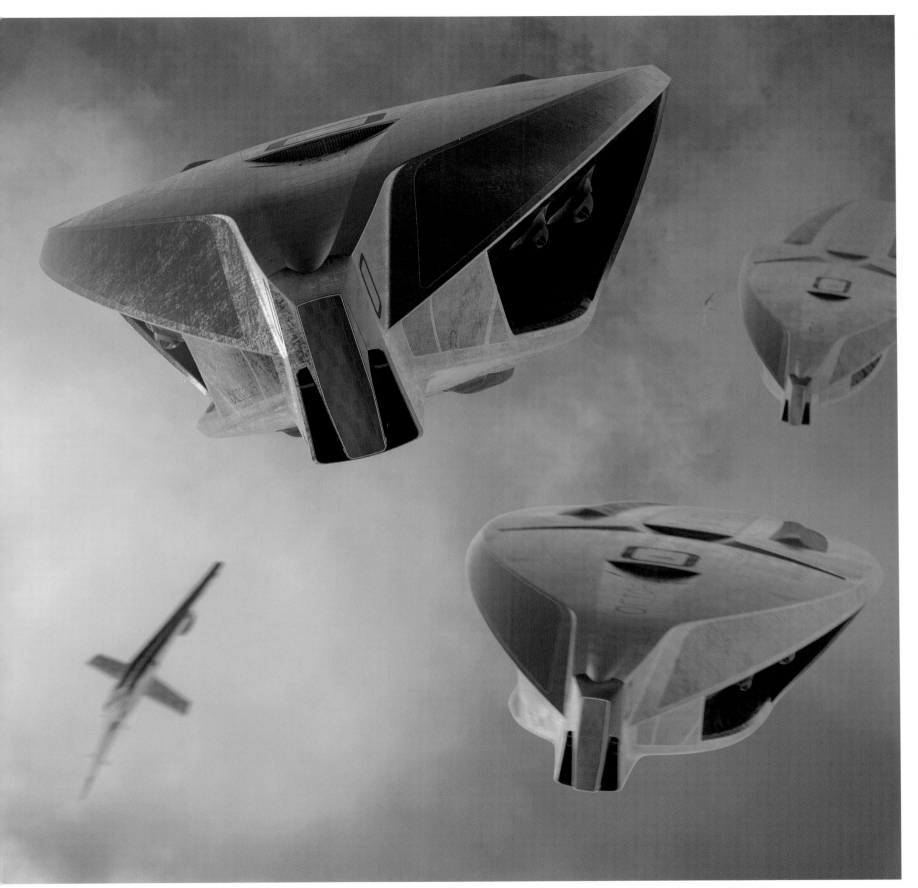

The Octopus: Underwater and Land Vessel

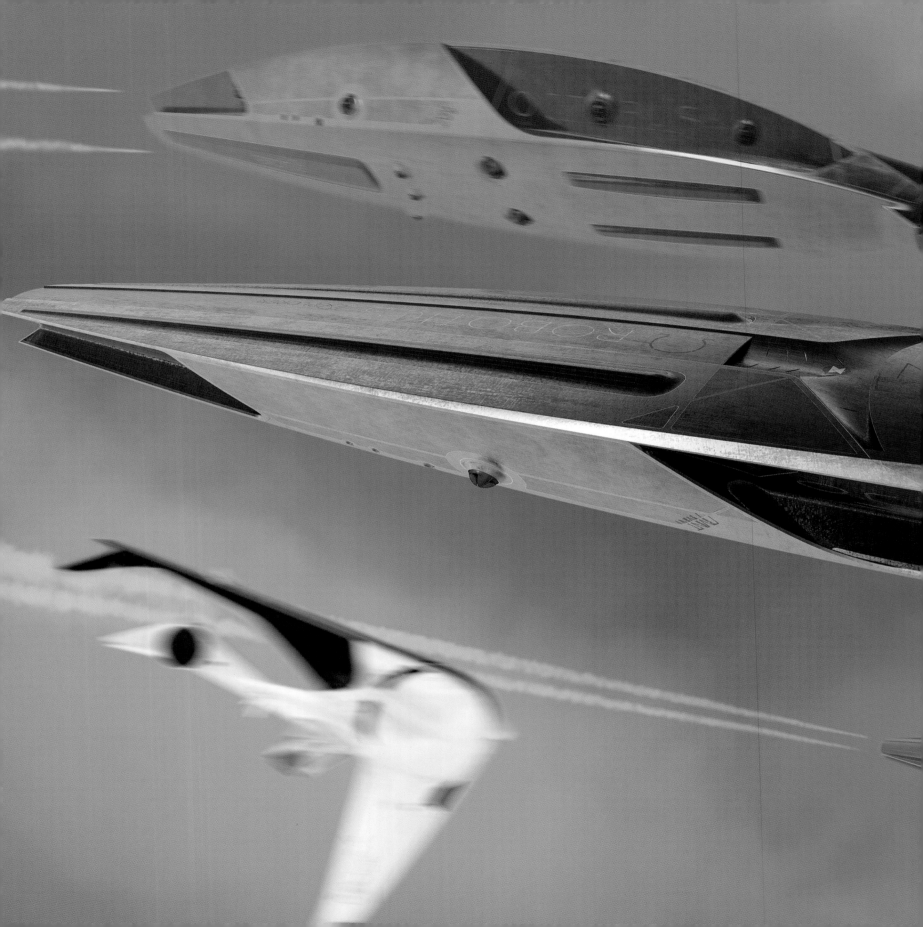

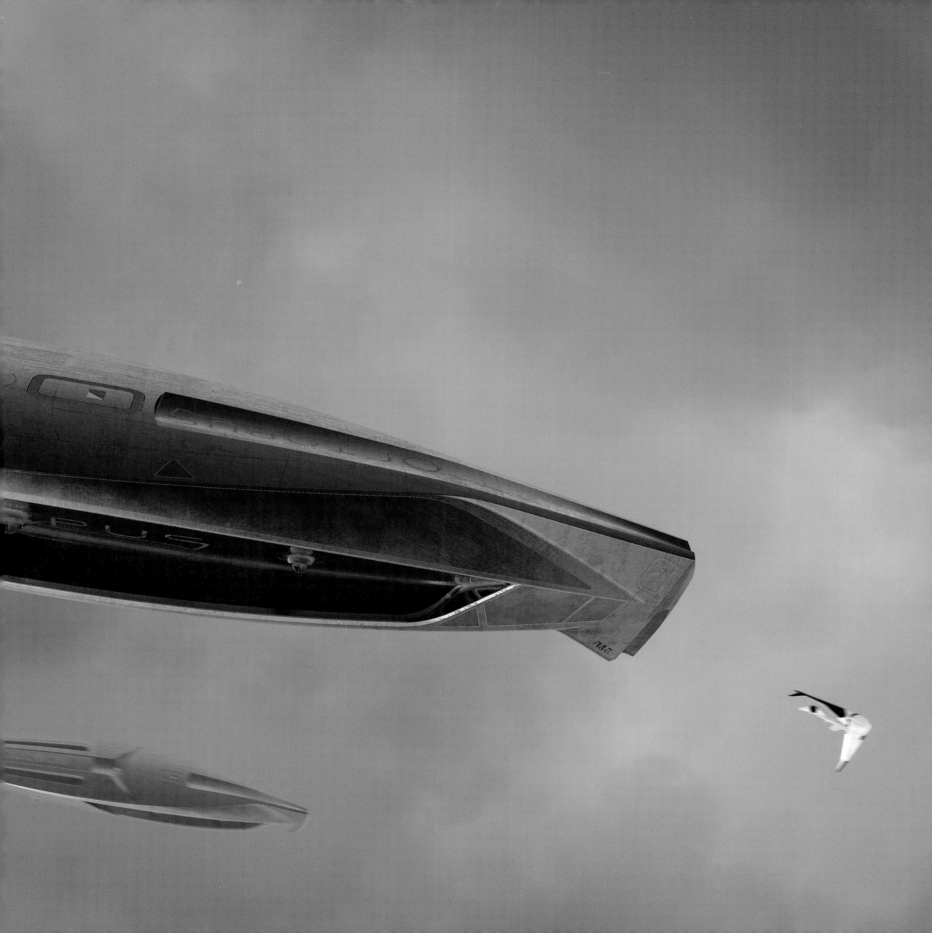

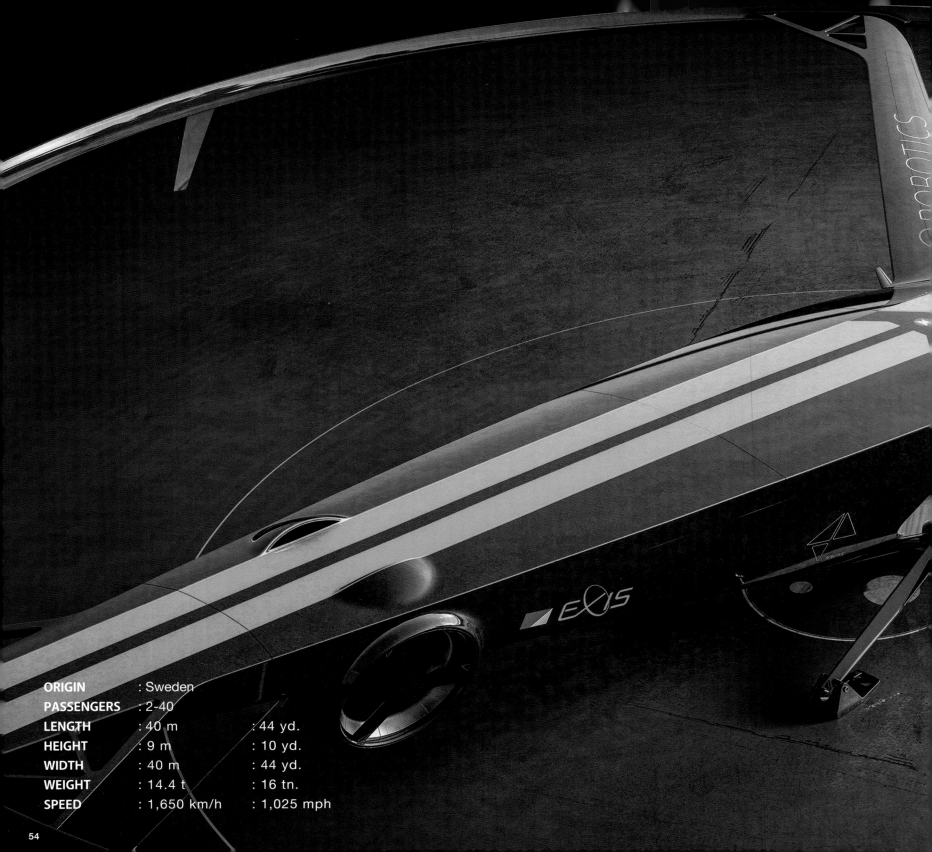

ORIGIN	: Sweden	
PASSENGERS	: 2-40	
LENGTH	: 40 m	: 44 yd.
HEIGHT	: 9 m	: 10 yd.
WIDTH	: 40 m	: 44 yd.
WEIGHT	: 14.4 t	: 16 tn.
SPEED	: 1,650 km/h	: 1,025 mph

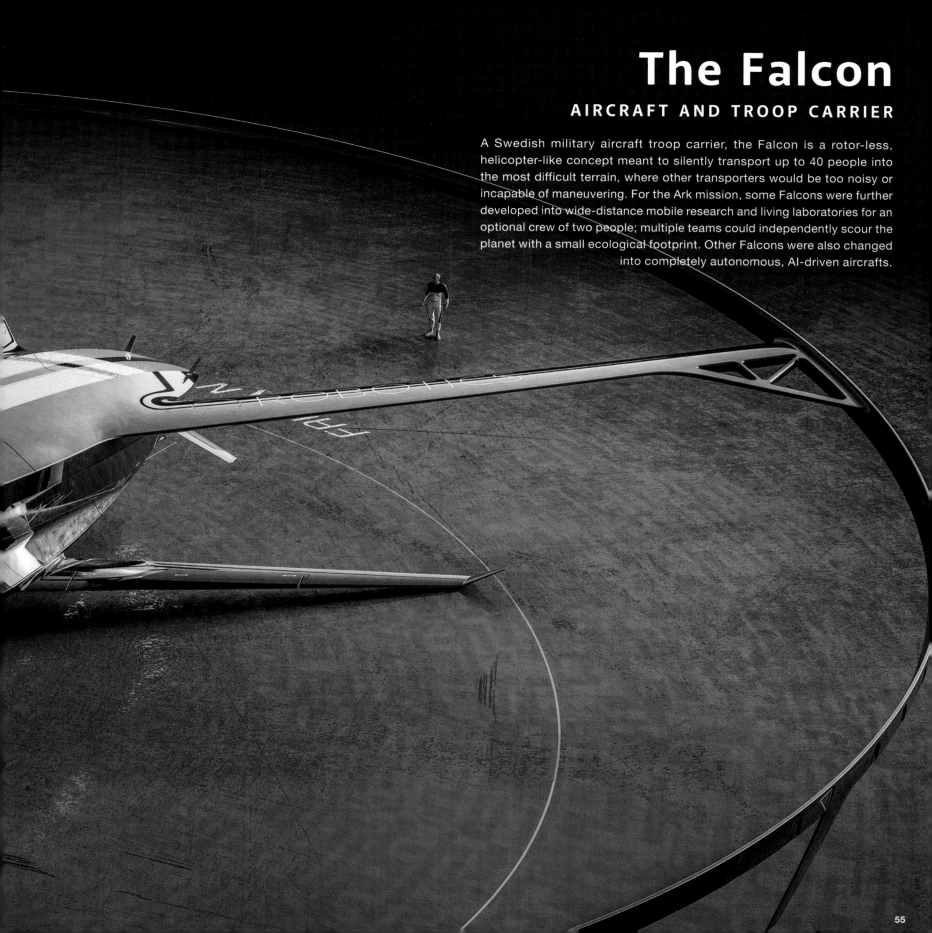

The Falcon

AIRCRAFT AND TROOP CARRIER

A Swedish military aircraft troop carrier, the Falcon is a rotor-less, helicopter-like concept meant to silently transport up to 40 people into the most difficult terrain, where other transporters would be too noisy or incapable of maneuvering. For the Ark mission, some Falcons were further developed into wide-distance mobile research and living laboratories for an optional crew of two people; multiple teams could independently scour the planet with a small ecological footprint. Other Falcons were also changed into completely autonomous, AI-driven aircrafts.

TAIL ROTOR

I decided to go with a more traditional rotor design compared to my Dyson-inspired main rotor design. Because I like the idea of having some moving parts, they would give it a more dynamic appeal in case of an animation.

FLEX FLAPS

The idea and concepts for my flexible wing flaps do already exist. A friend of mine showed it to me after he saw my concept.

TROOP ENTRY HATCH

I haven't fully designed the Falcon interior yet. I just built a rough volume to estimate the space and where I could put seats and equipment. But it was important to know where you can get in and out of the design.

NOTE

My starting point for the Falcon was the bladeless fan from Dyson. My top view of the vehicle was already a big, circular, thin shape. For the side view, I had a very dynamic and aggressive silhouette in mind, like that of a falcon or sea eagle hunting prey. The same applied to the face, aggressive-looking; you should get the feeling the Falcon would attack at any second. I tried from the very beginning to integrate the wings with a single feature line into the overall design, as they would be very dominant. As with all of the designs, I tried to stay as simple as possible and just add details where necessary.

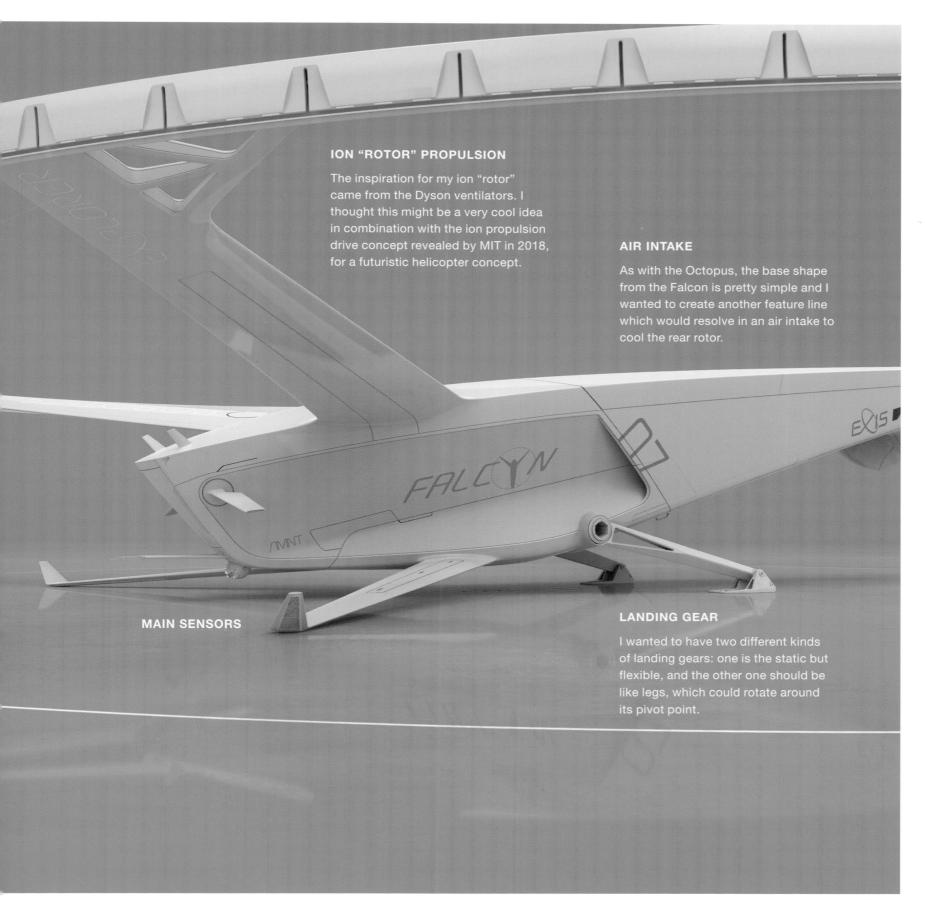

ION "ROTOR" PROPULSION

The inspiration for my ion "rotor" came from the Dyson ventilators. I thought this might be a very cool idea in combination with the ion propulsion drive concept revealed by MIT in 2018, for a futuristic helicopter concept.

AIR INTAKE

As with the Octopus, the base shape from the Falcon is pretty simple and I wanted to create another feature line which would resolve in an air intake to cool the rear rotor.

MAIN SENSORS

LANDING GEAR

I wanted to have two different kinds of landing gears: one is the static but flexible, and the other one should be like legs, which could rotate around its pivot point.

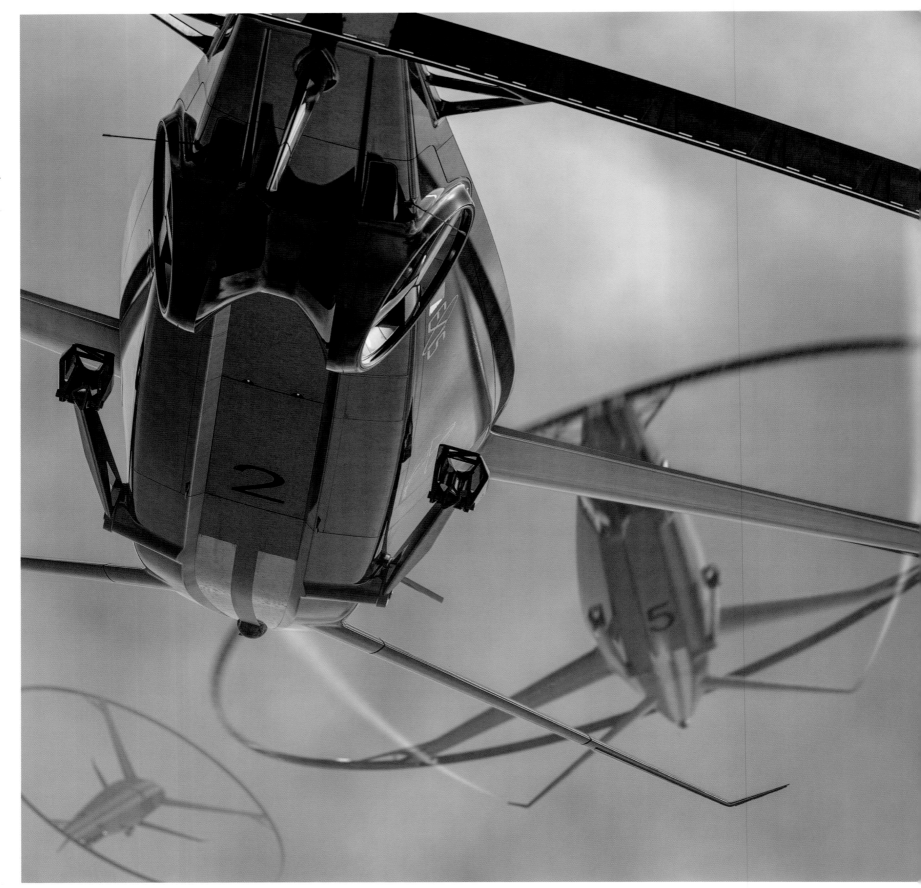

EXPLORER

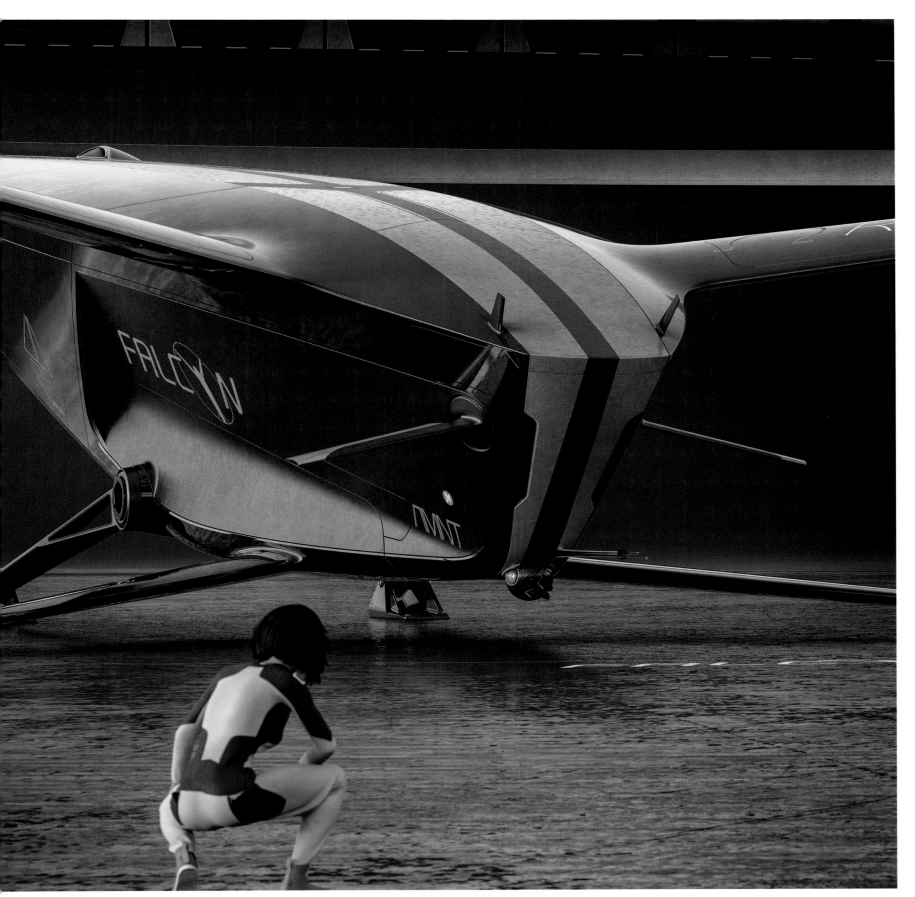

The Falcon: Aircraft and Troop Carrier

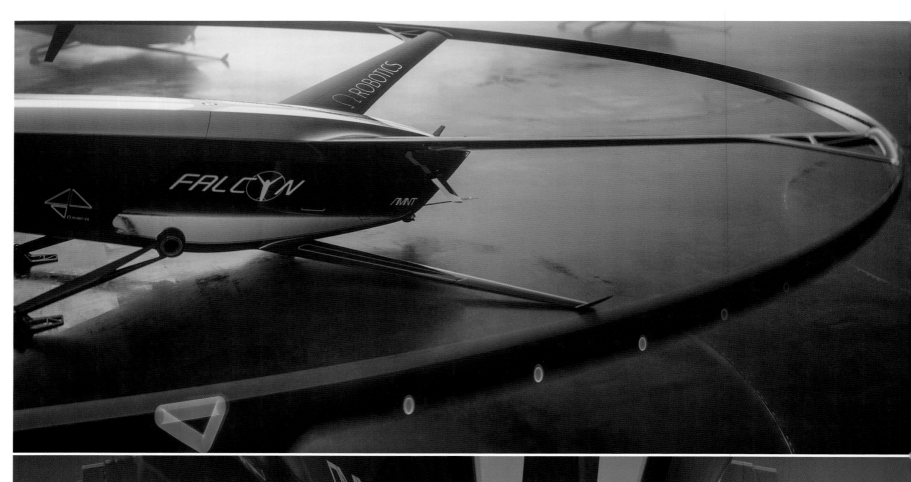

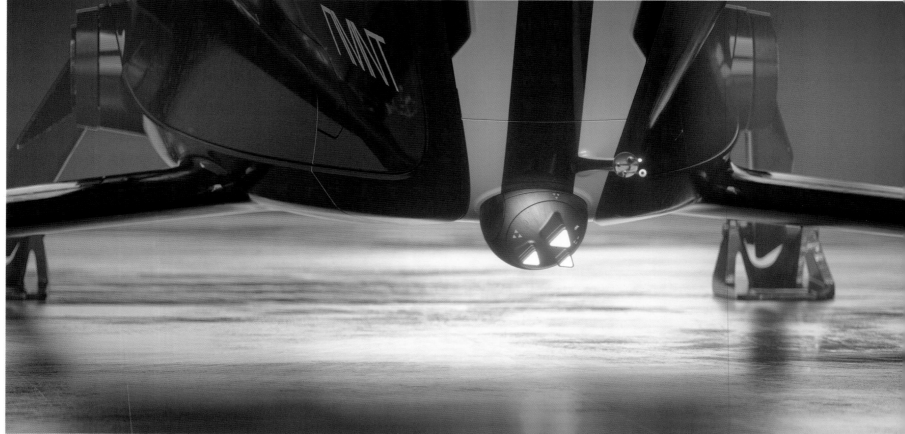

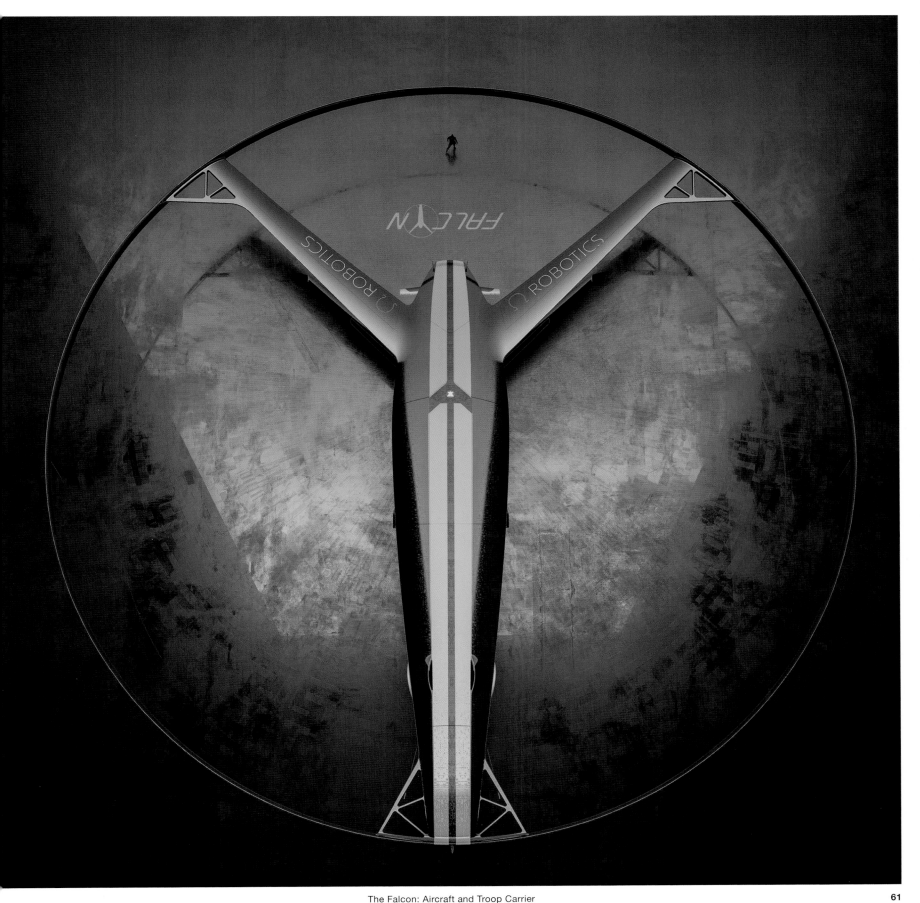

The Falcon: Aircraft and Troop Carrier

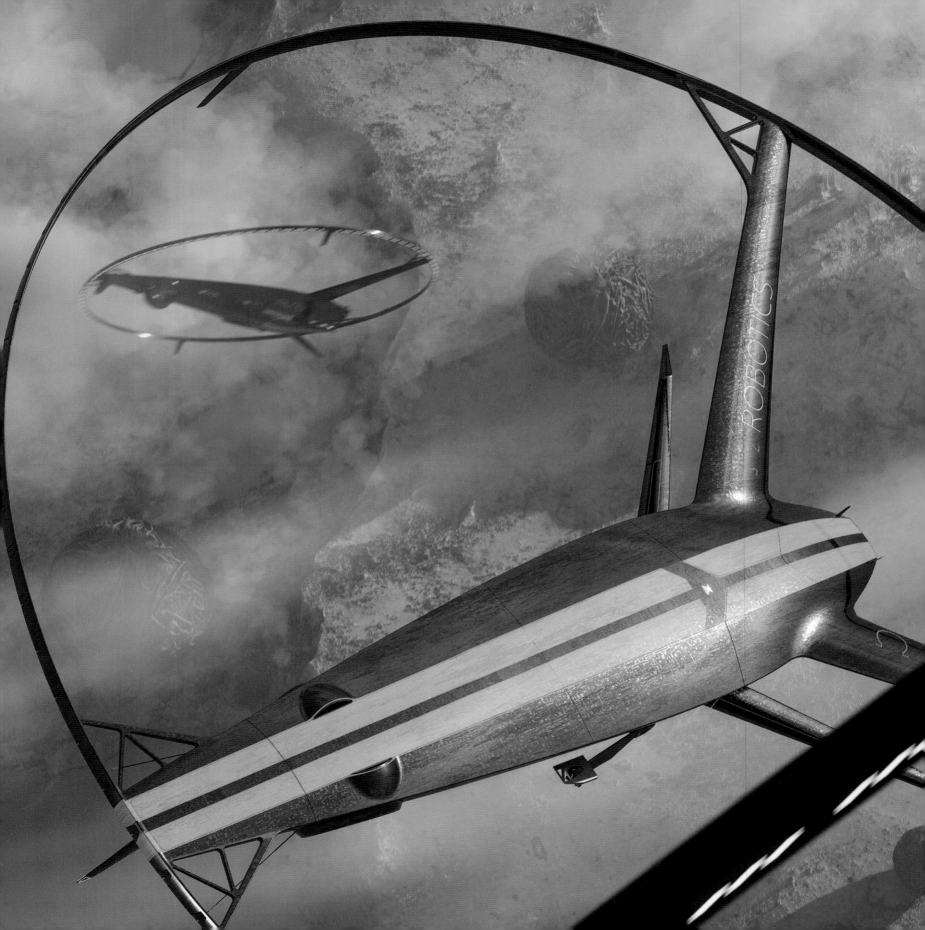

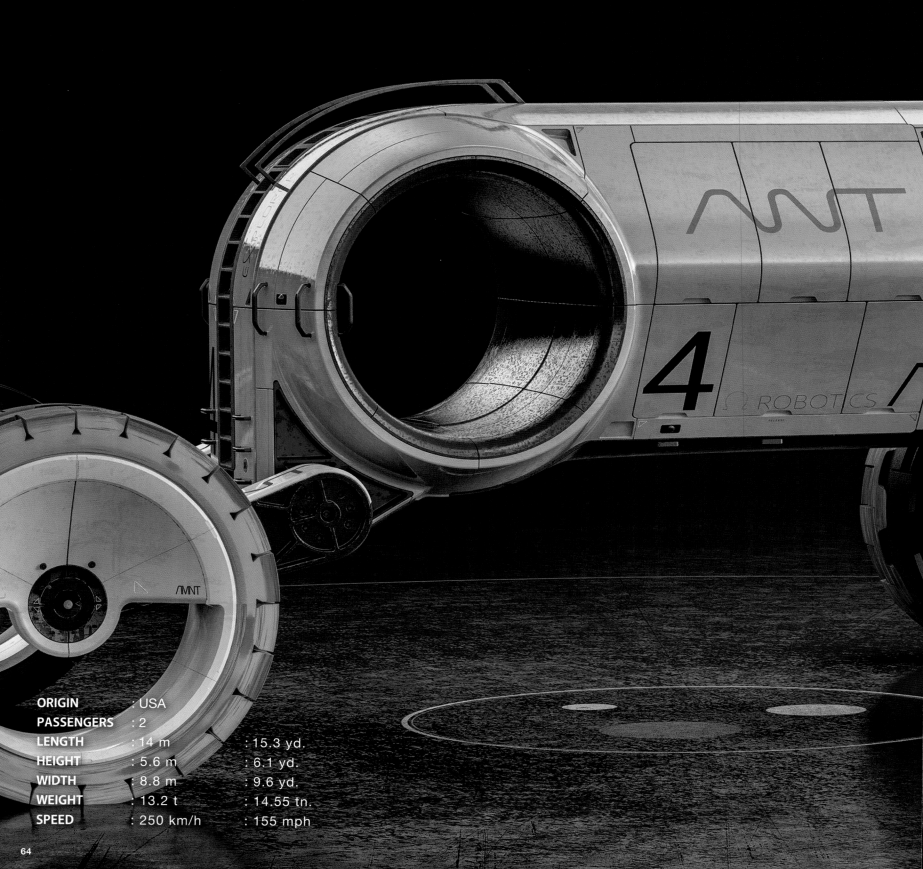

ORIGIN	: USA	
PASSENGERS	: 2	
LENGTH	: 14 m	: 15.3 yd.
HEIGHT	: 5.6 m	: 6.1 yd.
WIDTH	: 8.8 m	: 9.6 yd.
WEIGHT	: 13.2 t	: 14.55 tn.
SPEED	: 250 km/h	: 155 mph

The Ant

ALL-TERRAIN RESEARCH LAB

Named for its rear end, ant-like head, this vehicle was developed by a private spacecraft company with roots in the old Silicon Valley in northern California. The Ant was engineered as a mobile, all-terrain research laboratory and living quarters so its crew could stay independent from the base station for a long time while exploring a foreign planet. The Ant would be used on dense, jungle-like terrain, where it is impossible for the Falcon to travel. One major change from the original design was the back end. Its round tail with the large hole was constructed into an acutely sensitive, deep-surface scanner, so it can survey the ground down to three kilometers deep and deliver extremely detailed underground maps and material information.

Due to its wheel-and-axis design, the Ant has very good ground clearance and the ability to raise and lower its body up to a meter. Each wheel has its own engine where the rim itself is fixed and only the rubber is rotating for driving. The unique little hump at the front was kept from its original design, where it was used as a sensor cover to retain its unique outline.

PROCESS

Here you can see how my design evolves from sketch to sketch.
The first idea was still a very basic sketch, a long, cigar-like
shape with a hole in the back or front.

Sketch two has almost the final outline but it is still pretty rough.
I did support the sketch with a radial template to emphasize
some lines.

Sketch three is a more defined and clean drawing done with
tracing paper over sketch two. I used a basic ruler and some
radial templates to give it a final touch. In addition to that, I was
drawing a very simple top view.

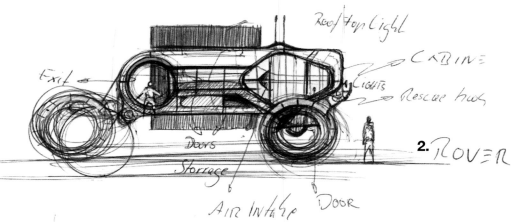

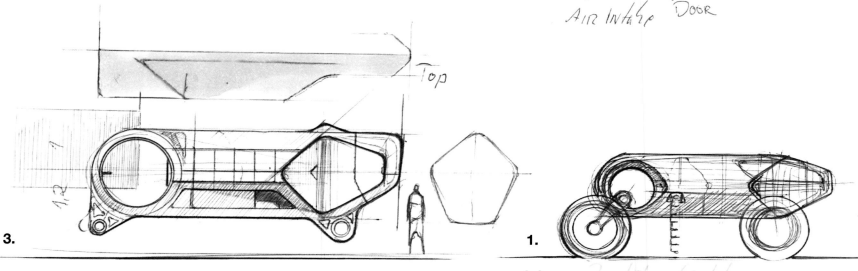

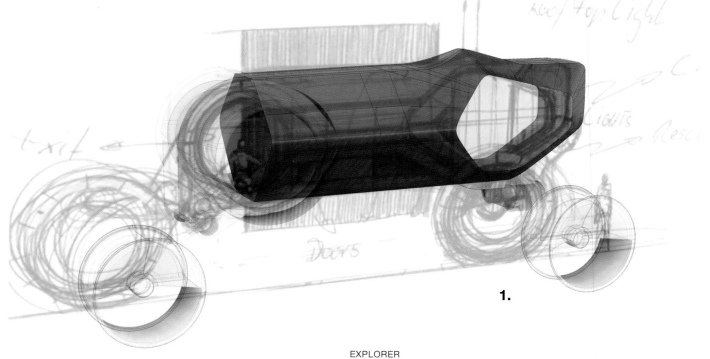

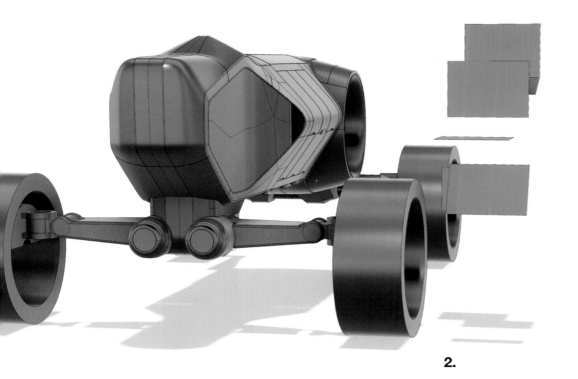

This model was completed 100 percent in Fusion 360. I was using the sculpt tool for the main body to create an Alias-like, organic shape, as you can see on picture one. That picture also shows my basic setup. I just took my sketch number two, placed it on the background, and from there I started modeling the organic main body. On picture two, you can see how I split my body to create shutlines and material separations. I use those orange planes and intersect them with the geometry. There is one area where I would have loved to use Alias to improve the surface quality, but I wanted to stick to Fusion and see how far I could push my design. In doing so, I was able to learn even more in Fusion, but I couldn't solve those areas 100 percent. It is much easier to create a beautiful fillet between those two intersecting bodies in Alias, picture three. But like I said, I decided to stick with what I got out of Fusion. The orange line shows what would be possible in Alias and results in a much better surface transition; the yellow one is from Fusion. I know 99 percent of people wouldn't care or see these little things, but those details make a big difference in the end. Your eyes may not see it all, but your subconsciousness will. Picture three shows the completed final model with all details.

2.

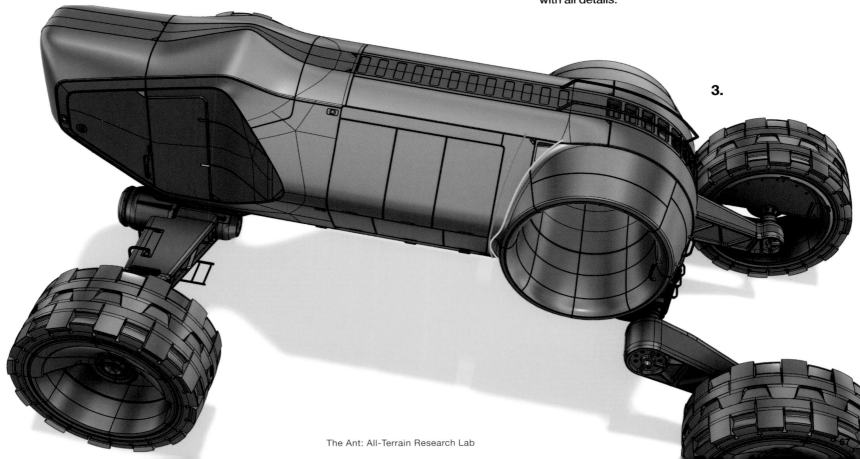

3.

The Ant: All-Terrain Research Lab

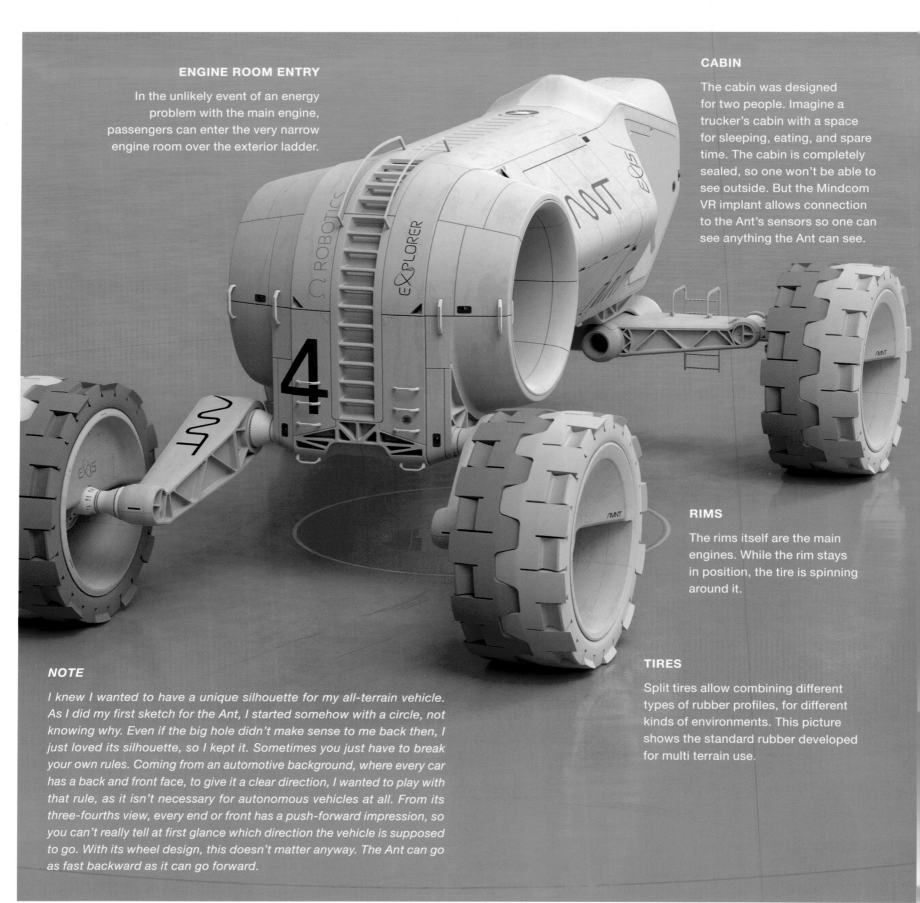

ENGINE ROOM ENTRY

In the unlikely event of an energy problem with the main engine, passengers can enter the very narrow engine room over the exterior ladder.

CABIN

The cabin was designed for two people. Imagine a trucker's cabin with a space for sleeping, eating, and spare time. The cabin is completely sealed, so one won't be able to see outside. But the Mindcom VR implant allows connection to the Ant's sensors so one can see anything the Ant can see.

RIMS

The rims itself are the main engines. While the rim stays in position, the tire is spinning around it.

TIRES

Split tires allow combining different types of rubber profiles, for different kinds of environments. This picture shows the standard rubber developed for multi terrain use.

NOTE

I knew I wanted to have a unique silhouette for my all-terrain vehicle. As I did my first sketch for the Ant, I started somehow with a circle, not knowing why. Even if the big hole didn't make sense to me back then, I just loved its silhouette, so I kept it. Sometimes you just have to break your own rules. Coming from an automotive background, where every car has a back and front face, to give it a clear direction, I wanted to play with that rule, as it isn't necessary for autonomous vehicles at all. From its three-fourths view, every end or front has a push-forward impression, so you can't really tell at first glance which direction the vehicle is supposed to go. With its wheel design, this doesn't matter anyway. The Ant can go as fast backward as it can go forward.

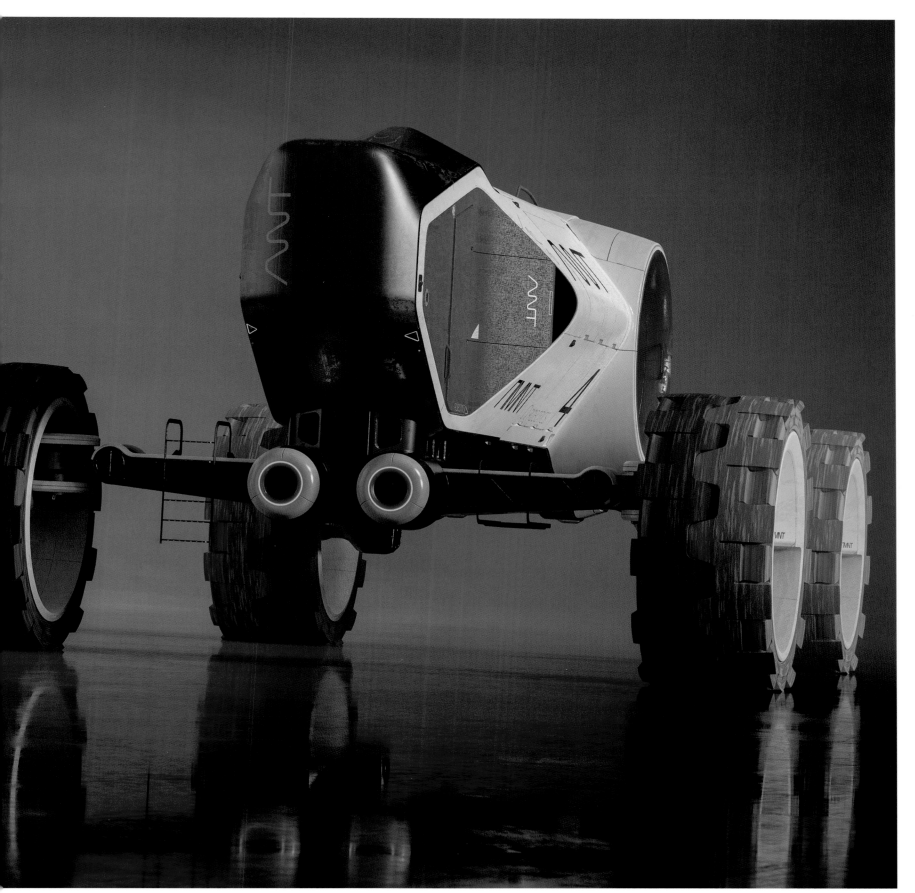

The Ant: All-Terrain Research Lab

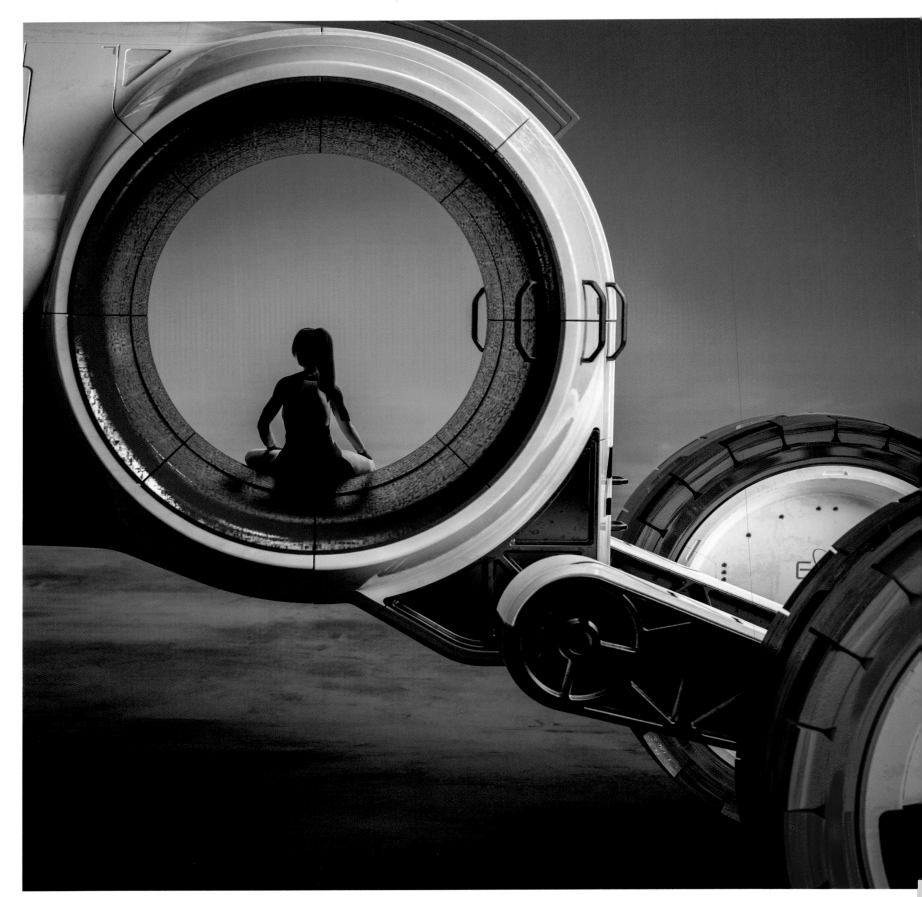

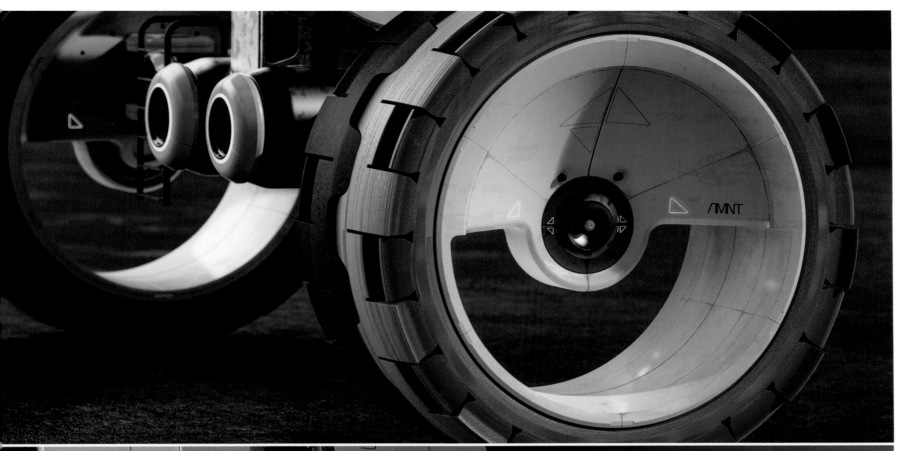

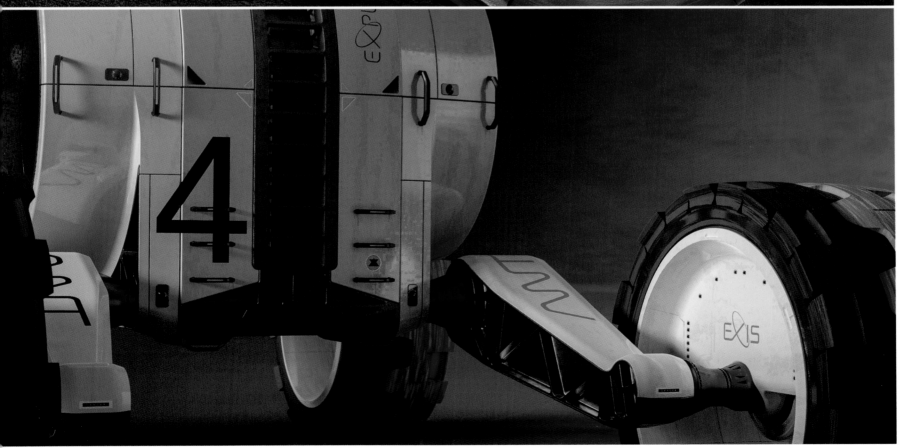

The Ant: All-Terrain Research Lab

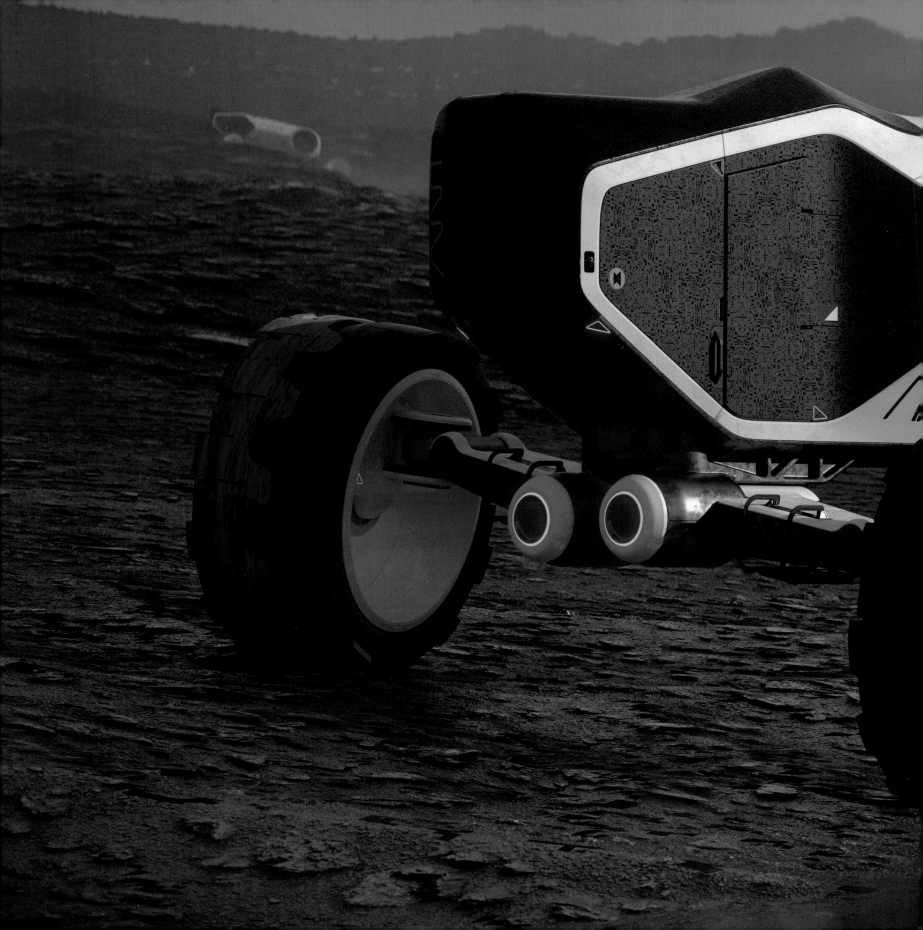

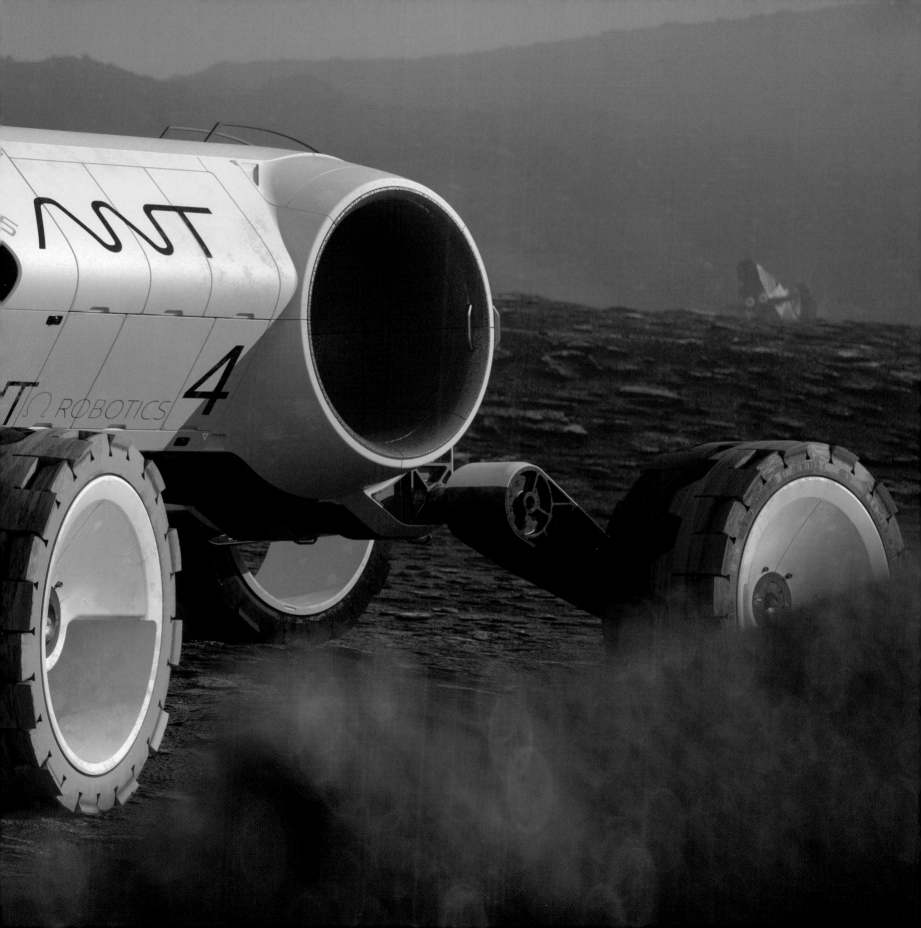

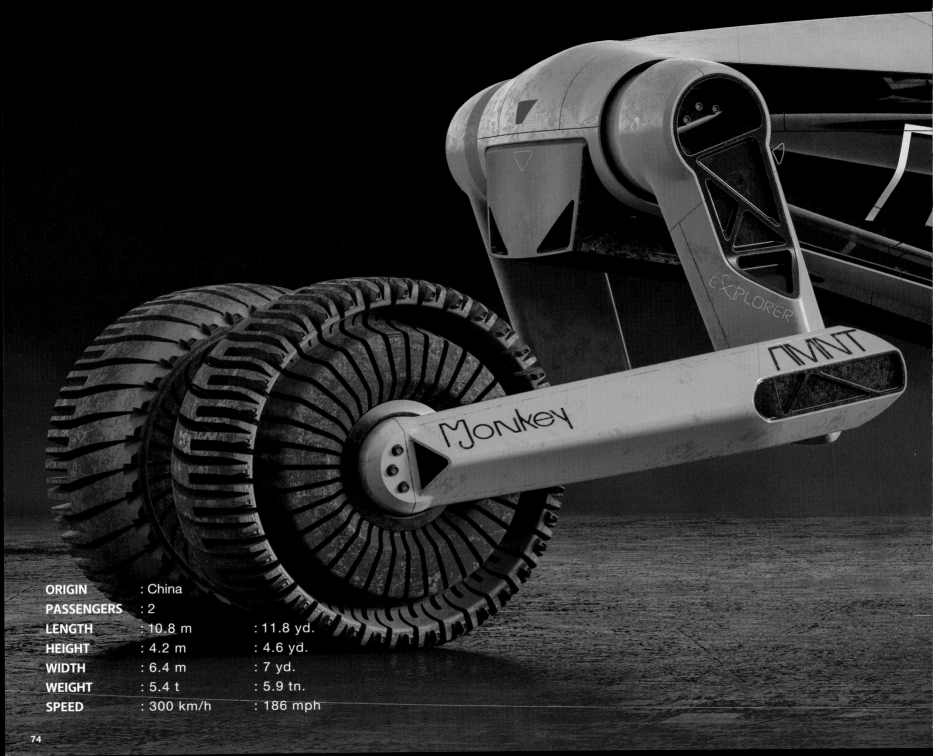

ORIGIN	: China	
PASSENGERS	: 2	
LENGTH	: 10.8 m	: 11.8 yd.
HEIGHT	: 4.2 m	: 4.6 yd.
WIDTH	: 6.4 m	: 7 yd.
WEIGHT	: 5.4 t	: 5.9 tn.
SPEED	: 300 km/h	: 186 mph

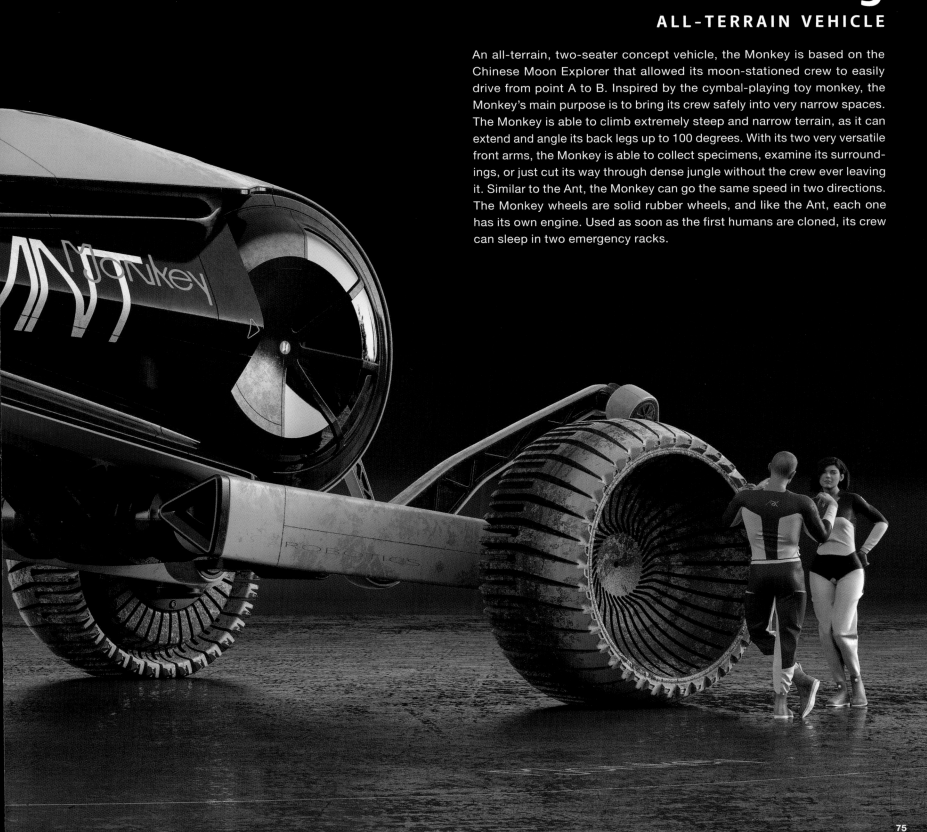

The Monkey

ALL-TERRAIN VEHICLE

An all-terrain, two-seater concept vehicle, the Monkey is based on the Chinese Moon Explorer that allowed its moon-stationed crew to easily drive from point A to B. Inspired by the cymbal-playing toy monkey, the Monkey's main purpose is to bring its crew safely into very narrow spaces. The Monkey is able to climb extremely steep and narrow terrain, as it can extend and angle its back legs up to 100 degrees. With its two very versatile front arms, the Monkey is able to collect specimens, examine its surroundings, or just cut its way through dense jungle without the crew ever leaving it. Similar to the Ant, the Monkey can go the same speed in two directions. The Monkey wheels are solid rubber wheels, and like the Ant, each one has its own engine. Used as soon as the first humans are cloned, its crew can sleep in two emergency racks.

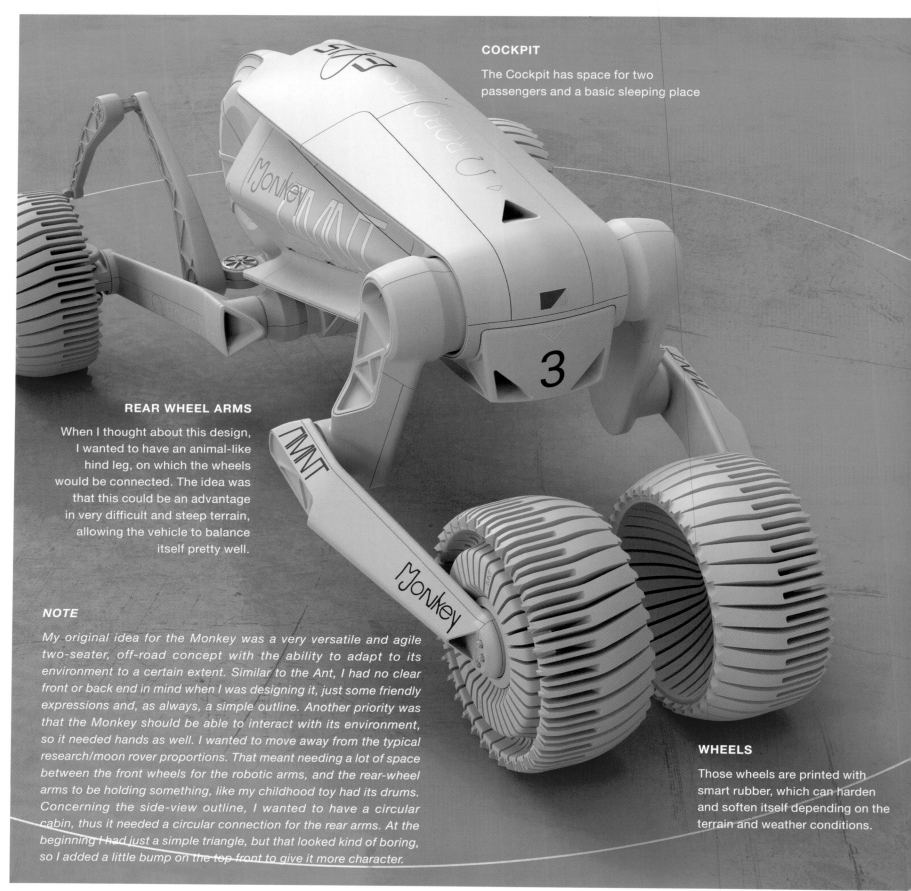

COCKPIT

The Cockpit has space for two passengers and a basic sleeping place

REAR WHEEL ARMS

When I thought about this design, I wanted to have an animal-like hind leg, on which the wheels would be connected. The idea was that this could be an advantage in very difficult and steep terrain, allowing the vehicle to balance itself pretty well.

NOTE

My original idea for the Monkey was a very versatile and agile two-seater, off-road concept with the ability to adapt to its environment to a certain extent. Similar to the Ant, I had no clear front or back end in mind when I was designing it, just some friendly expressions and, as always, a simple outline. Another priority was that the Monkey should be able to interact with its environment, so it needed hands as well. I wanted to move away from the typical research/moon rover proportions. That meant needing a lot of space between the front wheels for the robotic arms, and the rear-wheel arms to be holding something, like my childhood toy had its drums. Concerning the side-view outline, I wanted to have a circular cabin, thus it needed a circular connection for the rear arms. At the beginning I had just a simple triangle, but that looked kind of boring, so I added a little bump on the top front to give it more character.

WHEELS

Those wheels are printed with smart rubber, which can harden and soften itself depending on the terrain and weather conditions.

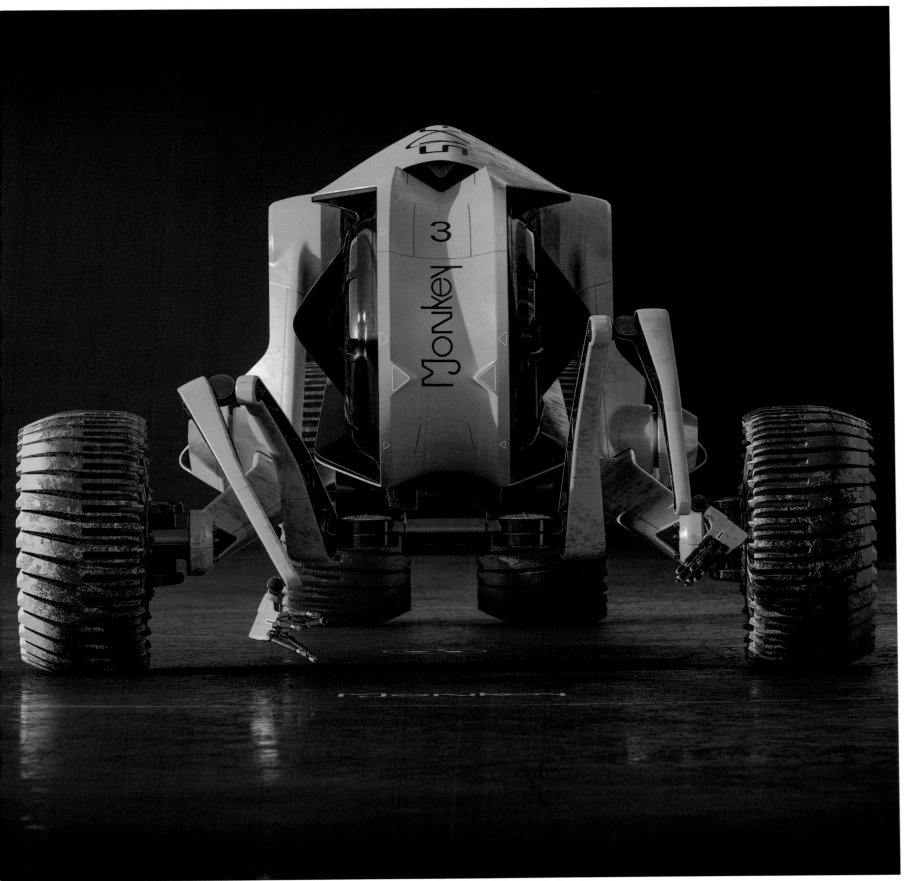

The Monkey: All-Terrain Vehicle

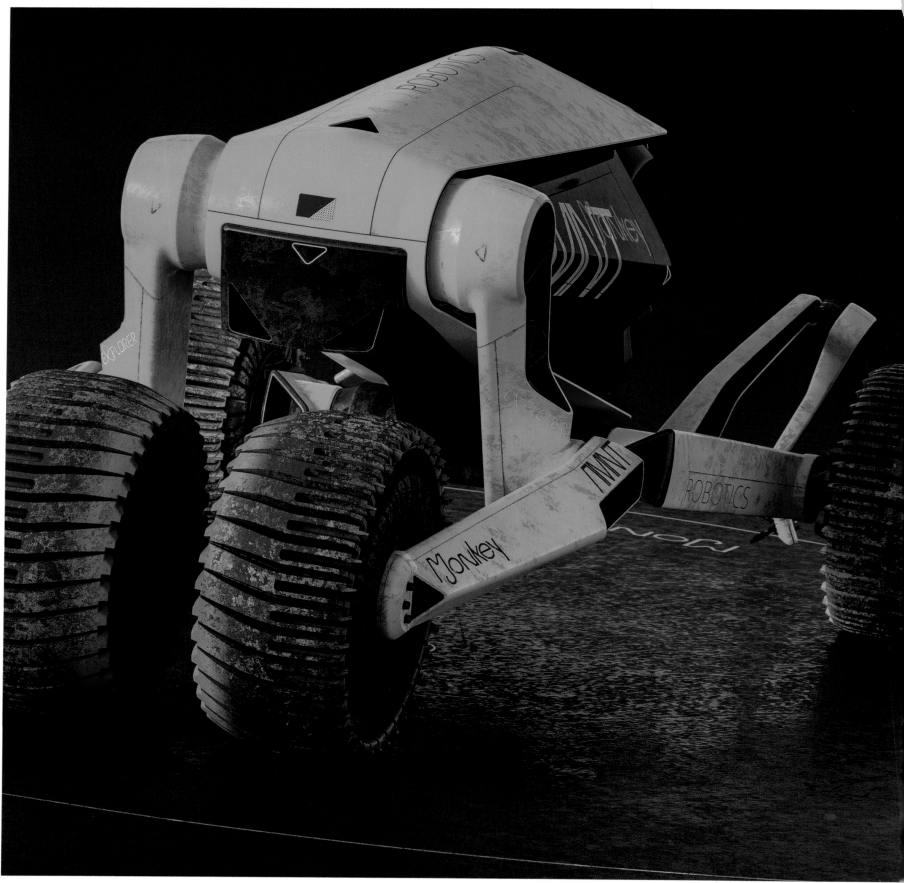

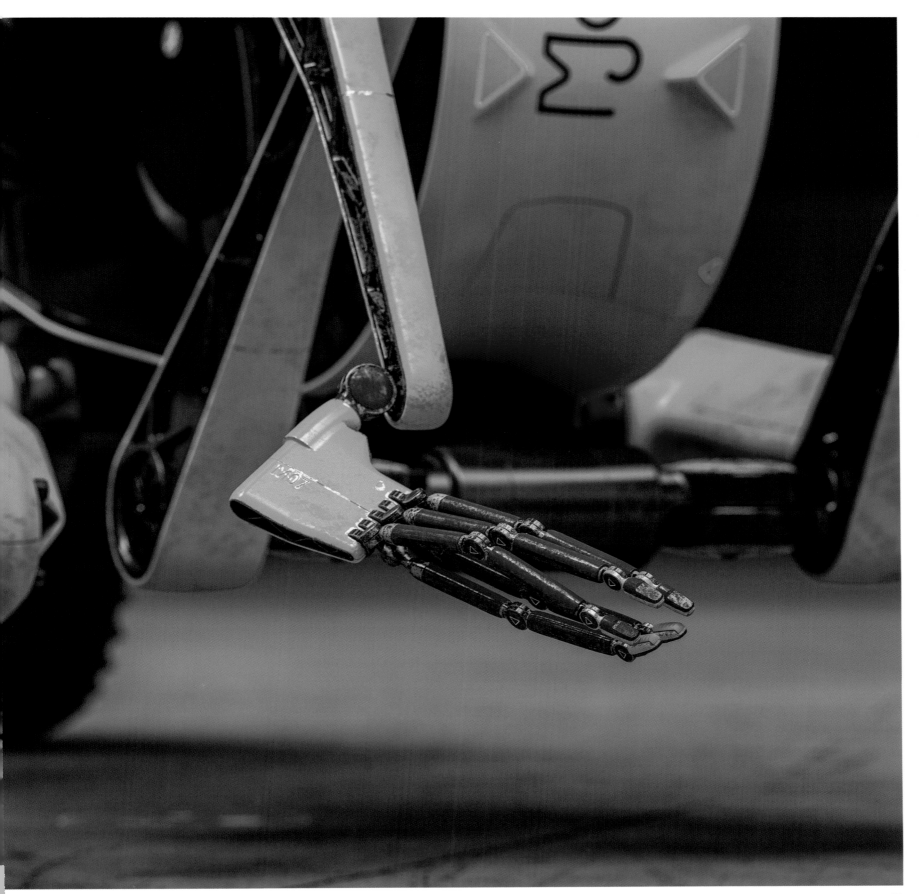

The Monkey: All-Terrain Vehicle

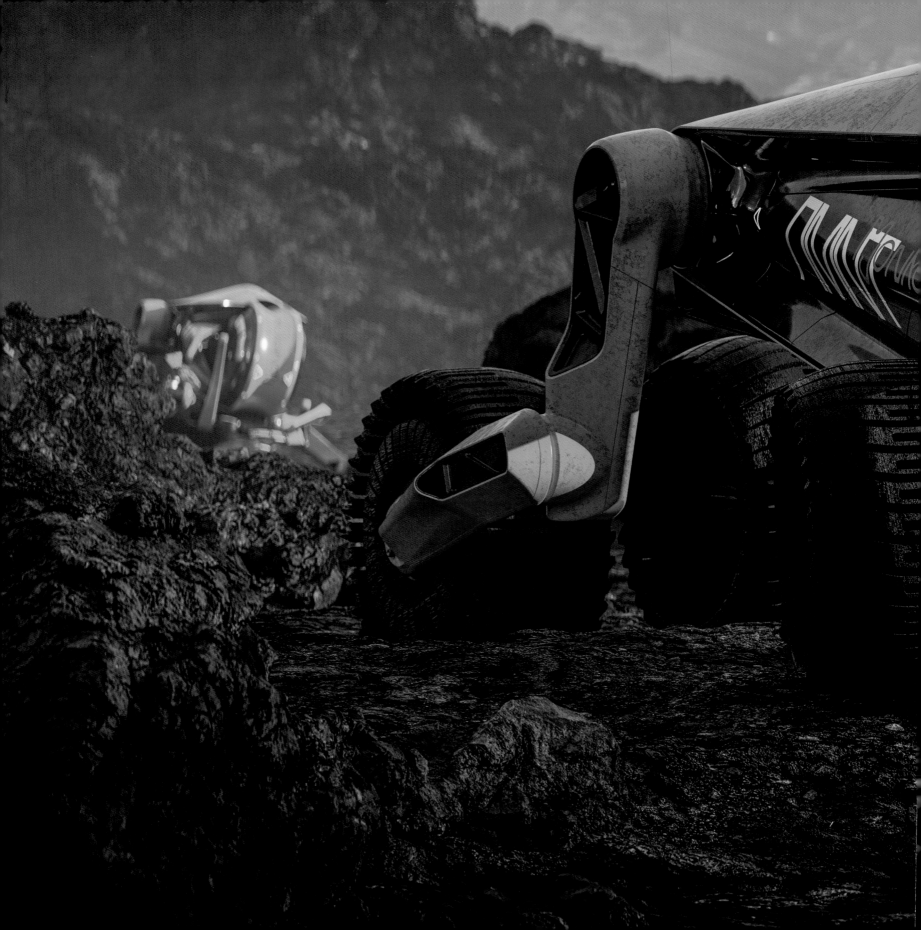

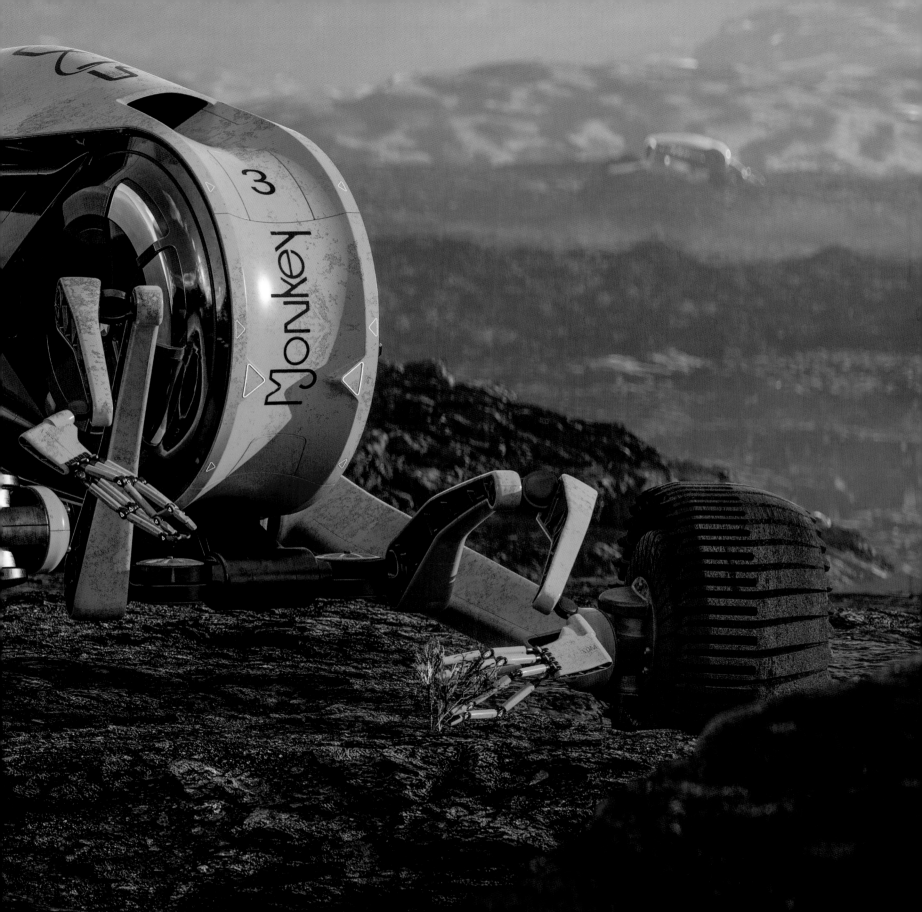

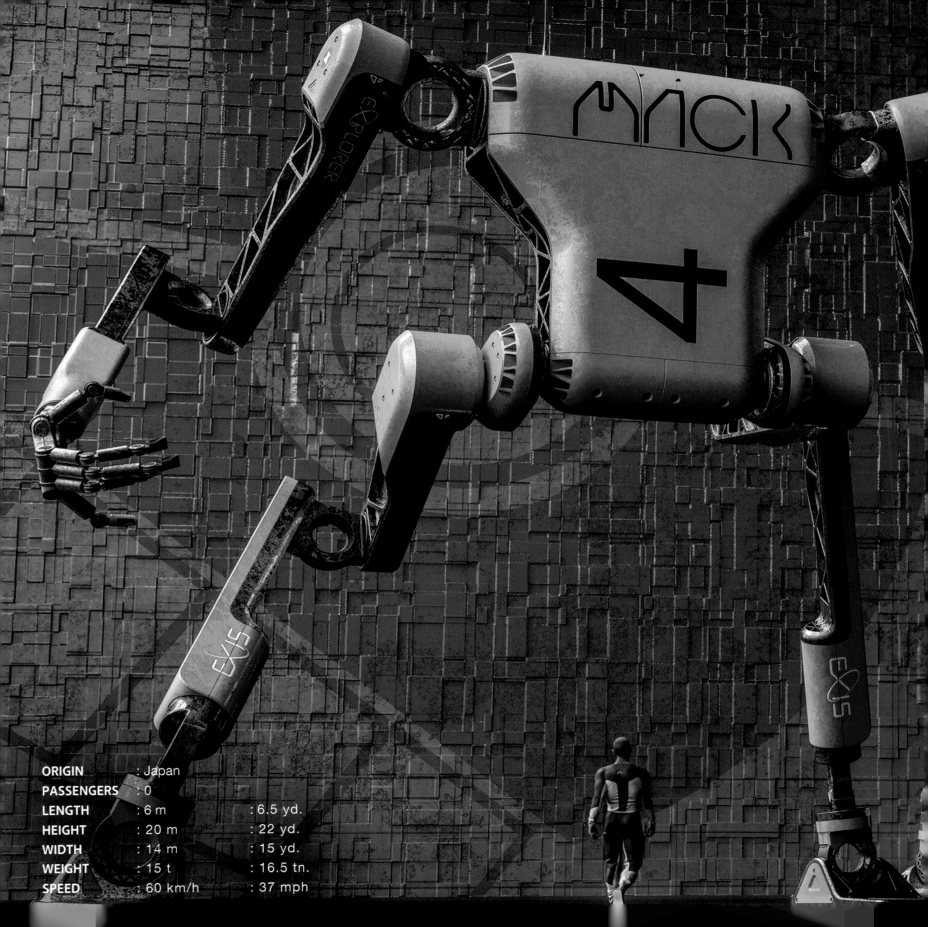

ORIGIN	: Japan	
PASSENGERS	: 0	
LENGTH	: 6 m	: 6.5 yd.
HEIGHT	: 20 m	: 22 yd.
WIDTH	: 14 m	: 15 yd.
WEIGHT	: 15 t	: 16.5 tn.
SPEED	: 60 km/h	: 37 mph

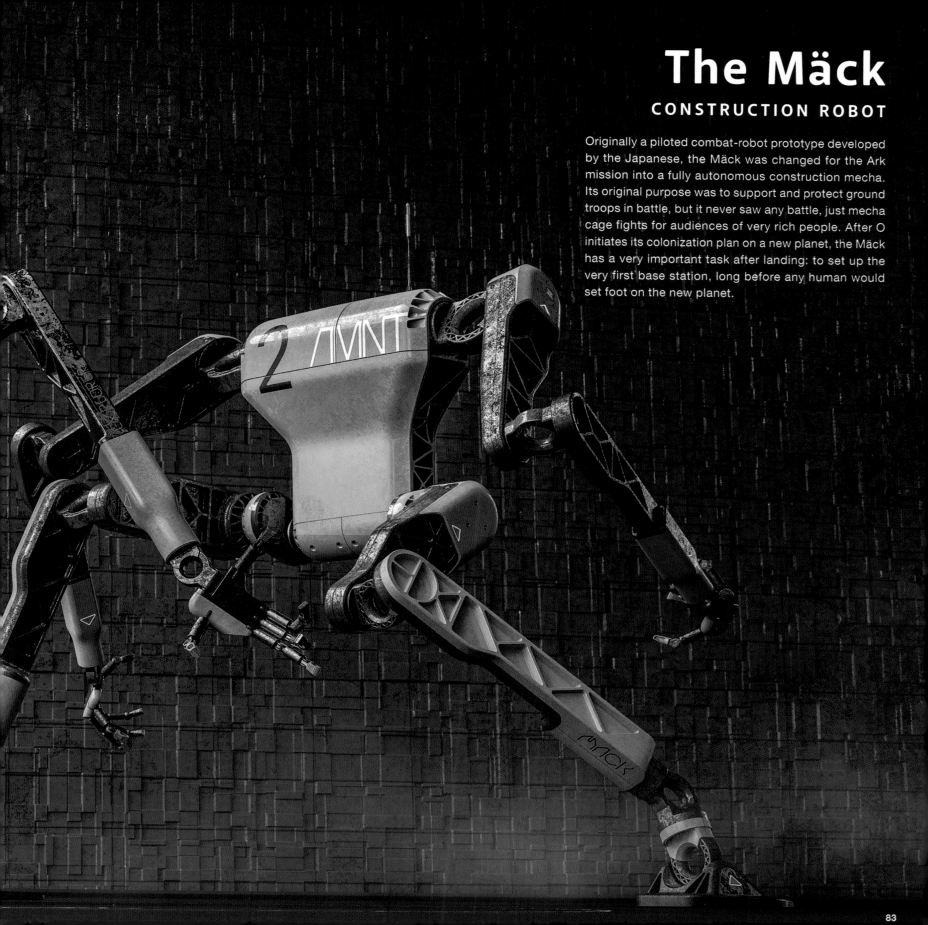

The Mäck

CONSTRUCTION ROBOT

Originally a piloted combat-robot prototype developed by the Japanese, the Mäck was changed for the Ark mission into a fully autonomous construction mecha. Its original purpose was to support and protect ground troops in battle, but it never saw any battle, just mecha cage fights for audiences of very rich people. After O initiates its colonization plan on a new planet, the Mäck has a very important task after landing: to set up the very first base station, long before any human would set foot on the new planet.

BODY

When I started with the design, I decided to build a robot without an obvious head. I wanted to try to create some kind of a face without a face. I hope that makes sense. If you look at the robot, you still have the feeling that he is looking at you due to the circular joints.

NOTE

My vision for the construction robot was simple: no clear head or face and very simple shapes and single body parts, as it would need a lot of maintenance due to its heavy workload. The Mäck was modeled almost completely in Fusion 360, with the exception of its torso. I wasn't happy with the surface quality result Fusion gave me, so I had to jump into Alias, where I had more control over the look of the surfaces. To jump back and forth between both programs became a new and important process, as it is super easy and much faster to build radii or to split bodies in Fusion than in Alias.

HANDS

I replaced the pinky with a second thumb. I thought this might give it better grip along with the hands working in both ways. The fingers can rotate 360 degrees in every direction.

JOINTS

I tried my best to build all the mechanics and joints as "logically" as possible. If you see the robot for the first time you believe that it can move in every direction and those joints are working, at least in my universe.

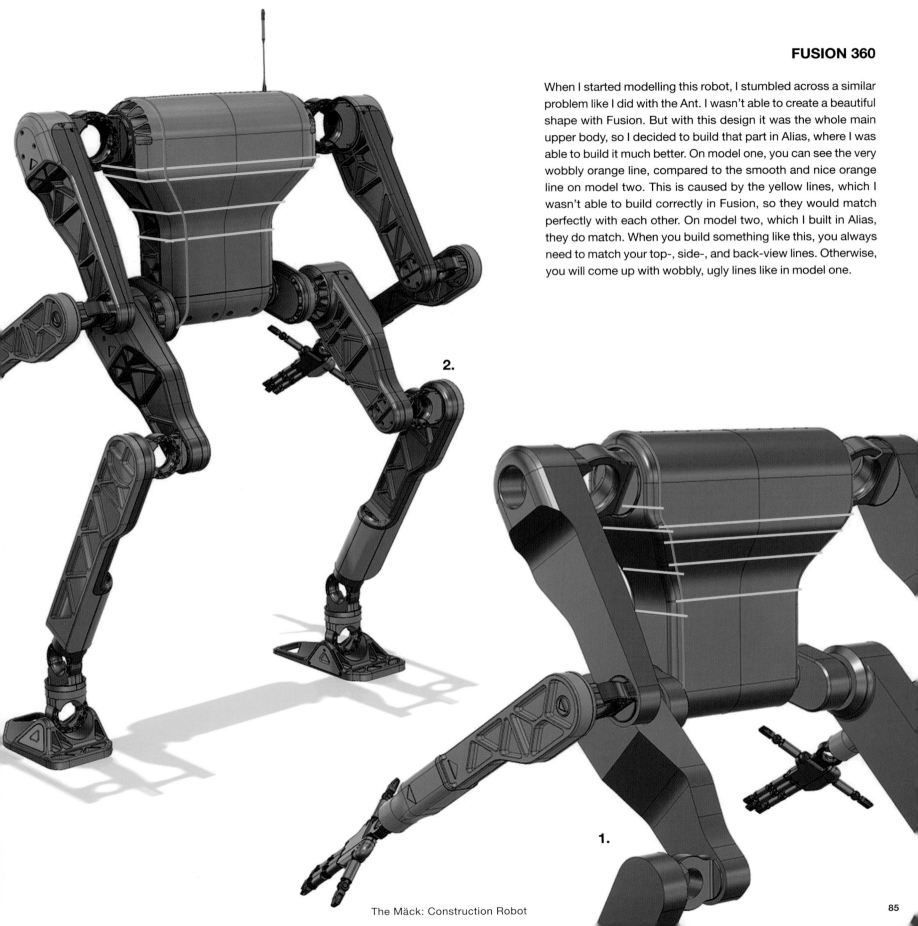

FUSION 360

When I started modelling this robot, I stumbled across a similar problem like I did with the Ant. I wasn't able to create a beautiful shape with Fusion. But with this design it was the whole main upper body, so I decided to build that part in Alias, where I was able to build it much better. On model one, you can see the very wobbly orange line, compared to the smooth and nice orange line on model two. This is caused by the yellow lines, which I wasn't able to build correctly in Fusion, so they would match perfectly with each other. On model two, which I built in Alias, they do match. When you build something like this, you always need to match your top-, side-, and back-view lines. Otherwise, you will come up with wobbly, ugly lines like in model one.

2.

1.

The Mäck: Construction Robot

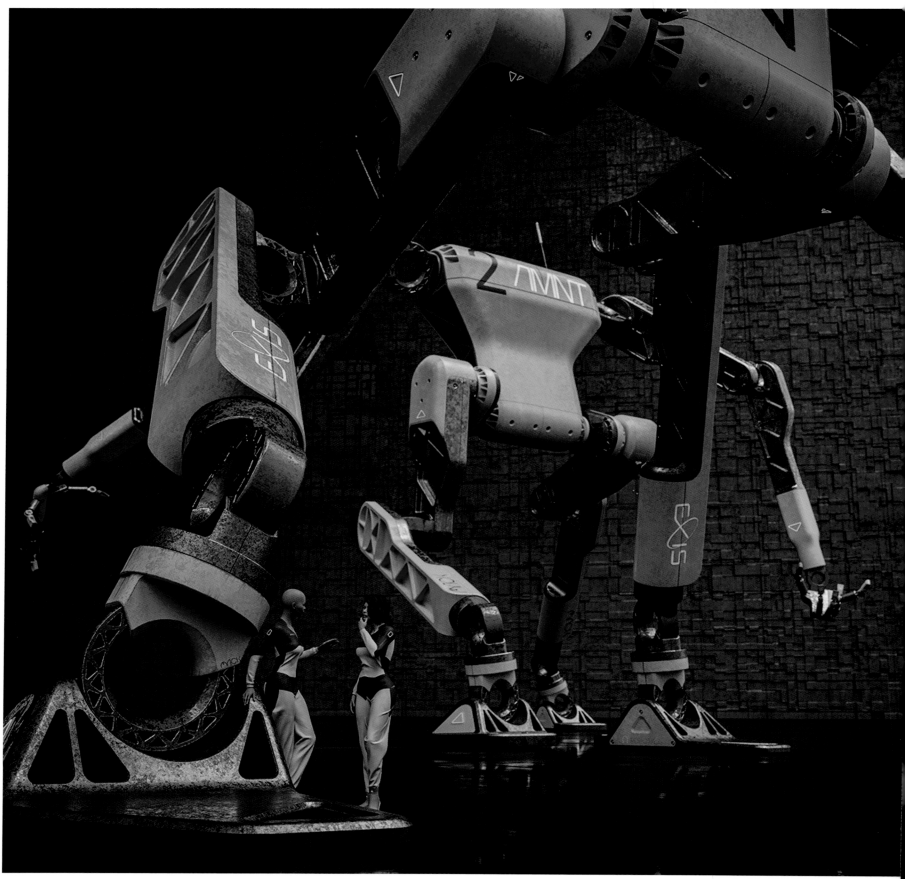

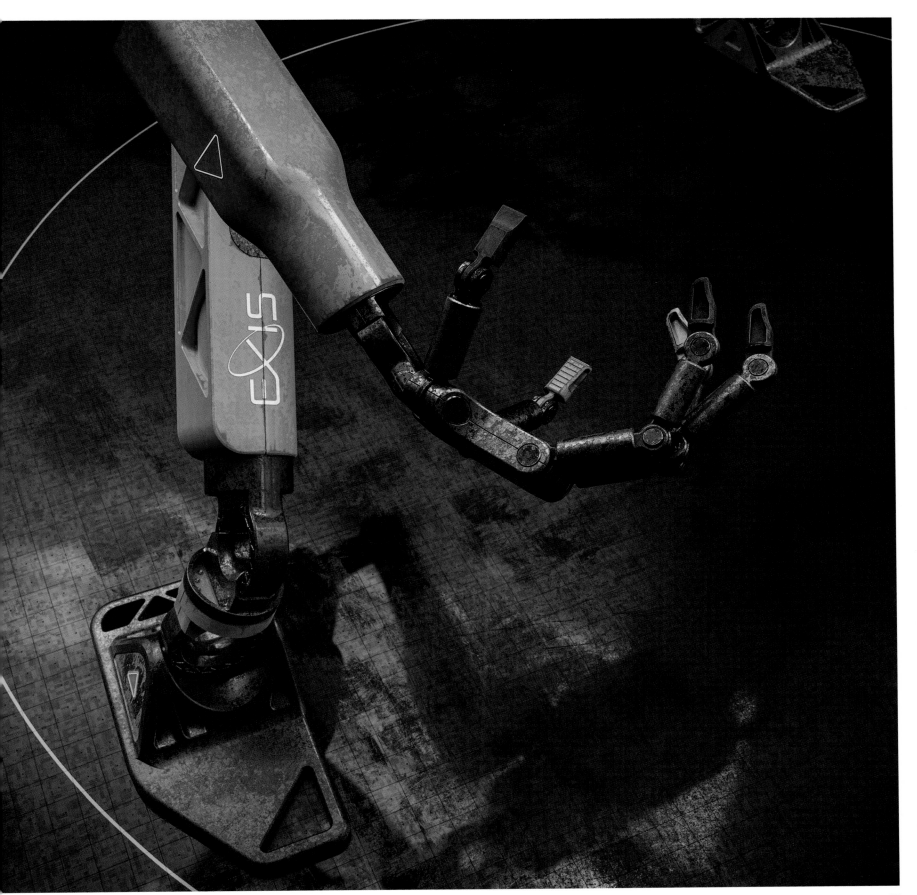

The Mäck: Construction Robot

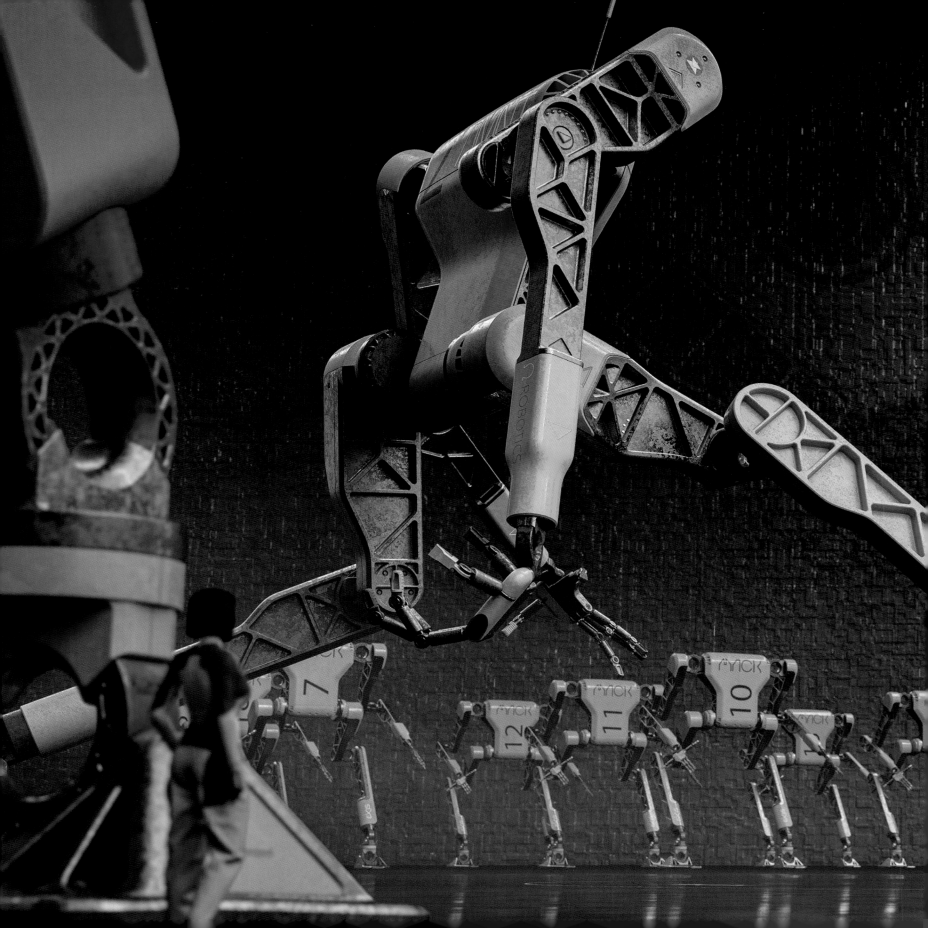

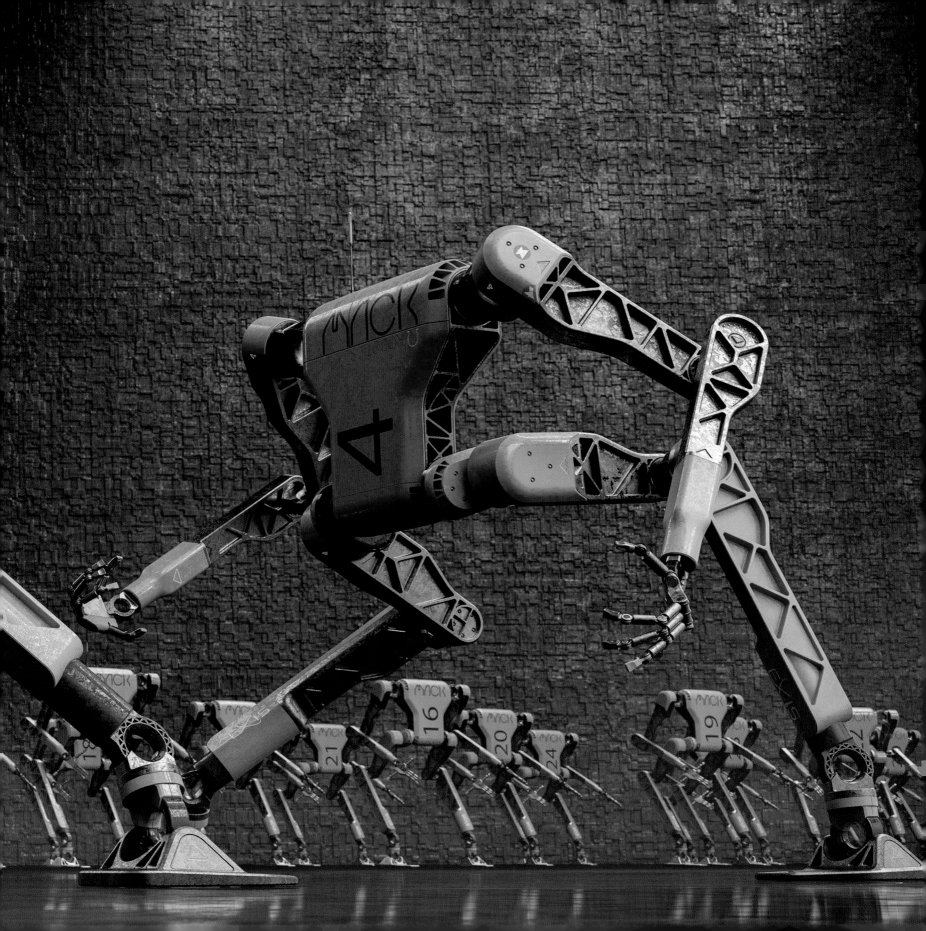

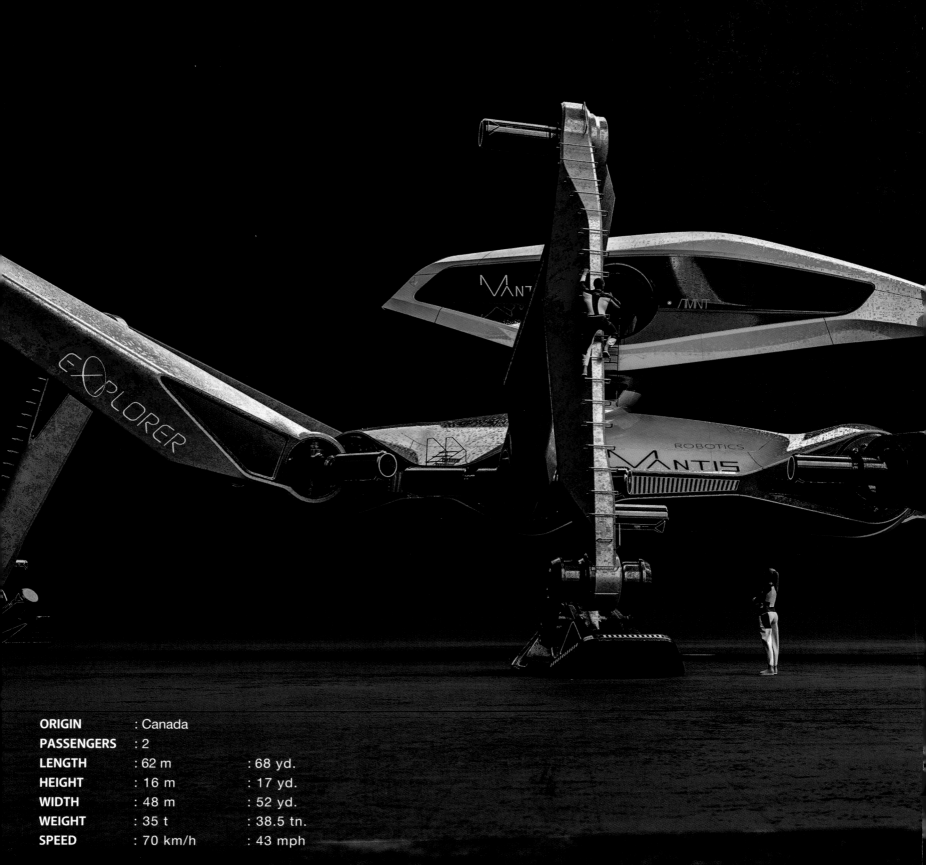

ORIGIN	: Canada	
PASSENGERS	: 2	
LENGTH	: 62 m	: 68 yd.
HEIGHT	: 16 m	: 17 yd.
WIDTH	: 48 m	: 52 yd.
WEIGHT	: 35 t	: 38.5 tn.
SPEED	: 70 km/h	: 43 mph

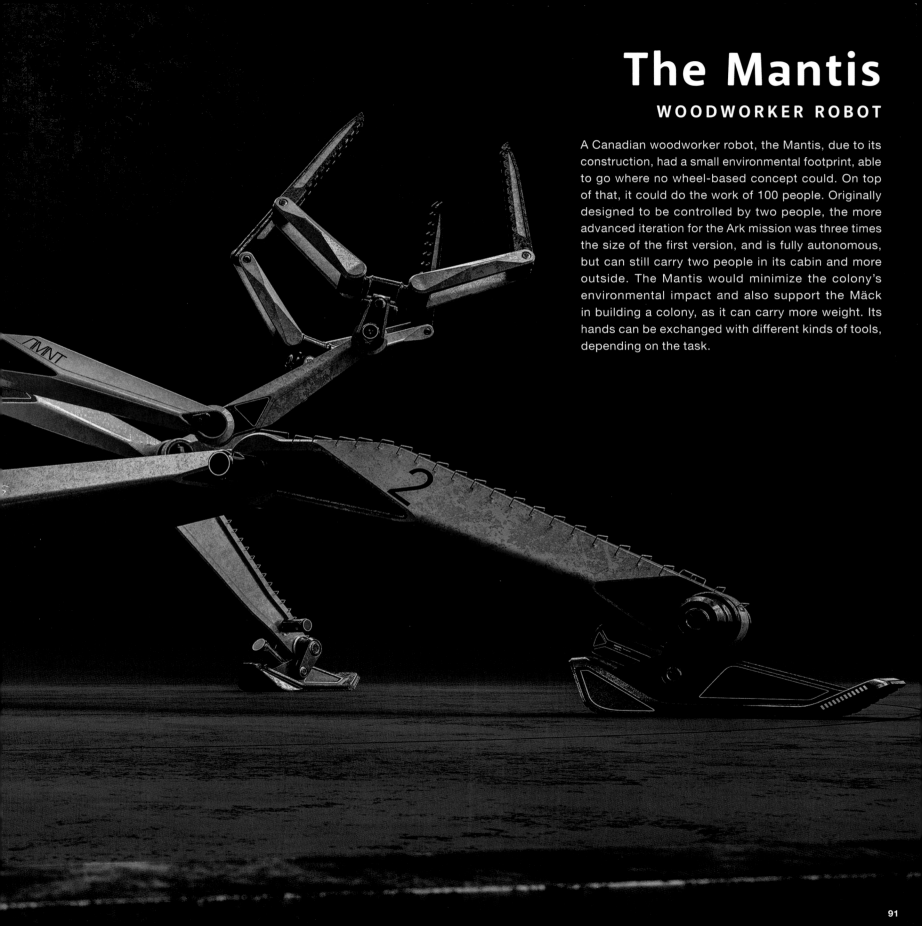

The Mantis
WOODWORKER ROBOT

A Canadian woodworker robot, the Mantis, due to its construction, had a small environmental footprint, able to go where no wheel-based concept could. On top of that, it could do the work of 100 people. Originally designed to be controlled by two people, the more advanced iteration for the Ark mission was three times the size of the first version, and is fully autonomous, but can still carry two people in its cabin and more outside. The Mantis would minimize the colony's environmental impact and also support the Mäck in building a colony, as it can carry more weight. Its hands can be exchanged with different kinds of tools, depending on the task.

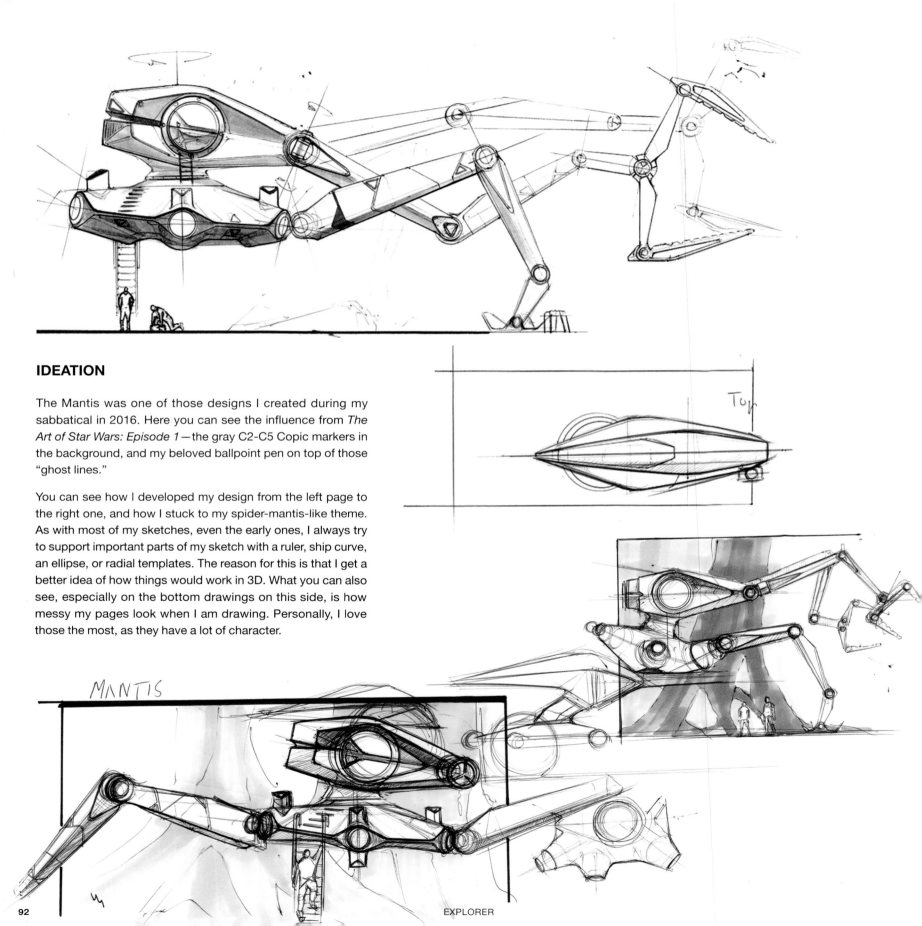

IDEATION

The Mantis was one of those designs I created during my sabbatical in 2016. Here you can see the influence from *The Art of Star Wars: Episode 1*—the gray C2-C5 Copic markers in the background, and my beloved ballpoint pen on top of those "ghost lines."

You can see how I developed my design from the left page to the right one, and how I stuck to my spider-mantis-like theme. As with most of my sketches, even the early ones, I always try to support important parts of my sketch with a ruler, ship curve, an ellipse, or radial templates. The reason for this is that I get a better idea of how things would work in 3D. What you can also see, especially on the bottom drawings on this side, is how messy my pages look when I am drawing. Personally, I love those the most, as they have a lot of character.

MANTIS

EXPLORER

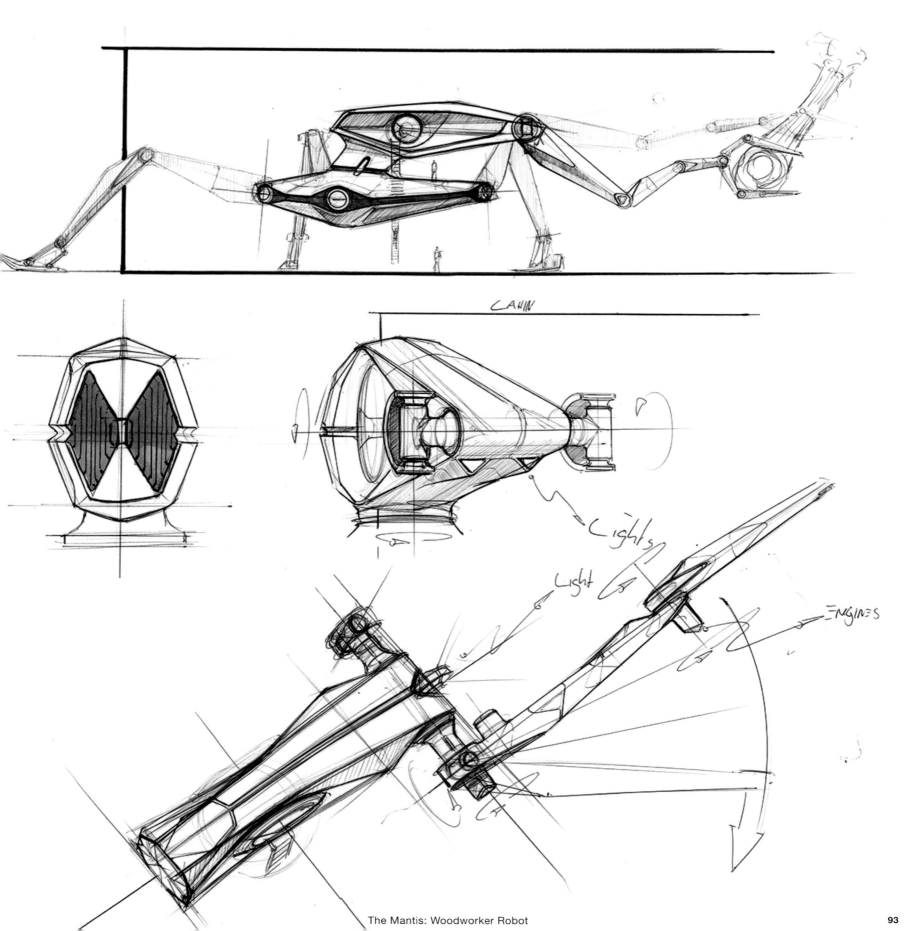

CABIN

Lights

Light

ENGINES

The Mantis: Woodworker Robot

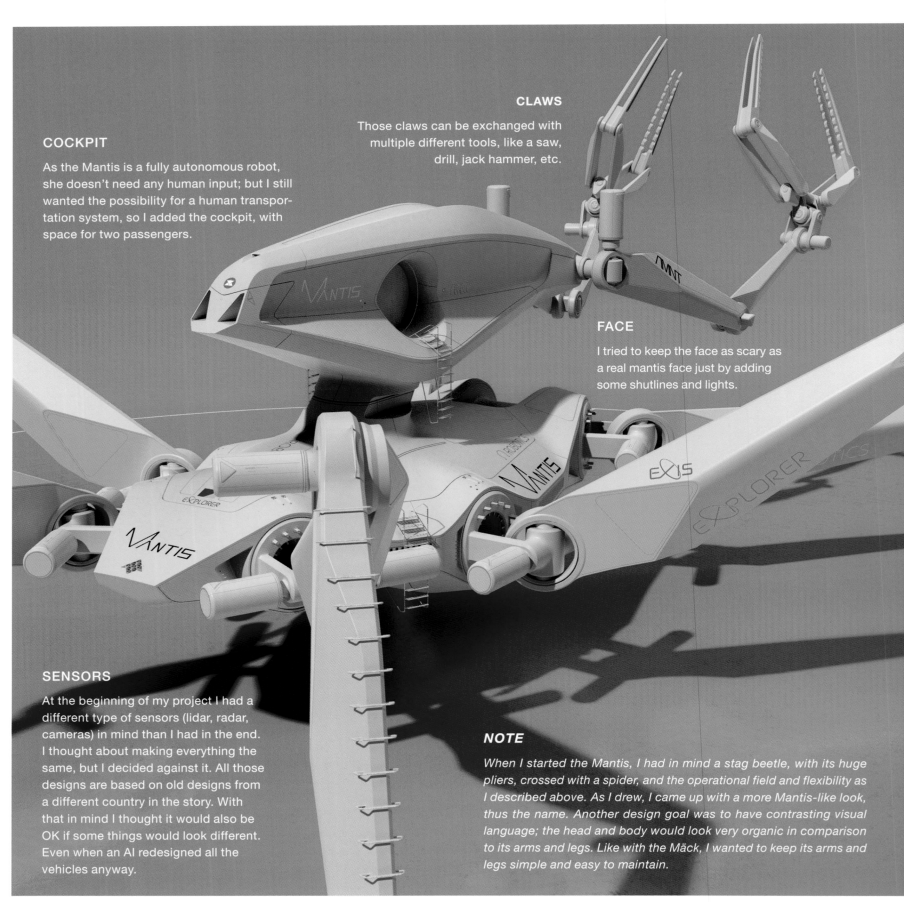

COCKPIT

As the Mantis is a fully autonomous robot, she doesn't need any human input; but I still wanted the possibility for a human transportation system, so I added the cockpit, with space for two passengers.

CLAWS

Those claws can be exchanged with multiple different tools, like a saw, drill, jack hammer, etc.

FACE

I tried to keep the face as scary as a real mantis face just by adding some shutlines and lights.

SENSORS

At the beginning of my project I had a different type of sensors (lidar, radar, cameras) in mind than I had in the end. I thought about making everything the same, but I decided against it. All those designs are based on old designs from a different country in the story. With that in mind I thought it would also be OK if some things would look different. Even when an AI redesigned all the vehicles anyway.

NOTE

When I started the Mantis, I had in mind a stag beetle, with its huge pliers, crossed with a spider, and the operational field and flexibility as I described above. As I drew, I came up with a more Mantis-like look, thus the name. Another design goal was to have contrasting visual language; the head and body would look very organic in comparison to its arms and legs. Like with the Mäck, I wanted to keep its arms and legs simple and easy to maintain.

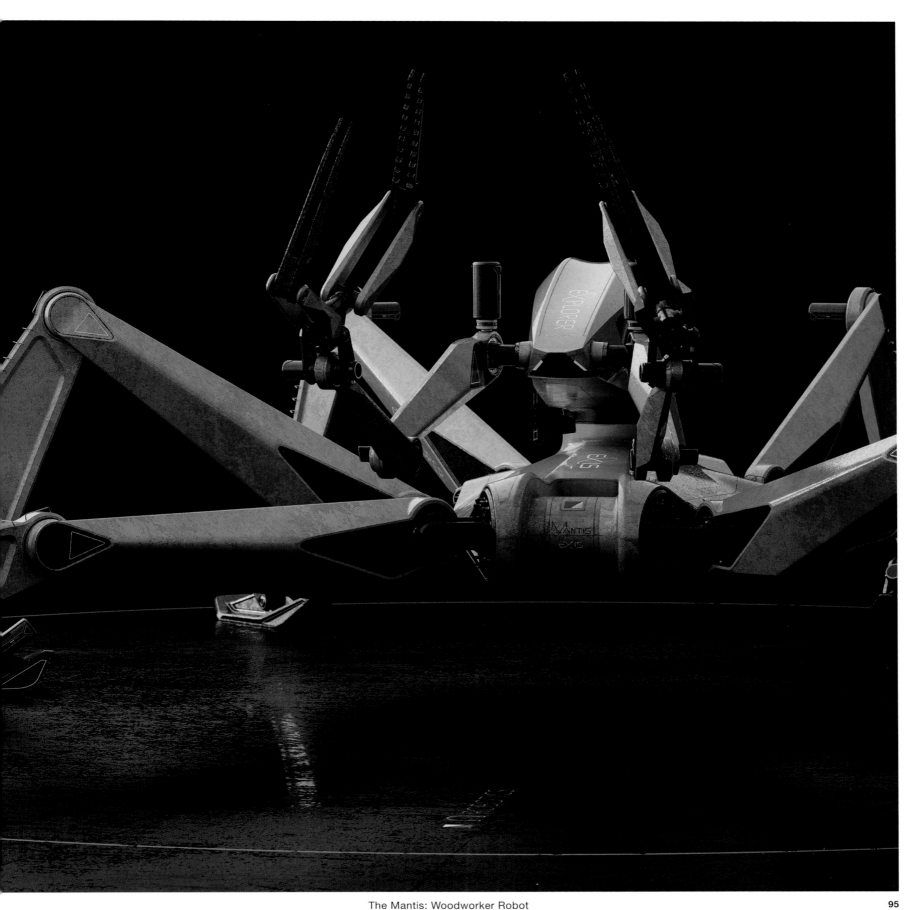

The Mantis: Woodworker Robot

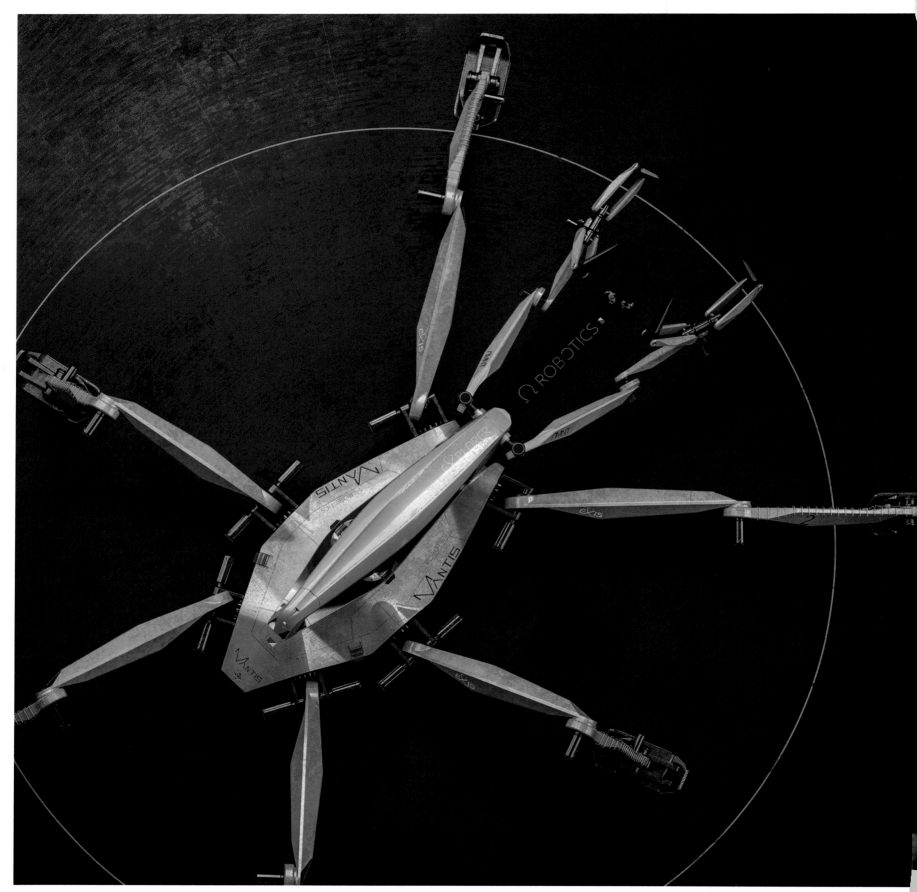

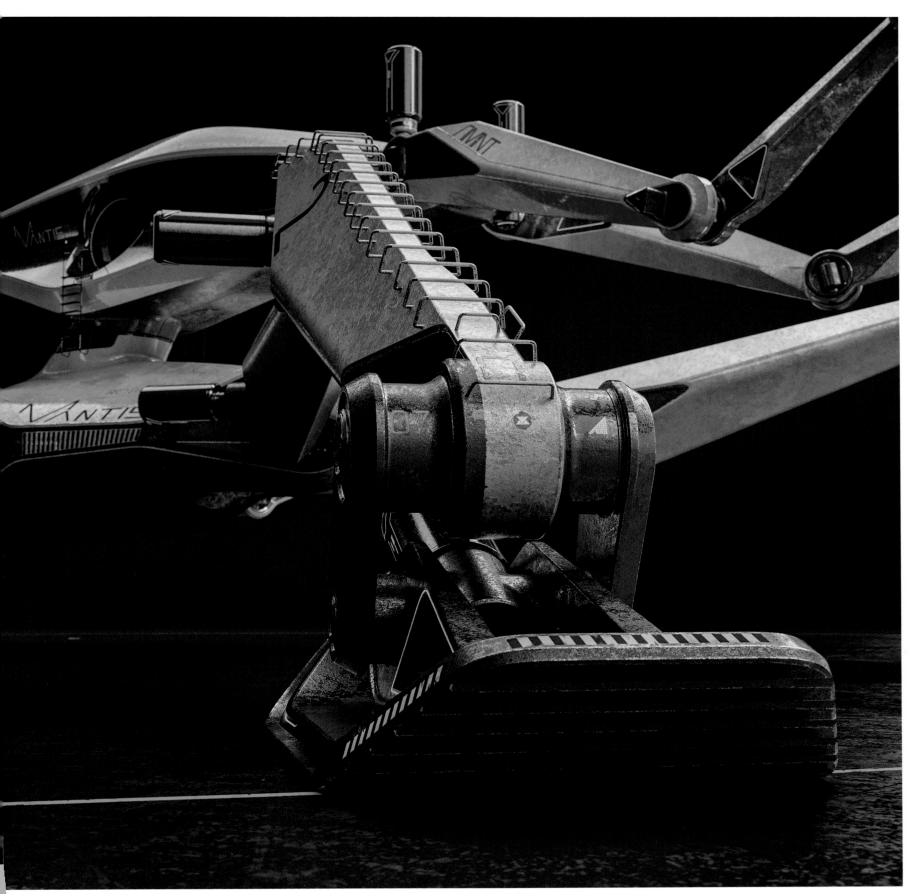

The Mantis: Woodworker Robot

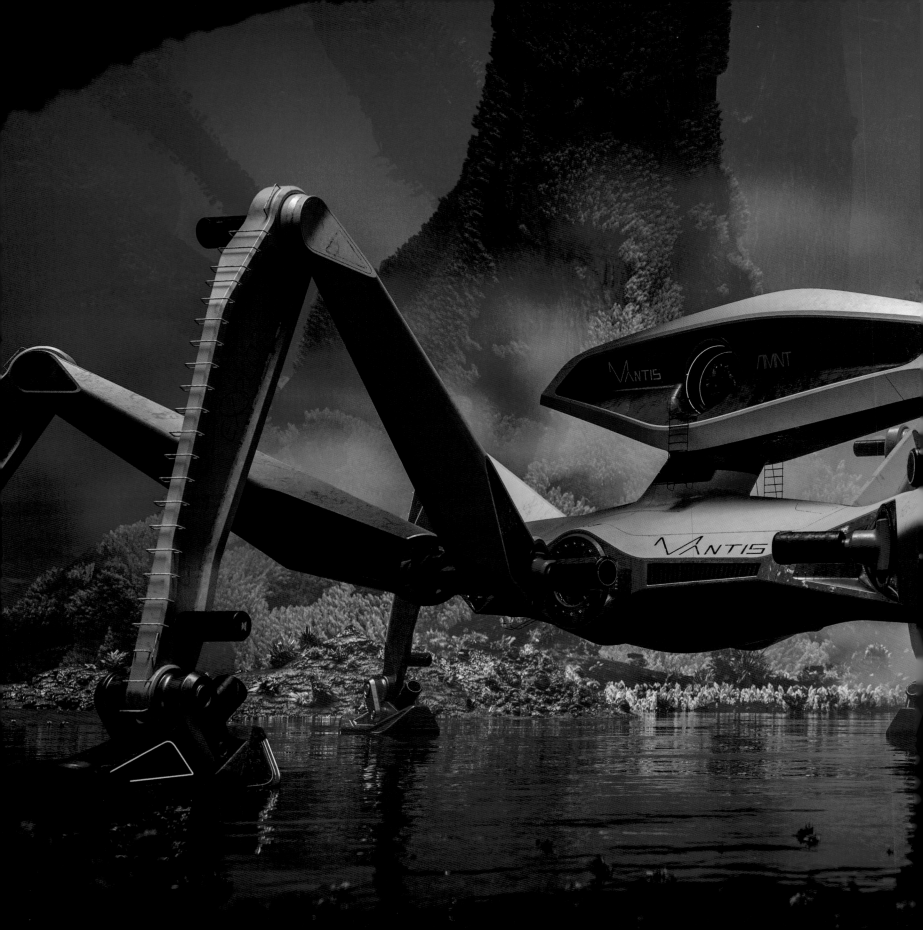

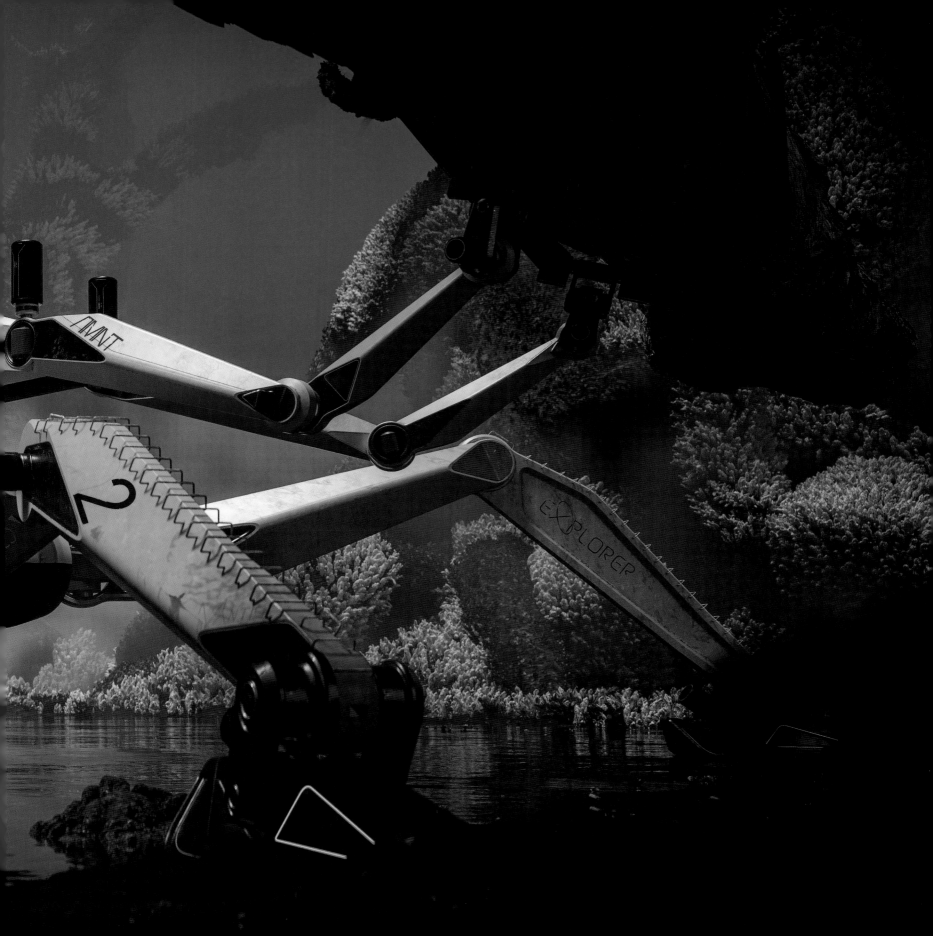

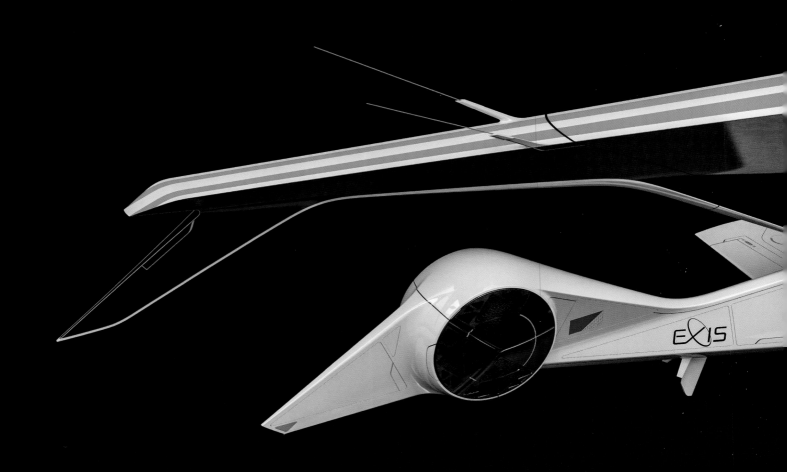

ORIGIN	: India	
PASSENGERS	: 2	
LENGTH	: 8 m	: 8.7 yd.
HEIGHT	: 9.8 m	: 10.7 yd.
WIDTH	: 4.4 m	: 5.2 yd.
WEIGHT	: 2.9 t	: 3.2 tn.
SPEED	: 2,850 km/h	: 1,770 mph

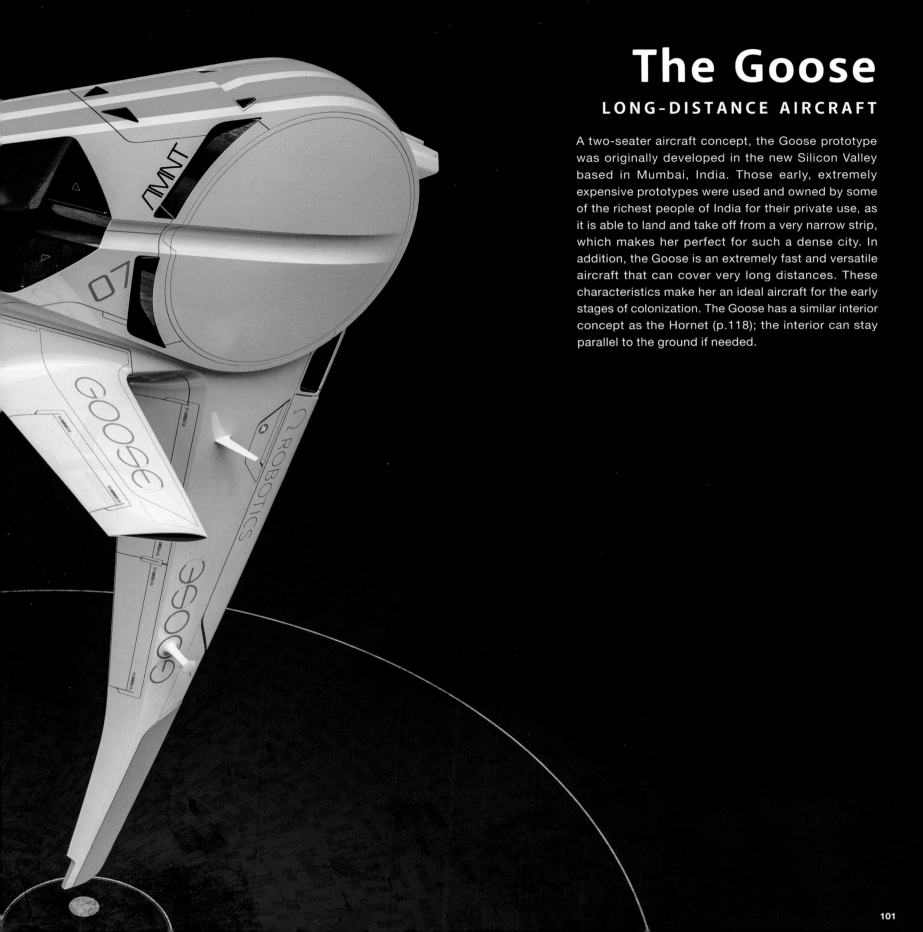

The Goose
LONG-DISTANCE AIRCRAFT

A two-seater aircraft concept, the Goose prototype was originally developed in the new Silicon Valley based in Mumbai, India. Those early, extremely expensive prototypes were used and owned by some of the richest people of India for their private use, as it is able to land and take off from a very narrow strip, which makes her perfect for such a dense city. In addition, the Goose is an extremely fast and versatile aircraft that can cover very long distances. These characteristics make her an ideal aircraft for the early stages of colonization. The Goose has a similar interior concept as the Hornet (p.118); the interior can stay parallel to the ground if needed.

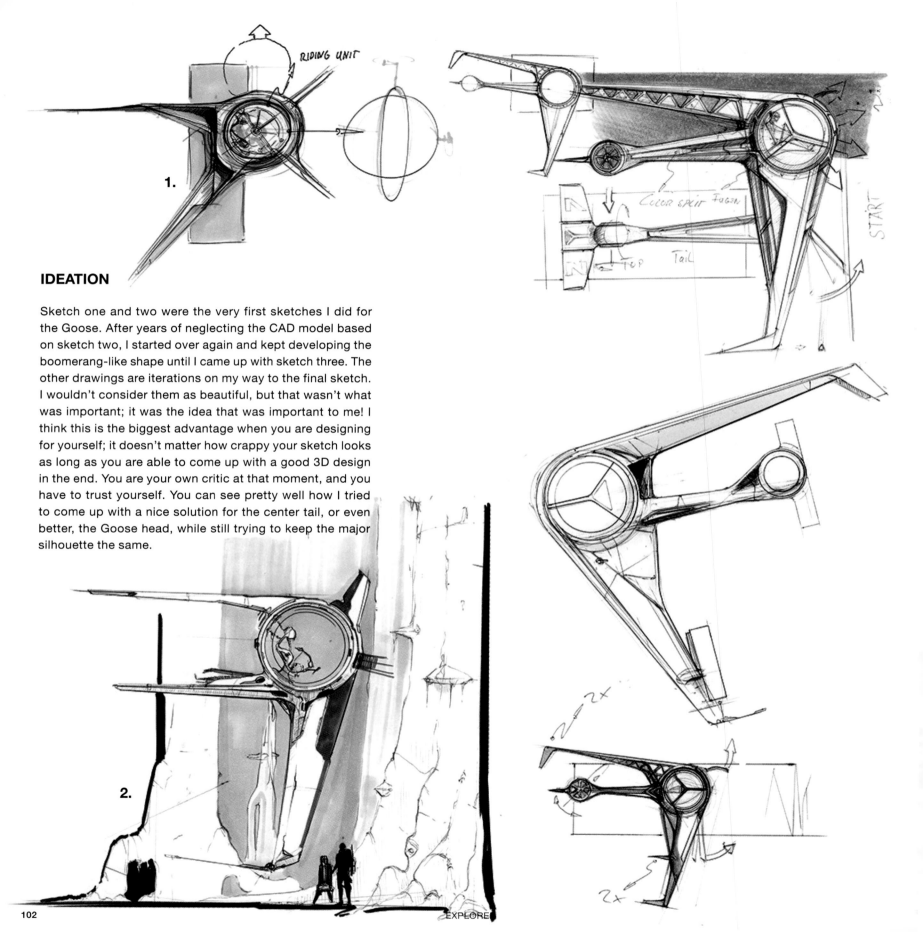

IDEATION

Sketch one and two were the very first sketches I did for the Goose. After years of neglecting the CAD model based on sketch two, I started over again and kept developing the boomerang-like shape until I came up with sketch three. The other drawings are iterations on my way to the final sketch. I wouldn't consider them as beautiful, but that wasn't what was important; it was the idea that was important to me! I think this is the biggest advantage when you are designing for yourself; it doesn't matter how crappy your sketch looks as long as you are able to come up with a good 3D design in the end. You are your own critic at that moment, and you have to trust yourself. You can see pretty well how I tried to come up with a nice solution for the center tail, or even better, the Goose head, while still trying to keep the major silhouette the same.

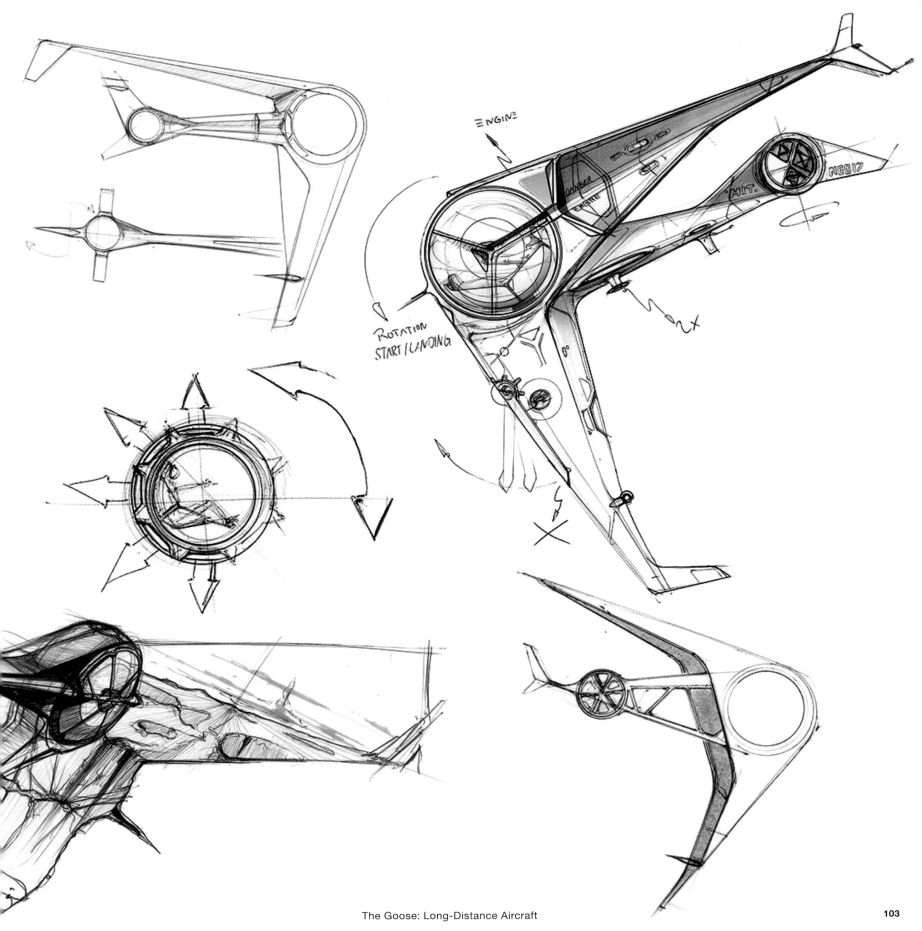

ENGINE

DANGER
ENGINE

MIT.

N8817

ROTATION
START / LANDING

0°

The Goose: Long-Distance Aircraft

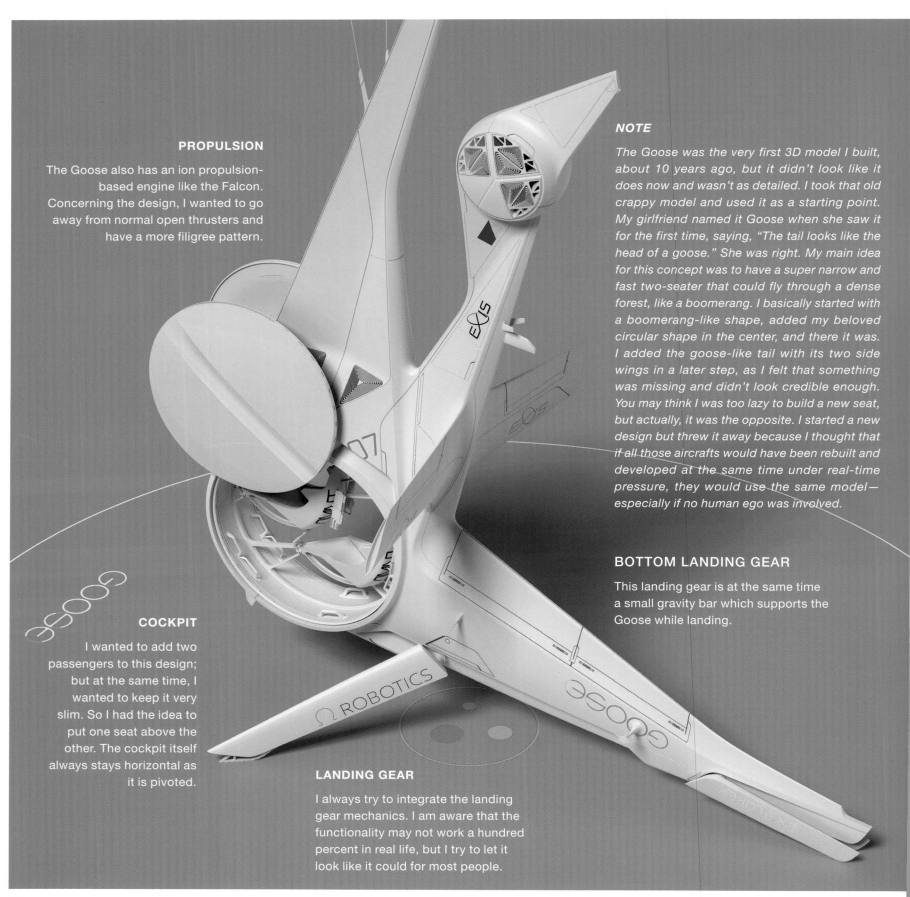

PROPULSION

The Goose also has an ion propulsion-based engine like the Falcon. Concerning the design, I wanted to go away from normal open thrusters and have a more filigree pattern.

NOTE

The Goose was the very first 3D model I built, about 10 years ago, but it didn't look like it does now and wasn't as detailed. I took that old crappy model and used it as a starting point. My girlfriend named it Goose when she saw it for the first time, saying, "The tail looks like the head of a goose." She was right. My main idea for this concept was to have a super narrow and fast two-seater that could fly through a dense forest, like a boomerang. I basically started with a boomerang-like shape, added my beloved circular shape in the center, and there it was. I added the goose-like tail with its two side wings in a later step, as I felt that something was missing and didn't look credible enough. You may think I was too lazy to build a new seat, but actually, it was the opposite. I started a new design but threw it away because I thought that if all those aircrafts would have been rebuilt and developed at the same time under real-time pressure, they would use the same model—especially if no human ego was involved.

COCKPIT

I wanted to add two passengers to this design; but at the same time, I wanted to keep it very slim. So I had the idea to put one seat above the other. The cockpit itself always stays horizontal as it is pivoted.

BOTTOM LANDING GEAR

This landing gear is at the same time a small gravity bar which supports the Goose while landing.

LANDING GEAR

I always try to integrate the landing gear mechanics. I am aware that the functionality may not work a hundred percent in real life, but I try to let it look like it could for most people.

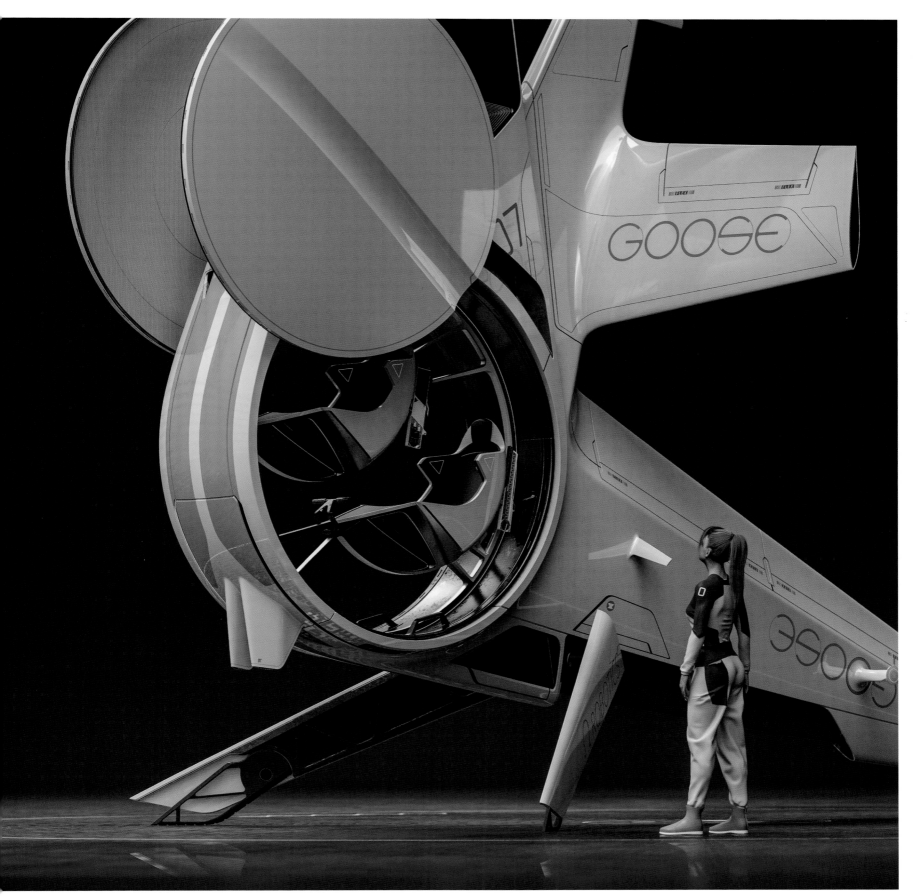

The Goose: Long-Distance Aircraft

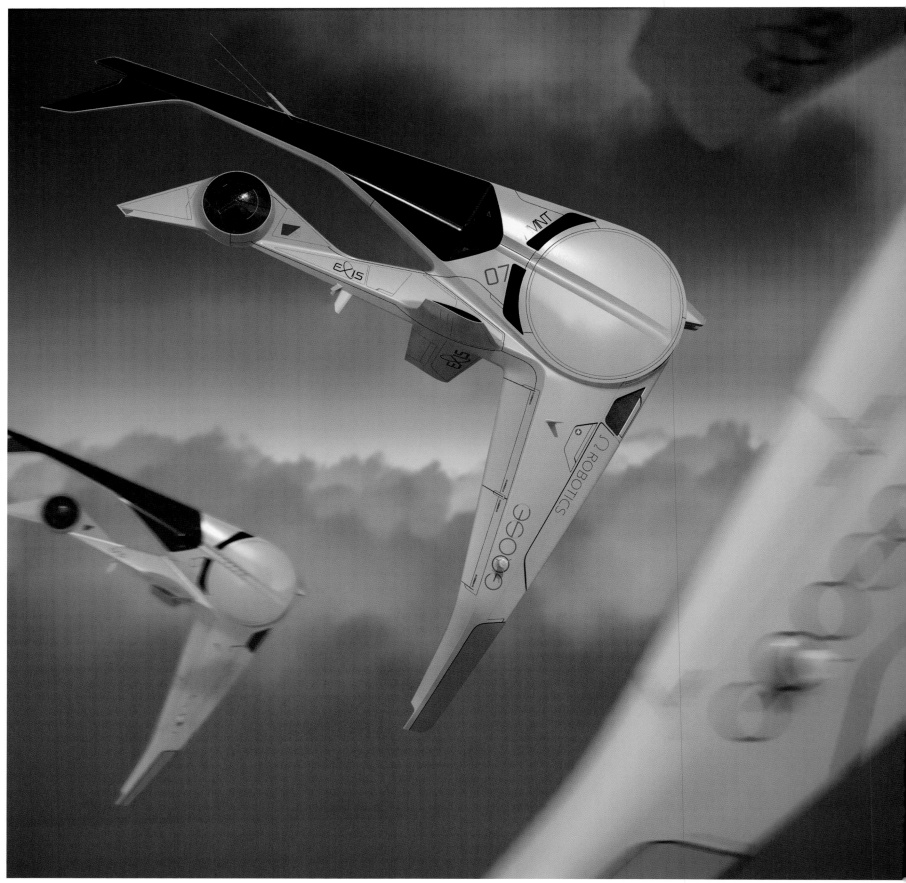

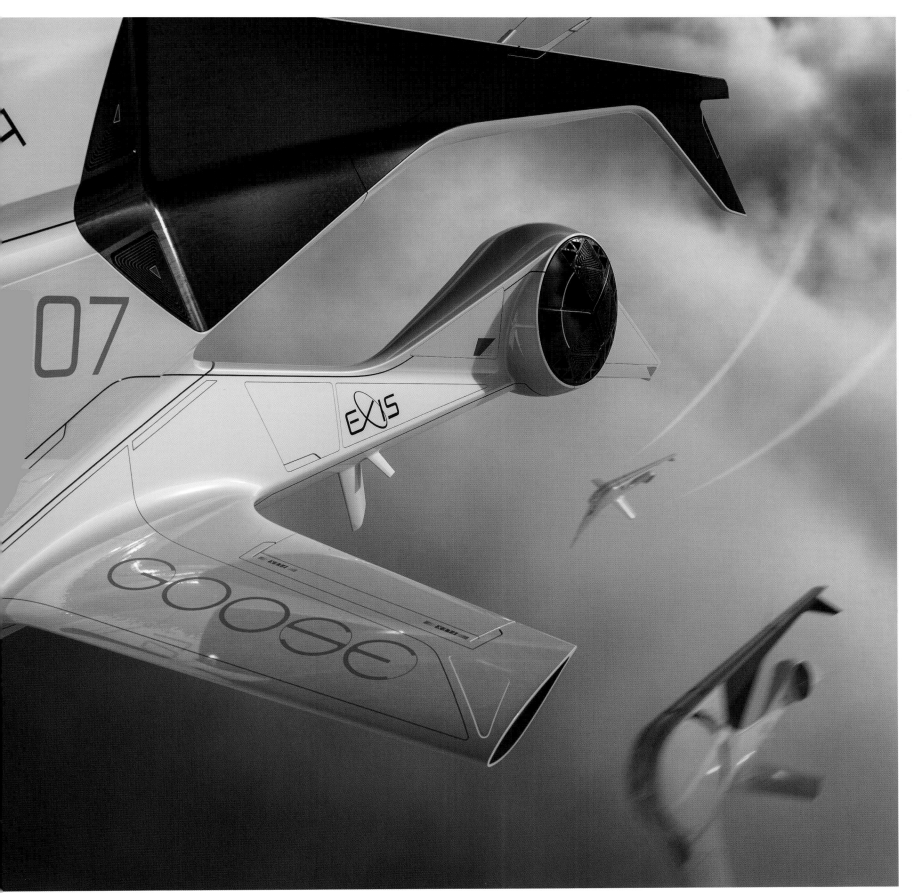

The Goose: Long-Distance Aircraft

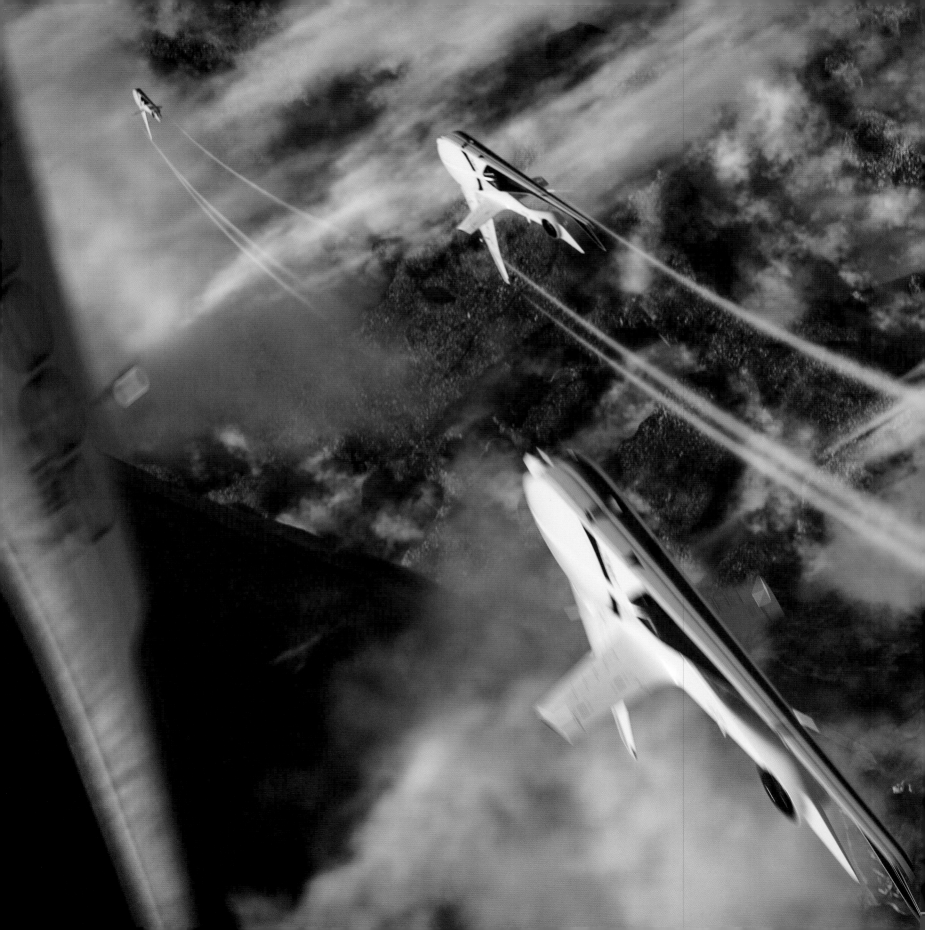

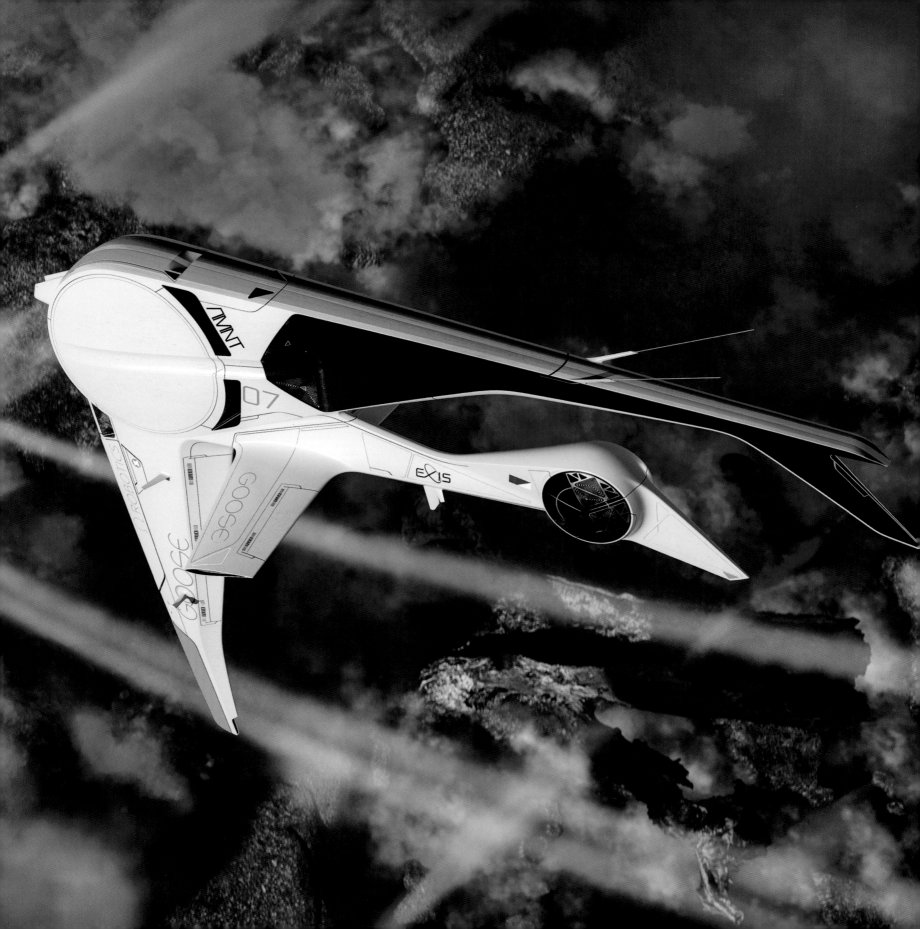

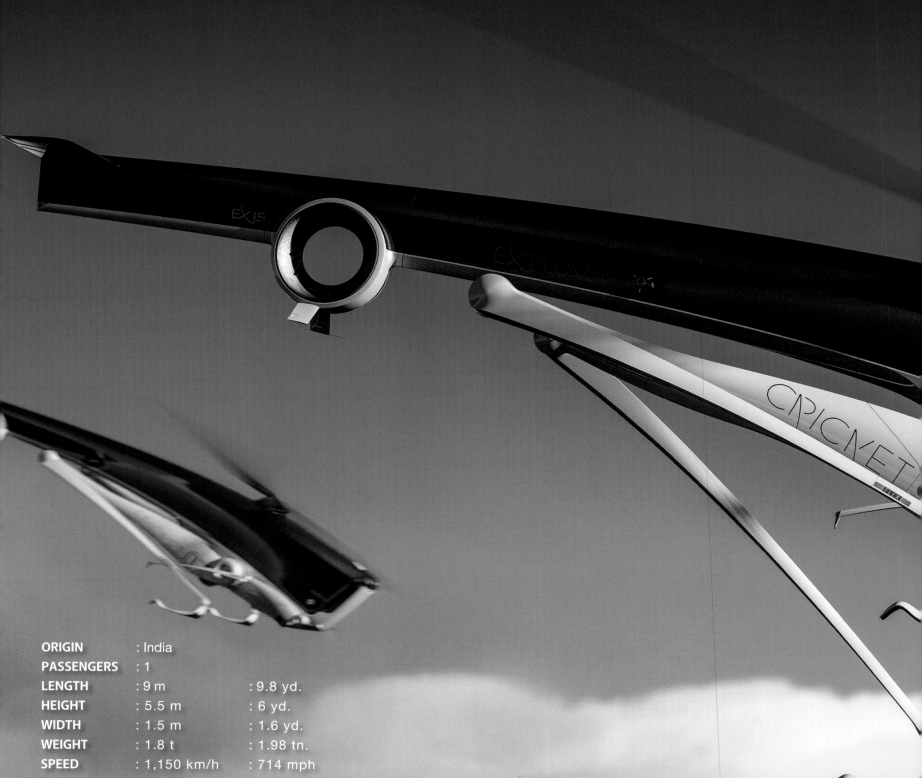

ORIGIN	: India	
PASSENGERS	: 1	
LENGTH	: 9 m	: 9.8 yd.
HEIGHT	: 5.5 m	: 6 yd.
WIDTH	: 1.5 m	: 1.6 yd.
WEIGHT	: 1.8 t	: 1.98 tn.
SPEED	: 1,150 km/h	: 714 mph

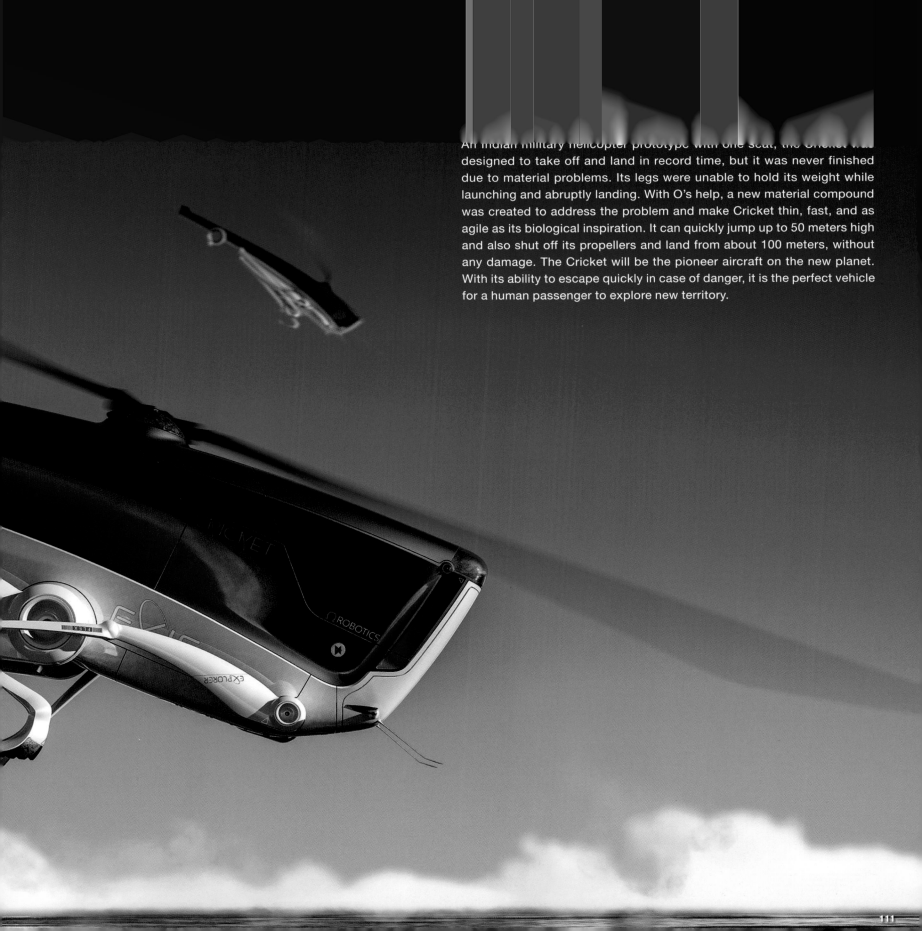

An Indian military helicopter prototype with one seat, the Cricket was designed to take off and land in record time, but it was never finished due to material problems. Its legs were unable to hold its weight while launching and abruptly landing. With O's help, a new material compound was created to address the problem and make Cricket thin, fast, and as agile as its biological inspiration. It can quickly jump up to 50 meters high and also shut off its propellers and land from about 100 meters, without any damage. The Cricket will be the pioneer aircraft on the new planet. With its ability to escape quickly in case of danger, it is the perfect vehicle for a human passenger to explore new territory.

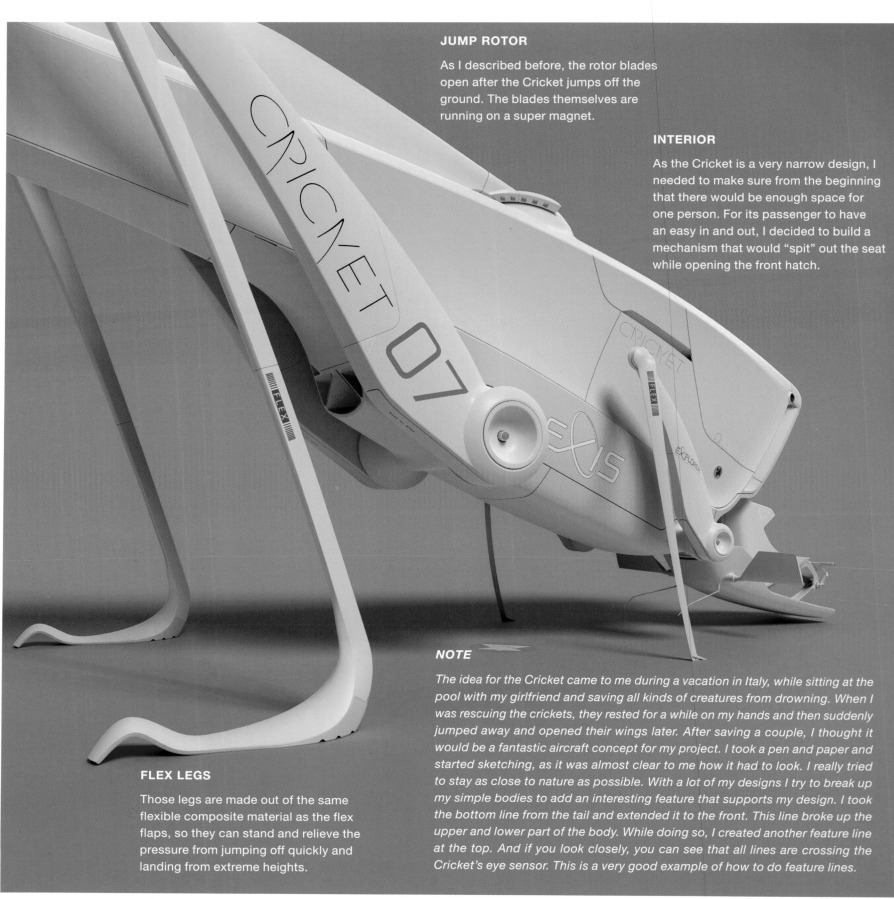

JUMP ROTOR

As I described before, the rotor blades open after the Cricket jumps off the ground. The blades themselves are running on a super magnet.

INTERIOR

As the Cricket is a very narrow design, I needed to make sure from the beginning that there would be enough space for one person. For its passenger to have an easy in and out, I decided to build a mechanism that would "spit" out the seat while opening the front hatch.

NOTE

The idea for the Cricket came to me during a vacation in Italy, while sitting at the pool with my girlfriend and saving all kinds of creatures from drowning. When I was rescuing the crickets, they rested for a while on my hands and then suddenly jumped away and opened their wings later. After saving a couple, I thought it would be a fantastic aircraft concept for my project. I took a pen and paper and started sketching, as it was almost clear to me how it had to look. I really tried to stay as close to nature as possible. With a lot of my designs I try to break up my simple bodies to add an interesting feature that supports my design. I took the bottom line from the tail and extended it to the front. This line broke up the upper and lower part of the body. While doing so, I created another feature line at the top. And if you look closely, you can see that all lines are crossing the Cricket's eye sensor. This is a very good example of how to do feature lines.

FLEX LEGS

Those legs are made out of the same flexible composite material as the flex flaps, so they can stand and relieve the pressure from jumping off quickly and landing from extreme heights.

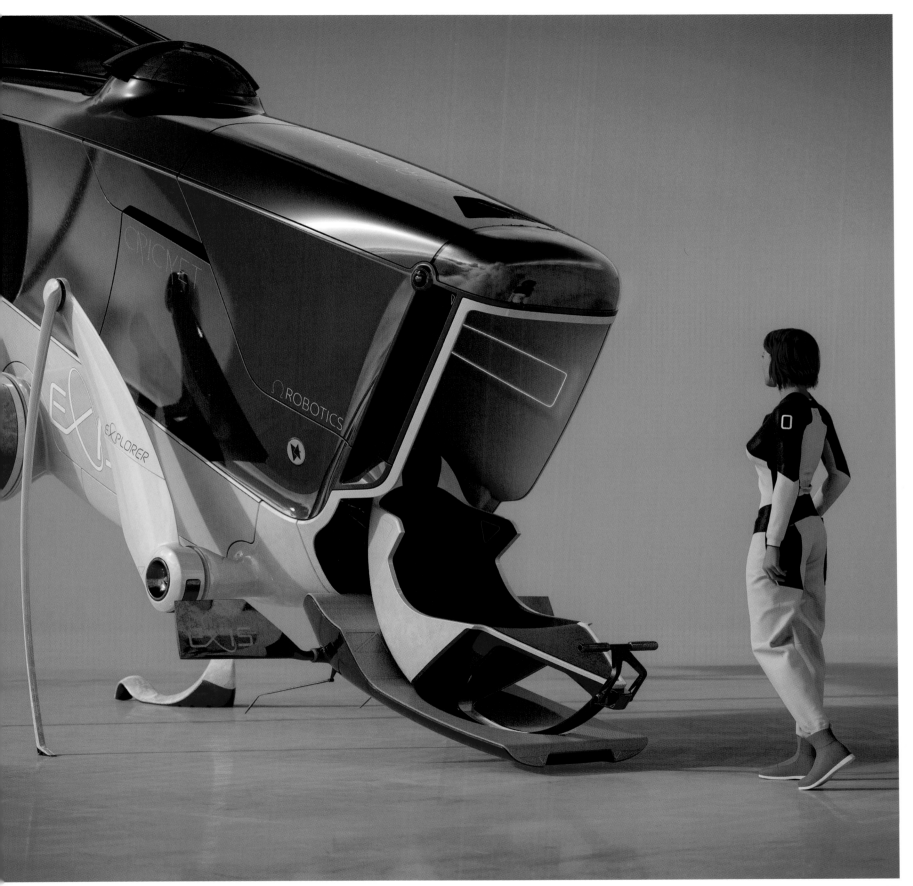

The Cricket: Exploratory Vehicle

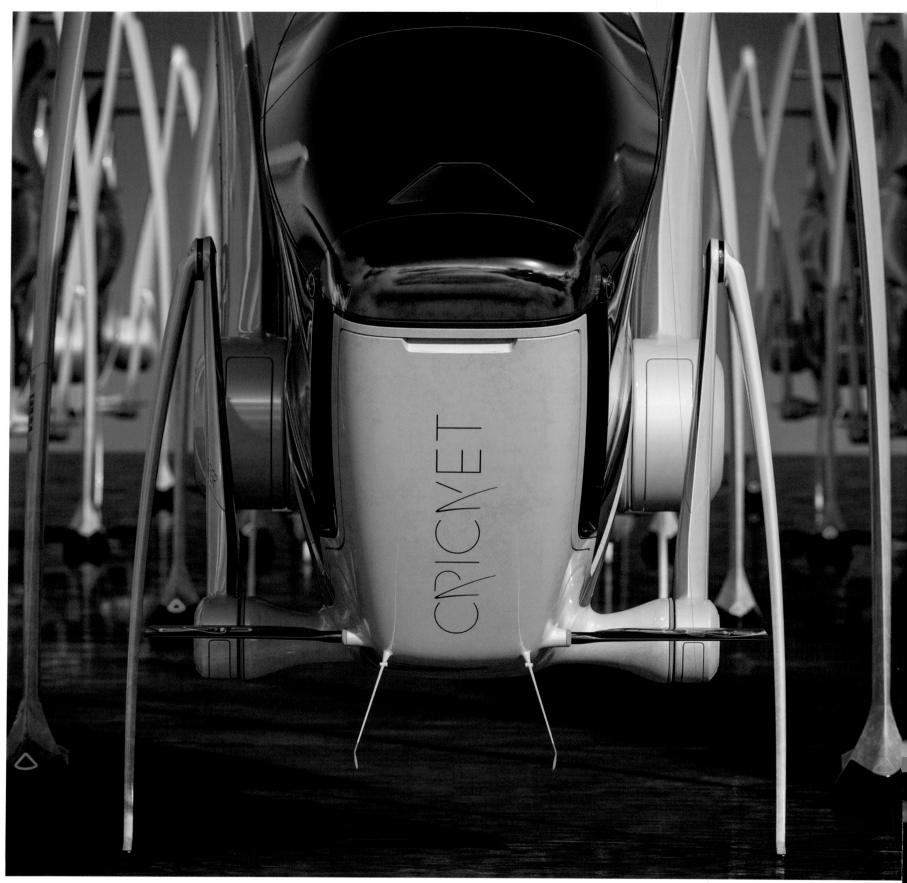

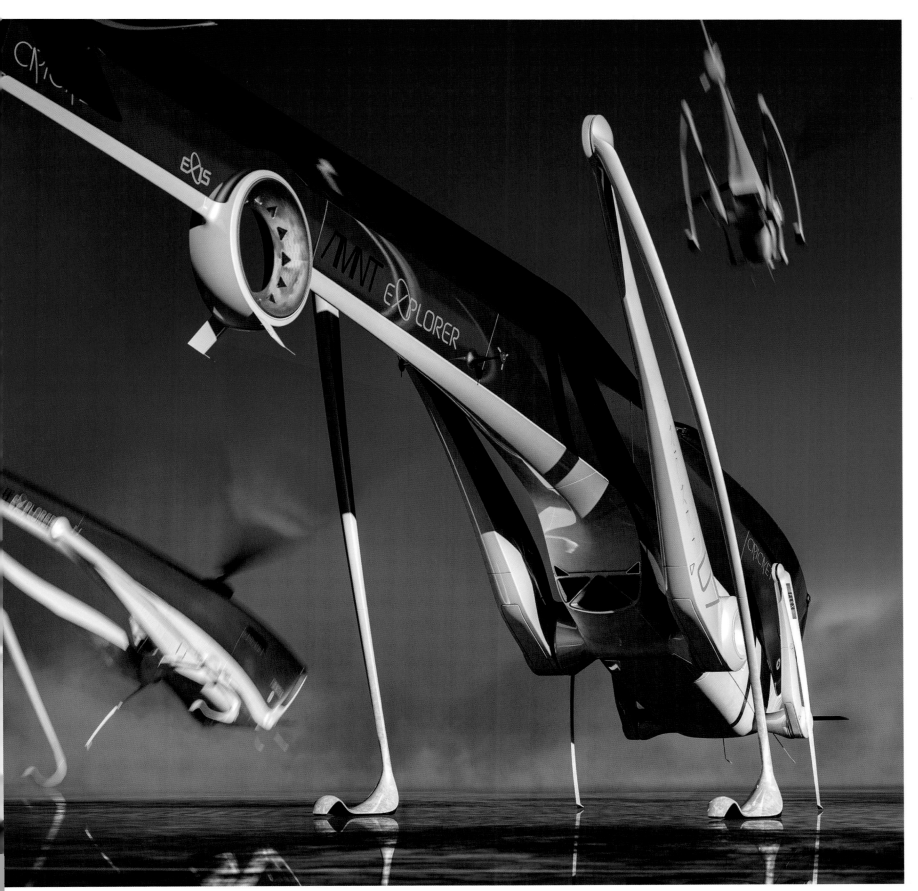

The Cricket: Exploratory Vehicle

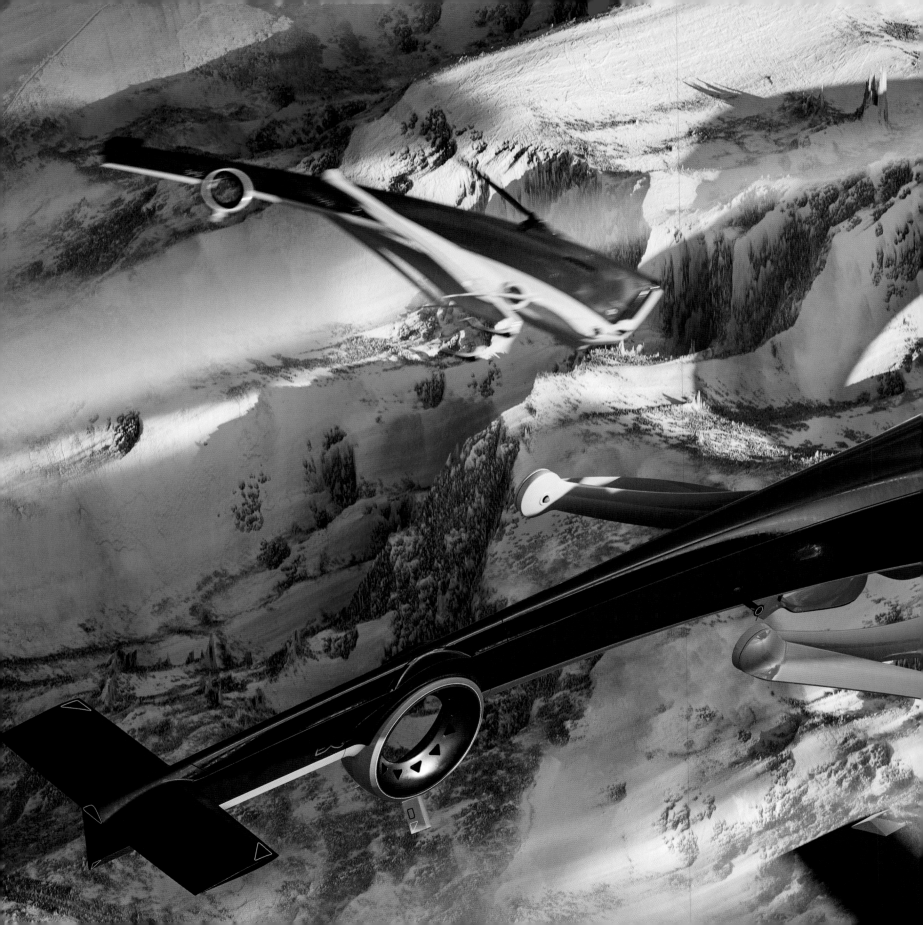

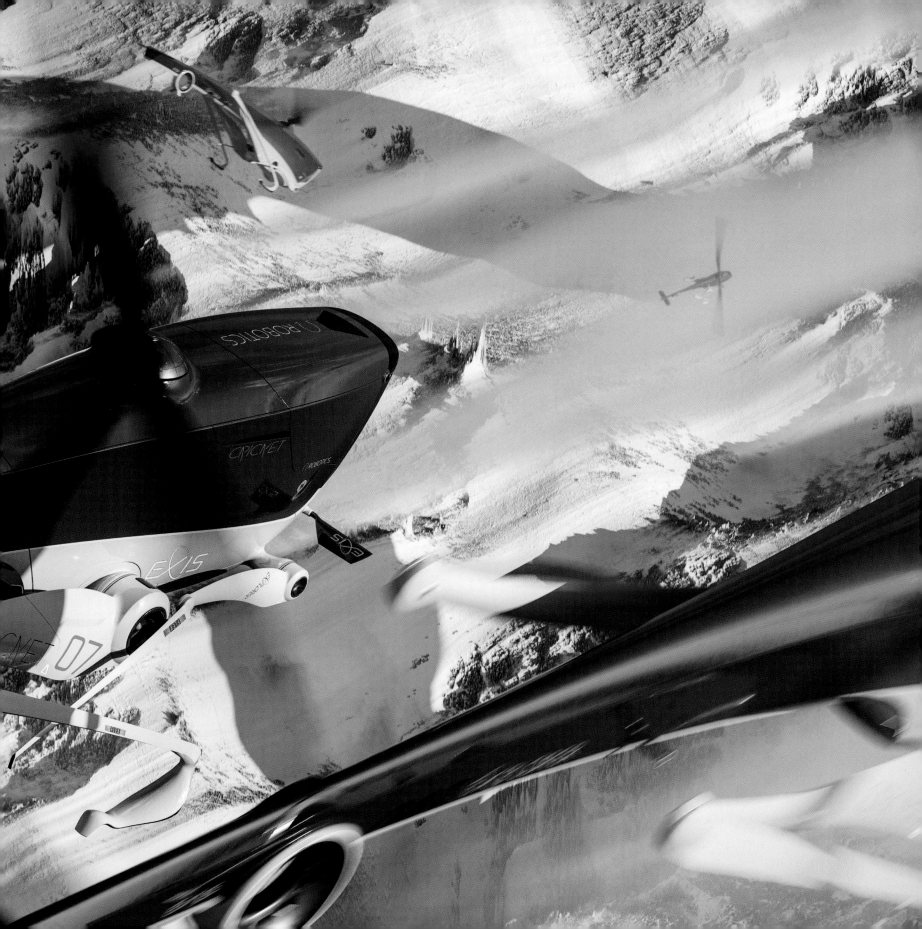

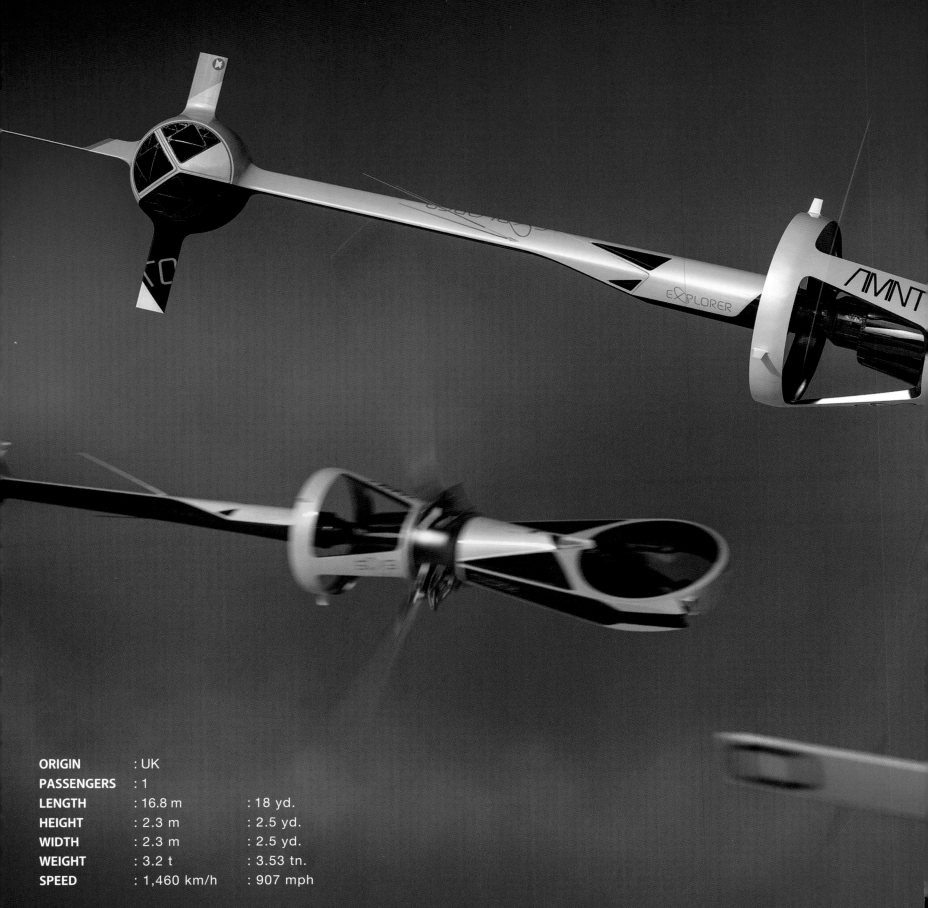

ORIGIN	: UK	
PASSENGERS	: 1	
LENGTH	: 16.8 m	: 18 yd.
HEIGHT	: 2.3 m	: 2.5 yd.
WIDTH	: 2.3 m	: 2.5 yd.
WEIGHT	: 3.2 t	: 3.53 tn.
SPEED	: 1,460 km/h	: 907 mph

The Hornet
STEALTH ROTORCRAFT

A single-seater helicopter concept, the Hornet was developed by the British Special Forces. Its ability to land on very dense terrain makes it the perfect tool for maverick stealth missions. The Hornet is similar to the Cricket with its ability for precision landings, but is not as fast at takeoff or landing. And due to its large rotor, the Hornet needs a lot more space for landing, thus it will be used on the new planet when it is more secure. But the Hornet does have one advantage over the Cricket: it is able to shut off its rotor and use it for gliding in the air while its center propulsion engine drives it forward.

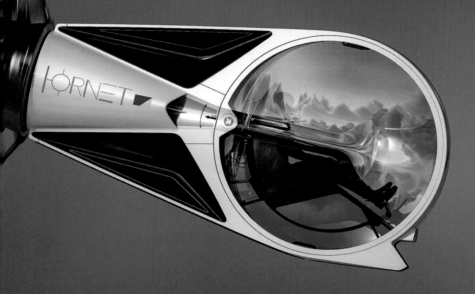

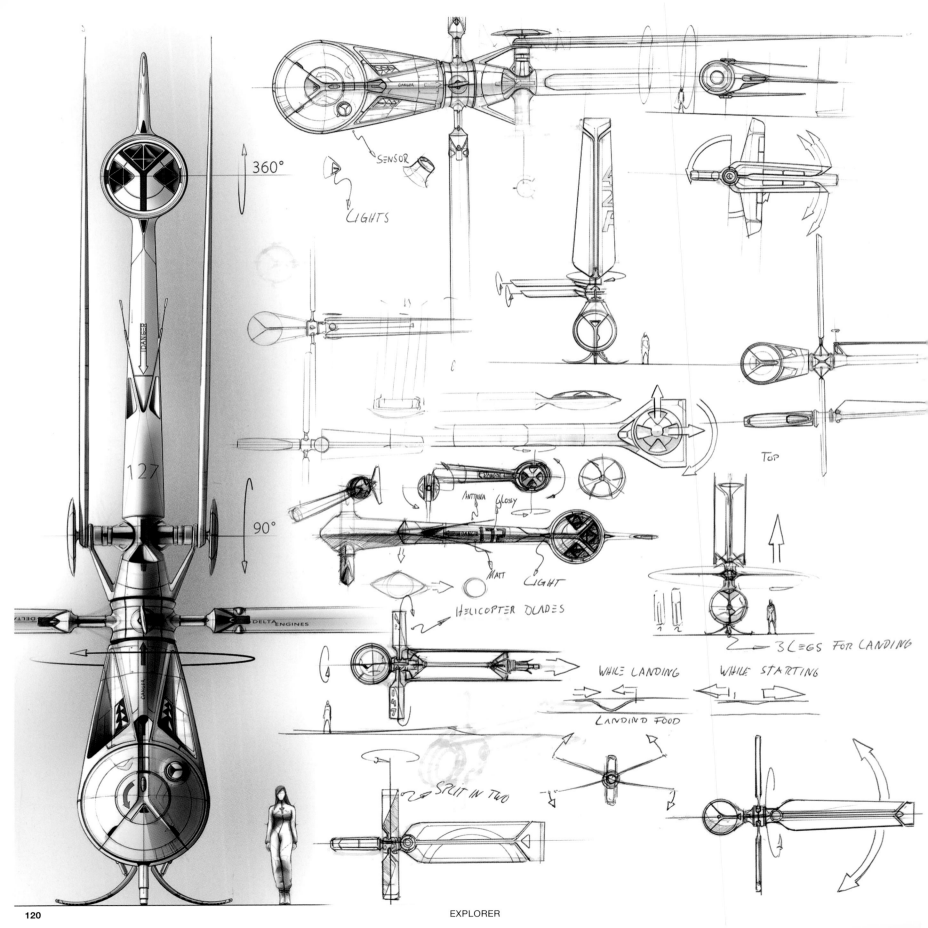

SENSOR

LIGHTS

360°

127

90°

DELTA ENGINES

DANGER

ANTENNA

GLOSSY

MATT

LIGHT

HELICOPTER BLADES

TOP

3 LEGS FOR LANDING

WHILE LANDING

WHILE STARTING

LANDING FOOD

SPLIT IN TWO

IDEATION

On the left side you can see my ideation process for the Hornet at the beginning of 2015. The design was inspired by Daniel Simon's dragonfly concept for *Oblivion*. I really loved the idea of this beautiful futuristic aircraft, so I tried to come up with my own idea for such an aircraft concept without copying that dragonfly. Back then I was just sketching my ideas and not really building proper 3D models of my work (except for those two basic models of the old Goose and the Octopus). I just started really modeling my own proper 3D models with the beginning of my sabbatical in 2016. You can see how my idea for this aircraft developed with all those sketches, little arrows and notes.

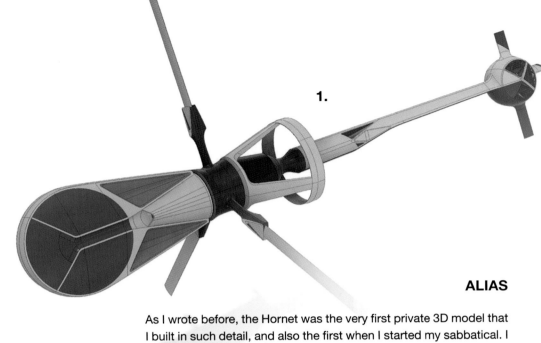

1.

ALIAS

As I wrote before, the Hornet was the very first private 3D model that I built in such detail, and also the first when I started my sabbatical. I was very eager to see if I could build an Alias CAD model from my own concepts and not just interiors. But I was lucky; all the 3D training I had in my professional career was a tremendous help and it wasn't that difficult. But when I started using Alias more than I used to, I started to change my Alias interface by adding many more shortcuts to become faster and more efficient. Model one shows a very early stage, as you can see on the different rotor wing mounting concept, which I changed to what you can see on pictures two and three. On picture two, you can see that I also modeled names and graphics into my 3D model because I only had a basic knowledge of rendering and didn't know that you can easily map logos onto your models in KeyShot.

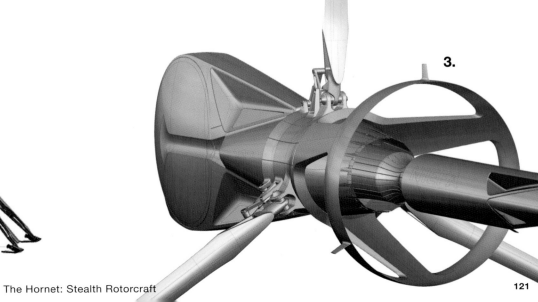

2.

3.

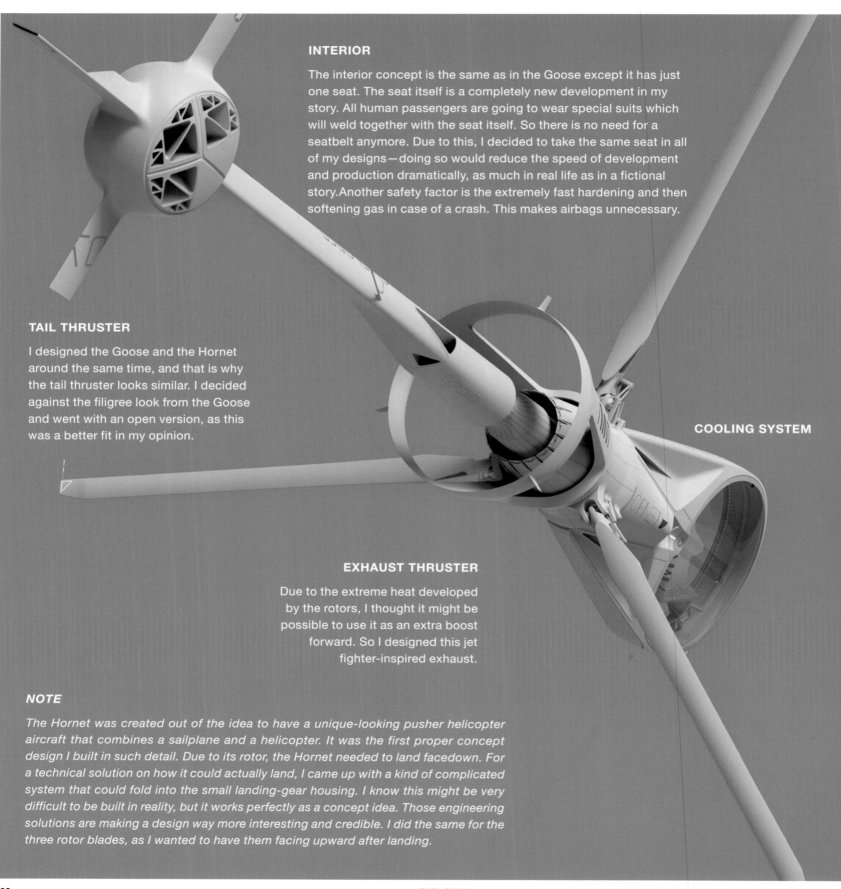

INTERIOR

The interior concept is the same as in the Goose except it has just one seat. The seat itself is a completely new development in my story. All human passengers are going to wear special suits which will weld together with the seat itself. So there is no need for a seatbelt anymore. Due to this, I decided to take the same seat in all of my designs—doing so would reduce the speed of development and production dramatically, as much in real life as in a fictional story.Another safety factor is the extremely fast hardening and then softening gas in case of a crash. This makes airbags unnecessary.

TAIL THRUSTER

I designed the Goose and the Hornet around the same time, and that is why the tail thruster looks similar. I decided against the filigree look from the Goose and went with an open version, as this was a better fit in my opinion.

COOLING SYSTEM

EXHAUST THRUSTER

Due to the extreme heat developed by the rotors, I thought it might be possible to use it as an extra boost forward. So I designed this jet fighter-inspired exhaust.

NOTE

The Hornet was created out of the idea to have a unique-looking pusher helicopter aircraft that combines a sailplane and a helicopter. It was the first proper concept design I built in such detail. Due to its rotor, the Hornet needed to land facedown. For a technical solution on how it could actually land, I came up with a kind of complicated system that could fold into the small landing-gear housing. I know this might be very difficult to be built in reality, but it works perfectly as a concept idea. Those engineering solutions are making a design way more interesting and credible. I did the same for the three rotor blades, as I wanted to have them facing upward after landing.

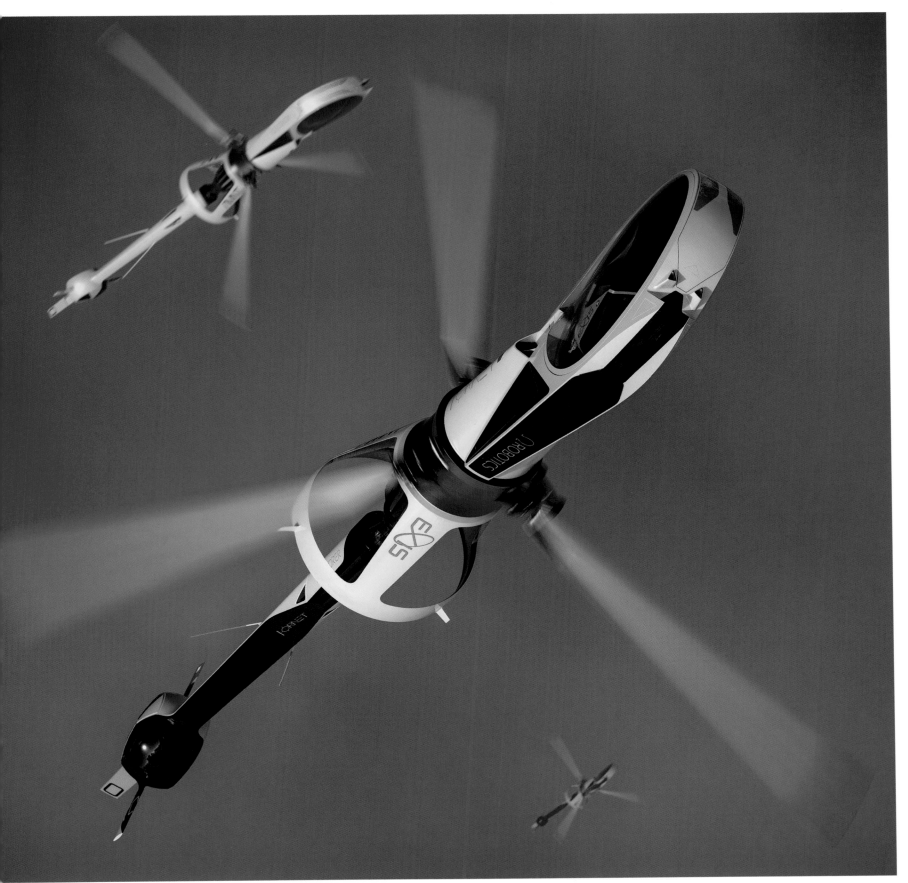

The Hornet: Stealth Rotorcraft

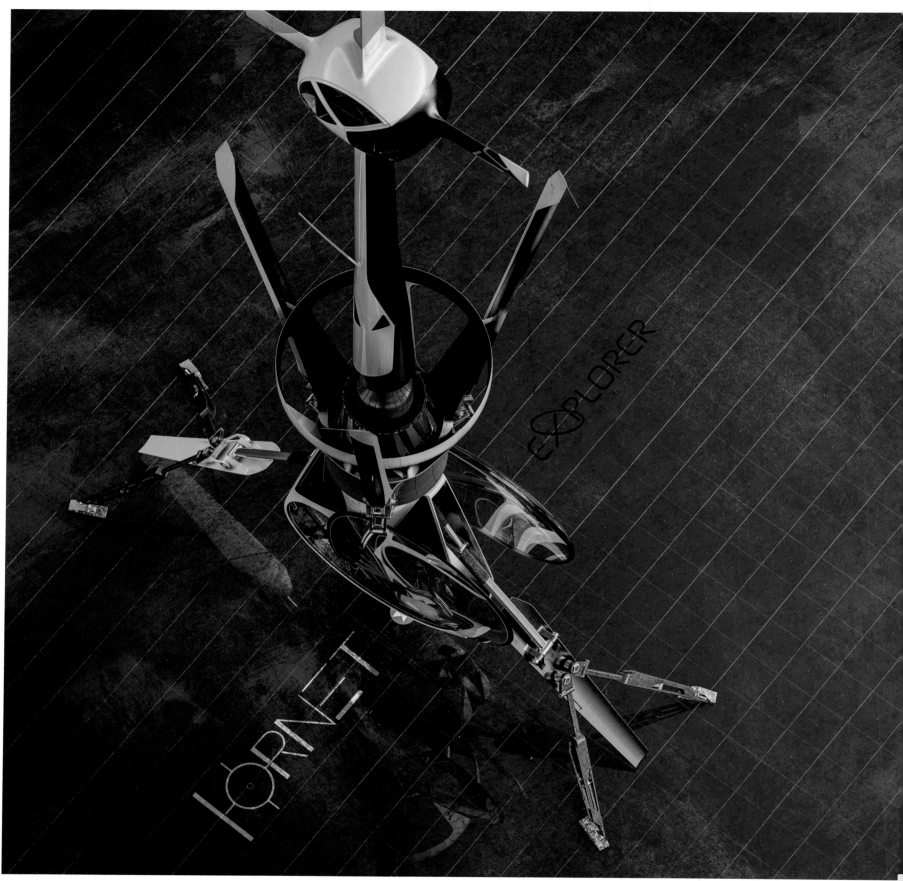

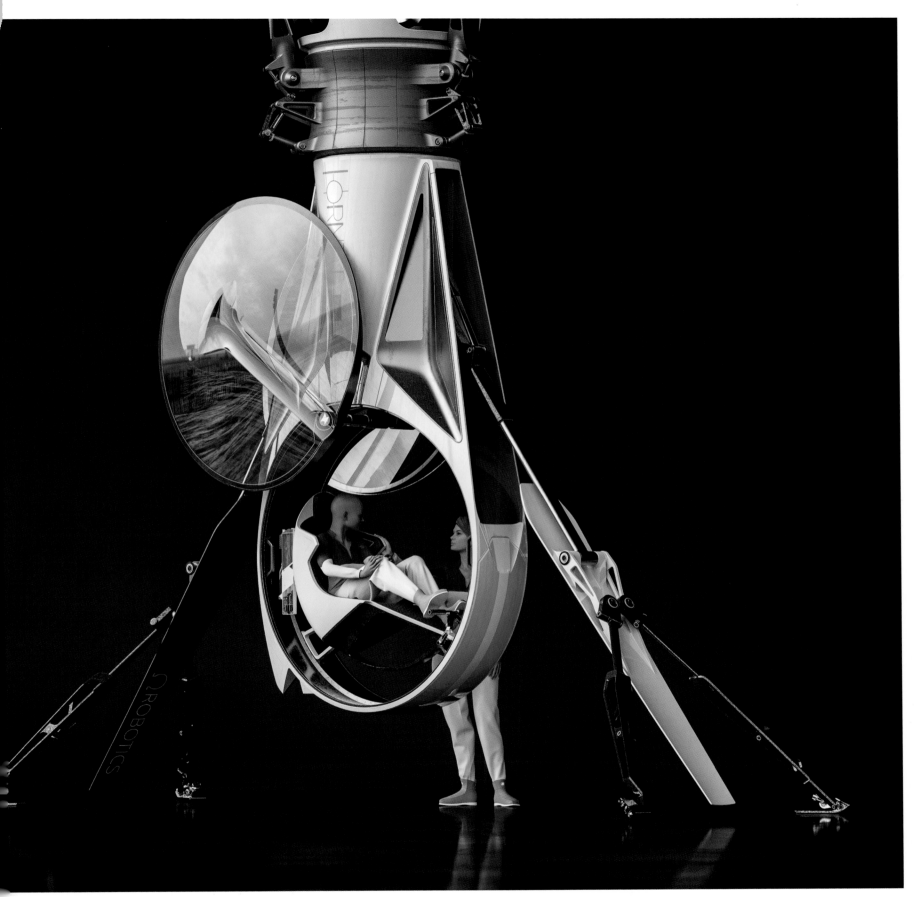

The Hornet: Stealth Rotorcraft

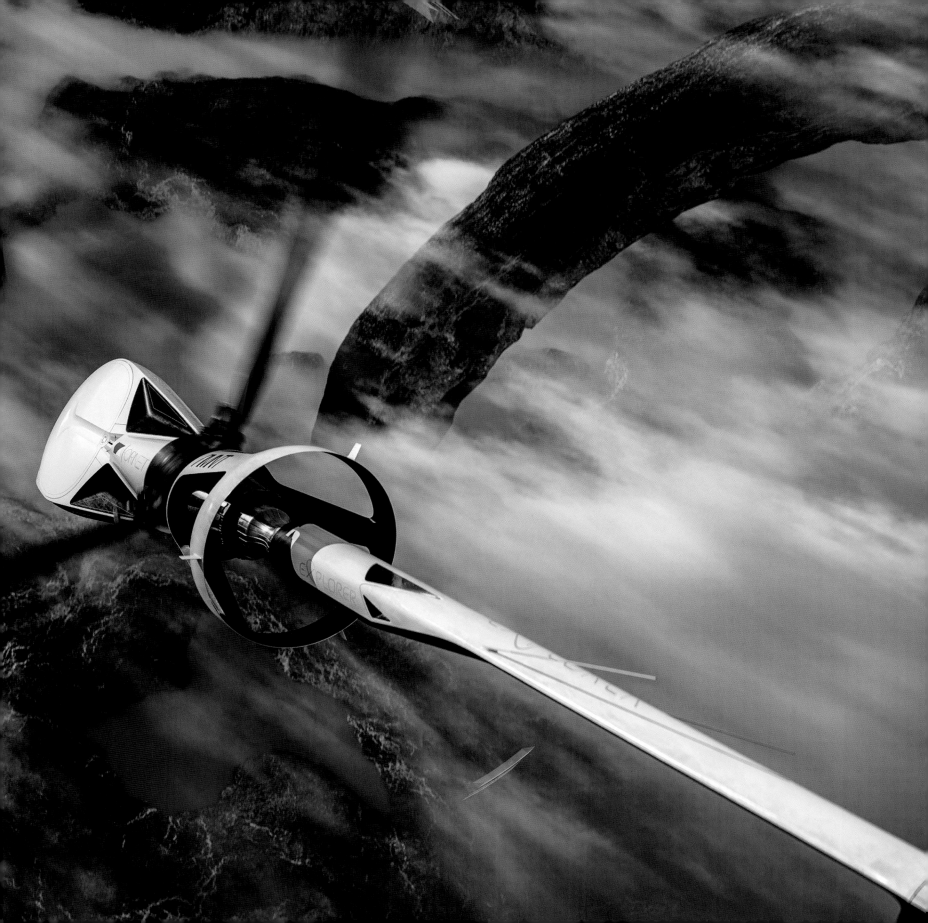

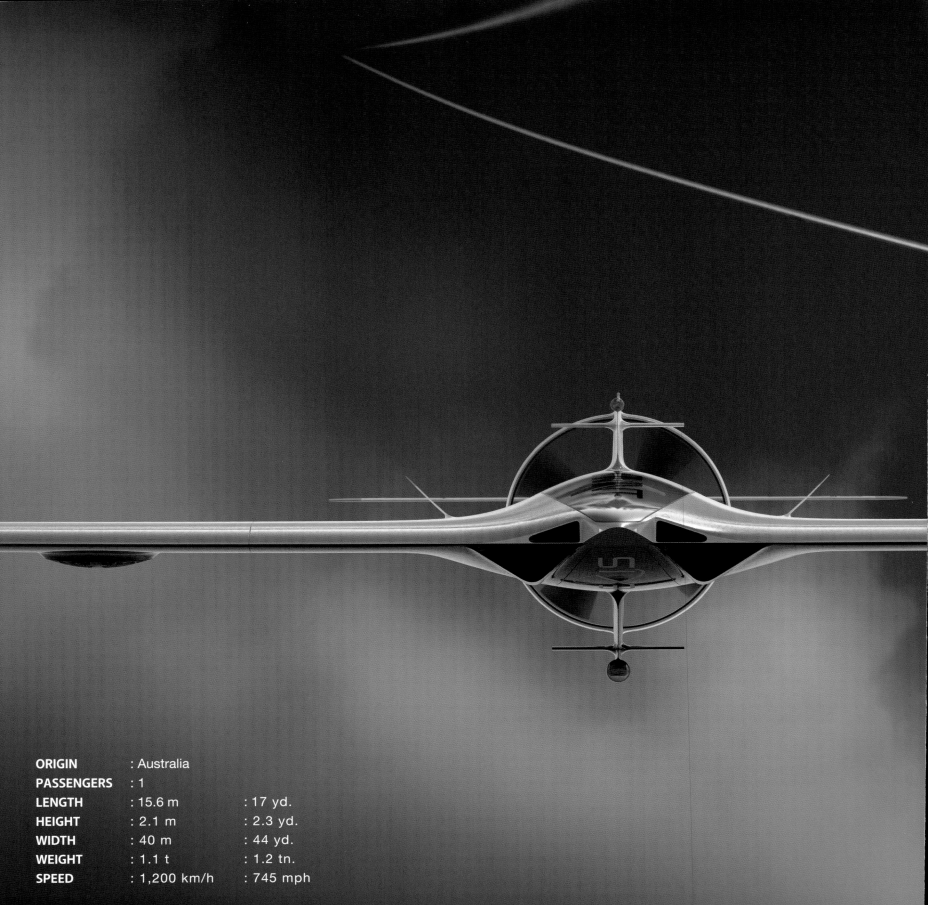

ORIGIN	: Australia	
PASSENGERS	: 1	
LENGTH	: 15.6 m	: 17 yd.
HEIGHT	: 2.1 m	: 2.3 yd.
WIDTH	: 40 m	: 44 yd.
WEIGHT	: 1.1 t	: 1.2 tn.
SPEED	: 1,200 km/h	: 745 mph

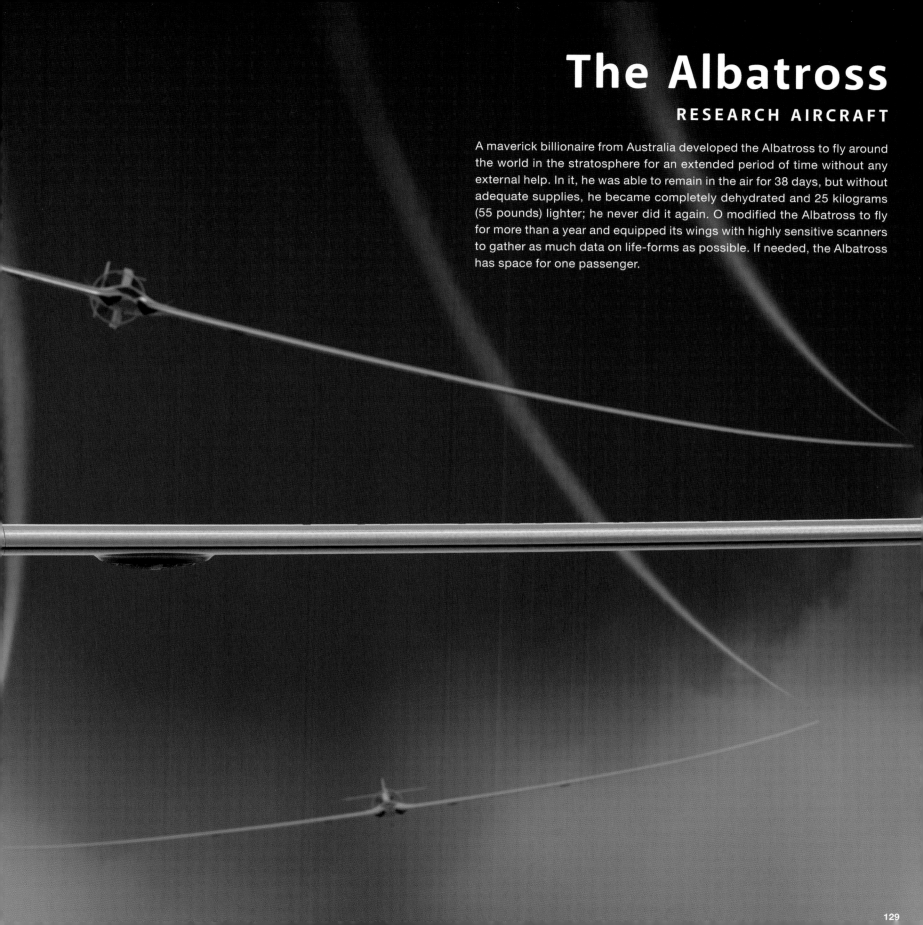

The Albatross
RESEARCH AIRCRAFT

A maverick billionaire from Australia developed the Albatross to fly around the world in the stratosphere for an extended period of time without any external help. In it, he was able to remain in the air for 38 days, but without adequate supplies, he became completely dehydrated and 25 kilograms (55 pounds) lighter; he never did it again. O modified the Albatross to fly for more than a year and equipped its wings with highly sensitive scanners to gather as much data on life-forms as possible. If needed, the Albatross has space for one passenger.

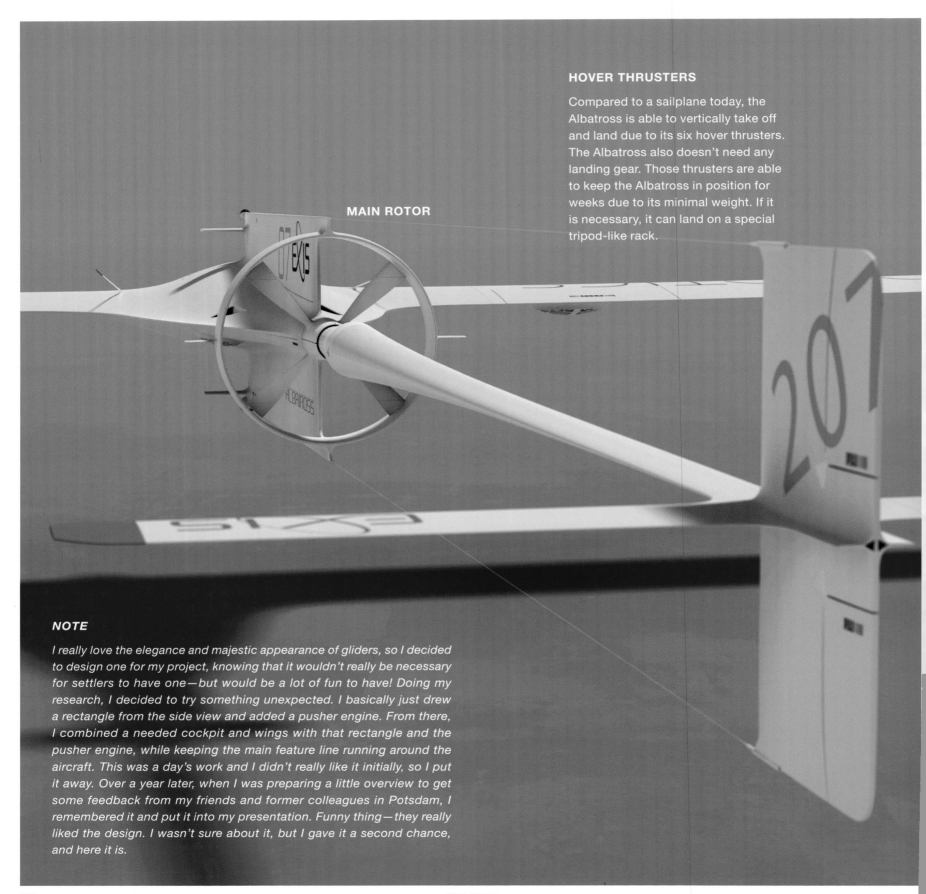

HOVER THRUSTERS

Compared to a sailplane today, the Albatross is able to vertically take off and land due to its six hover thrusters. The Albatross also doesn't need any landing gear. Those thrusters are able to keep the Albatross in position for weeks due to its minimal weight. If it is necessary, it can land on a special tripod-like rack.

MAIN ROTOR

NOTE

I really love the elegance and majestic appearance of gliders, so I decided to design one for my project, knowing that it wouldn't really be necessary for settlers to have one—but would be a lot of fun to have! Doing my research, I decided to try something unexpected. I basically just drew a rectangle from the side view and added a pusher engine. From there, I combined a needed cockpit and wings with that rectangle and the pusher engine, while keeping the main feature line running around the aircraft. This was a day's work and I didn't really like it initially, so I put it away. Over a year later, when I was preparing a little overview to get some feedback from my friends and former colleagues in Potsdam, I remembered it and put it into my presentation. Funny thing—they really liked the design. I wasn't sure about it, but I gave it a second chance, and here it is.

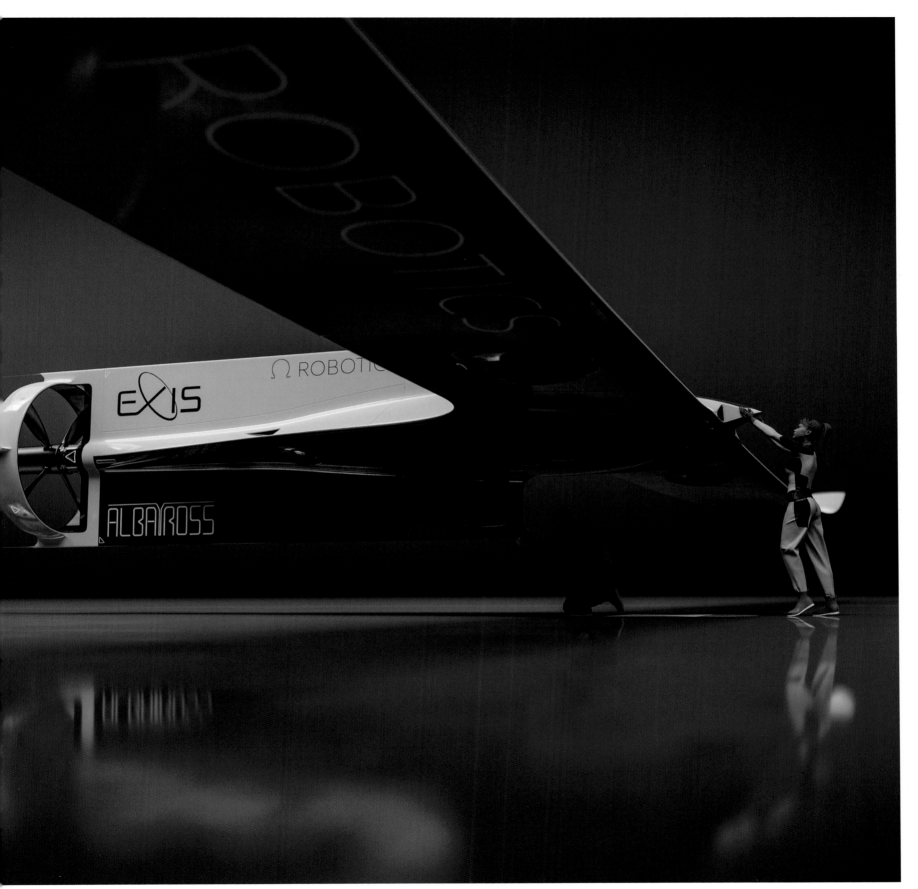

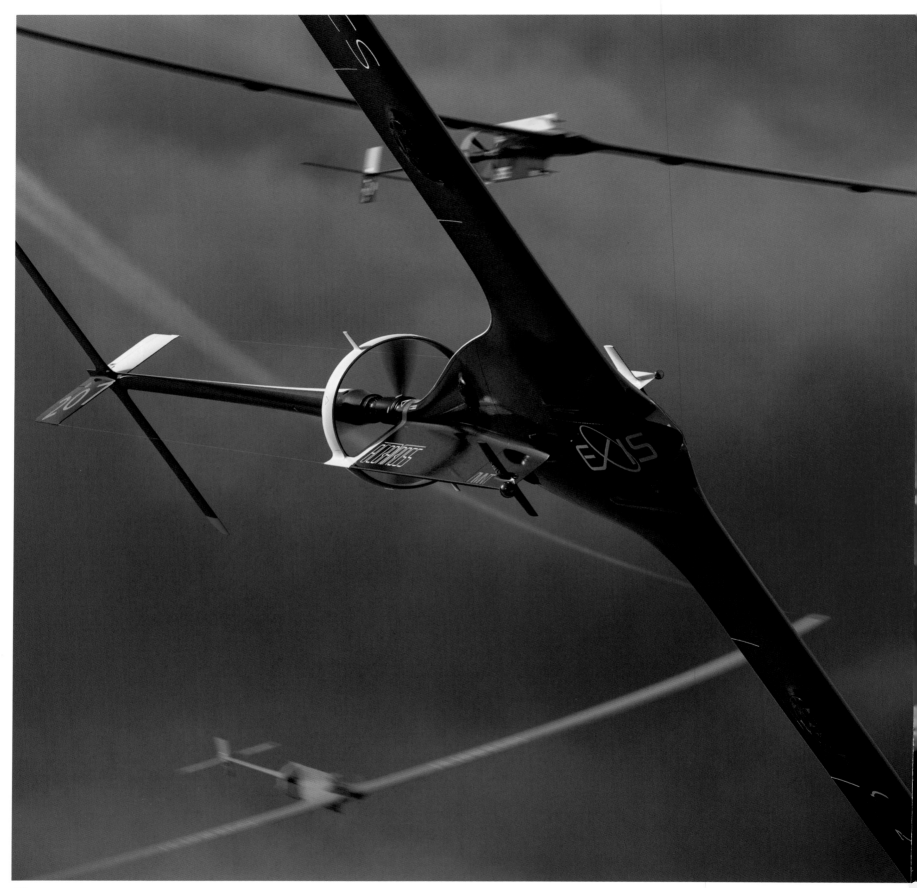

EXPLORER

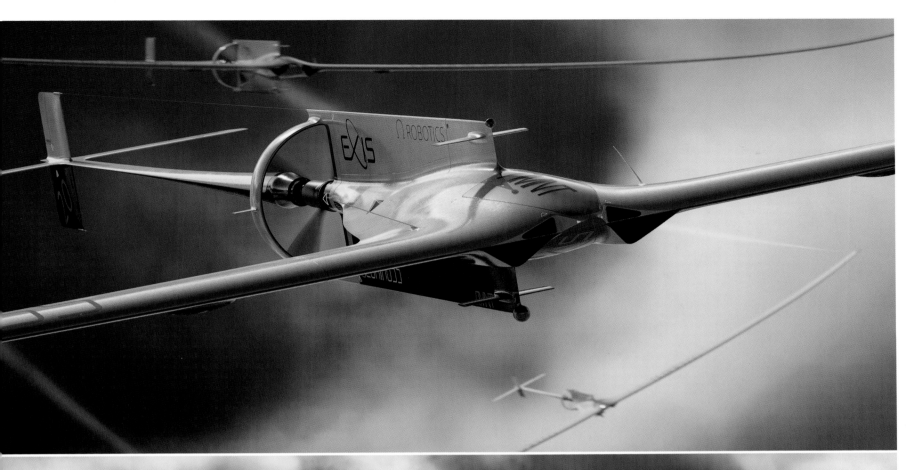

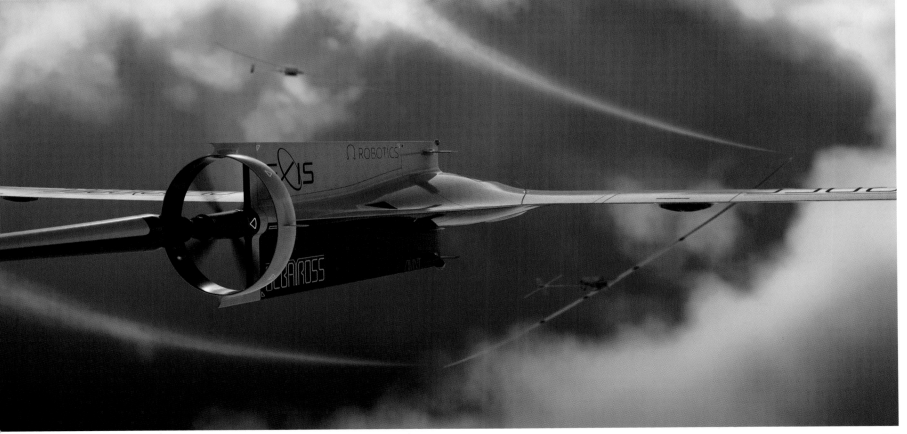

The Albatross: Research Aircraft

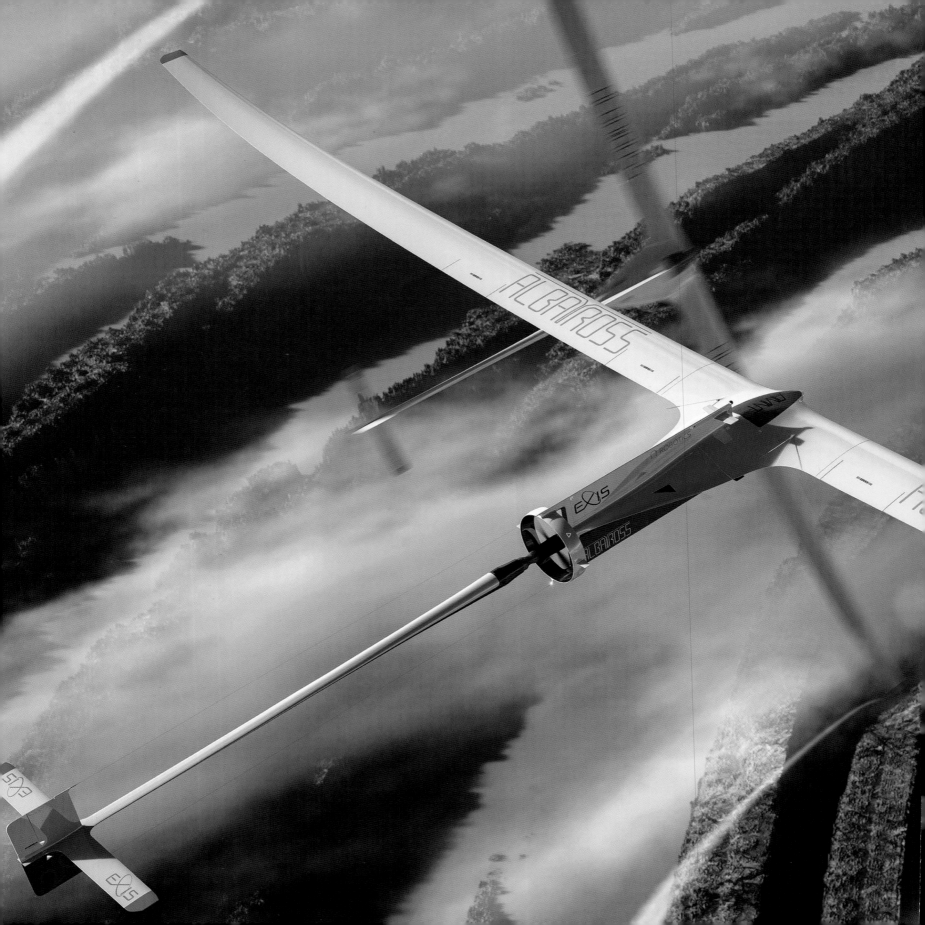

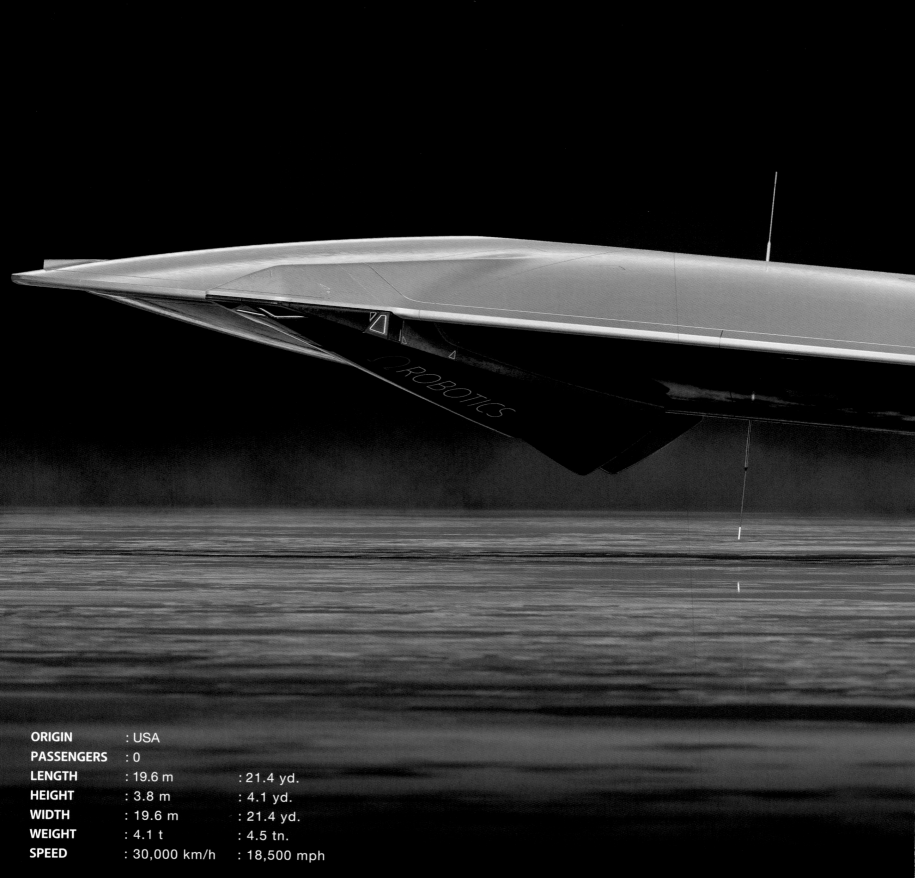

ORIGIN	: USA	
PASSENGERS	: 0	
LENGTH	: 19.6 m	: 21.4 yd.
HEIGHT	: 3.8 m	: 4.1 yd.
WIDTH	: 19.6 m	: 21.4 yd.
WEIGHT	: 4.1 t	: 4.5 tn.
SPEED	: 30,000 km/h	: 18,500 mph

The UFO

SATELLITE AND SCANNER DRONE

Developed by the US military, the UFO drone is responsible for the modern myth. It was engineered over generations and went through dozens of iterations. The UFO was constructed as the ultimate weapon, but it officially never saw the light of day—except for the front covers of thousands of tabloids, which turned out to be right, in a way. For the Ark mission, the Omnipresence redesigned the UFO to be a satellite and scanner drone. With its 360-degree ion propulsion engine, it is still the most versatile aircraft in the Ark fleet.

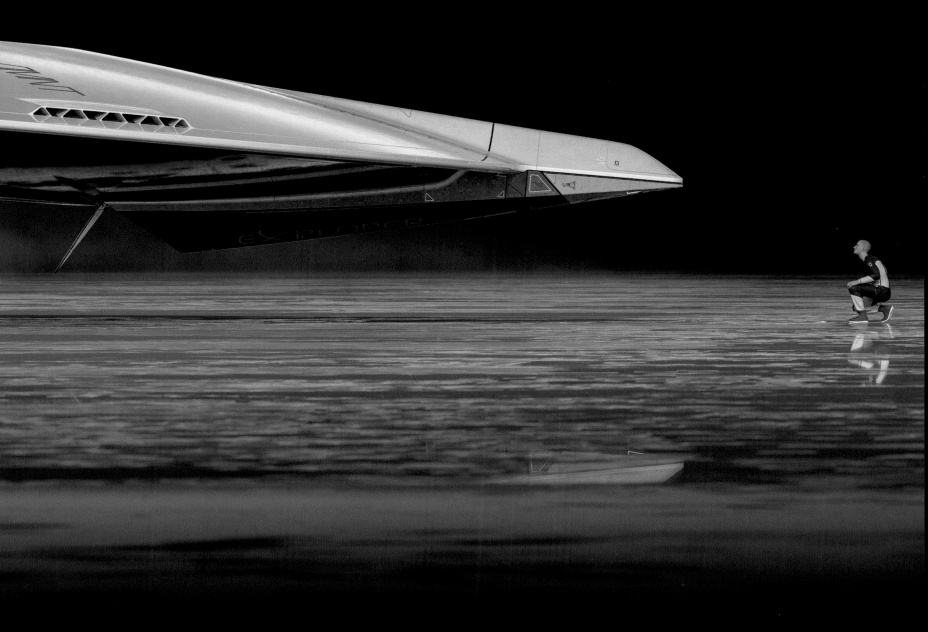

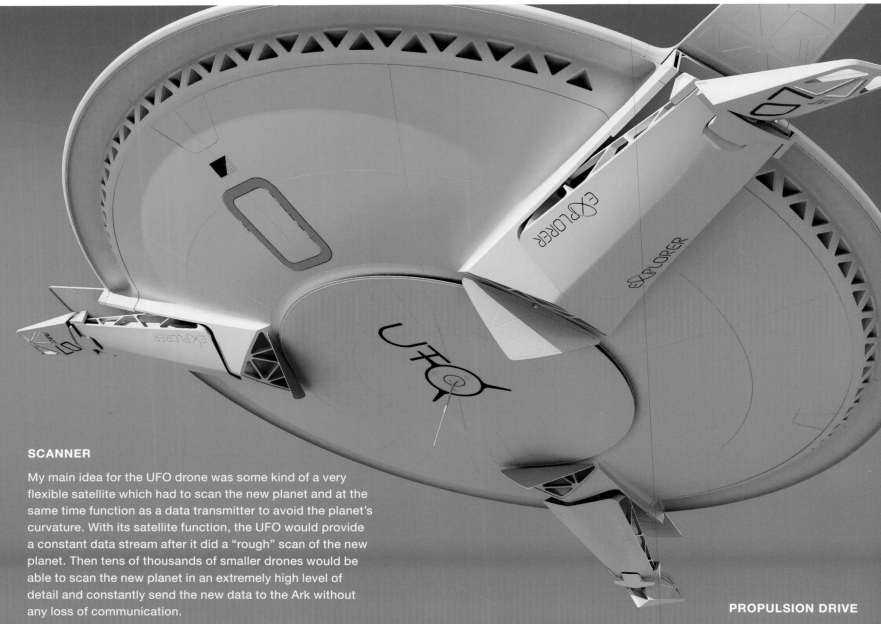

SCANNER

My main idea for the UFO drone was some kind of a very flexible satellite which had to scan the new planet and at the same time function as a data transmitter to avoid the planet's curvature. With its satellite function, the UFO would provide a constant data stream after it did a "rough" scan of the new planet. Then tens of thousands of smaller drones would be able to scan the new planet in an extremely high level of detail and constantly send the new data to the Ark without any loss of communication.

NOTE

I was, and still am, fascinated by those unknown flying objects, so I decided to design one for my book. I was curious what I could do with just a circular shape. In addition to the circle, I added three head-like features that would serve as the ship's brains in a way. After a rough top view and more detailed sketches of the heads, I immediately jumped into Fusion 360 and started modeling. With those features, it became possible to integrate the UFO's landing gear much better; otherwise, the shape would have been way too simple and close to an UFO as we already know it.

LANDING GEAR

The two integrated containers are the energy source for the UFO. When I built and designed the UFO in Fusion 360, it was much faster for me to design the landing gear compared to Alias, as Alias doesn't have a proper joint assemble function.

PROPULSION DRIVE

The UFO has the most advanced propulsion system, which is based on the Falcon ion-propulsion drive. Due to its constructed space, the ion drive is able to reach an enormous maximum speed of 30,000 km/h/18,500 mph. Due to its propulsion drive, the UFO has a fantastic agility; it can change the direction of speed within seconds in every direction.

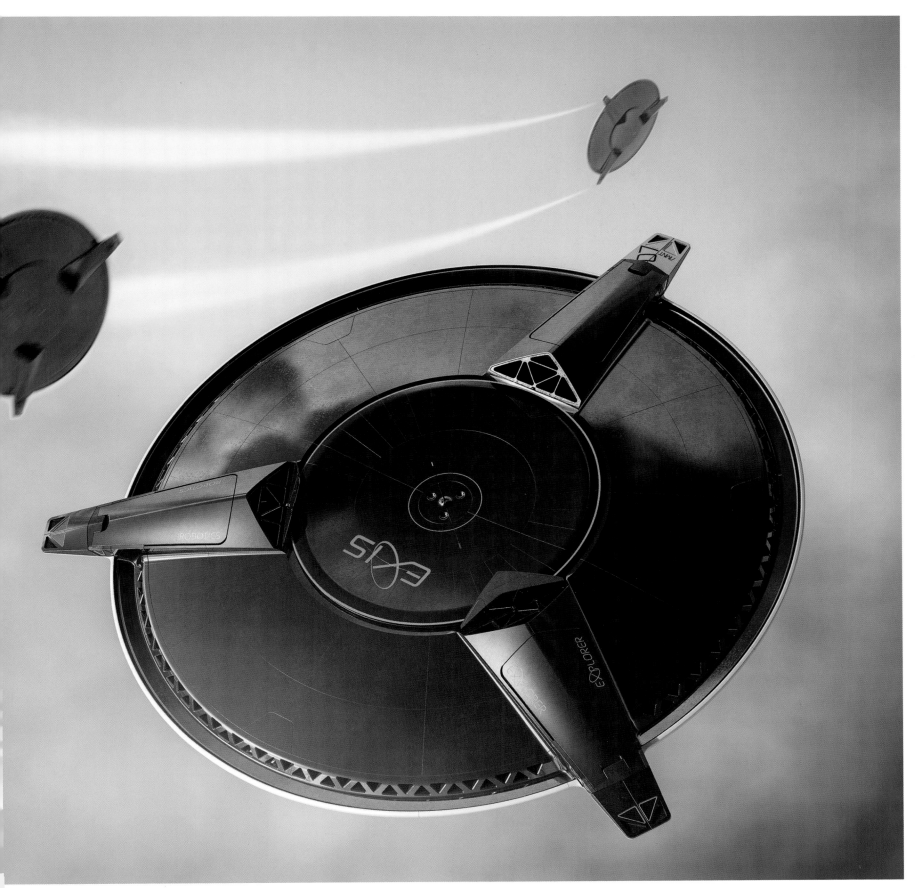

The UFO: Satellite and Scanner Drone

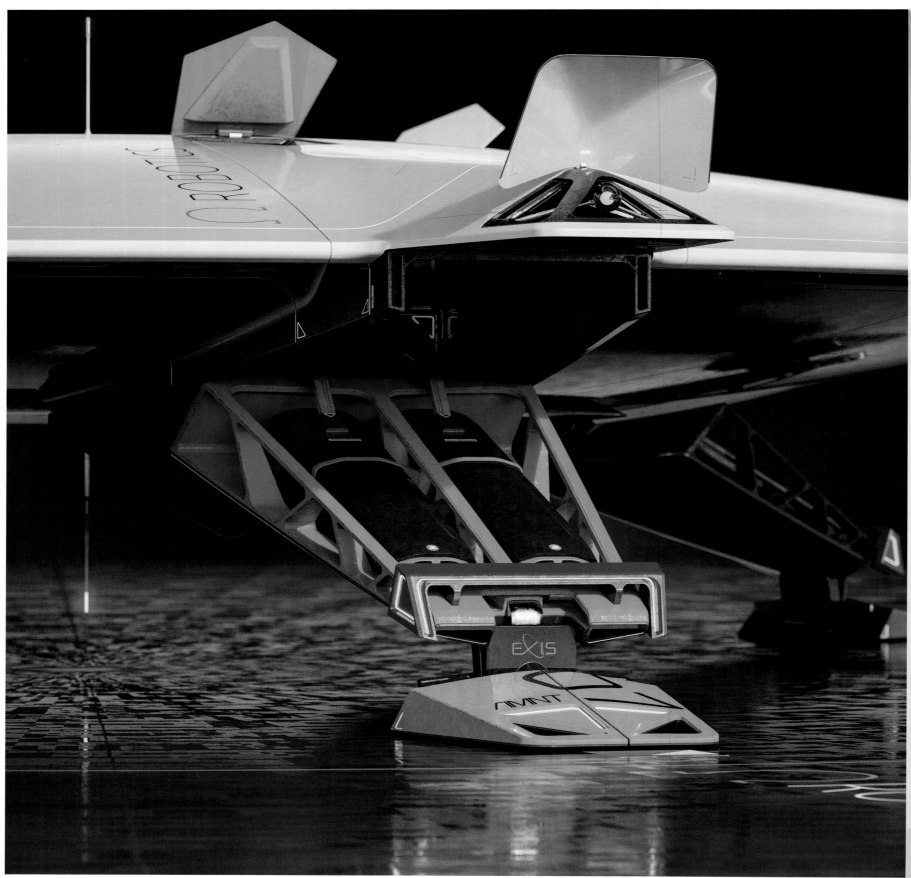

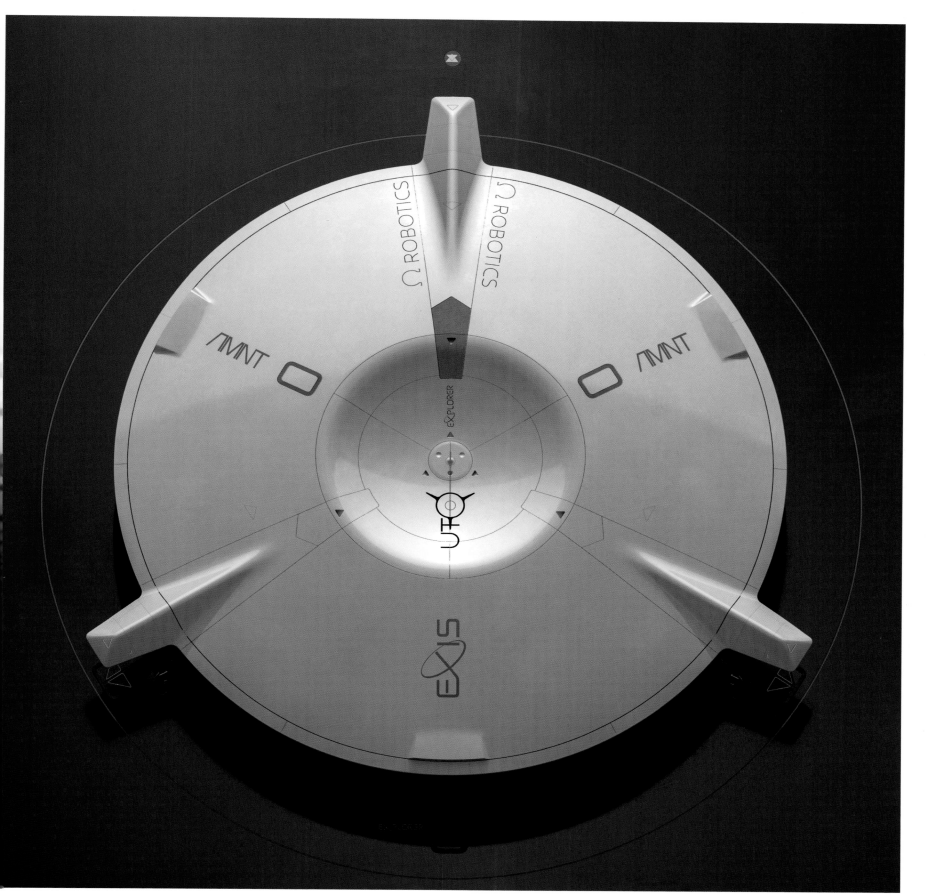

The UFO: Satellite and Scanner Drone

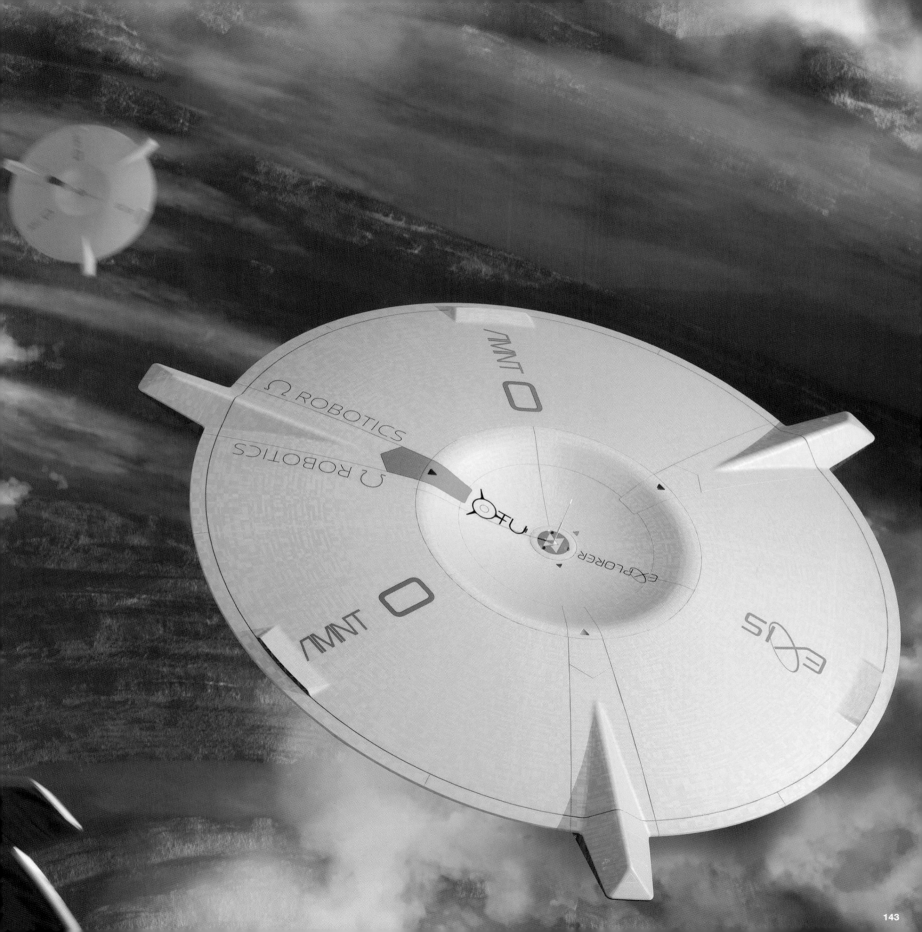

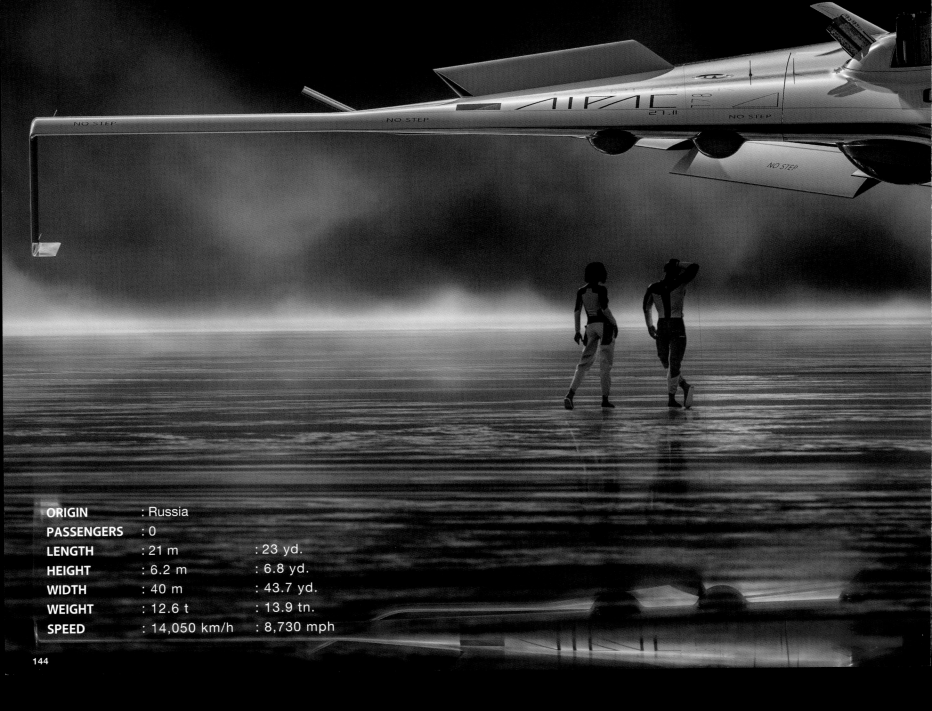

ORIGIN	: Russia	
PASSENGERS	: 0	
LENGTH	: 21 m	: 23 yd.
HEIGHT	: 6.2 m	: 6.8 yd.
WIDTH	: 40 m	: 43.7 yd.
WEIGHT	: 12.6 t	: 13.9 tn.
SPEED	: 14,050 km/h	: 8,730 mph

The Boomer

DEFENSIVE DRONE

The Boomer was a Russian military drone built to protect Lake Baikal, the biggest freshwater reservoir on Earth. After water became scarce, the Russians produced a hundred Boomers to protect their precious water. The drones were heavily armed with nine guns in each of their three turrets, equipped with extremely advanced sensors and programmed to kill everything that wasn't an animal or Russian military. The Boomer lets nothing escape thanks to four spherical and one center propulsion unit providing it incredible maneuverability. It will protect the colonies from any kind of danger.

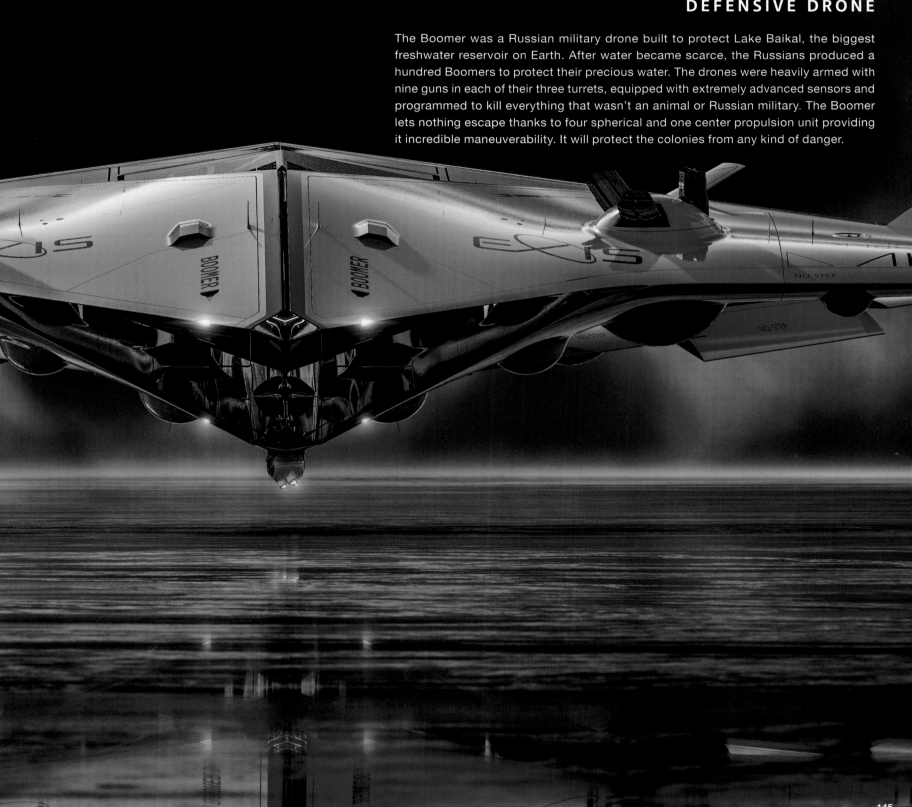

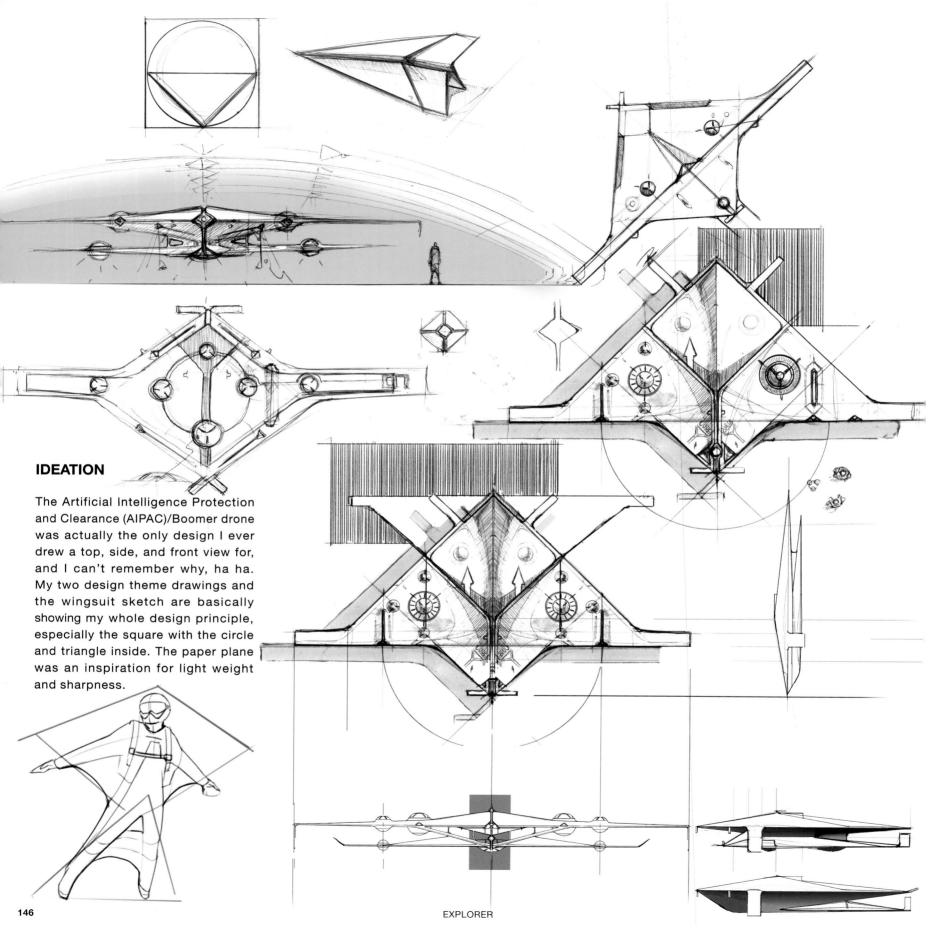

IDEATION

The Artificial Intelligence Protection and Clearance (AIPAC)/Boomer drone was actually the only design I ever drew a top, side, and front view for, and I can't remember why, ha ha. My two design theme drawings and the wingsuit sketch are basically showing my whole design principle, especially the square with the circle and triangle inside. The paper plane was an inspiration for light weight and sharpness.

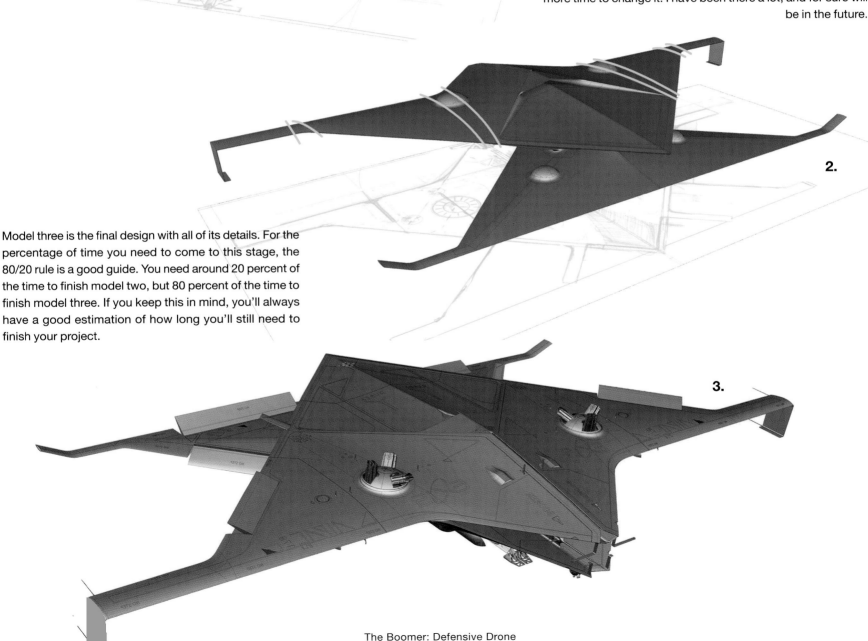

I took the Boomer as an example for my different stages while modeling in 3D, because as you can see, its base shape is super simple; there isn't a lot to it. This, in combination with the necessary functions and split lines, will create a lot of details by itself and will end up a credible design.

On model one you can see how I build the main surfaces and proportions without any fillets (red lines). In this stage you can still make changes very fast and easily, whereas model two is already pretty far developed with its fillets (yellow lines) and to make changes usually takes longer. So you should be happy with your proportions at this point, otherwise it will cost you more time to change it. I have been there a lot, and for sure will be in the future.

Model three is the final design with all of its details. For the percentage of time you need to come to this stage, the 80/20 rule is a good guide. You need around 20 percent of the time to finish model two, but 80 percent of the time to finish model three. If you keep this in mind, you'll always have a good estimation of how long you'll still need to finish your project.

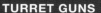

TURRET GUNS

Those six top turret guns are inspired by the old war aircraft, but without any human sitting in them. Combined with the bottom three, they have a 360-degree operational radius, and each individual gun is able to rotate 90 degrees around the y-axis.

FACE SENSORS

As with all my concepts, I always try to create some kind of a character face when designing. When I did this concept, I had to go with four eyes, as I tried very hard to stick to my square/four, triangle/three, and circular-design language brief.

BOTTOM THRUSTERS

The bottom and top thrusters give the aircraft an extremely high agility while flying, which makes them almost impossible to destroy.

NOTE

Boomer was the drone that I designed for the CGSociety Thrust Challenge back in 2016. I decided to change the name to honor our departed and beloved dog, Boomer. I always wanted the ship to be as simple as possible from the top view, so I decided to work just with triangles and squares. In addition, I wanted to give it the feeling of a wingsuit and attacking sea eagle. With that in mind, I did some sketches and jumped into 3D, working on the proportions for days until I was happy with the result. Then I started adding the turret guns and engines. The drone was supposed to be very agile, which meant putting engines on the top and bottom in order to make it fly in every direction.

MAIN SENSOR

BOMB BAY

The Boomer isn't just equipped with nine turret guns; it also has four bomb bays loaded with 20 highly destructive drone bombs.

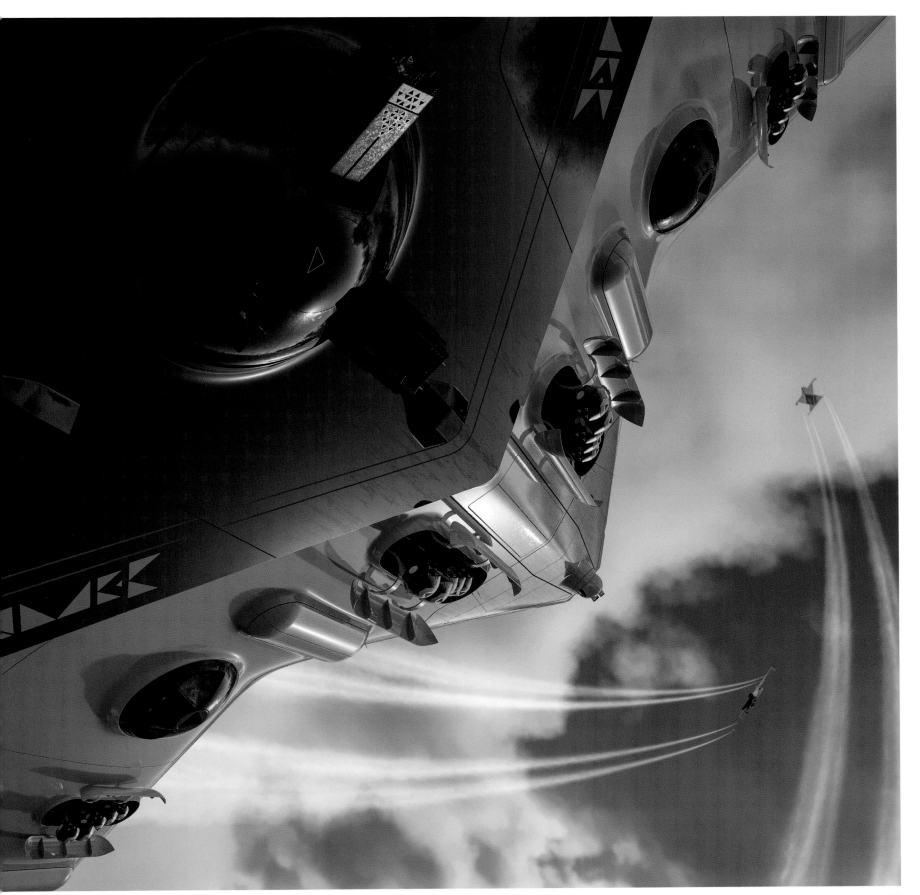

The Boomer: Defensive Drone

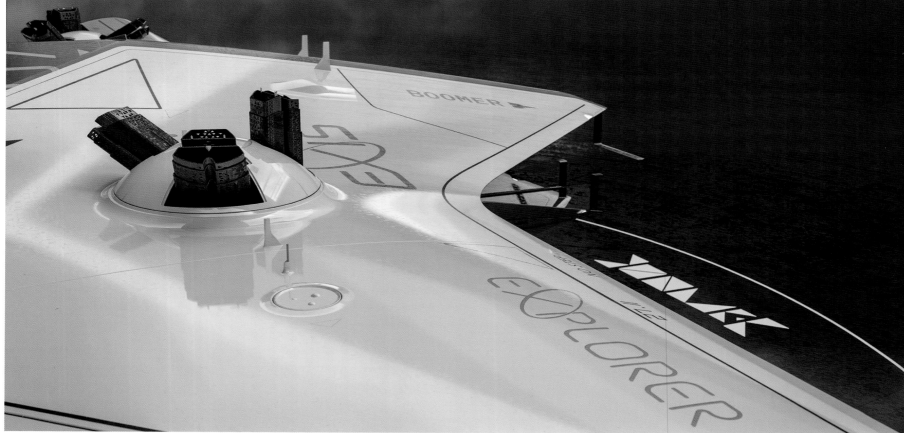

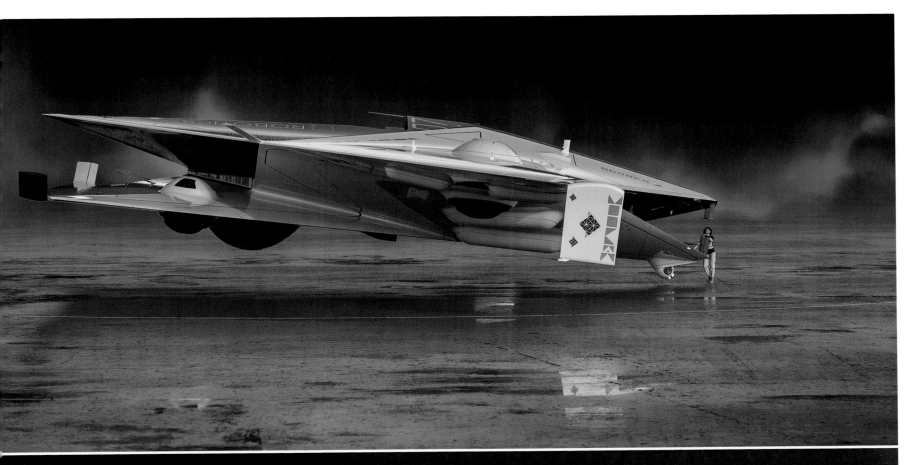

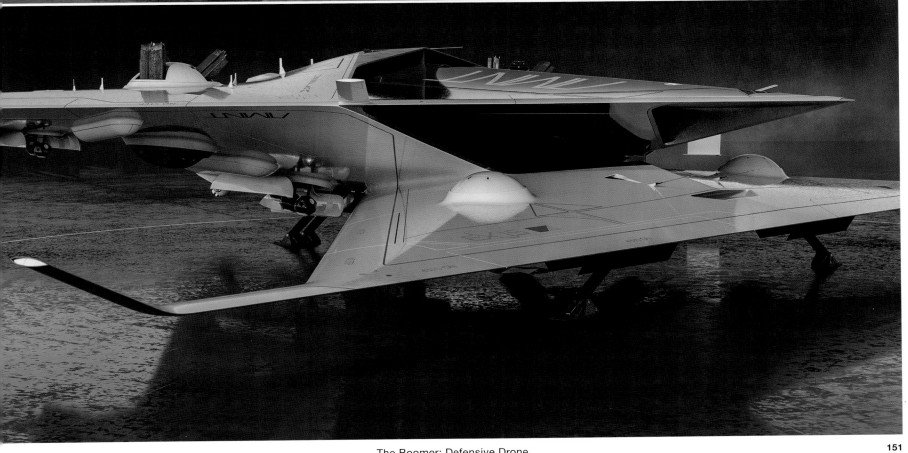

The Boomer: Defensive Drone

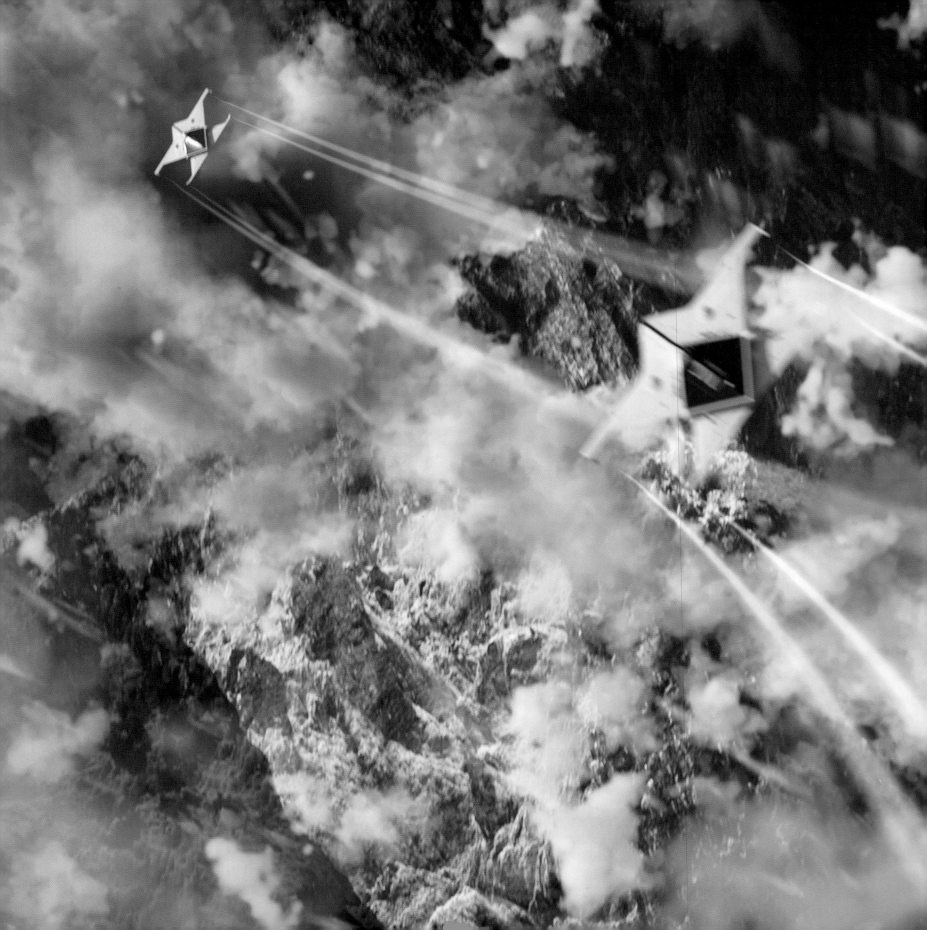

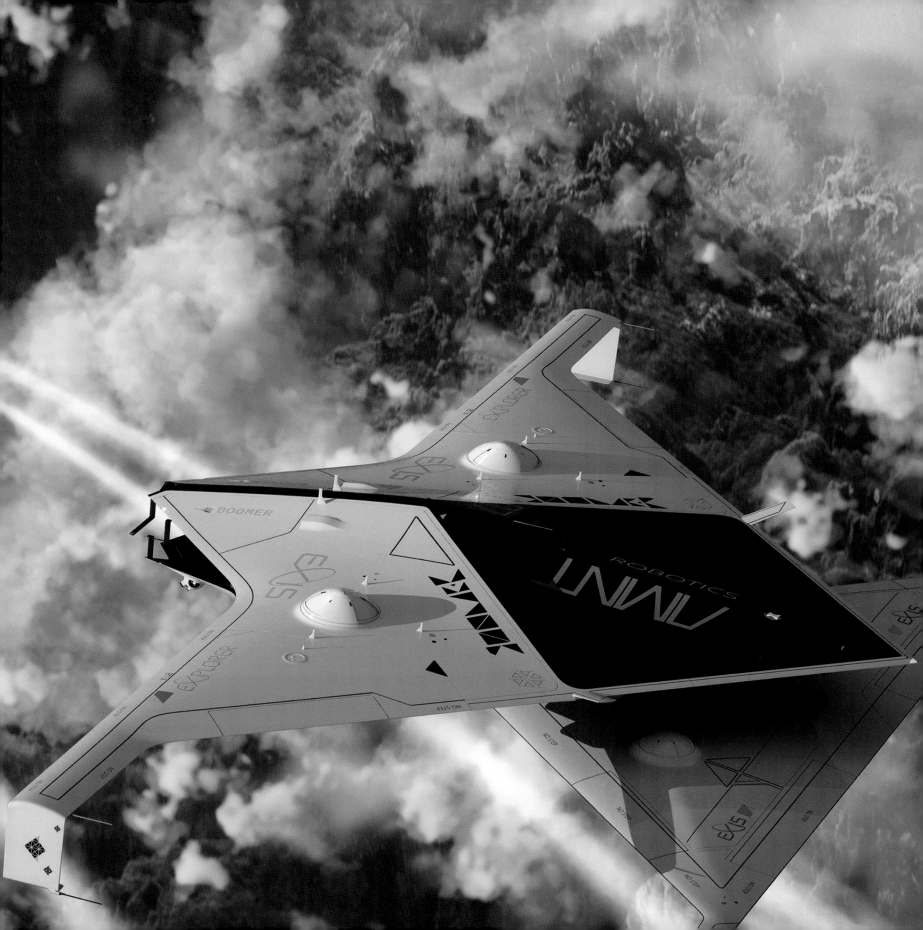

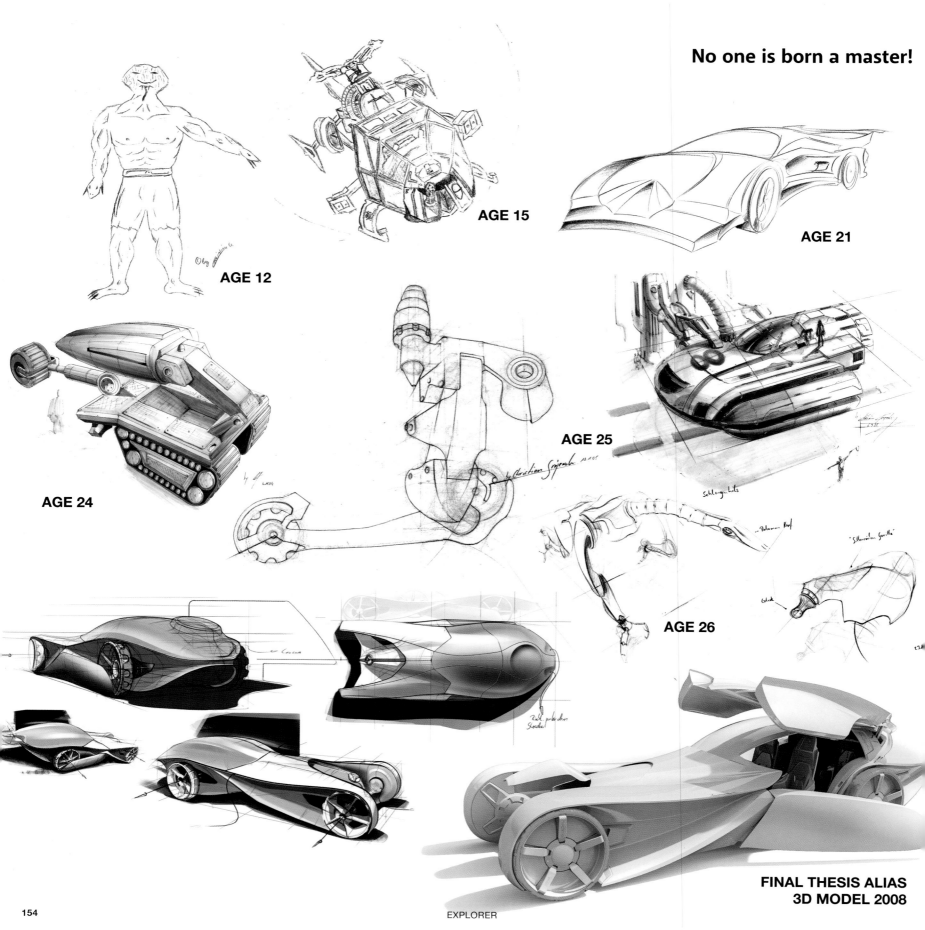

No one is born a master!

AGE 12

AGE 15

AGE 21

AGE 24

AGE 25

AGE 26

**FINAL THESIS ALIAS
3D MODEL 2008**

EXPLORER

My Journey into Uncharted Lands

As a child, I read Disney, Marvel, and other comics and loved everything with dinosaurs. Then, everything around me seemed so big, and the idea of walking with these gigantic, stunning, and beautiful creatures never let me go. As I became older and real life hit, they were always there, somewhere, hidden.

I think it was my passion for drawing that kept that wonder alive somehow. I wasn't able to draw my own worlds yet, but I spent time trying to copy those comics I read. It took me more than 12 years to get on a path that led me back in that direction, and another 16 to what you're holding in your hands right now, and hopefully enjoying.

I first lived in a small village, then in a small city, and left school at the age of 16 after 10th grade. I would have loved to do something with drawing, but everyone told me to train as a technical draftsman. This had nothing to do with creativity, so I did something rather different and trained as a metal worker, building lifeboats.

Back then I had no idea what design was, and the Internet wasn't there for me yet.

During training, I didn't draw much, but when I did, I was drawing all kinds of stuff—my favorite movie posters, comic characters, portraits of family and friends, and dinosaurs—for weeks, and then stopped for months. But all those drawings were actually copies of something; I did not invent anything new. When my friends saw my drawings, they always said that I should try to do something in that direction. That was easier said than done, and making money drawing was unimaginable, except a little bit for the portrait drawings I did for friends and family.

Years passed, and at the age of 21 I had to decide if I wanted to do the mandatory basic training of the Bundeswehr (Federal Defense Forces of Germany) or the alternative, community service with Zivildienst. (Back then you had to choose one of the two.) I decided to do the latter and helped in a convalescent home.

As I thought about what to do with the rest of my life, I decided to take the advice of my best friend, Tobi, and my family, and did some research on what one could do with drawing. I found an art school, the Fachoberschule für Gestaltung in Hannover, and if I went there for one year and passed, I would be allowed to study at a Fachhochschule, similar to a college. In order to get a spot at that school, I submitted my portfolio and took an art test. I got lucky with both, and was accepted. But how would I be able to finance that year? I went back to my old work, and for the next eight months I put as much money aside as I could.

When I started at the art school, I had just turned 23 and still had no idea what design was. I always felt the need to correct shapes, to bring them in order. When I built things out of Lego as a kid, I had to do it in one color; it drove me nuts if it wasn't. (I still have the same urge.)

It was 2003, and for the first time in my life, I met people like me, people who loved to draw. When I saw how good they were, I wished to become just a little bit like them. This was the point I actually learned how to draw properly, because of a very strict teacher, and I am so thankful that he was like that. Nowadays people just want to hear positive things, but in order to become better at whatever you do, you need to hear what is bad, what is not working!

That same year, some of my friends from art school and I decided to study product design at the University of Applied Sciences and Arts in Hannover, where I quickly learned that compared to the other students, I had no idea about what product design really meant.

I was very naive, but I think not knowing much helped me a lot. The same thing happened when I started my career in the automotive industry: I had no idea what it meant to be an interior designer. But I told myself as I always had: give the best you can, work as hard as possible. That's when my friend Jan showed me the book *The Art of Star Wars: Episode I—The Phantom Menace*, at the beginning of 2005. From that moment on, my long-forgotten childhood worlds with all those fantastic creations started to slowly come up again. I realized that actually just "ordinary" people were doing this. They just had to work very hard to become that amazingly good, to get that job.

I spent all the time I could studying that book and other concept art online, sketching for myself. I wasn't able to come up with my own designs yet, but I was building up a visual library of shapes in my mind. Later on, while on school breaks, I came up with my own design briefings to apply my knowledge. Going on vacation was no option; I stayed at home and drew.

My drawing teacher, Mr. Barwig, really liked my concept art ambitions and asked for my email address because he wanted to connect me with an old friend and colleague of his, the legendary Syd Mead. Of course, I gave him my address, but I did not expect anything. Then I got an email from Syd Mead himself; I really couldn't believe it! Like many others before me, the beloved Syd Mead was, and still is, the most favorite futurist and inspiration! Syd asked me to send him some sketches and gave me some really kind feedback; I was so thrilled and inspired by this.

Later in my studies, I had the chance to work with some like-minded friends on a construction-vehicle interior concept. That was followed a few months later by a Formula Student race car project with our Alias software teacher. This was when I learned how to model a car the proper way in 3D and when I realized the power of CAD modeling. This opened many doors for me career-wise. I am so happy that I stuck with it; otherwise you wouldn't be holding this book in your hands.

I went on to product design, concept art, and transportation design and started applying for internships towards the end of my sixth term. My initial portfolio received no responses, but after generating new work, eliminating others, and investing more time into it, I received calls from all the companies I reached out to. This showed me that hard work gets rewarded and that you have to

be honest with yourself about your own work quality. If your work isn't good enough, be open about constructive feedback and not offended.

Choosing Volkswagen Design Center Potsdam (DCP) for my internship was one of the best decisions I ever made. I had a trusting and supportive boss and an amazingly talented interior team that helped shape who I am today. When I started my internship, another amazing book came out, *Cosmic Motors* by Daniel Simon, who became another great inspiration to me! Funnily enough, he used to work for DCP as well before he went on to do his own book with Design Studio Press.

After that internship I worked at the automotive engineering company MBtech while I also worked on my final thesis. This was a very nice, intense, and instructive time; and due to my 3D skills, I could do everything on my own, even preparing milling and printing pieces.

Upon completing my final thesis in July 2008, I was hired by DCP again to be part of the interior design team for the Lamborghini Estoque show car at Italdesign Giugiaro S.p.A. in Italy. After the car was finished, I continued working as a trainee and they made me a permanent interior designer in 2009. I had the chance to work on so many projects that I cannot talk about, which is fine, but some are public: the Lamborghini Estoque and Aventador, the VW Milano Taxi and Taigun, and the Bentley EXP 10 Speed 6 Concept.

When I quit that job in 2017 to focus on my concept art, two more fantastic things happened. The first: I got hired as a freelance industrial designer by an autonomous robotics vehicle company in San Francisco, called ZOOX, based on the online portfolio that I created during my sabbatical in 2016. Working in the Silicon Valley with all those brilliant people was a fantastic experience. I learned so much and met so many wonderful people there.

After ZOOX, I continued my new lifestyle, living off my savings, being close to my loved ones, learning new things, and working on my own projects. Then I saw, one Saturday at the beginning of August 2019, a post from my Facebook friend, Matt Hill, that Warner Bros. London was looking for someone with automotive and SolidWorks program experience for a feature film. I contacted him, he got me interviews, and within a week, I started the job. It turned out that I was supposed to work on the new *Batman* movie. What a childhood dream to be part of such a project and again working with such an amazingly talented team.

Looking back, all of my decisions looked like the obvious choices, but they were not at the time. It is hard to let loose of something fantastic and get out of your comfort zone in order to follow a vague dream of yours, while having way less money than before. But in my opinion, when you work hard and really know what you want (or even better, what you don't want), life becomes way easier and clearer.

I wish you the best on your own journey into uncharted lands, and hopefully you'll be able to inspire others in the future.

1. My stand-up workstation desk for GPU rendering
2. My normal desk, as always, pretty messy

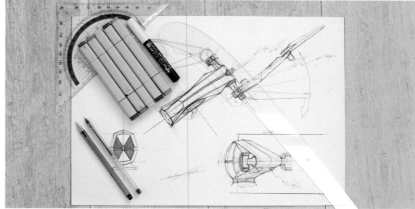

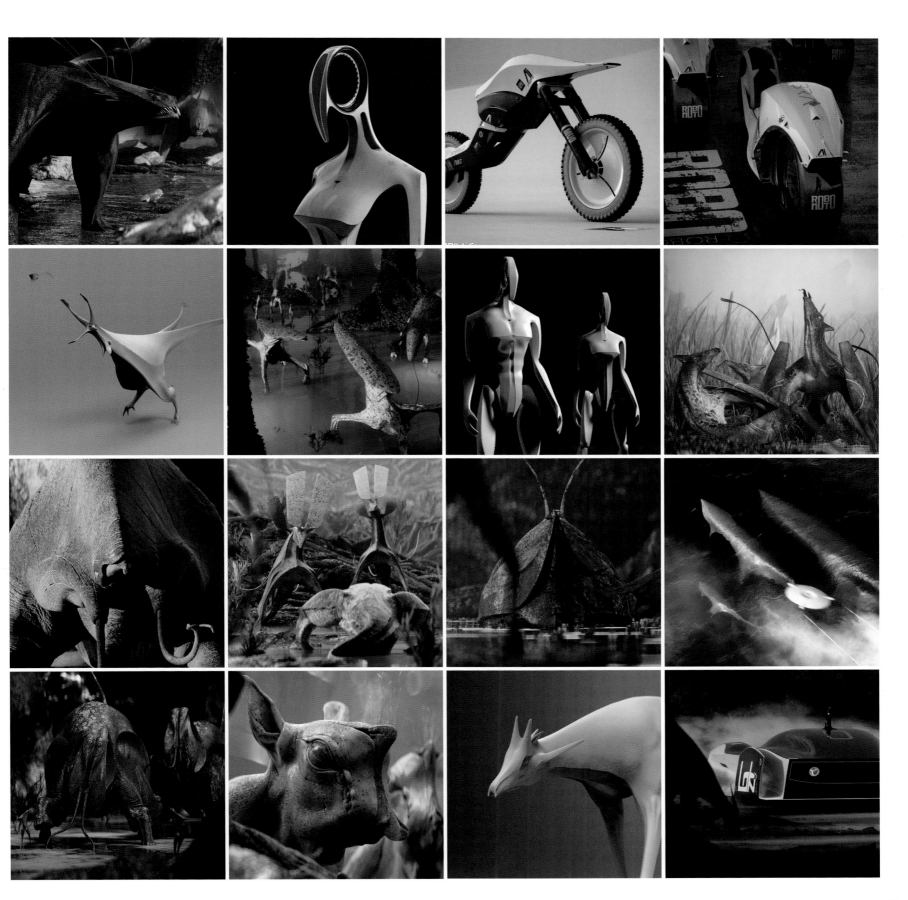

My Journey into Uncharted Lands

Acknowledgments

Supporters!

Autodesk / Special thank you for the kind support and supplying me with Autodesk Autostudio/Alias Surface, used in the development of modeling 3D content for my book.

Pixologic / Jaime Labelle, thank you so much for all your kind feedback, the nice little chats, and supporting me with ZBrush in the first years, so I could learn the program and breathe life into my creatures and characters!

Luxion / Josh Mings, thank you very much for your kind replies and supporting me with KeyShot at the beginning of my journey as I learned how to render and make my creations a reality!

Deon / Tomas Sommer, thank you very much for your extremely fast replies, even on the weekend and supporting me with the Deon.de Visual Collaboration Platform, which was a great help to me!

For design feedback!

Thank you, Mathias and Markus, for your constant feedback and being part of such a great adventure!

Thank you so much for your honest, constructive, and fast feedback, Christoph Prößler and Michael Mieskes!

Big thanks to Felix Runde, Florian Kristen, and Jan Henemann for our in-depth feedback rounds at the best beer and burger place in the world, The Harp in Hannover. Guys, those rounds were intense!

Thank you

Big thanks to www.nasa.gov for providing such amazing materials, which I used as background starting templates and textures on pages 2, 14, 18, 19, 20, 23, and 24.

For all who helped, inspired, or influenced me!

For all of my close and dear friends, thank you so much for always being supportive with all of my life-changing decisions and just being very good friends!

Romulus Rost, for being such a fantastic boss at the DCP, your trust in me, and your support for my first sabbatical—which led me to this book!

Norbert Schneider, for being such a great mentor and inspiration in all those years at the DCP!

Jürgen Michel, for all of our heated discussions, which always lead to a better interior design, and all those funny evenings in the Bavarian restaurants!

Frederic Seemann, Marian Hilgers, Erik Haberman, Christian Schreiber, Fabian Bartelt, Philipp Lüdicke, Sascha Bantje, Matt Hill, Haisu Wang, Joe Hiura, Michael Borman, Andy Hart Baron, David Drobny, Lena Netschajew, Aaron Post, Anno Stake, Alexander Schott, Sam Ofsowitz, Michele Conti, Eric Skoglund, Horst Vogt, Alexander Kraus ,Thomas Teger, Dominic, Detlev, Charlie, and Lieven

Thank you so much, free online tutorial guys!

Raphael Rau (silverwing-vfx.de), thank you so much for your kind replies, and for even creating a Quick Tip video for my problem—and, of course, for all your other free Cinema 4D and Octane tutorials, which were very helpful to me!

Travis Davids, for your fantastic Marvelous Designer, World Creator, Octane tutorials, all your other great stuff, and your kind replies, thank you so much. Go and check out his tutorials on YouTube; just search for Travis Davids!

David Ariew (arievvisuals.com), your eyedesyn channel (eyedesyn.com) with those fantastic Cinema 4D and Octane project tutorials really helped me to understand and develop a work process for those programs, especially all your neat little tricks. Thank you so much for that!

Esben Oxholm (esbenoxholm.dk), your great tutorials made me understand KeyShot way better and helped me in improving my render skills a lot. Thank you very much!

Thank you so much to all the other artists who are sharing their knowledge online to help others!

Tools & Software

Used Software

Cover: Alias, KeyShot, Lightroom, Photoshop, **P.1:** Alias, KeyShot, Lightroom, **P.2:** Alias, Cinema4D, Octane, Lightroom, Photoshop, **P.3:** Alias, KeyShot, Lightroom, Photoshop, **P.4:** Alias, KeyShot, Lightroom, **P.6:** Alias, Fusion 360, KeyShot, Lightroom, Photoshop, **P.7:** Fusion 360, KeyShot, Lightroom, Photoshop, **P.10:** Alias KeyShot, Lightroom, Photoshop, **P.14:** Alias, Cinema 4D, Octane, Lightroom, Photoshop, **P.16:** Alias, KeyShot, Lightroom, **P.18,19:** Alias, Cinema 4D, Octane, Lightroom, **P.20-27:** Alias, KeyShot, Lightroom, Photoshop, **P.30:** Alias, KeyShot, Lightroom, **P.32-35:** Alias, KeyShot, Lightroom, Photoshop, **P.36:** Alias, WorldCreator, Cinema 4D, Octane, Lightroom, Photoshop, **P.38:** Fusion 360, Alias, KeyShot, Lightroom, Photoshop, **P.40:** Alias, KeyShot, Lightroom, **P.41-43:** Fusion 360, Alias, KeyShot, Lightroom, Photoshop, **P.44:** Fusion 360, Alias, WorldCreator, Cinema 4D, Octane, Lightroom, Photoshop, **P.46:** Alias, Fusion 360, Daz 3D, Marvelous Designer, ZBrush, KeyShot, Lightroom, Photoshop, **P.48:** Alias, KeyShot, Lightroom, **P.50-55:** Alias, KeyShot, Lightroom, Photoshop, **P.56,57:** Alias, KeyShot, Lightroom, **P.58:** Alias, KeyShot, Lightroom, Photoshop, **P.59:** Alias, Daz 3D, Marvelous Designer, ZBrush, KeyShot, Lightroom, Photoshop, **P.60,61:** Alias, Cinema 4D, Octane, Lightroom, Photoshop, **P.62,63:** Alias, WorldCreator, ZBrush, Cinema 4D, Octane, Lightroom, Photoshop, **P.64:** Fusion 360, Alias, Daz 3D, Marvelous Designer, ZBrush, KeyShot, Lightroom, Photoshop, **P.68:** Fusion 360, Alias, KeyShot, Lightroom, **P.69:** Fusion 360, Alias, KeyShot, Lightroom, Photoshop, **P.70:** Fusion 360, Alias, Daz 3D, Marvelous Designer, ZBrush, KeyShot, Lightroom, **P.71:** Fusion 360, Alias, KeyShot, Lightroom, Photoshop, **P.72:** Fusion 360, Alias, WorldCreator, Quixel, Cinema 4D, Octane, Lightroom, Photoshop, **P.74:** Alias, Daz 3D, Marvelous Designer, ZBrush, KeyShot, Lightroom, Photoshop, **P.76:** Alias, Fusion 360, KeyShot, Lightroom, **P.77-79:** Alias, Fusion 360, KeyShot, Lightroom, Photoshop, **P.80:** Alias, Fusion 360, WorldCreator, Quixel, Cinema 4D, Octane, Lightroom, Photoshop, **P.82:** Fusion 360, Alias, Daz 3D, Marvelous Designer, ZBrush, KeyShot, Lightroom, Photoshop, **P.84:** Fusion 360, Alias, KeyShot, Lightroom, **P.86:** Fusion 360, Alias, Daz 3D, Marvelous Designer, ZBrush, KeyShot, Lightroom, Photoshop, **P.87:** Fusion 360, Alias, KeyShot, Lightroom, Photoshop, **P.88:** Fusion 360, Alias, Daz 3D, Marvelous Designer, ZBrush, KeyShot, Lightroom, Photoshop, **P.90:** Alias, Daz 3D, Marvelous Designer, ZBrush, KeyShot, Lightroom, Photoshop, **P.94:** Alias, KeyShot, Lightroom, **P.95:** Alias, KeyShot, Lightroom, Photoshop, **P.96:** Alias, Daz 3D, Marvelous Designer, ZBrush, KeyShot, Lightroom, Photoshop, **P.97:** Alias, KeyShot, Lightroom, Photoshop, **P.98:** Alias, Quixel, ZBrush, Cinema4D, Octane, Lightroom, Photoshop, **P.100:** Alias, KeyShot, Lightroom, Photoshop, **P.104:** Alias, KeyShot, Lightroom, **P.105:** Alias, Daz 3D, Marvelous Designer, ZBrush, KeyShot, Lightroom, Photoshop, **P.106,107:** Alias, KeyShot, Lightroom, Photoshop, **P.108:** Alias, WorldCreator, Quixel, Cinema 4D, Octane, Lightroom, Photoshop, **P.110:** Alias, Fusion 360, KeyShot, Lightroom, Photoshop, **P.112:** Alias, Fusion 360, KeyShot, Lightroom, **P.113:** Alias, Fusion 360, Daz 3D, Marvelous Designer, ZBrush, KeyShot, Lightroom, Photoshop, **P.114,115:** Alias, Fusion 360, KeyShot, Lightroom, Photoshop, **P.116:** Alias, Fusion 360, WorldCreator, Cinema 4D, Octane, Lightroom, Photoshop, **P.118:** Alias, KeyShot, Lightroom, Photoshop, **P.122:** Alias, KeyShot, Lightroom, **P.123,124:** Alias, KeyShot, Lightroom, Photoshop, **P.125:** Alias, Daz 3D, Marvelous Designer, ZBrush, KeyShot, Lightroom, Photoshop, **P.126:** Alias, WorldCreator, Cinema 4D, Octane, Lightroom, Photoshop, **P.128:** Alias, KeyShot, Lightroom, Photoshop, **P.130:** Alias, KeyShot, Lightroom, **P.131:** Alias, Daz 3D, Marvelous Designer, ZBrush, KeyShot, Lightroom, Photoshop, **P.132,133:** Alias, KeyShot, Lightroom, Photoshop, **P.134:** Alias, WorldCreator, Cinema 4D, Octane, Lightroom, Photoshop, **P.136:** Fusion 360, Daz 3D, Marvelous Designer, ZBrush, KeyShot, Lightroom, Photoshop, **P.138:** Fusion 360, KeyShot, Lightroom, **P.139-141:** Alias, KeyShot, Lightroom, Photoshop, **P.142:** Alias, WorldCreator, Cinema 4D, Octane, Lightroom, Photoshop, **P.144:** Alias, Daz 3D, Marvelous Designer, ZBrush, KeyShot, Lightroom, Photoshop, **P.148:** Alias, KeyShot, Lightroom, **P.149-151:** Alias, KeyShot, Lightroom, Photoshop, **P.152:** Alias, WorldCreator, Cinema 4D, Octane, Lightroom, Photoshop, **P.158:** Fusion 360, Cinema 4D, Octane, Lightroom, Photoshop

Traditional

For drawing: Pentel Superb BK77M Premium Ballpoint pen. It has a super thin 1 mm tip, which is perfect for details.

For shading: Copic Markers. I use mostly N and C grey scales, the B29 ultramarine, YR09 Chinese Orange, and the YR16 Apricot.

For supporting my lines: cheap ship curves, a basic ruler, ellipse curves, and circular templates.

For paper: ultra white copy paper on an A4 aluminum clipboard. The paper has a fantastic feeling and nice contrast for sketching.

And since I don't like to use sketchbooks, I use the clipboard, as it is much more practical.

Hard and Software

Workstation one: AMD Ryzen 7 3700x 8 Core, Nvidia Quadro K6000, 32 GB Ram, Win10

Workstation two: Intel Core I7 Quad Core 4Ghz, GTX 1080 Ti, 2x RTX 2080 Ti, 32 GB Ram, Win10

Autodesk Alias Surface, ZBrush, KeyShot 8, Cinema 4D R19, Octane, Deon, Fusion 360, Daz 3D, Photoshop, Lightroom, InDesign, Illustrator, Marvelous Designer, World Creator, Quixel Megascans, MoI 3D

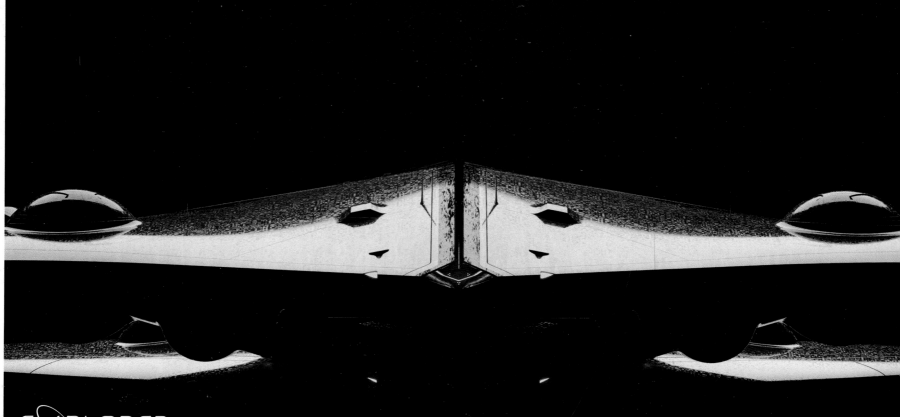

EⓍPLORER

Futuristic Vehicles for Uncharted Lands

Book Design: Christian Grajewski

Typeface: Jenny Suh

Editor: Teena Apeles

Proofreader: Sara Richmond

Published by

Design Studio Press

Website: www.designstudiopress.com

E-mail: info@designstudiopress.com

Contact

www.christiangrajewski.com / contact@christiangrajewski.com

Printed in Korea

10 9 8 7 6 5 4 3 2 1

Softcover ISBN: 9781624650529 | Hardcover ISBN: 9781624650543

Library of Congress Control Number: 2020948690

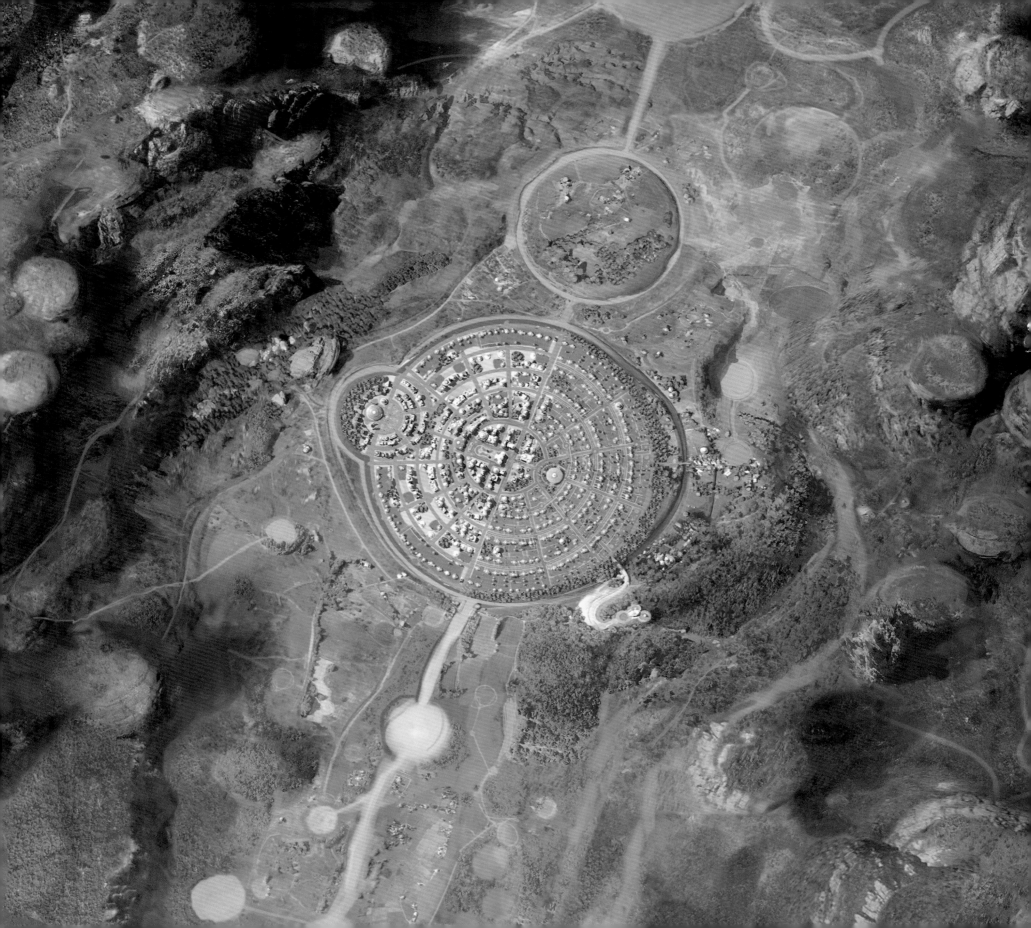

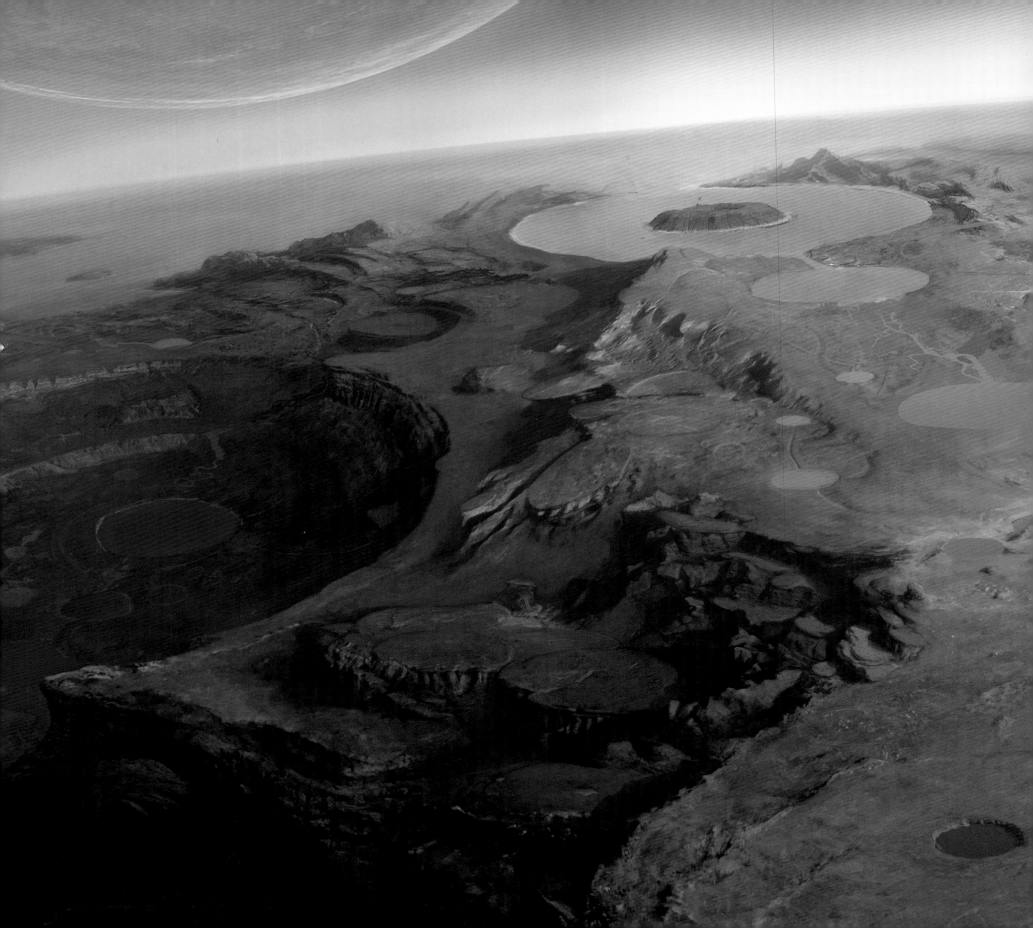

The Art of

PLANET 51

Foreword by **Gary Oldman**

Text by **Danny Graydon**

INSIGHT EDITIONS

San Rafael, California

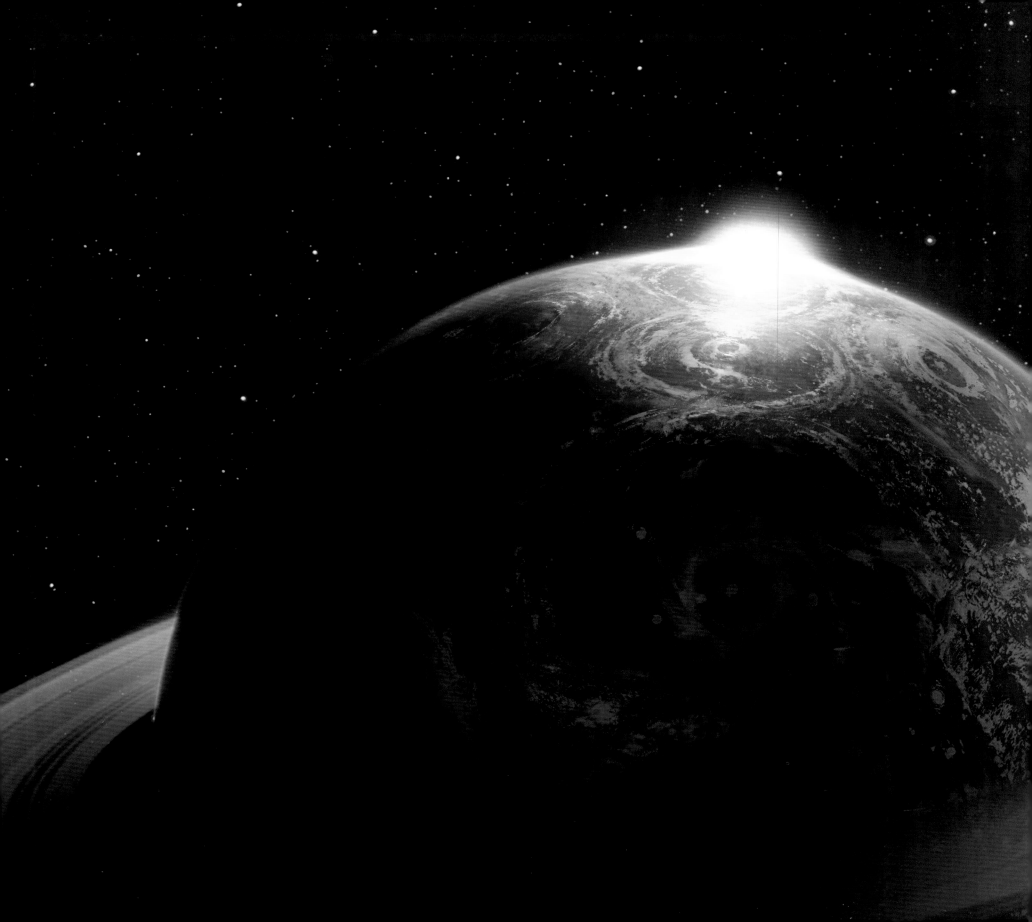

Contents

10 Foreword by Gary Oldman

12 Introduction

14 Characters

16 Chuck T. Baker

20 Lem

24 Skiff

26 Rover

28 General Grawl

30 Professor Kipple

32 Eckle

34 Neera

36 Glar

38 Fauna

40 Glipforg Townsfolk

50 Tea Ladies

52 Humaniacs!

62 The World of Planet 51

64 Inspirations

68 Landscapes

78 The Observatory

86 Haglog Comics

92 Entertainment Locations

96 Residential Locations

104 Midtown Buildings

112 Base 9

124 Vehicles

130 Props & Signs

134 Appendices

136 Appendix A

140 Appendix B

142 Acknowledgements

144 Colophon

Foreword.

Planet 51 was one of those rare projects that I selected on the basis of it being so intriguing. The beautifully simple twist of an Earthlike alien culture reeling at the arrival of a human invader was enormously appealing and clearly bore a lot of potential. Such was my enthusiasm for the idea that it placed me in the unusual position of agreeing to do the film without seeing the script first.

What I *did* see, however, and which certainly cemented my enthusiasm, was an array of the film's gorgeous production art. Having never heard of Ilion Animation Studios and being genuinely curious as to their abilities to craft a feature of such size and scope, I was literally stunned by the world that the artists had created. Gorgeous, rich with detail, and incorporating UFO motifs in an almost-bewildering number of clever ways—like everyone else, I *loved* the idea of a flying saucer crossed with a car—I became quickly confident that the crew at Ilion were a serious and committed lot, let alone hugely talented.

Admittedly, compared to some of the bad guys I've played in my career, General Grawl is on the lower end of the evil scale, but he was very fun to play nonetheless. The role was challenging on a comedic level, too, not least for the fact that much of Grawl's screen time is shared with Professor Kipple,

voiced by comedy god John Cleese. There was also something immensely satisfying about uttering the words of many a classic old-school sci-fi movie: "Take me to your leader!"

Voice acting presents a very specific challenge for an actor. While it's true that it's a comparatively more relaxed process—no need for costumes and makeup or the various other pressures of a film set—there remains the need to forge a character that rings true (no matter if alien) and fits the story. Yet, crucially, the actor will have to place their faith in the animation team to ensure that the character on screen perfectly fits their vocal performance, which can be nerve-wracking!

On that count, however, the folks at Ilion have surpassed my expectations and done a magnificent job—not just with Grawl, but with all of *Planet 51*'s characters. Along with Planet 51 itself—which, frankly, is a place I'd quite fancy living in myself—all of the characters make up a fun and engaging story as well as an enjoyable movie experience, which I am very satisfied to have been a part of.

Cheers!

Gary Oldman
May 2009

page 1 Glipforg aerial view • Jose Manuel Oli (matte painting), Jordi Villarroya (CGI)
pages 2/3 Planet 51 matte painting • Jose Manuel Oli and Germán Casado
pages 4/5 Glipforg and surroundings • Jose Manuel Oli (matte painting), Jordi VIllarroya (CGI)
pages 6/7 Desert landscape • Guillaume Bonamy
page 8/9 Planet 51 • Scott McInnes and Fernando López Juárez (matte painting)
opposite Color key • Fernando López Juárez and Gracia Artigas

Introduction

An alien race whose society is based upon 1950s America? That's a great twist. A funny twist—one worthy of Douglas Adams, author of the best-selling sci-fi comedy novel series *The Hitchhiker's Guide to the Galaxy*, in fact. Yet, when I first set eyes on *Planet 51*, the Madrid-based Ilion Animation's debut foray into feature-length CG animation, I was struck by an even more impressive twist.

As the film plays, I see all the hallmarks of a mainstream (that is, American) studio production tailor-made for multiplexes: top-flight animation; beautiful and beguiling production design; an array of appealing characters that utilizes a big-name voice cast; a sweet and funny story leavened with a witty script; an energetic orchestral score; and well-executed, pop culture–literate gags that can be appreciated by kids and adults alike. It's only when I exited the screening room that I was presented with the frankly startling truth—and here's that twist—*Planet 51* was produced *entirely* in Spain.

I find myself genuinely (and positively) surprised: While the realm of European animation is blessed with no shortage of huge talents and wonderful productions, it's something of an outright rarity to see a feature-length animation that possesses all the bearing of a mainstream contender for international audiences and box-office success.

As Ilion's CEO and *Planet 51*'s producer, Ignacio Pérez Dolset, tells me, I'm far from alone in my pleasant surprise: "The first time we met the [American] studios a few years ago, showing them three minutes of footage, the one thing I was not expecting was such a positive reaction to what we had started. The reaction from everyone was, 'I was not expecting *this*. . . .'"

What *really* draws me to *Planet 51* above and beyond the expert sheen of its presentation, however, is its fluency in a modern language—geek culture—that speaks to me directly and many others like me. For those born in the 1970s—as I was—ours is a generation that came with a pop culture that expanded at a furious, almost overwhelming rate. A major ingredient of this was the popular reemergence of the sci-fi and fantasy genres in cinema and TV that arrived like a tidal wave in the wake of 1977's immensely popular *Star Wars*. In the two decades that followed, this so-called *Star Wars* generation—a much more fun tag than Generation X, I think—witnessed cinematic, televisual, and comic book fare that achieved staggering popularity, instantly becoming major pop culture touchstones and allowing the previously very American sci-fi and comic book cultures to become globally accessible.

Moreover, one of the most intriguing (and yes, mocked) aspects of the above is the vast emotional attachment to and ongoing celebration of such pop culture ephemera by its rapacious audience. Ours is the first generation in which childhoods have been allowed to become massively (and perhaps limitlessly) extended, to the point where the annual Comic-Con in San Diego, California, is attended by more than one hundred thousand people a year, many in their thirties or older, who come to unashamedly revel in the glories of still-potent youthful passions. For these legions of geeks, nerds—call us what you will—there is a comforting delight in the minutiae of such pop culture, one which gives our generation a sense of uniqueness.

Watching *Planet 51*, I had a definite sense that the filmmakers understand this only too well. "I think this film works because American culture is everybody's second culture," Pérez observes. "It's a very common ground. Americans allow us to be part of a common culture, whether it's Superman, Batman, *Baywatch*, or so on—everyone recognizes that." Indeed, *Planet 51* is a film that positively thrives for those to whom such pop culture minutiae *really* matter, offering up not only nuances and jokes that pay tribute to their beloved cultural icons, but also a tacit connection to filmmakers who are clearly like-minded.

Yet, at the same time, the inclusion of such fare doesn't neglect or, ahem, *alienate* those audiences who are *actually* children. Like all the most successful animation ventures, it works on multiple levels, ensuring that Planet 51 is a place you'll want to go back to.

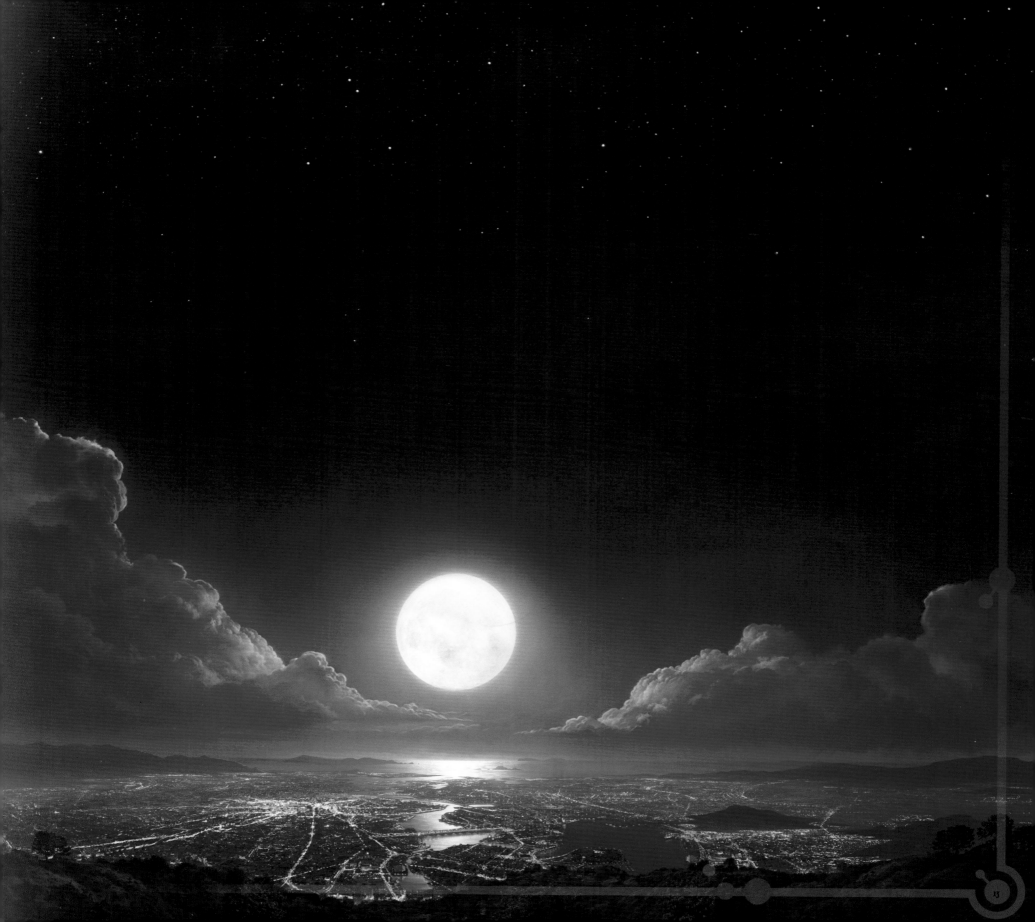

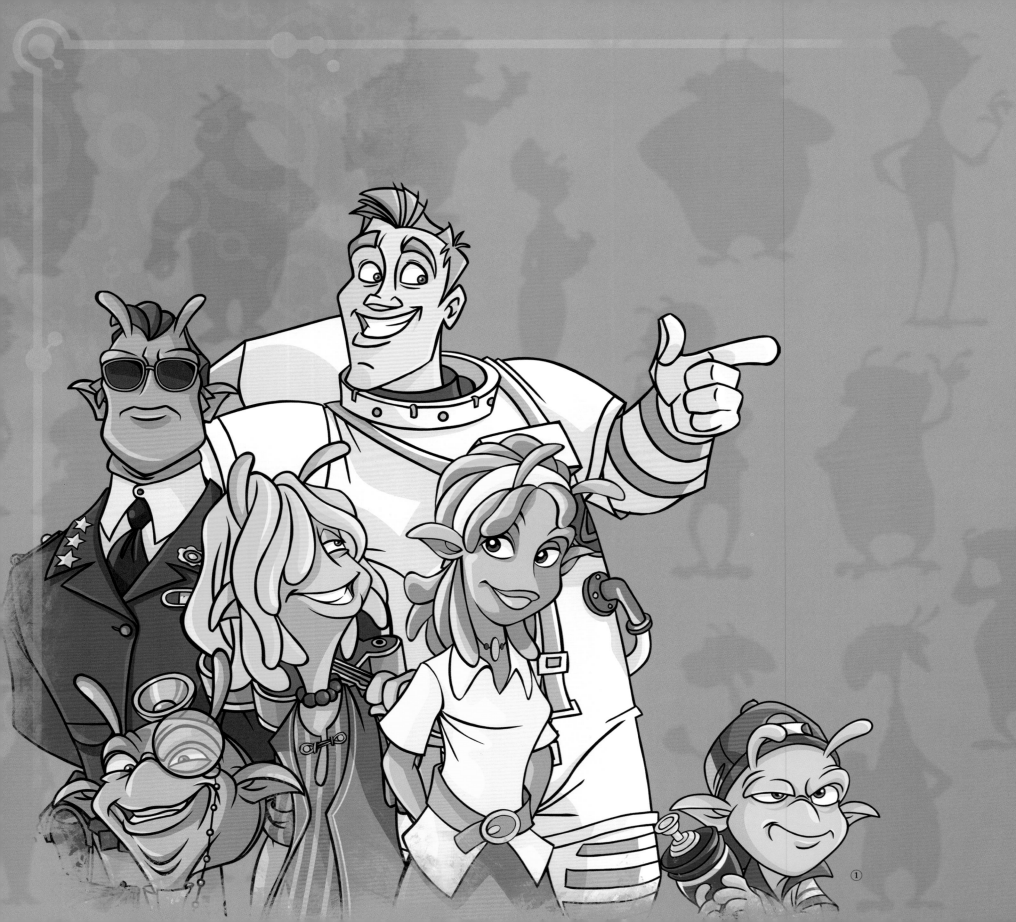

①

Characters

Chuck T. Baker

The thirty-seventh sexiest person on planet Earth, adored by millions and possessing a boundless charm, Chuck T. Baker is certainly not your average astronaut. A shameless glory hound with a strong improvisational streak, he's traveled millions of miles across space to achieve megastardom by discovering an uninhabited planet—which turns out to be not so uninhabited after all.

"With Chuck, it all evolved over time," says animation supervisor Fernando Moro. "We wanted him to have this poseur quality, like the captain of a football team who is popular with all the cheerleaders. Dumb, sometimes, and not a wise man, generally. He's actually something of a coward in the first part of the story, but by the end he shows his bravery."

"When we first visually considered Chuck, he was an easy design," head of character design Ignacio Güejes comments. "He was just an astronaut's suit, and in the initial versions of the script, he wouldn't take his helmet off for the bulk of the film. It was only at the end that he would appear. In the beginning, the focus was on the personality of Chuck. We wanted him to have an egotistical quality, his main desire being that he would return from his mission a megastar. That was the starting point: He has to rescue himself and be responsible."

Chuck is very much a catalyst for change on Planet 51, according to codirector Marcos Martínez Carvajal: "Chuck comes from a need to learn something from this trip. When Chuck arrives, there is an evolution. Their world will change, and everyone will learn something about themselves. The world is a better place."

Similarly, Chuck provided a good opportunity to poke some good-humored fun at the nature of heroism. "We needed to get away from the clichéd concept of heroes," says Martínez. "Every time heroes do something, they're on the news. We wanted him to be slightly flawed. What Chuck wants from being an astronaut is the fame. We get to make fun of the notion of explorers: From Christopher Columbus to Neil Armstrong, there's always been something extremely solemn about it. This is different!"

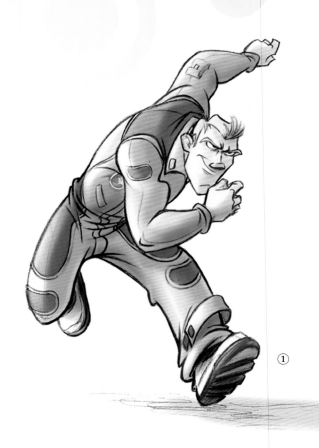

①

Overleaf: 1 *Line art • Carolina Cuenca and Ignacio Güejes (character design)* 2 *Lem and Skiff drawing • Ignacio Güejes*

1 *Chuck • Ignacio Güejes* 2 *Graphic • Jose M. Rodríguez* 3, 7, 9 *Chuck drawings • Pedro Pérez Valiente* 4 *Astronaut graphic • Olga Gridina and Jordi Villarroya*

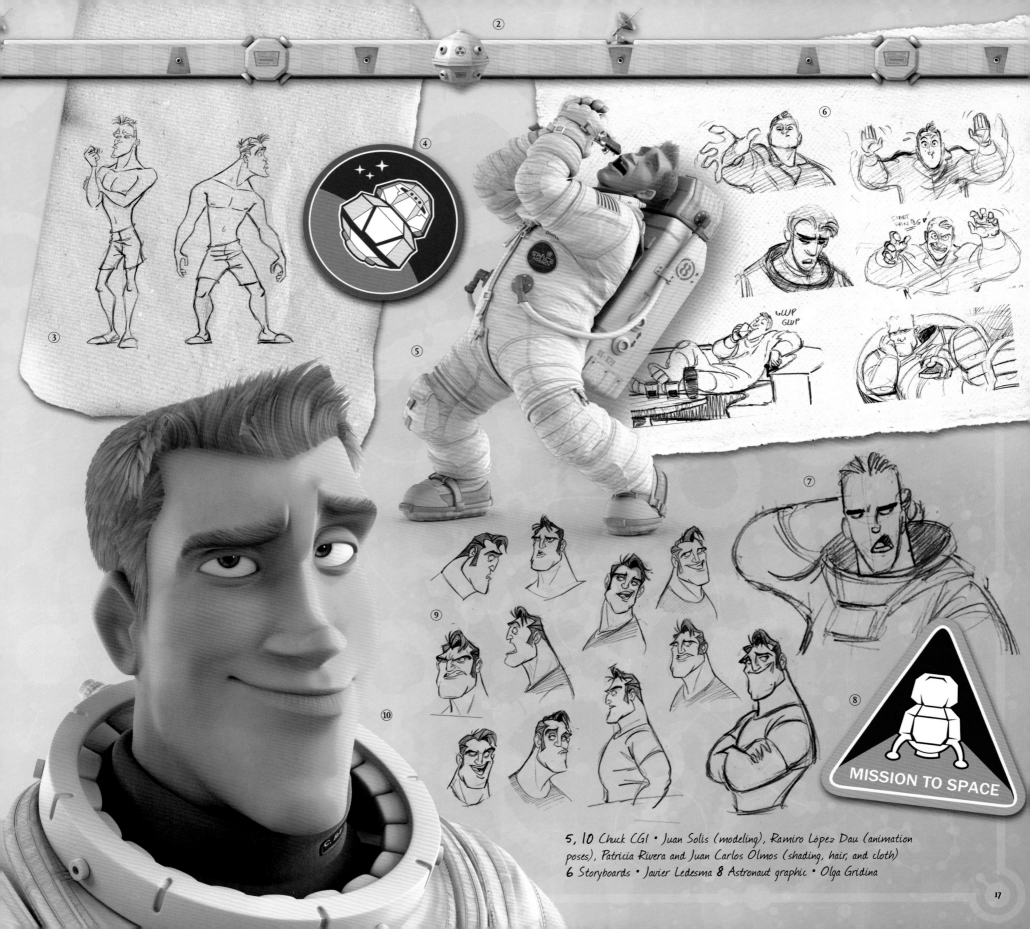

5, 10 Chuck CGI • Juan Solis (modeling), Ramiro López Dau (animation poses), Patricia Rivera and Juan Carlos Olmos (shading, hair, and cloth)
6 Storyboards • Javier Ledesma 8 Astronaut graphic • Olga Gridina

MISSION TO SPACE

GLUP GLUP

START HANDS

17

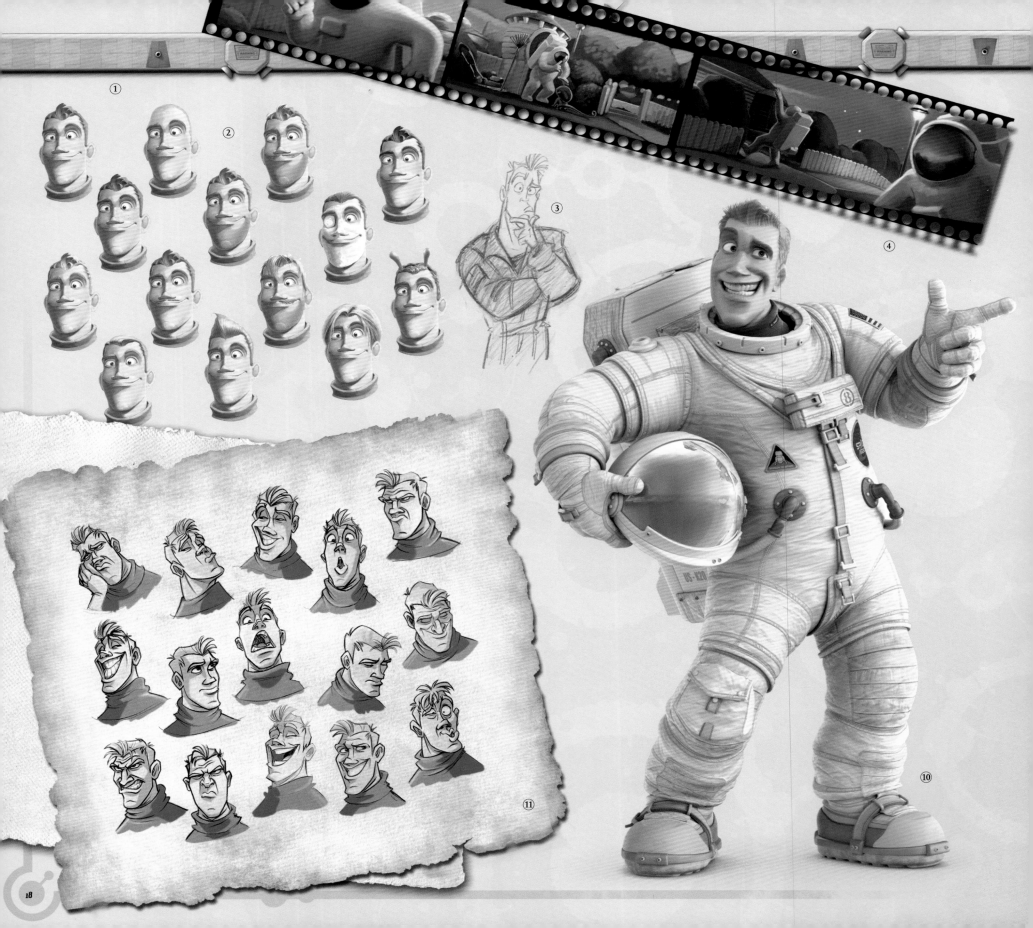

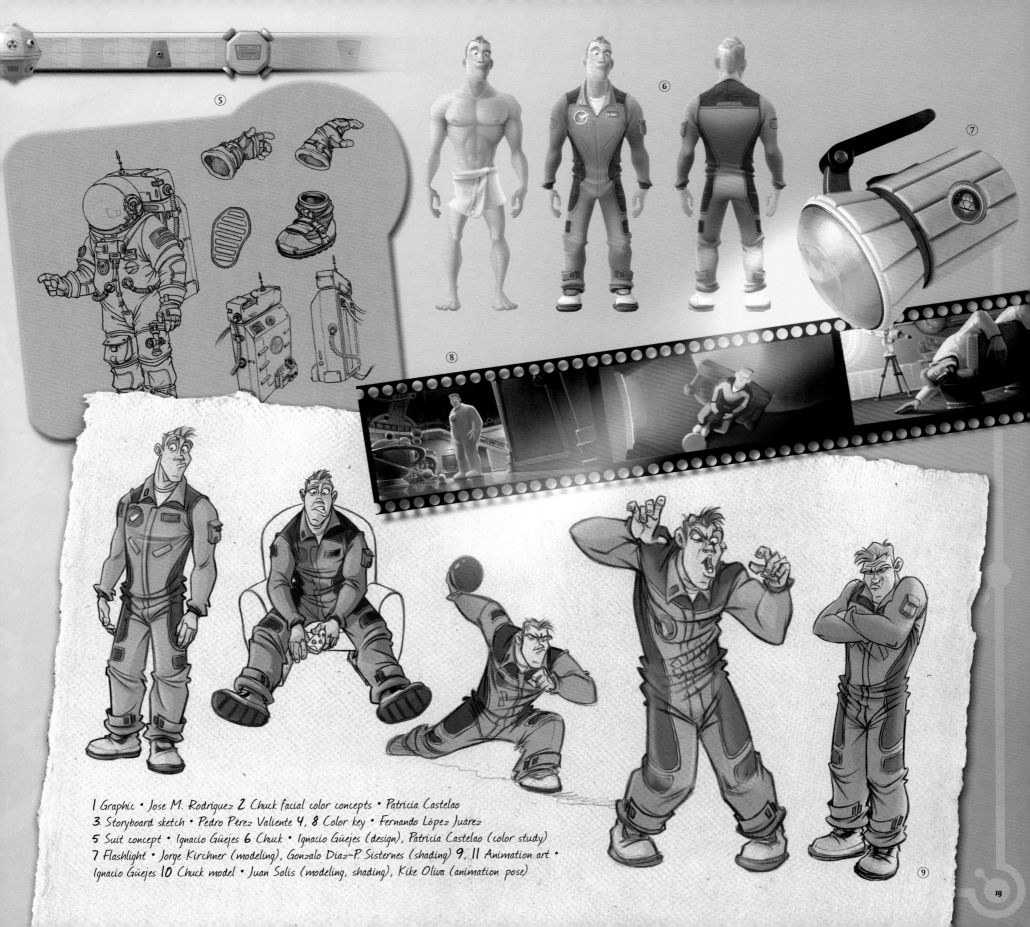

1 Graphic • Jose M. Rodriguez 2 Chuck facial color concepts • Patricia Castelao
3 Storyboard sketch • Pedro Pérez Valiente 4, 8 Color key • Fernando López Juárez
5 Suit concept • Ignacio Güejes 6 Chuck • Ignacio Güejes (design), Patricia Castelao (color study)
7 Flashlight • Jorge Kirchner (modeling), Gonzalo Díaz-P. Sisternes (shading) 9, 11 Animation art •
Ignacio Güejes 10 Chuck model • Juan Solís (modeling, shading), Kike Oliva (animation pose)

Lem

A model teenager, sixteen-year-old Lem lives a life that possesses absolutely no surprises—and that's fine by him. High school junior by day and the junior assistant curator of the Glipforg Observatory by night, Lem is entranced by two things: the stars and his next-door neighbor Neera, whom he yearns to date. The sudden arrival of "alien" Chuck not only turns Lem's life upside down, but ultimately gives him a dose of courage to relax and enjoy himself more.

"Lem, in his fashion, is a bit too old and too sensible for his age," observes director Jorge Blanco García. "He's conditioned to be a responsible young man. He's very square and very concerned with having his life organized."

In the earliest stages of production, Lem was a radically different character, according to codirector Javier Abad Moreno: "He was very similar to Fox Mulder from *The X-Files*. Lem was an FBI agent who was looking for alien invaders. The idea was that no one believed that aliens existed until Rover arrived, and then the conflict grew from there. Also, Lem was quite a boring character. We fought quite hard to make script changes that made Lem into a stronger and more interesting presence in the film."

Consequently, notes head of character design Ignacio Güejes, "Lem was more or less the last character to be designed. We thought about him having quite an open personality, so the audience can really identify with him. He's not the most open or intelligent character— or the silliest or the funniest—but he's the most adaptable, so the audience can see themselves in Lem. The other characters are more specific in terms of their personalities."

He is, however, a character that is invigorated by the presence of the more brash and unpredictable Chuck: "Lem is very lucky because, just as he's going through this bad patch with Neera, this 'life instructor' of sorts arrives to help him out when he most needs it," says Abad. "Ultimately, though, Lem finds his own way and becomes progressively more mature and assertive throughout the film."

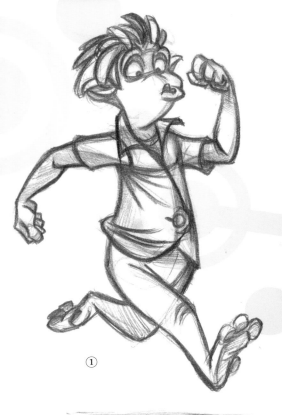

①

"This is a disaster!"

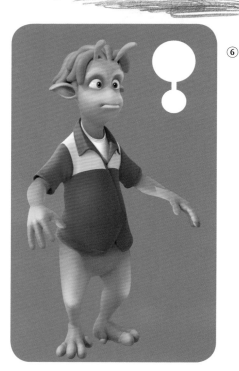

⑥

1, 3 Lem sketches • Ignacio Güejes 2 Graphic • Olga Gridina and Jose M. Rodriguez 4 Lem's collectibles • Olga Gridina and Gracia Artigas (graphic), Ramón López (modeling), Eva de Prado (shading) 5 Lem • Juan Solis (modeling, shading), Ramiro López Dau (animation pose) 6 Color study • Patricia Castelao

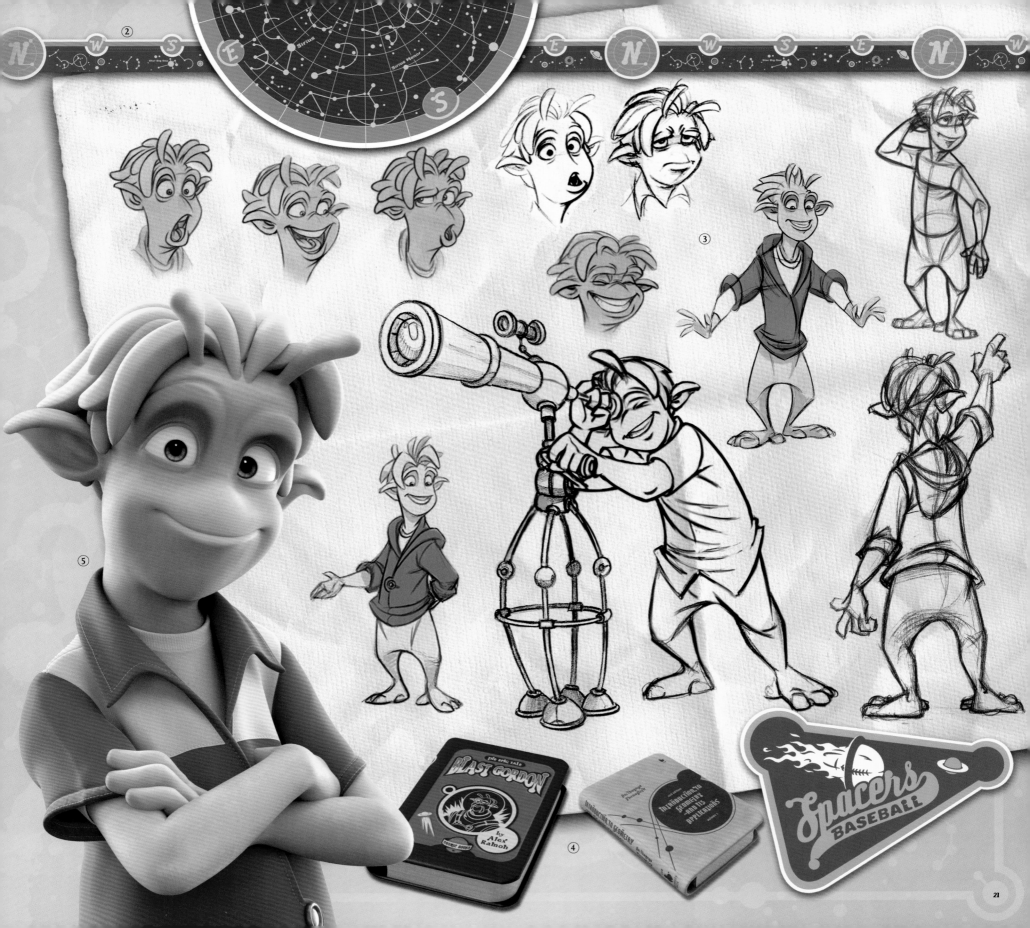

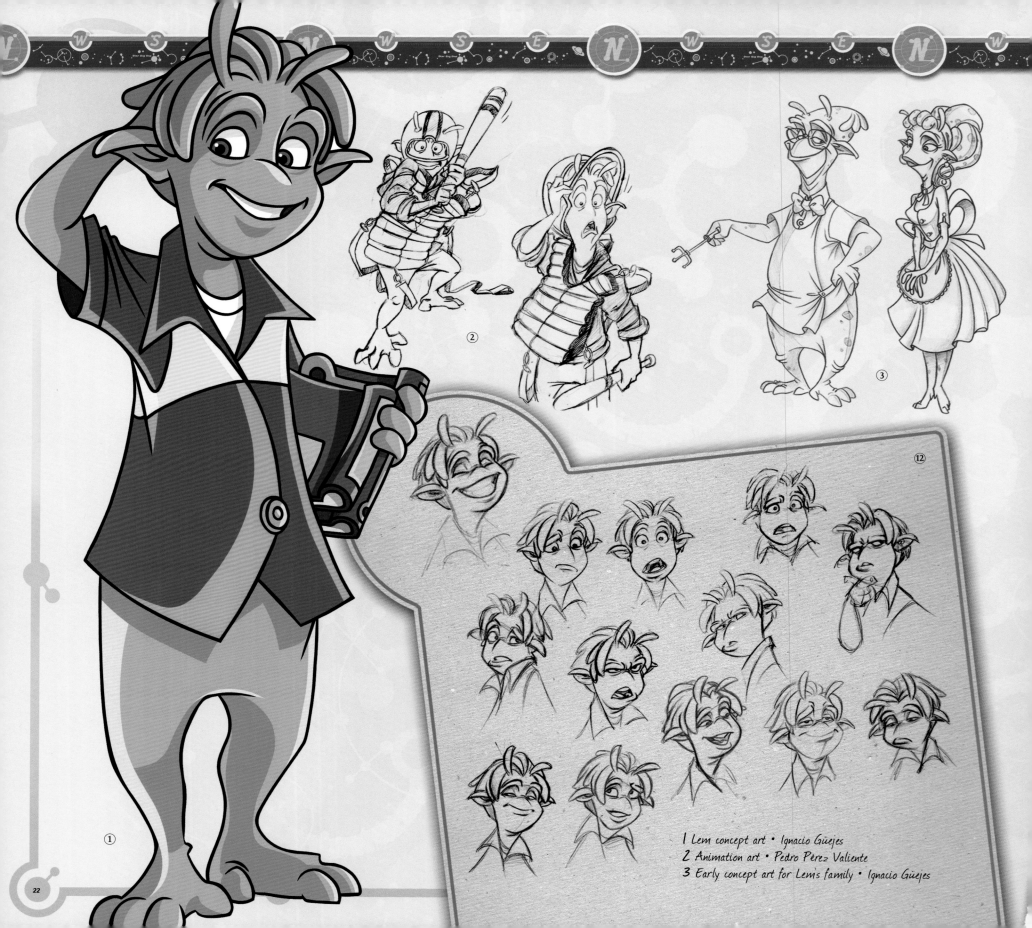

1 Lem concept art • Ignacio Güejes
2 Animation art • Pedro Pérez Valiente
3 Early concept art for Lem's family • Ignacio Güejes

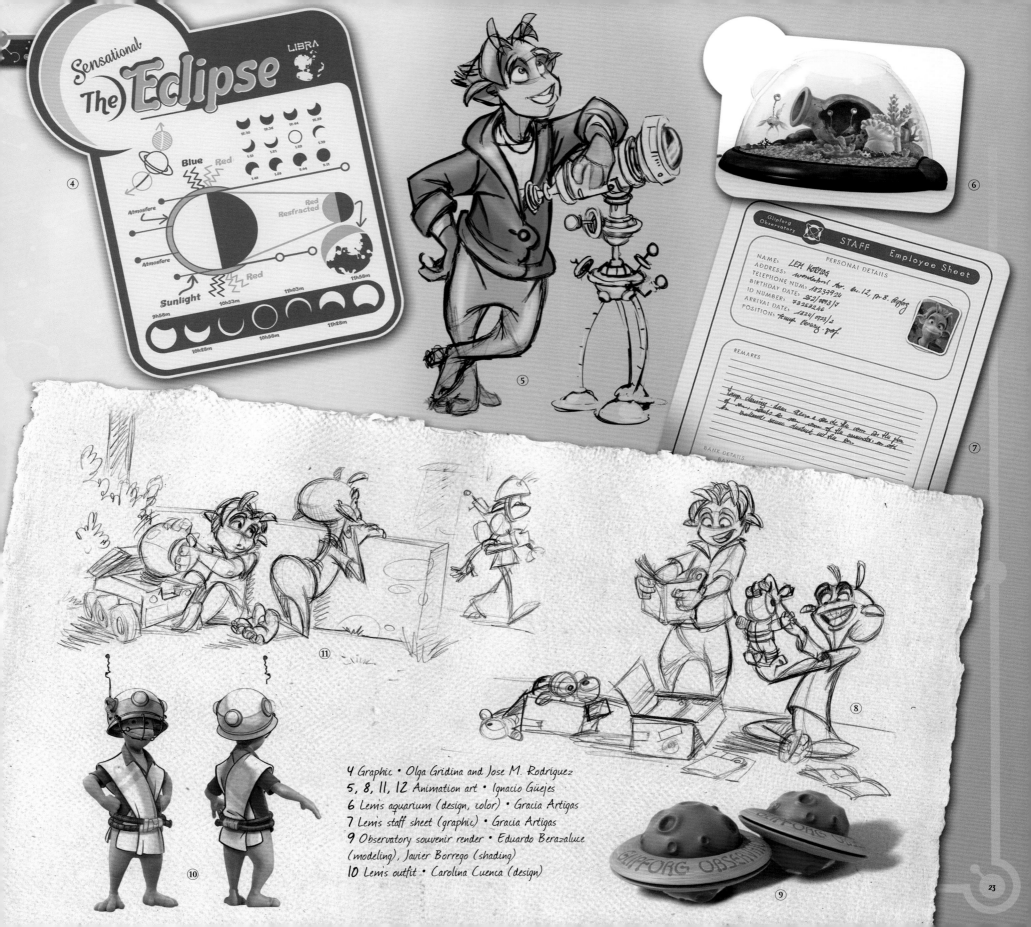

Sensational
The **Eclipse**
LIBRA

Blue Red

Atmosfere

Atmosfere

Red
Resfracted

Red

Sunlight

9h58m 10h28m 10h53m 10h58m 11h03m 11h28m 11h58m

④

⑤

⑥

Glipford
Observatory
STAFF Employee Sheet

PERSONAL DETAILS

NAME: LEM KORRIG
ADDRESS: Wonderland Av. N. 12, fl. 8. Glipford
TELEPHONE NUM: 18239924
BIRTHDAY DATE: 252/0493/4
ID NUMBER: 7325826
ARRIVAL DATE: 1424/0723/2
POSITION: Temp. clesing. pot.

REMARKS

BANK DETAILS

⑦

⑪

⑧

⑩

4 Graphic • Olga Gridina and Jose M. Rodríguez
5, 8, 11, 12 Animation art • Ignacio Güejes
6 Lem's aquarium (design, color) • Gracia Artigas
7 Lem's staff sheet (graphic) • Gracia Artigas
9 Observatory souvenir render • Eduardo Berazaluce
(modeling), Javier Borrego (shading)
10 Lem's outfit • Carolina Cuenca (design)

GLIPFORD OBSERVATORY

⑨

23

Skiff

"Aliens don't want
to eat us. They want
to harvest our organs
and enslave us
in their mines!"

Lem's quirky best friend, an übergeek and a conspiracy theorist extraordinaire, Skiff is an unalloyed subscriber to paranoia—much to the chagrin of his friends. He's absolutely convinced that not only is the government telling lies about the existence of aliens, but that there is also a mysterious "Base 9" where the proof of such beings are held. Funnily enough, he may well be right. . . .

Skiff's constant diet of comic books and sci-fi, courtesy of his job at the local comic book store, only heightens his overblown, reactionary attitude to the prospect of alien life visiting Planet 51—replete with their inevitable plans for total enslavement of Glipforg. So come the fateful day when it actually happens, he's a total wreck. "Skiff is a funny secondary character, much like Rover. He's so much into his comic books and has such an active imagination that he's just not a helpful presence in the slightest," says animation supervisor Fernando Moro.

"There is a definite duality between Lem and Skiff," observes head of character design Ignacio Güejes. "Lem is much more optimistic about Chuck's arrival, sensing that he's not entirely malevolent and that he should be given a chance. Skiff, on the other hand, is completely afraid from the very first second—very reactionary. He instantly realizes that Chuck is a stranger and something he's not familiar with, and so his first response is to run hard! He assumes that there's going to be an invasion by invaders who are obviously going to eat their brains!"

Despite the obvious comedy value of Skiff's constantly-on-the-verge-of-hysteria personality, he offers more than simple comedy relief. Güejes adds, "Skiff is also a character the audience can identify with because he represents our fear of the unknown. Skiff's overblown reactions to Chuck's arrival, however, are not meant to be attractive or sensible." At Skiff's core, though, is a yearning to be understood and loved, which he receives via his innately close bond with Chuck's robot vehicle, Rover, who, come the end of the film, becomes Skiff's new best friend.

①

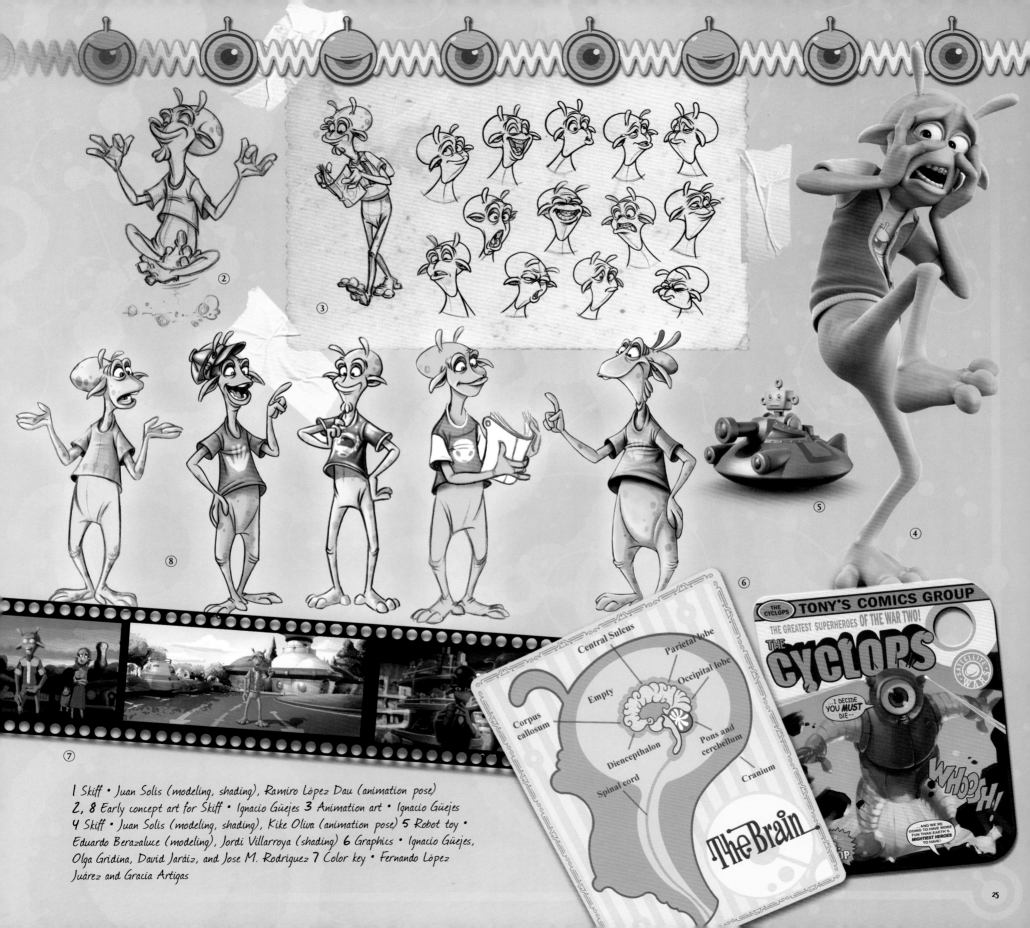

1 Skiff • Juan Solis (modeling, shading), Ramiro López Dau (animation pose)
2, 8 Early concept art for Skiff • Ignacio Güejes 3 Animation art • Ignacio Güejes
4 Skiff • Juan Solis (modeling, shading), Kike Oliva (animation pose) 5 Robot toy •
Eduardo Berazaluce (modeling), Jordi Villarroya (shading) 6 Graphics • Ignacio Güejes,
Olga Gridina, David Jaráiz, and Jose M. Rodríguez 7 Color key • Fernando López
Juárez and Gracia Artigas

Rover

A particularly eager and excitable space exploration robot, Rover's mission is to explore alien planets, send images back to Earth, and collect rock samples—the last task by far its favorite and one it pursues with ceaseless enthusiasm. "The robot who goes looking for rocks on other planets would therefore be the first to initiate contact with an alien race," codirector Marcos Martínez Carvajal observes. "Rover was one of the first characters that we thought of," he adds, further recognizing the character's pivotal off-screen role in bringing the protagonists together.

Rover's introduction finds him imprisoned in the mysterious Base 9, along with all the other captured space probes, in glass, egglike cells that were specifically designed in homage to Ridley Scott's *Alien*. Once alerted of Chuck's arrival on the planet, Rover becomes determined to reunite with his crewmate.

Despite being one of the first characters developed, Rover came with a very specific conundrum regarding his personality. "Rover is a very technical character and, once animated, it was immediately noticeable that he was a very cold character," remembers head of character design Ignacio Güejes. "So we had to make an effort to give Rover a personality."

The ideal answer soon presented itself: "Rover looks like a dog—given the rear-based antenna—so once the character was being animated, and people commented that it looked like a dog," says Güejes, "there was a drive to create gags in scenes that capitalized upon this fact. His job is to go to planets and then take stone samples for experiments. So Rover would be absolutely obsessed with obtaining these rocks, just as a dog would be with a bone."

Rover's doglike personality is played up beautifully in the relationship he develops with Skiff upon reaching Glipforg in his efforts to locate Chuck. Skiff's willingness to play fetch with Rover by throwing rocks immediately endears alien to robot. Given that Planet 51's weather patterns routinely involve light meteor showers that cover Glipforg in his beloved specimens, it's no wonder that Rover is happy to stay on Planet 51 come the film's conclusion.

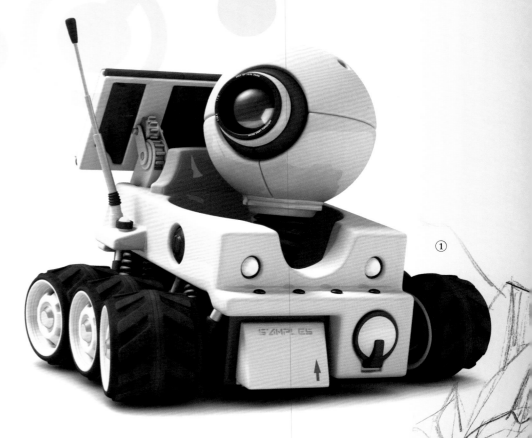

"PRIMARY SPECIMEN: ACQUIRE!"

①

1 Rover • Juan Solís (modeling, shading), Ramiro López Dau (animation pose) 2 Early concept art for Rover • Ignacio Güejes 3 Graphic • Gracia Artigas 4 Concept art of Skiff and Rover's interaction • Ignacio Güejes (pencil drawing) 5 Rover and Skiff • Ignacio Güejes (line art)

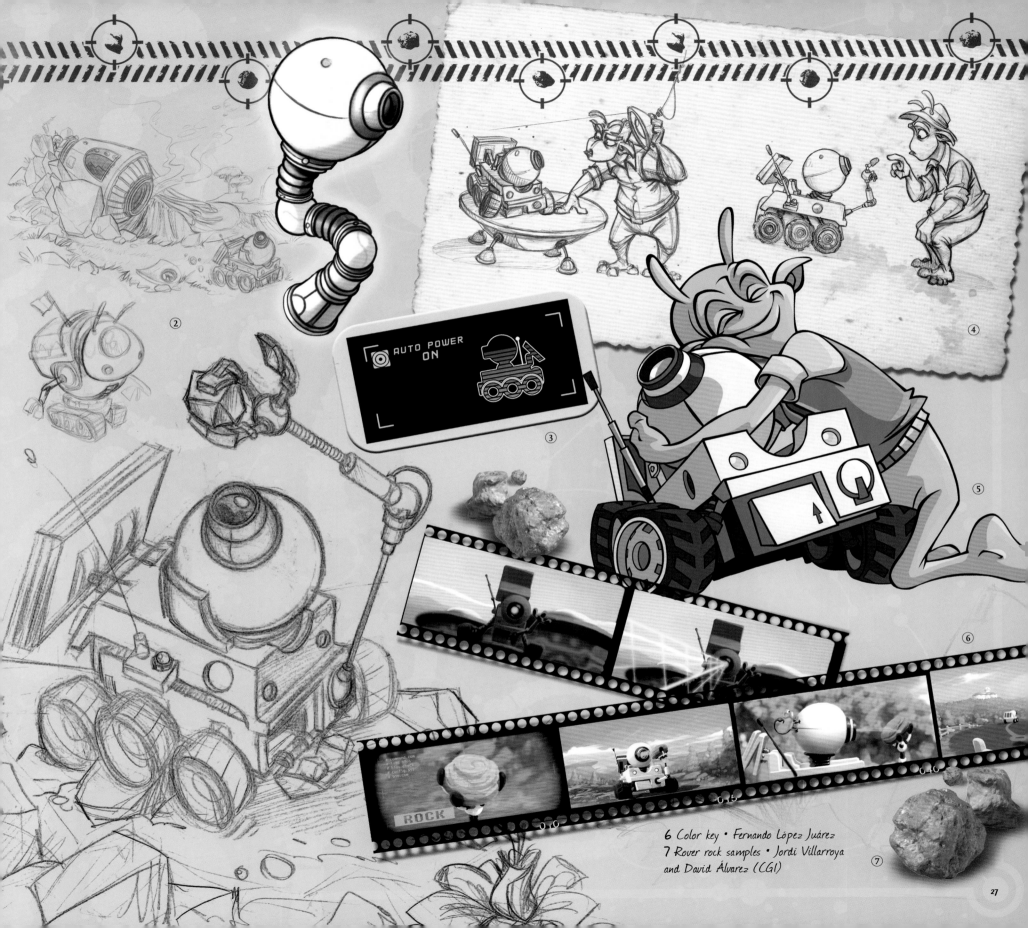

AUTO POWER
ON

ROCK

6 Color key • Fernando López Juárez
7 Rover rock samples • Jordi Villarroya
and David Álvarez (CGI)

② ③ ④ ⑤ ⑥ ⑦

General Grawl

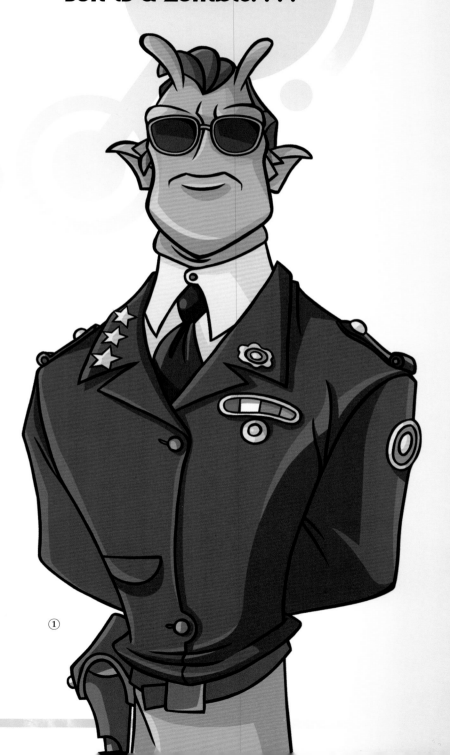

> "I'm afraid your son is a zombie. . . ."

The most powerful person on Planet 51, General Grawl is the commander of the armed forces, ruthlessly dedicated to his mission to protect his planet from any—no, all—alien invasions, completely prepared to fight until the end. Strong, willful, and highly intimidating, Grawl's relentless (and rather mindless) pursuit of Chuck is very much informed by his dependency on Professor Kipple, whose apparent authority on aliens he never questions.

Described in the script as "handsome and stern; Burt Lancaster with antennae," General Grawl clearly stands apart from the other alien characters: taller, altogether more muscular, and with a suitably commanding bearing. Grawl's imposing physicality also provides an amusing contrast to the comparatively tiny Professor Kipple, who is never far from the General's side.

"Grawl isn't a bad person, he is just exceedingly loyal to his military orders," recalls codirector Javier Abad Moreno. "All he wants to do is protect his world from lethal outside intervention—and he'll do whatever it takes, even if it's against his better judgment. In the end, though, he reacts in a positive and decent manner."

One of the core concerns with Grawl was that despite his obvious threat to Chuck, he wasn't particularly evil. "There were initial problems with Kipple and Grawl," Abad adds, "given that they are essentially the antagonists of the film. We played around with the dynamic between them, where Grawl was worse than Kipple and vice versa, but the aim was to have neither worse than the other."

Indeed, the amusing relationship between Grawl and Kipple exposes the General as somewhat more pliable than he'd ever like to admit, instantly ordering his own arrest when Kipple suggests that even he might be a mind-controlled zombie! Grawl is equally as reactionary as Kipple when it comes to Chuck and his apparent threat, yet he allows himself to be guided by Kipple's imbalanced view.

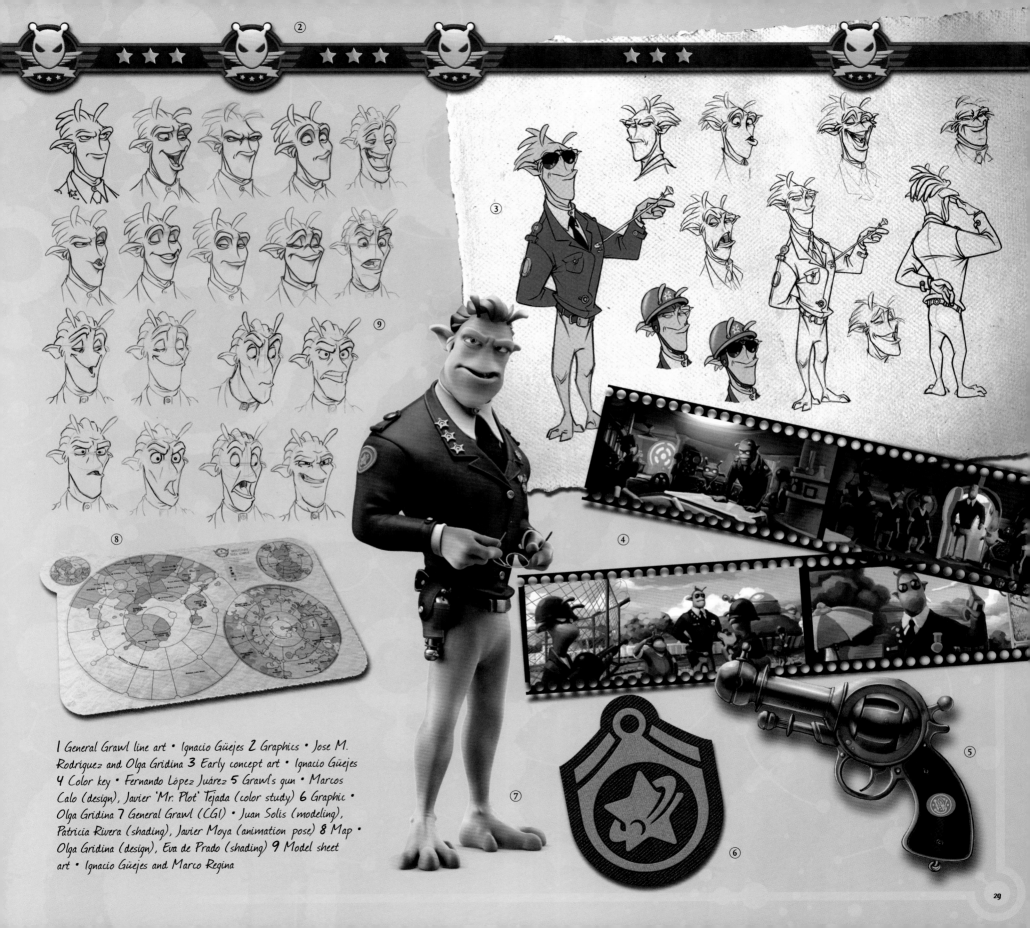

1 General Grawl line art • Ignacio Güejes 2 Graphics • Jose M.
Rodriguez and Olga Gridina 3 Early concept art • Ignacio Güejes
4 Color key • Fernando López Juárez 5 Grawl's gun • Marcos
Calo (design), Javier 'Mr. Plot' Tejada (color study) 6 Graphic •
Olga Gridina 7 General Grawl (CGI) • Juan Solís (modeling),
Patricia Rivera (shading), Javier Moya (animation pose) 8 Map •
Olga Gridina (design), Eva de Prado (shading) 9 Model sheet
art • Ignacio Güejes and Marco Regina

Professor Kipple

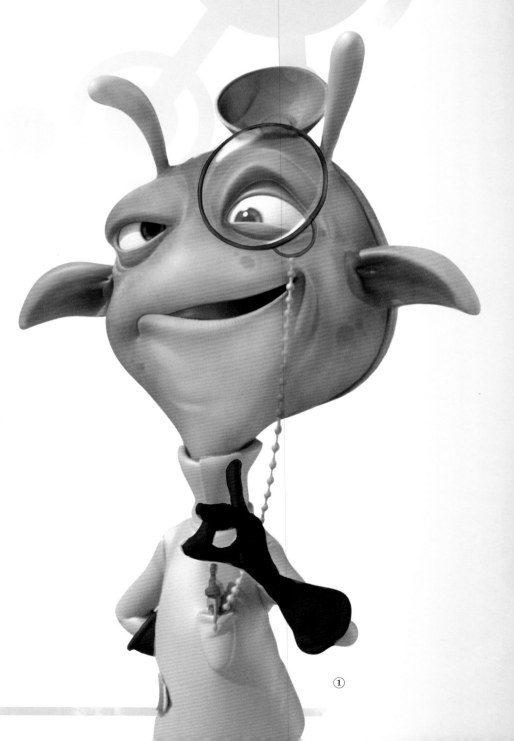

Playing a (literally) small but very potent role in *Planet 51*, Professor Kipple is a gleeful take on the classic genre trope of the mad scientist—and the filmmakers certainly enjoyed crafting a character they didn't have to be too delicate with in terms of personality. Animation supervisor Fernando Moro describes the professor as a familiar character saying that he's "very much the cliché of the mad professor that we all know from many films—totally unhinged and manic—and he's always like that. Grawl, on the other hand, is more delicate because his motivations can and does change."

The diminutive and brilliant Kipple is Planet 51's preeminent scientist, an intellectual superstar of sorts and the proud owner of the planet's largest brain. The foremost authority on all things alien, Kipple takes an overwhelming interest in the arrival of Chuck on Planet 51, fanning the flames of paranoia and hysteria among the easily scared Glipforg populace. Aided by General Grawl, he leads the relentless pursuit of the beleaguered astronaut. The brain-obsessed Kipple has an ulterior motive, however—to operate on Chuck and remove his brain!

Early in the design stages of *Planet 51*, the filmmakers were adamant that Kipple had to have a look that would immediately make him stand out from every other character. "When we first designed Kipple, the only thing we had in mind was ensuring that he is clearly the most intelligent character in the film," recalls head of character design Ignacio Güejes. "He is Planet 51's authority on all things 'alien,' so he really needed to have the biggest head!"

The key development of Kipple, however, provided the character a much better potential for physical comedy. "In the initial design stages," Güejes notes, "Kipple had a normal-size body with a massive head, but it didn't really work, so we decided it would be far funnier to have the large head with a tiny body." The result is a kind of amusingly malevolent Yoda, wide-eyed, imperious, and sneering, whose single-minded pursuit of his selfish goals makes him a formidable—if mad—adversary!

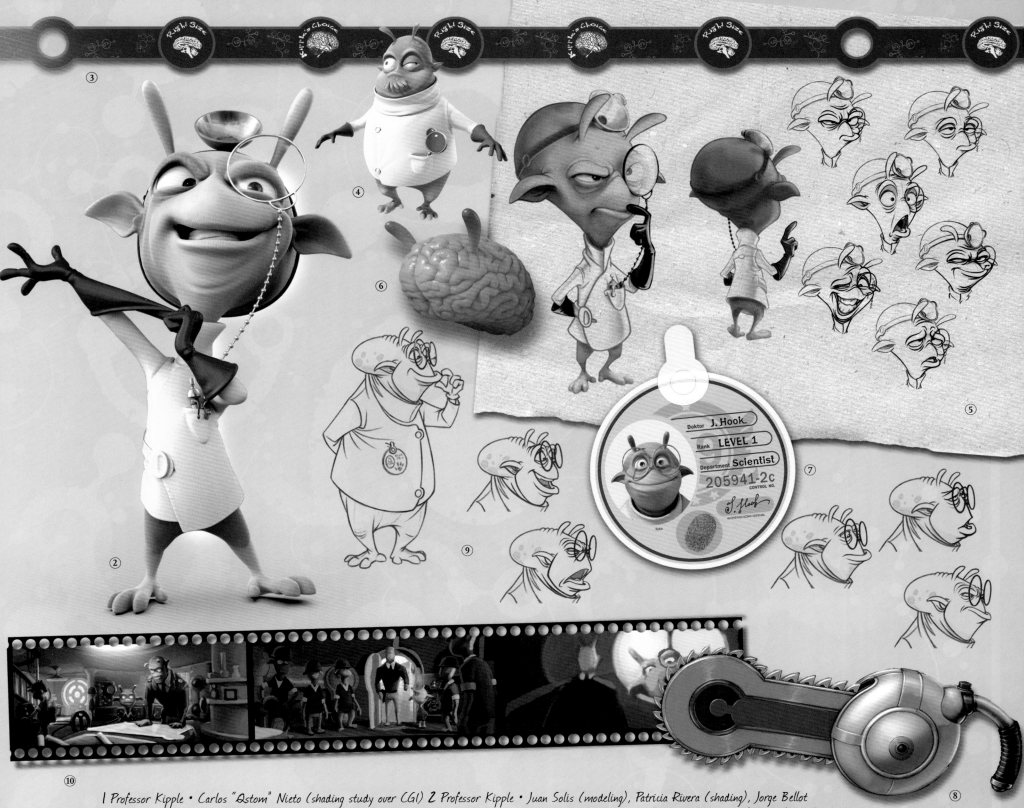

1 Professor Kipple • Carlos "Qstom" Nieto (shading study over CGI) 2 Professor Kipple • Juan Solis (modeling), Patricia Rivera (shading), Jorge Bellot (animation pose) 3 Graphic design • Jose M. Rodriguez 4 Dumb scientist color study • Patricia Castelao, Abraham Meneu (CGI modeling) 5 Professor Kipple: color study • Carlos "Qstom" Nieto, Ignacio Güejes (drawing) 6 Alien brain CGI • Jordi Villarroya 7 Graphic • Olga Gridina 8 Professor Kipple's surgery chainsaw • Javier "Mr. Plot" Tejada (visual development) 9 Animation art • Carolina Cuenca 10 Color key • Fernando López Juárez

Eckle

"I got you, alien!"

The youngest of Lem's group of friends—and Neera's younger brother—Eckle possesses a quality that pretty much sets him apart from every other inhabitant of Planet 51: He absolutely loves aliens—and this drives his parents mad!

Utterly obsessed with comics, science fiction, monsters, and aliens—usually to the exclusion of everything else—and possessing a fervent ambition to somehow obtain an alien's autograph, the seven-year-old Eckle's thoughts are never far away from his all-consuming passions, and he is rarely seen without a comic book or a toy ray gun in his hands.

Clad in a baseball shirt and cap, Eckle's chief love is the film series *Humaniacs!*—the first two installments of which are his all-time favorite films. At the opening of *Planet 51*, the wide-eyed boy's mother catches him attending a screening of the latest *Humaniacs!* movie, and she drags him out of the theater by his antenna and makes him attend a school field trip to the Glipforg Observatory.

While Eckle does not heavily contribute to *Planet 51*'s main storyline, he does play an important role as an unbiased observer. "We wanted a young child that is a passionate fan of aliens—particularly *Humaniacs!*—but someone who is not yet a total geek about it," explains head of character design Ignacio Güejes. Eckle also provides an important contrast to the film's other characters: "We wanted to have a character that was brimming with enthusiasm and, importantly, had a huge sense of wonder," Güejes adds. So while everyone else recoils in abject horror at Chuck's arrival in Glipforg, Eckle instantly considers it to be the most tremendously exciting event of his life. "He is not afraid of anything and has a bearing of constant surprise," says Güejes. This innocent and unsuspicious perspective is instrumental in proving to Lem and his other friends that Chuck is not nearly as malevolent as they assume he is—and the vain Chuck certainly doesn't mind the lavish attention paid to him by his new No.1 Fan!

1 Eckle • Juan Solís (modeling, shading), Julen Santiago (animation pose) 2 Graphic • Jose M. Rodríguez 3 Eckle's camera color study • Carlos "Qstom" Nieto, Jorge Kirschner (modeling), Anna Sitja (shading) 4 Shading study over CGI • Patricia Castelao 5 Eckle's comic book • Julián Romero Muñoz (concept), Gracia Artigas (color painting), Ignacio Güejes (base drawing)

①

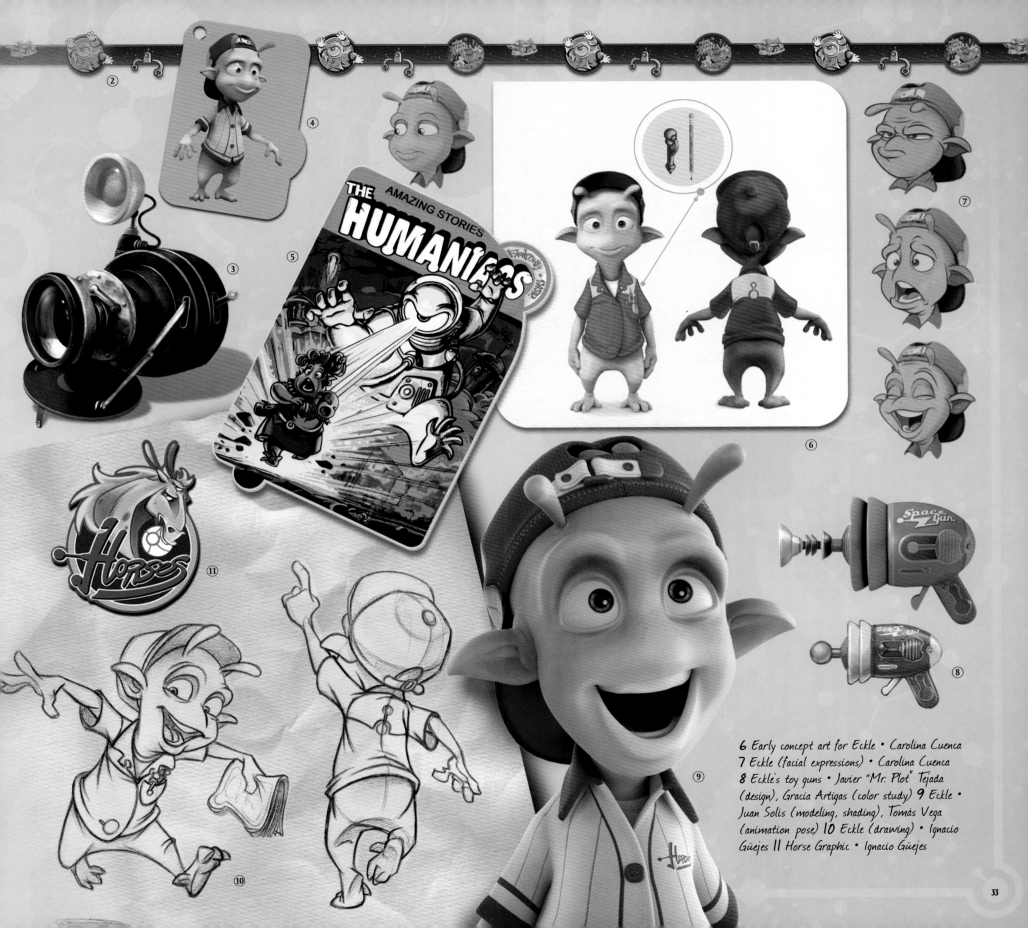

6 Early concept art for Eckle • Carolina Cuenca
7 Eckle (facial expressions) • Carolina Cuenca
8 Eckle's toy guns • Javier "Mr. Plot" Tejada (design), Gracia Artigas (color study) 9 Eckle • Juan Solís (modeling, shading), Tomás Vega (animation pose) 10 Eckle (drawing) • Ignacio Güejes 11 Horse Graphic • Ignacio Güejes

Neera

"Kill any aliens, Lem?"

Lem's next-door neighbor and the great love of his young life, Neera is a beautiful, determined, and strong-willed girl who is very aware that the world extends far beyond the sleepy, uneventful confines of Glipforg. Unlike Lem, who is perfectly content to do what is expected of him, Neera possesses a rebellious streak that she is trying to define — something not particularly aided by hanging out with the unfocused hippie Glar. While Neera certainly has feelings for Lem, she would like Lem to be more assertive and less accepting of the simple route.

Neera possesses an important design element that allows for a distinction between male and female aliens: her toes are distributed so that one toe acts as a high heel — with or without a shoe. Head of character design Ignacio Güejes says that this aesthetic change came in the animation phase: "Once we had designed the characters and they were moving in scenes, we discovered that if the females had that extra heel on their feet, then they would move differently than the male aliens, with swaying hips."

While the film is anchored on the core duality of Lem and Chuck, Neera provides an equally important function, according to Güejes. "The other duality in the film is between Lem and Neera. They are neighbors who have known each other since they were very young — they are very good friends. While Lem is quiet, Neera is far more active and rebellious. She wants to travel, to meet new people, and to discover things in life. In comparison, Lem is a normal boy who just wants a normal life, a normal job, and a normal family."

Neera progressively defines herself throughout the film, ultimately discovering that her urge to rebel leads to her understanding her own bravery and virtue. "At the end of the film, Neera is the only one who openly believes in Chuck," says Güejes. "Lem still feels this privately."

①

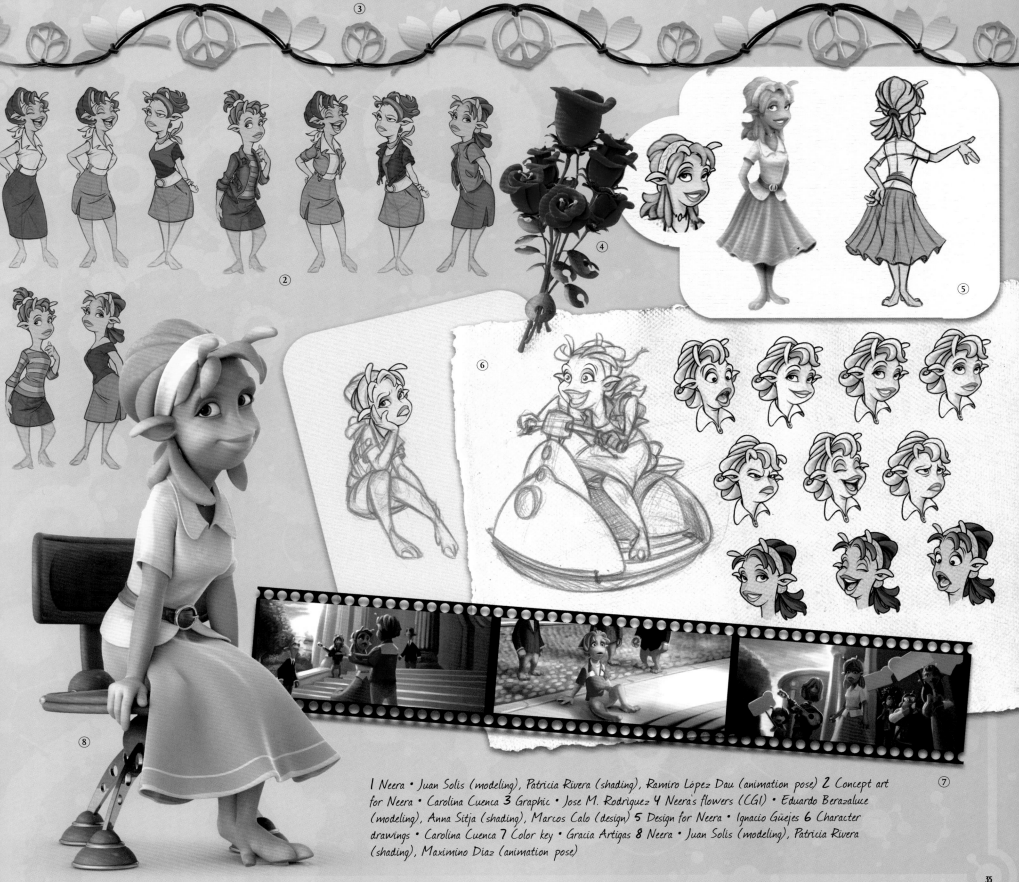

1 Neera • Juan Solís (modeling), Patricia Rivera (shading), Ramiro López Dau (animation pose) 2 Concept art for Neera • Carolina Cuenca 3 Graphic • Jose M. Rodriguez 4 Neera's flowers (CGI) • Eduardo Berazaluce (modeling), Anna Sitja (shading), Marcos Calo (design) 5 Design for Neera • Ignacio Güejes 6 Character drawings • Carolina Cuenca 7 Color key • Gracia Artigas 8 Neera • Juan Solís (modeling), Patricia Rivera (shading), Maximino Diaz (animation pose)

Glar

Of all the alien characters in *Planet 51*, the hippie Glar stands out as somewhat anachronistic to the film's pervading 1950s feel. Art supervisor Fernando Moro asserts, however, that "It's important to remember that this is not the United States. It's an alien world—and we have the freedom to throw in various elements, like hippies, who are not from the '50s. We were not that strict on adhering to 'reality.'"

Despite this, Moro adds, "All the characters have to [allude] to Americana—mainly that of the '50s, but some elements from the '60s and even '70s, too. They have to be very naïve and not aggressive or as

intense as we are nowadays. It plays as a nice contrast." This is certainly true of the slang-speaking, permanently easygoing Glar, whose laughably earnest and misguided attempts at rebellion provide some superb humor.

"Glar is one of my favorite characters in the film," enthuses codirector Marcos Martínez Carvajal, "He's honest and he's dumb. He's very, very funny and he's a little ahead of his time, inasmuch as he's the first hippie on this world—but he doesn't know it yet!"

Planet 51's very own Bob Dylan is never without his acoustic guitar and is never at a loss for a song. He sings about his dislike of everything that is plain and normal—even if the result is hilariously mangled. With his long, unkempt hairstyle and loose shirt, vest, and necklace, Glar not only provides a sharp visual contrast to the clean-cut Lem, but with his devotion to protesting, is also a rival for the affections of the rebellion-loving Neera, failing to understand what she sees in the dull Lem.

"Lem is the perfect teenager—he goes to school, does his work, and is perfectly happy with his regimented lifestyle. Glar isn't at all like this," Martínez continues. "On top of all the songs that he sings, he says things that are heartfelt and well-meant, but then he blows everything with his own stupidity. He's brilliantly funny."

1, 2 Glar • Abraham Meneu (modeling), Patricia Rivera (shading), Elena Ortego, Javier Moya (animation poses)
3 Glar (facial expressions) • Ignacio Güejes 4 Glar's friends • Carolina Cuenca (design), Carlos "Qstom" Nieto (color study)

①

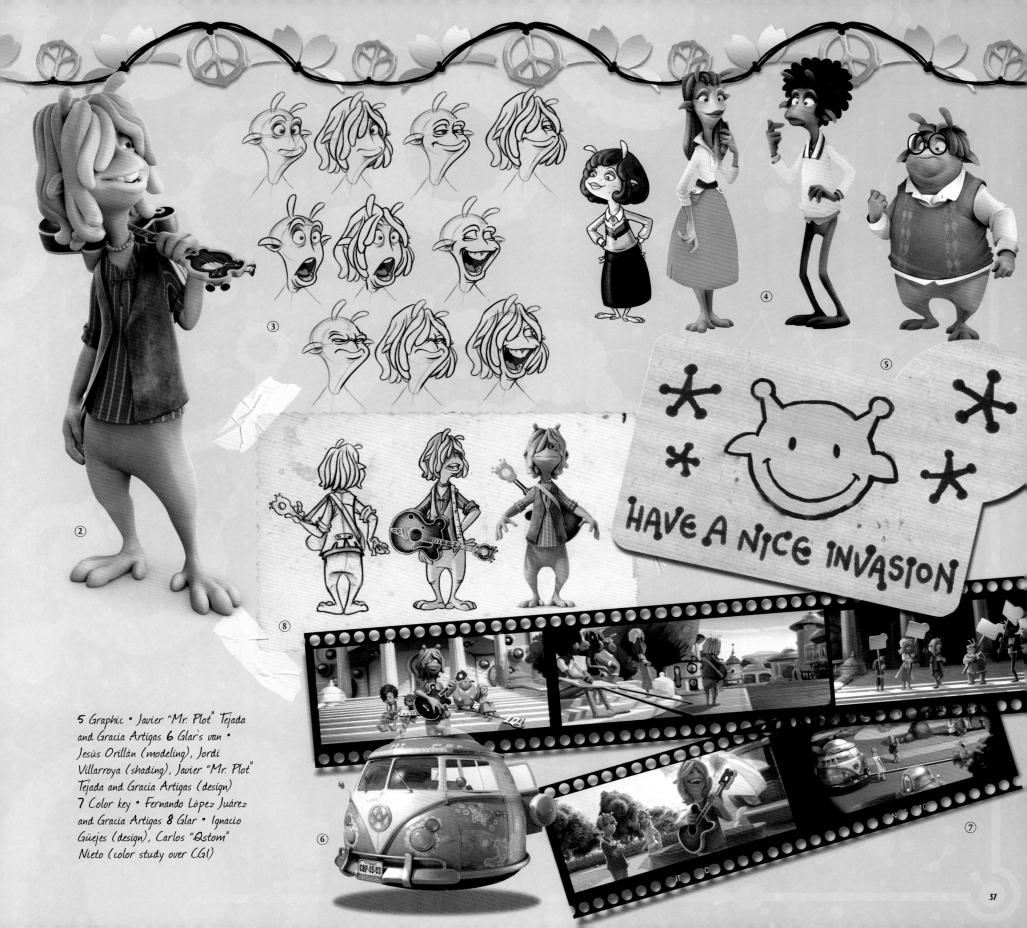

HAVE A NICE INVASION

5 Graphic • Javier "Mr. Plot" Tejada
and Gracia Artigas 6 Glar's van •
Jesús Orillán (modeling), Jordi
Villarroya (shading), Javier "Mr. Plot"
Tejada and Gracia Artigas (design)
7 Color key • Fernando López Juárez
and Gracia Artigas 8 Glar • Ignacio
Güejes (design), Carlos "Qstom"
Nieto (color study over CGI)

Fauna

① ② ③ ⑪ ⑫ ⑬ ⑭

Milk

1, 3, 4, 8, 10, 11, 12, 13, 14 Animal and plants concept art • Ignacio Güejes 2 Animal
illustration • Ignacio Güejes, Olga Gridina (graphic design) 5, 6, 9 Animal designs • Carolina
Cuenca, Carlos "Qstom" Nieto (color and shading study) 7 Concept art • Julián Romero Muñoz

38

Glipforg Townsfolk

O f the 440 characters that appear in *Planet 51*, the bulk of them are the peaceful and very unassuming inhabitants of Glipforg, the town which, by some strange cosmic coincidence, is strikingly reminiscent of 1950s America.

To create this environment, the filmmakers had an opportunity to indulge a well-established and much-evoked cliché of American suburban life. "We tried to create a classic small-town environment where everyone knows each other, where the cop is very friendly, and you have the genial postman, the chatty barber, and so on," explains animation supervisor Fernando Moro.

The outright familiarity of this iconic era greatly aided the film's design team: "It was quite easy to develop all those characters because there was so much reference for these types of people, be it from TV shows or films," notes head of character design Ignacio Güejes. "We really wanted to get across a clichéd myth of that era where there was a very happy atmosphere of contentment with no problems."

Consequently, it was especially important that the alien inhabitants of this environment looked peaceful. Director Jorge Blanco García recalls that, "People look back on '50s culture as a simpler and more innocent time, so it was an inevitable change to make [the aliens of Planet 51] less threatening and more adorable. In the first of the designs, they were far more pointedly alien in look. Everything was later rounded off and made cuddly."

The other major group of the Glipforg populace is the military personnel who swarm over the town in their efforts to capture the alien threat of Chuck. Fiercely determined yet tremendously clumsy and ineffectual, at the forefront of the army's destructive chase is a mismatched pair of soldiers. "They developed primarily from the established comedy pairing à la Laurel and Hardy, one intelligent and one stupid," says Güejes. "These characters always appear together. They are never apart."

Glipforg's military makes a significant contribution to *Planet 51*'s slapstick humor, particularly in a scene that has become a firm favorite of the crew: "I love the sequence where all the soldiers start firing on each other," laughs codirector Javier Abad Moreno. "It's the first sequence that we animated and one that worked perfectly in the script. A very funny sequence."

1 Dustman • Carlos "Qstom" Nieto (color and shading study), Ignacio Güejes, and Carolina Cuenca (design) 2 Firemen • Ignacio Güejes (design), Carlos "Qstom" Nieto 3 Milkman • Carlos "Qstom" Nieto (color study), Carolina Cuenca (drawing), Olga Gridina (graphic design) 4 Reporters concept art • Ignacio Güejes

② ③ ④

Drink Milk More

41

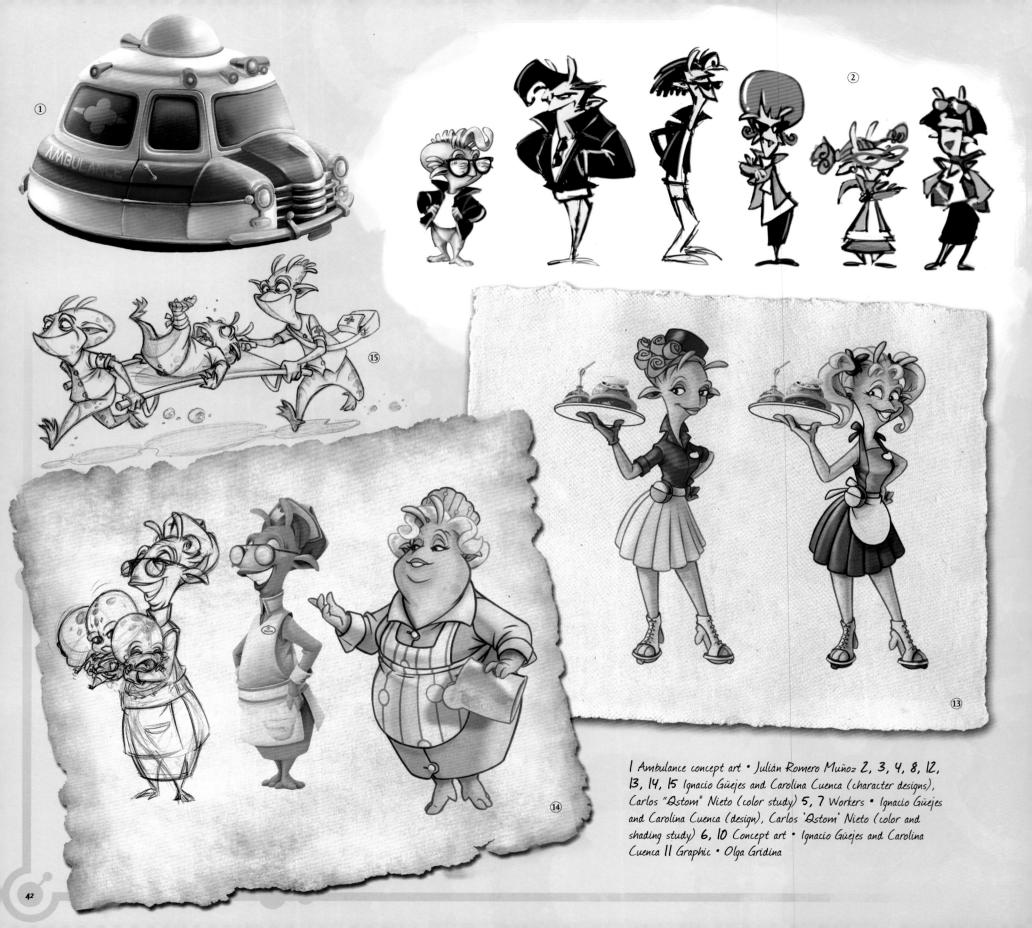

1 Ambulance concept art • Julián Romero Muñoz 2, 3, 4, 8, 12, 13, 14, 15 Ignacio Güejes and Carolina Cuenca (character designs), Carlos "Qstom" Nieto (color study) 5, 7 Workers • Ignacio Güejes and Carolina Cuenca (design), Carlos "Qstom" Nieto (color and shading study) 6, 10 Concept art • Ignacio Güejes and Carolina Cuenca 11 Graphic • Olga Gridina

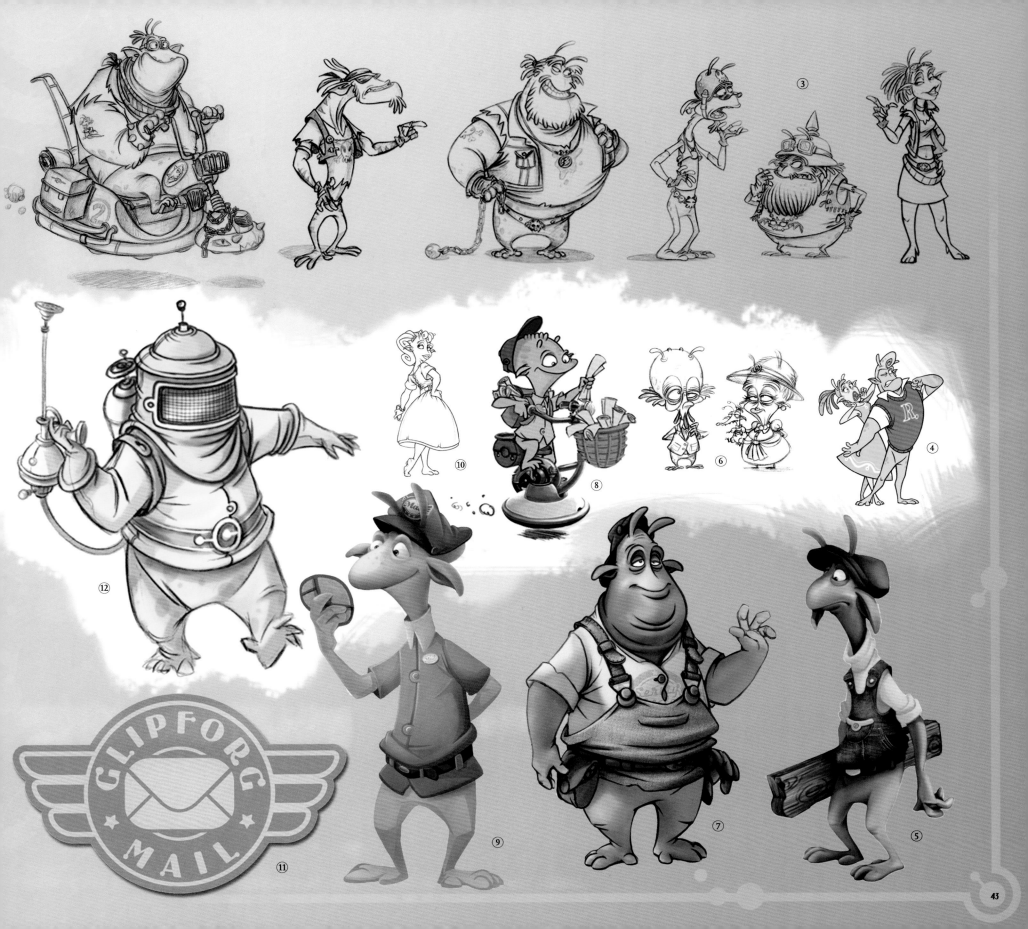

③

④

⑥

⑧

⑩

⑫

GLIPFORG MAIL ⑪

⑨

⑦

⑤

43

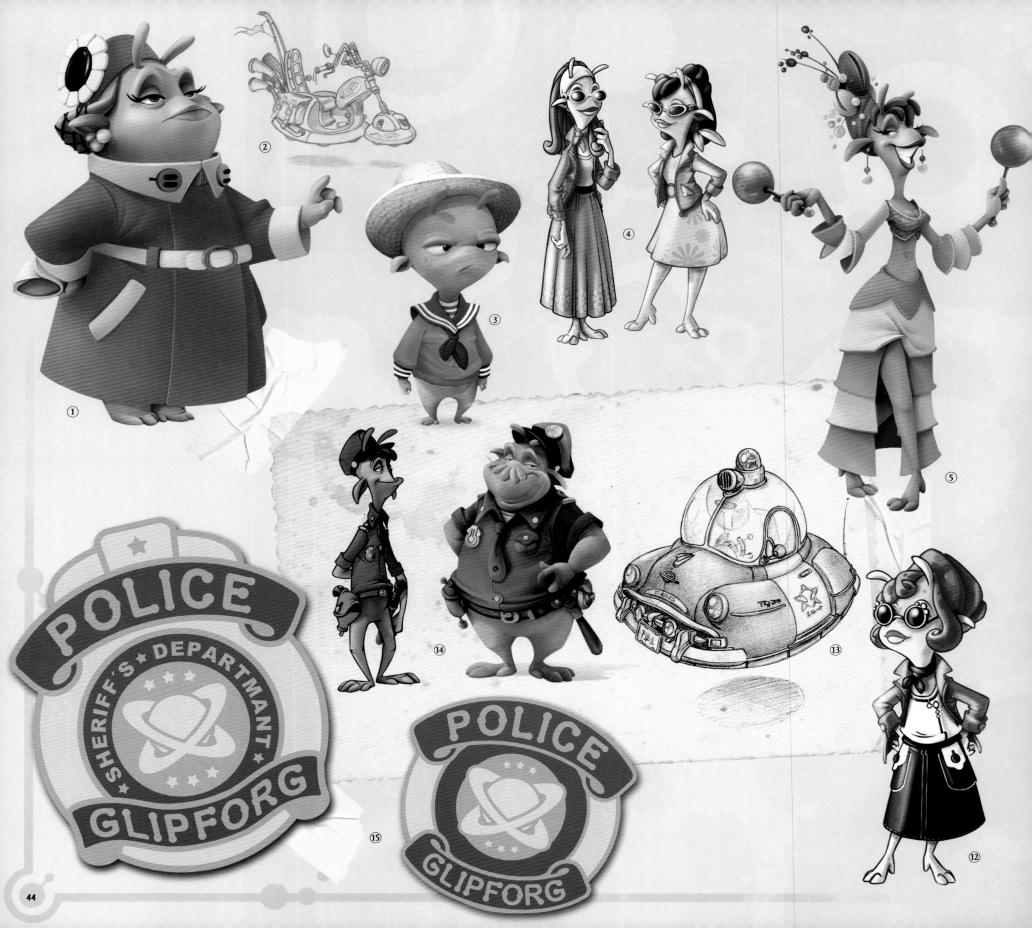

① ② ③ ④ ⑤

POLICE
SHERIFF'S · DEPARTMANT
GLIPFORG

POLICE
GLIPFORG

⑭ ⑬ ⑫

⑮

44

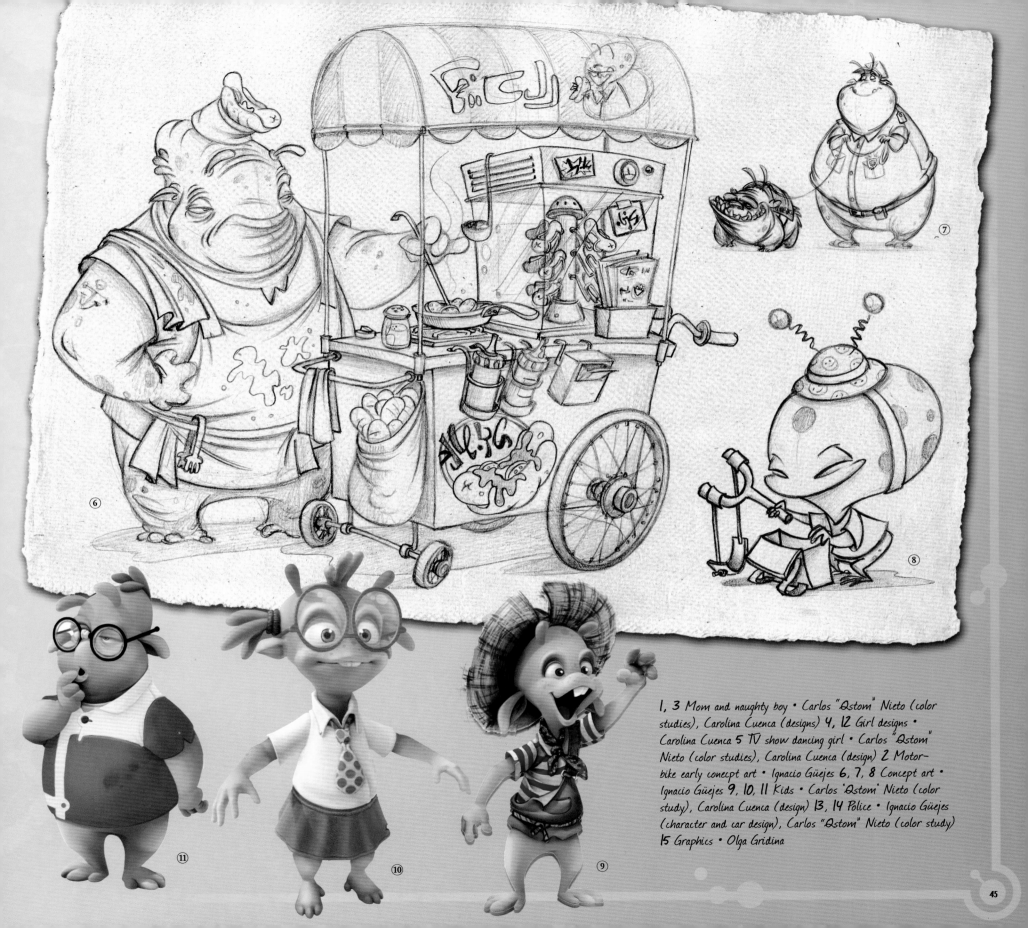

1, 3 Mom and naughty boy • Carlos "Qstom" Nieto (color studies), Carolina Cuenca (designs) 4, 12 Girl designs • Carolina Cuenca 5 TV show dancing girl • Carlos "Qstom" Nieto (color studies), Carolina Cuenca (design) 2 Motorbike early conecpt art • Ignacio Güejes 6, 7, 8 Concept art • Ignacio Güejes 9, 10, 11 Kids • Carlos "Qstom" Nieto (color study), Carolina Cuenca (design) 13, 14 Police • Ignacio Güejes (character and car design), Carlos "Qstom" Nieto (color study) 15 Graphics • Olga Gridina

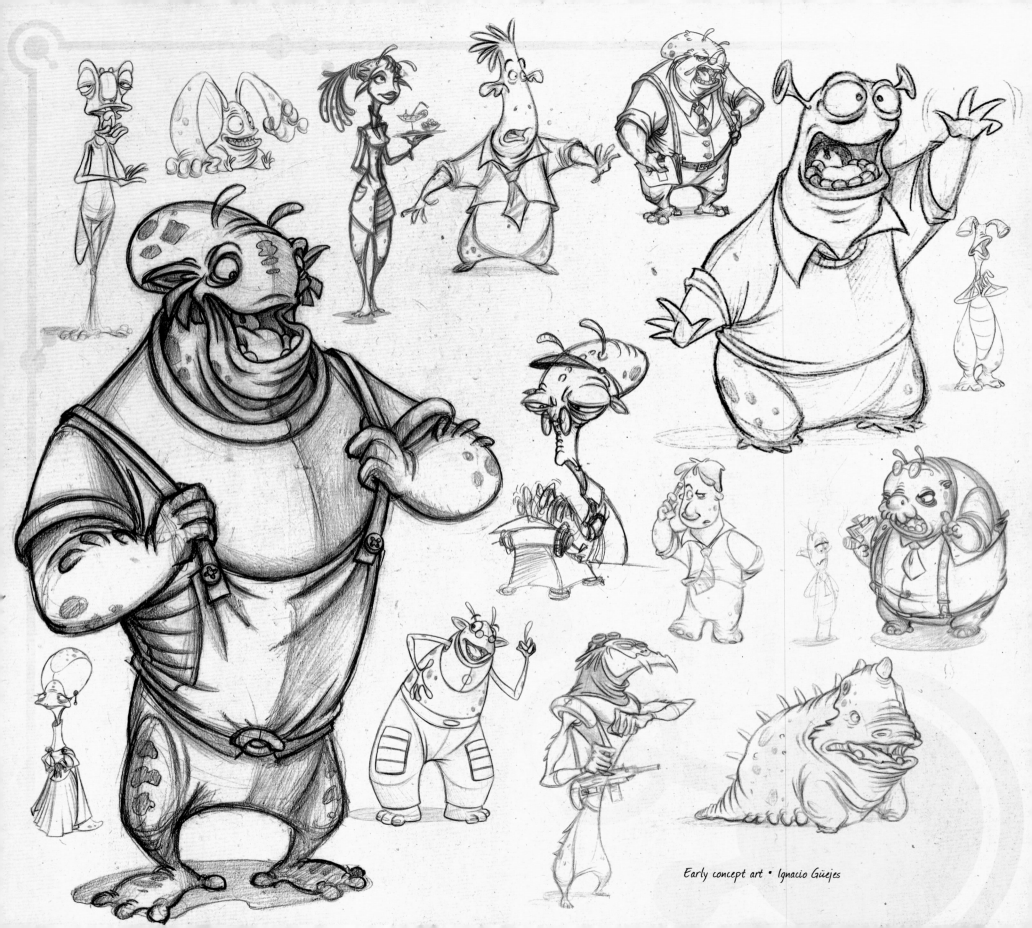

Early concept art • Ignacio Güejes

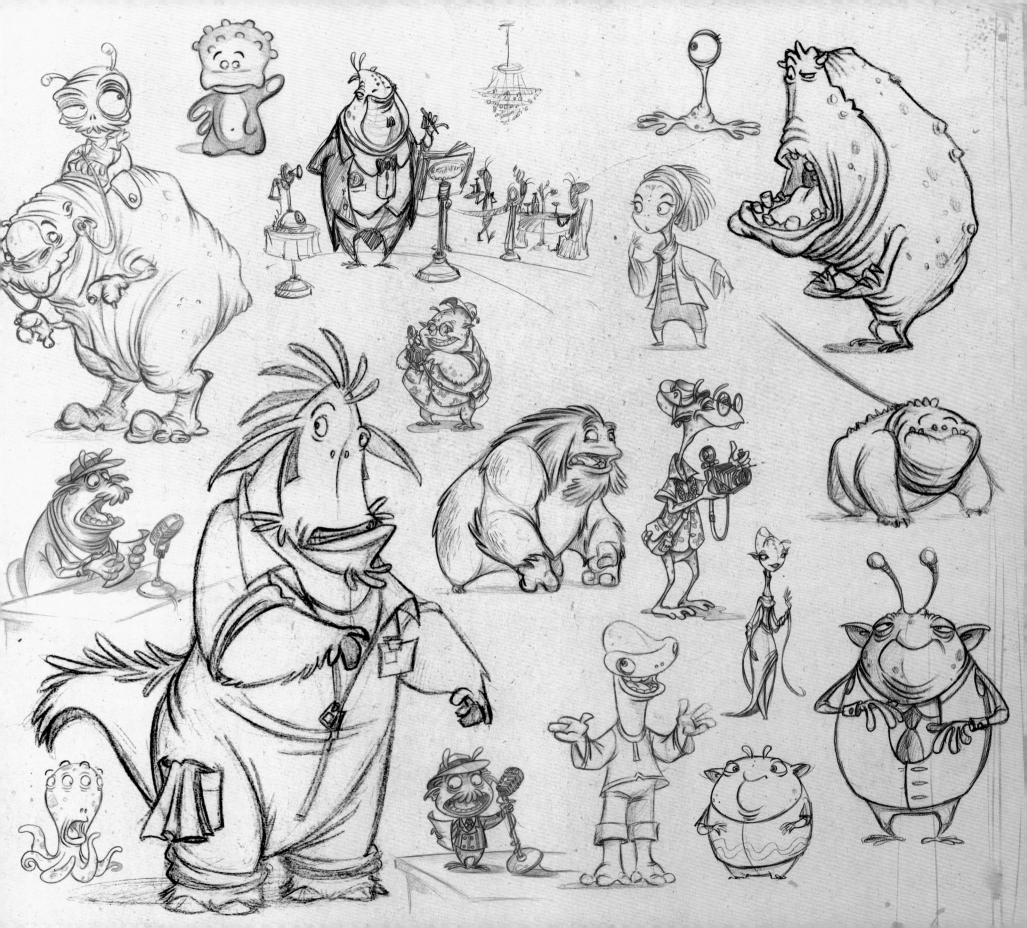

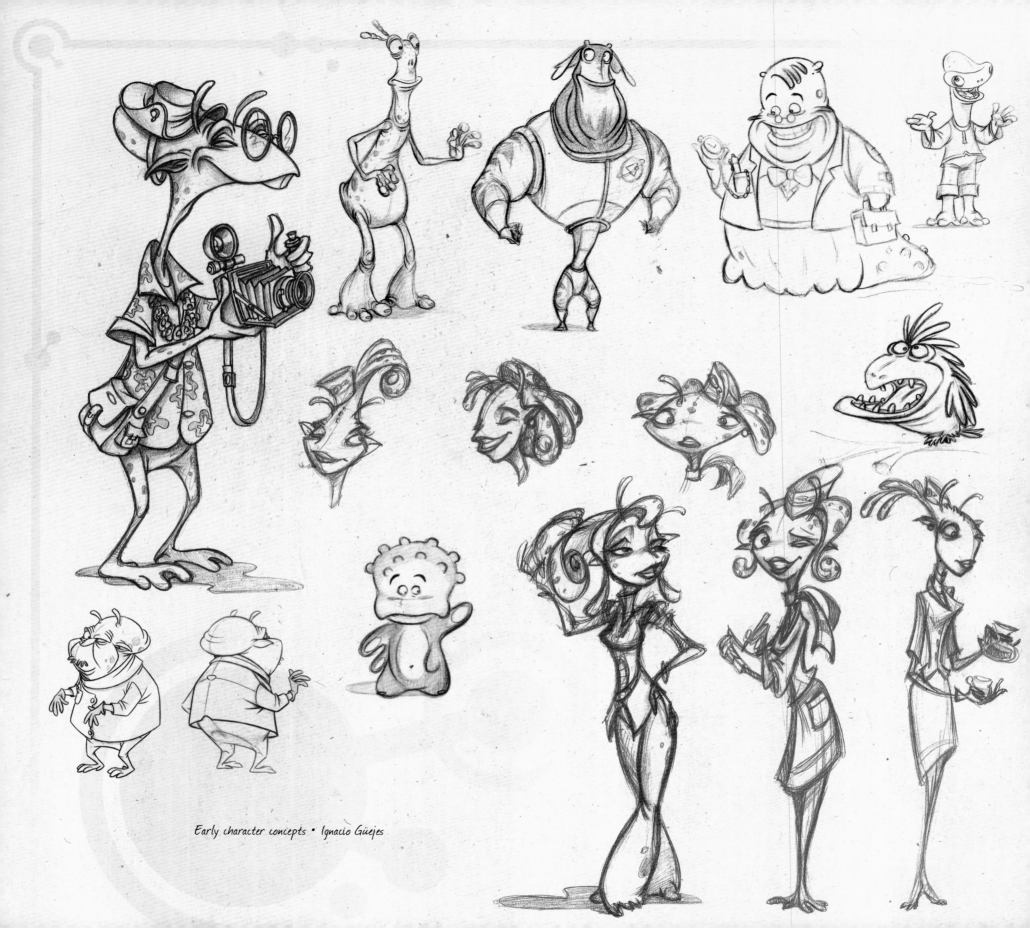

Early character concepts • Ignacio Güejes

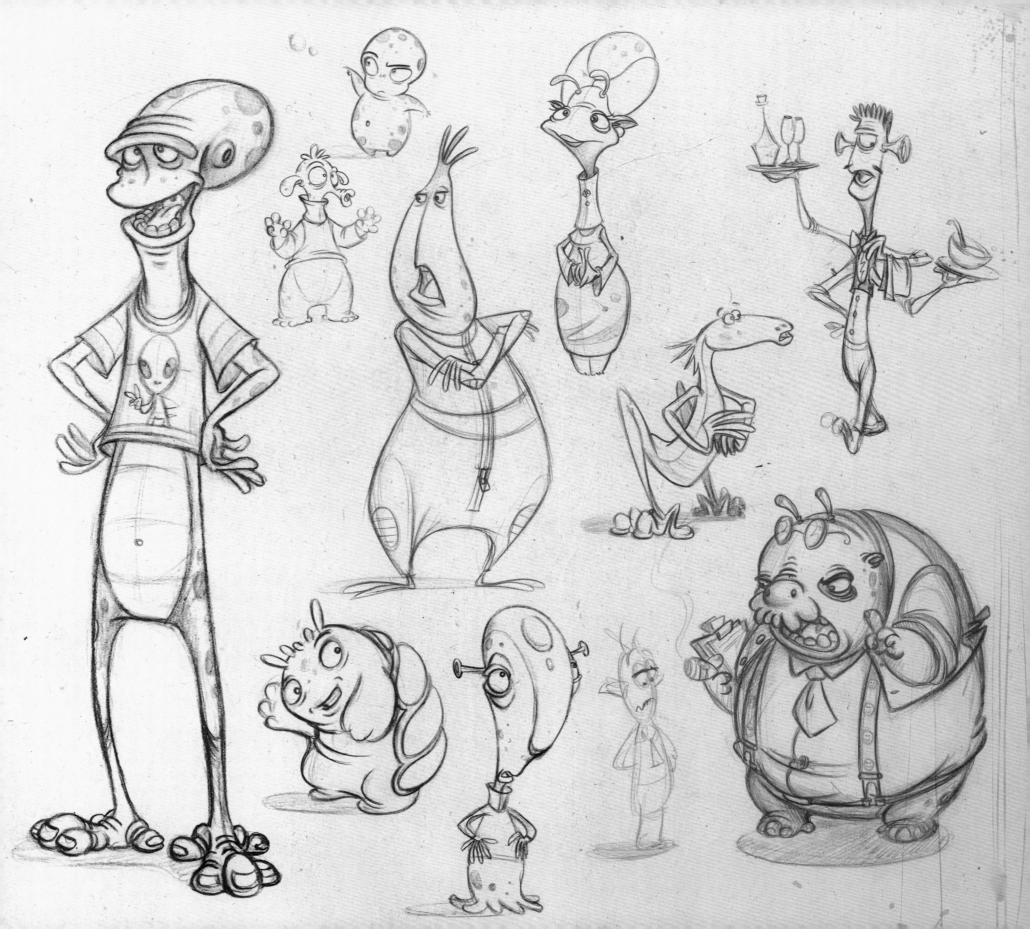

Tea Ladies

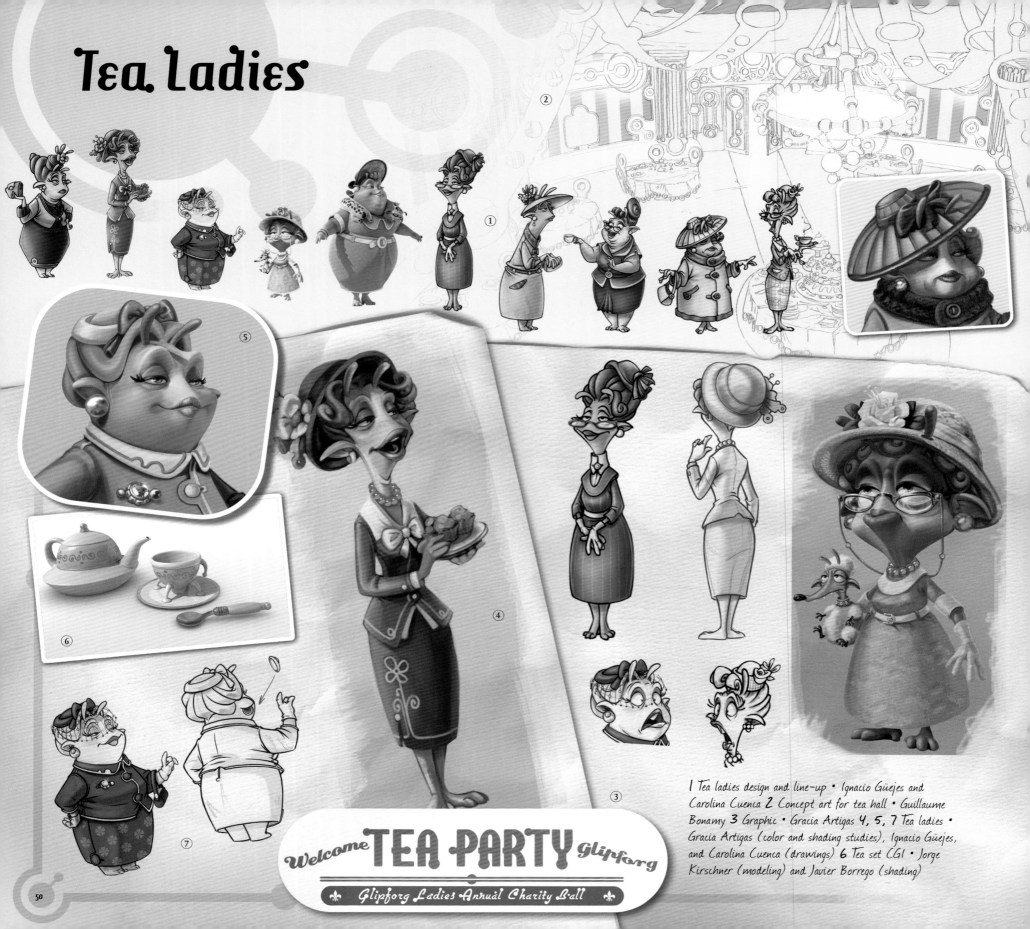

1 Tea ladies design and line-up • Ignacio Güejes and Carolina Cuenca 2 Concept art for tea hall • Guillaume Bonamy 3 Graphic • Gracia Artigas 4, 5, 7 Tea ladies • Gracia Artigas (color and shading studies), Ignacio Güejes, and Carolina Cuenca (drawings) 6 Tea set CGI • Jorge Kirschner (modeling) and Javier Borrego (shading)

Welcome TEA PARTY Glipforg

Glipforg Ladies Annual Charity Ball

Character Color Study

children

elder

army soldiers

teens and adults

scientific

Character color study • Patricia Castelao

①

PATH	ASTRONAUT	LEM	SKIFF	GENERAL	
CARA					
ROPA					TIERRA
CUERPO					
CARA					
ROPA					AIRE
CUERPO					
CARA					
ROPA					MARINA
CUERPO					
CARA					
ROPA					ARENA
CUERPO					

①

Humaniacs!

② ⑤ ④ ③

DON'T LOOK IN HIS EYE!!!

"Resistance is futile..."

①

Before we even lay eyes on the pristine, ordered, and resolutely pleasant township of Glipforg, *Planet 51* opens with a vision of fear, panic, and destruction as a malevolent and rampaging alien force attacks a peaceful small town—soon revealed to actually be the latest installment of the *Humaniacs!* movie series that is playing at Glipforg's cinema.

A supremely well-observed pastiche of the paranoia-drenched, alien invasion–themed B movies that proliferated in the 1950s, it's not a reference to any one film, notes animation supervisor Fernando Moro, but "a mishmash of all those movies that enthusiastically played on cold war fears." Moro adds that the sequence "was originally going to be done in black and white, but the directors decided it would be stronger in color. It's very well done."

The sequence is instrumental in establishing the considerable—but ultimately unfounded—fear factor of Chuck: "It was designed in such a way that the humaniac would be an exaggerated and frightful version of Chuck," art director Fernando López Juárez explains, "not least via the circular helmet that the monster wears. It provided the ideal way of setting up the fear that will surround Chuck's imminent arrival on Planet 51."

The visual parallel was a design choice that generated huge comedic dividends later on in the film, according to sets and props supervisor Fernando Huélamo García: "One of the funniest things in the movie is how Chuck is among the aliens, and he thinks the only way to hide himself is to put his helmet on—which, to the people of Glipforg, immediately makes him the most terrifying thing imaginable! It also provides a nice contrast, because Chuck doesn't look anything like a humaniac."

The *Humaniacs!* sequence isn't merely an extended gag, however, it's a forthright expression of the film's central theme of paranoia: "The sequence plays a very important role in the film," says Juárez, "because it taps into an innate fear of the unknown and, more specifically, of invasion by aliens, which is at the core of this society on Planet 51. It's why the film starts with this image in the cinema."

"Since Planet 51 is a faithful, yet different, portrait of '50s America," explains visual designer Julián Romero Muñoz, "paranoia is a

constant mood amongst its inhabitants. The America of that era endured the omnipresent threat of invasion from the USSR—whether actual or perceived—and this provided a striking counterpoint to the presentation of almost perfect society. Consequently, in our film, such paranoia is stressed in some characters and less highlighted in others, but is always an intrinsic concept."

Beyond the characters, cultural icons also infused paranoia into the film's design concepts: "The design elements of Planet 51," says Romero, are "adaptations of actual design motifs relating to UFOlogy—flying saucers, crop circles, etc.—or 'outer space life' like the humaniacs, which embodies the aliens' innate fear of the unknown."

Romero and his fellow designers feel that they have executed an effective balance between paranoia and comfort in Glipforg, but the former is rife in a variety of subtle ways: "You can find many representations of paranoia throughout the film, always based on the 'humanized' archetype of alien invader, the humaniacs," he says. Romero further explains that, just like '50s America, the fear of an attack on a precious way of life is more prevalent than at first glance: "The best examples exist in leisure-related elements, such as films, books, and comics, but also in their education—invasion drills at school, civil patrols, TV shows instructing on alien identification, and, of course, the presence of an army whose sole purpose is to protect the planet."

Overleaf: 1 Humaniacs! • Gracia Artigas (color painting), Carolina Cuenca (drawing) 2 Humaniacs flying saucers concept art • Julián Romero Muñoz 3 Humaniacs ship concept art • Marcos Calo 4 Comic vignette • Ignacio Güejes 5 Concept drawings • Ignacio Güejes and Carolina Cuenca

1 Alien school drawings • Olga Gridina 2 Color key • Fernando López Juárez 3 Alien newspaper • Olga Gridina and Gracia Artigas 4 Designs and Graphics • Gracia Artigas 5 Aliens Attack! manuals • Olga Gridina and Fernando López Juárez 6 Graphics • Ignacio Güejes 7 Humaniacs fancy dress designs • Carolina Cuenca

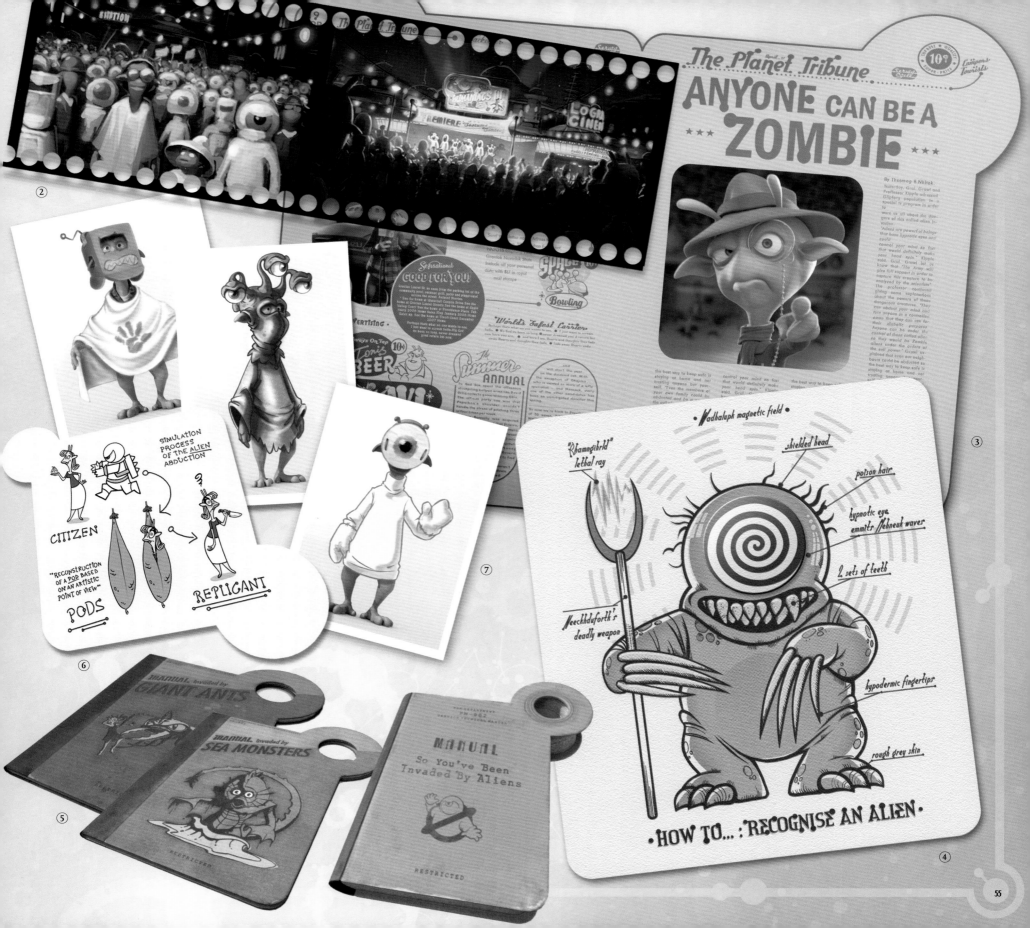

The Planet Tribune
ANYONE CAN BE A ★★★ ZOMBIE ★★★

SIMULATION
PROCESS
OF THE ALIEN
ABDUCTION

CITIZEN

"RECONSTRUCTION
OF A POD BASED
ON AN ARTISTIC
POINT OF VIEW"

PODS

REPLICANT

⑥ ⑦

MANUAL Invaded by
GIANT ANTS

MANUAL Invaded by
SEA MONSTERS

MANUAL
So You've Been
Invaded By Aliens

RESTRICTED

⑤

• Vadhalupk magnetic field •

"Rhamngibrld"
lethal ray

shielded head

poison hair

hypnotic eye
emmits Schneuk waves

2 sets of teeth

Veechhduforth's
deadly weapon

hypodermic fingertips

rough grey skin

• HOW TO... : RECOGNISE AN ALIEN •

④

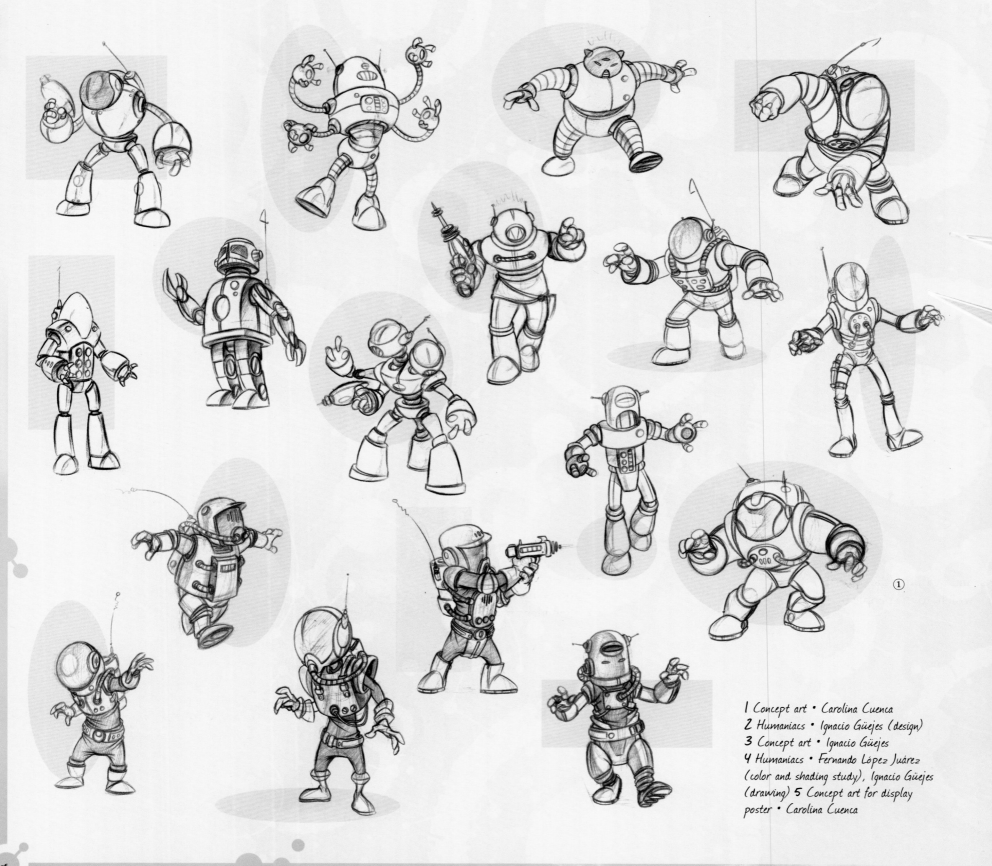

1 Concept art • Carolina Cuenca
2 Humaniacs • Ignacio Güejes (design)
3 Concept art • Ignacio Güejes
4 Humaniacs • Fernando López Juárez
(color and shading study), Ignacio Güejes
(drawing) 5 Concept art for display
poster • Carolina Cuenca

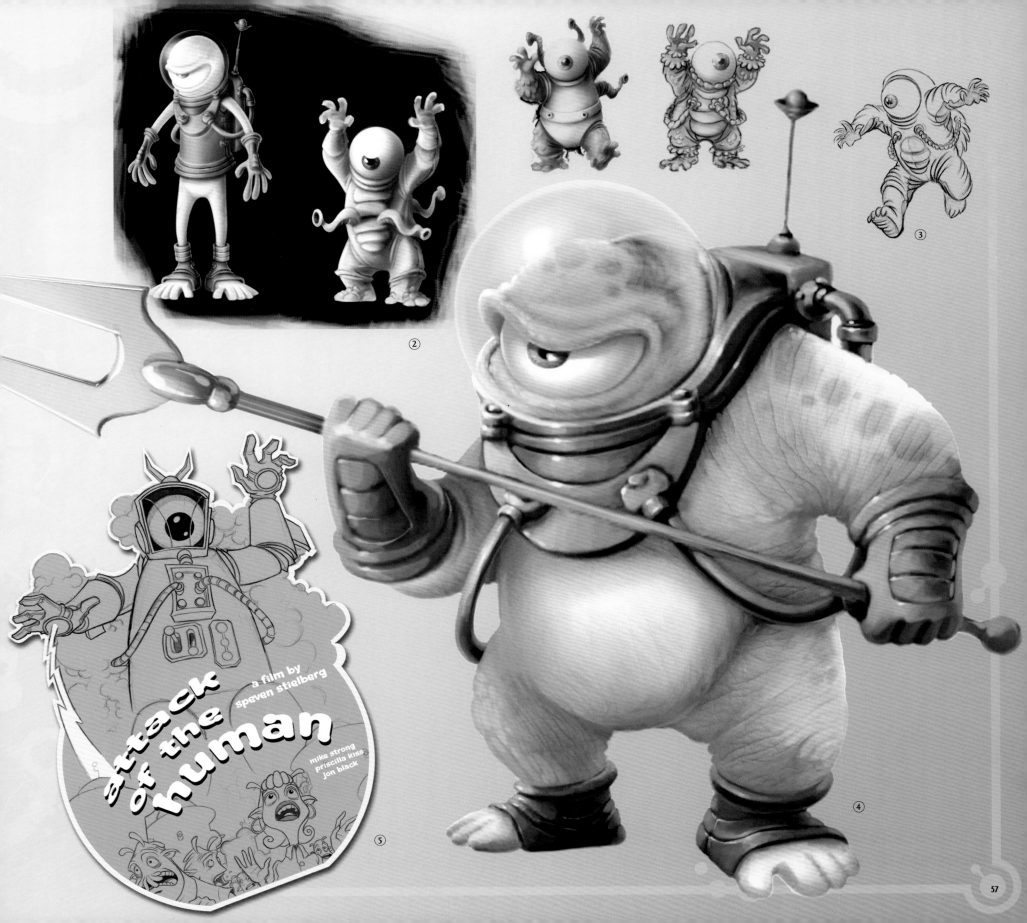

② ③ ④

a film by
speven stielberg

attack of the human

mike strong
priscilla kiss
jon black

⑤

57

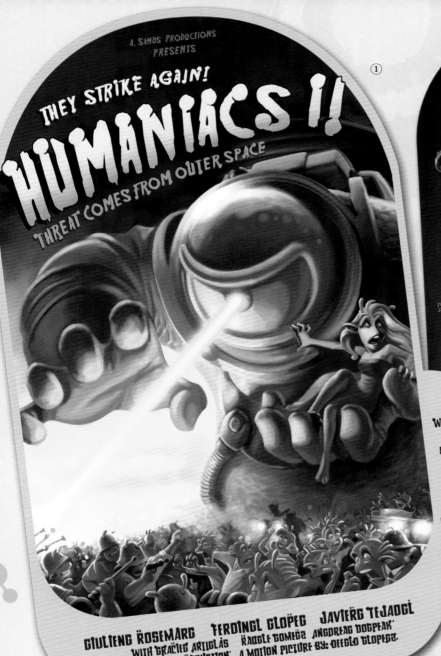
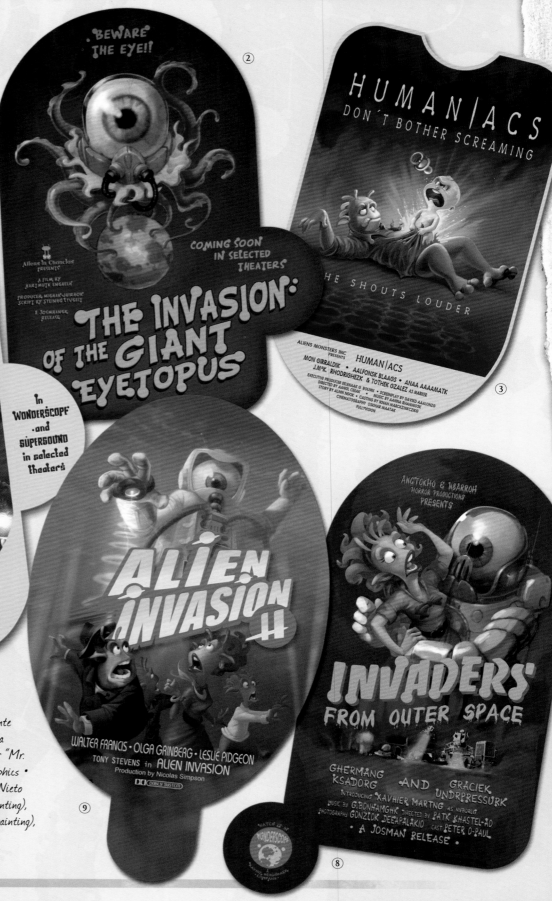

1, 3 Poster • Gracia Artigas (color paintings), Carolina Cuenca and Pedro Pérez Valiente (drawings) 2 Poster • David Jaráiz (color painting), Carolina Cuenca (drawing), Gracia Artigas (graphic design) 4 Humaniacs • David Jaráiz (color and shading study), Javier "Mr. Plot" Tejada, Marcos Calo, and Julián Romero Muñoz (concept and design) 5, 6 Graphics • Olga Gridina 7 Humaniacs! comic pages • Ignacio Güejes (drawings), Carlos "Qstom" Nieto and Gracia Artigas (color graphics and final layout) 8 Poster • David Jaráiz (color painting), Carolina Cuenca (drawing), Gracia Artigas (graphics) 9 Poster • David Jaráiz (color painting), Carolina Cuenca (drawing), Olga Gridina (graphics)

⑤

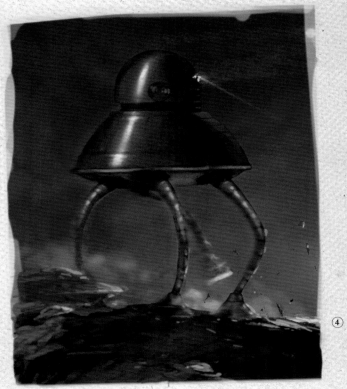

④

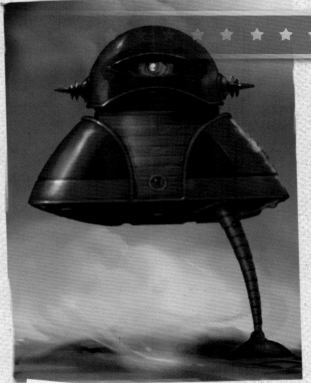

A TIN METAL ALIEN

HORROR ALIEN

⑥

⑦

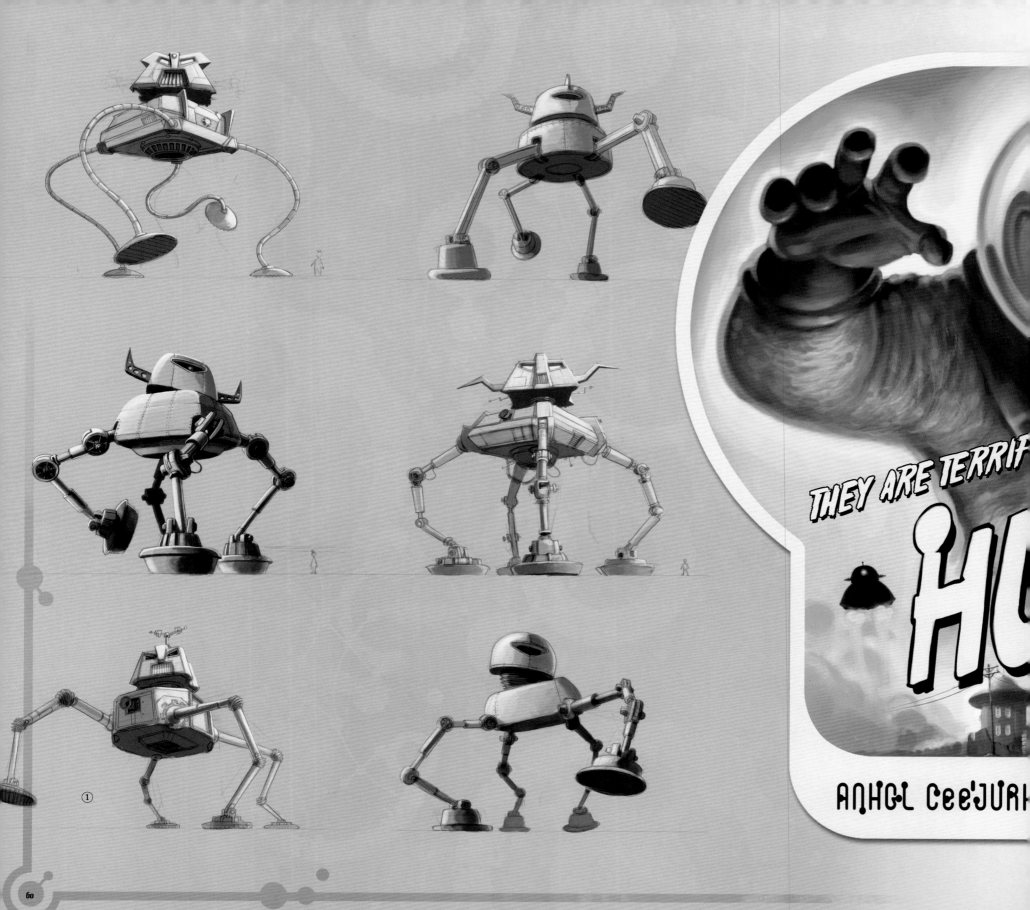

THEY ARE TERRIF

H

ANHGL Cee'JURH

The World of
Planet 51

Inspirations

Circles, spheres, and saucers: These three related patterns form the basis of *Planet 51*'s graphical style, which was specifically designed to reach far beyond the locations of the film itself and would not only inform the look of any *potential* location but also provide consistency and credibility overall.

The filmmakers extracted the circle and saucer patters from two icons of sci-fi pop culture and mythology—flying saucers and crop circles—while the spheres were derived from Googie architecture, a form of novelty/futurist design originating in Southern California that thrived from the late 1940s to the mid-1960s and which was highly influenced by automobile culture and the space and atomic ages. The futuristic designs that typified Googie architecture—motion-led motifs such as boomerangs, flying saucers, atom symbols, and parabolas— particularly informed the notably retro look of Glipforg.

"It's been a great challenge for us," sets and props supervisor Fernando Huélamo García explains. "We all had the retro look from the '50s in our minds, having researched many, many movies and comics that utilized that look." Yet, adds art director Fernando López Juárez, the designers were aided by focusing on such heavily explored motifs: "It sounds like a complex process, but it actually wasn't. Fortunately, there was a vast amount of reference material available for us to draw from. Whether that be documentaries or *Back to the Future*, we were able to reproduce it on a planetary scale."

The team's rigorous adherence to maintaining these references resulted in a world that teems with enriching detail in the finished film. Codirector Marcos Martínez Carvajal cites a perfect example with regards to the flying saucer motif: "With the landscape of the town, the idea was to have flying saucers on top of the city. That's why the roofs are shaped like flying saucers, so from above you would get the impression of an invasion."

Yet, Planet 51's overarching design generated a considerable test that struck at the heart of production, according to Huélamo: "The greatest challenge that we faced was creating circular objects in 3-D— very, very difficult. Three-dimensional objects are, by definition, essentially cubes!"

①

④

Overleaf: The sky of Planet 51 • Fabio Barretta Zungrone (matte painting)

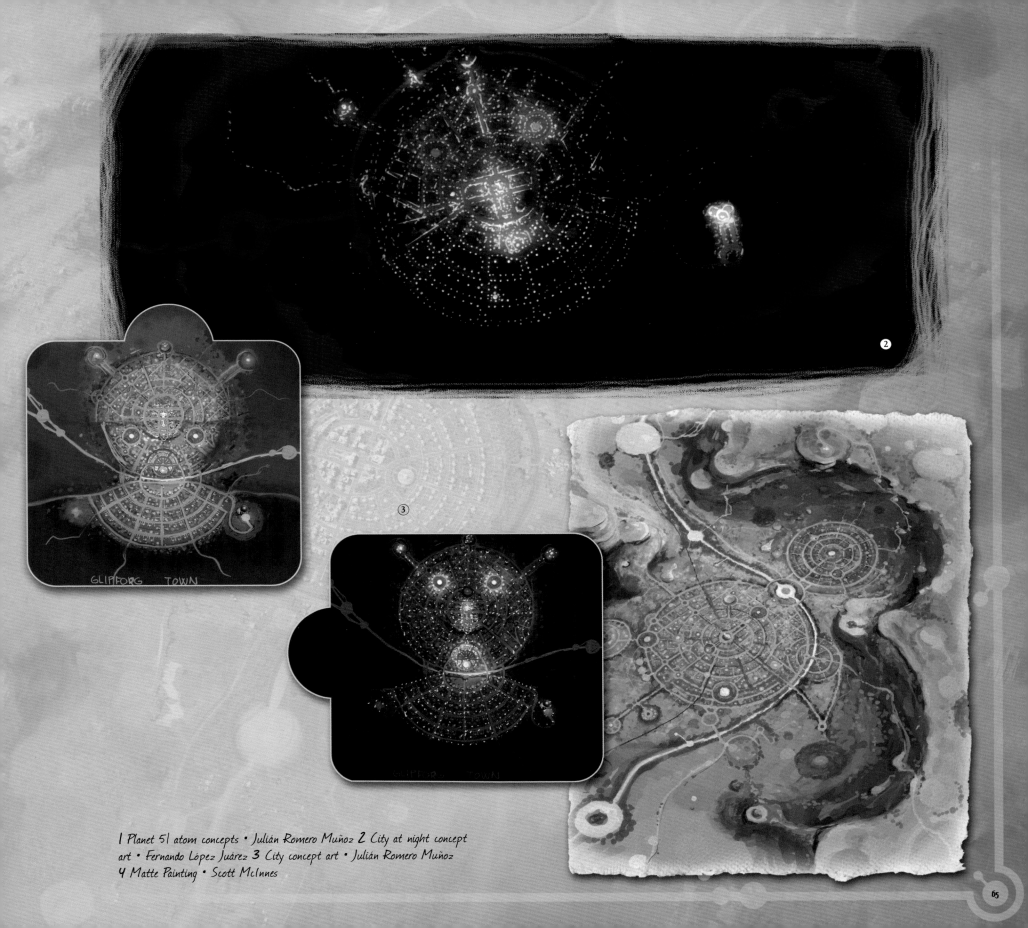

1 Planet 51 atom concepts • Julián Romero Muñoz **2** City at night concept art • Fernando López Juárez **3** City concept art • Julián Romero Muñoz **4** Matte Painting • Scott McInnes

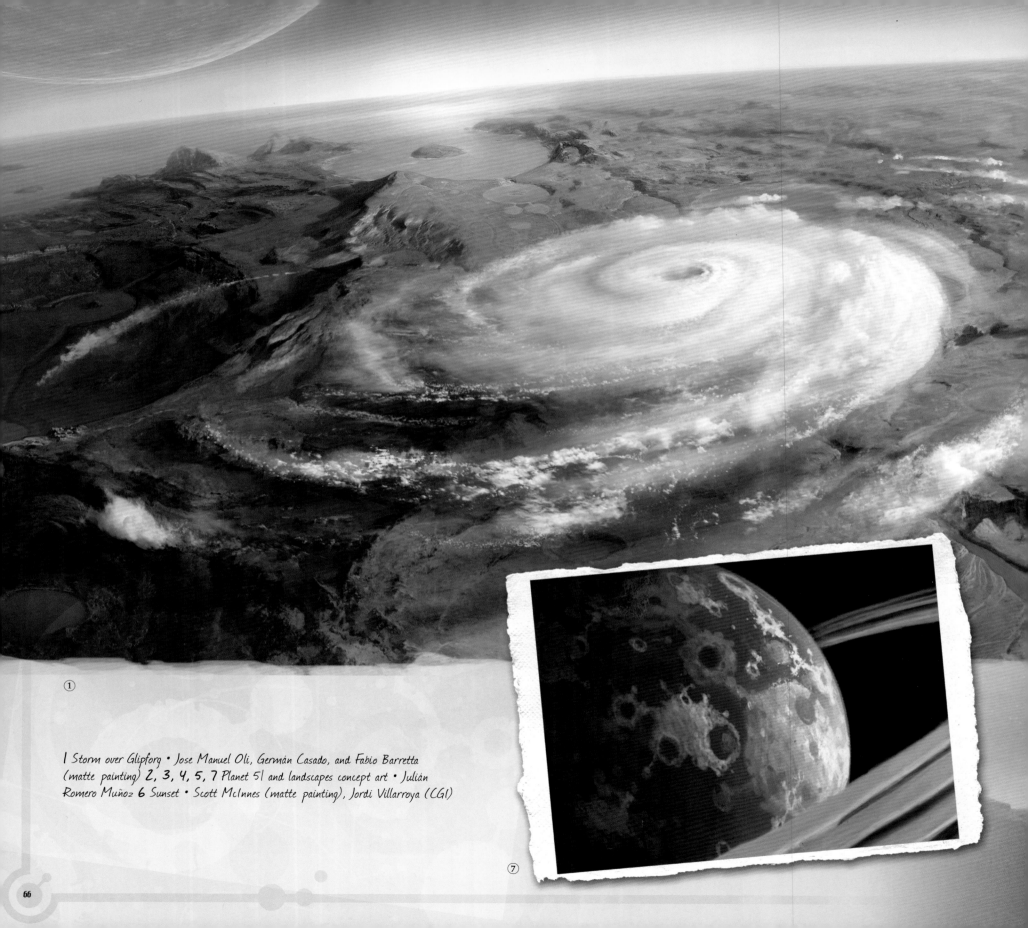

1 Storm over Glipforg • Jose Manuel Oli, Germán Casado, and Fabio Barretta (matte painting) 2, 3, 4, 5, 7 Planet 51 and landscapes concept art • Julián Romero Muñoz 6 Sunset • Scott McInnes (matte painting), Jordi Villarroya (CGI)

① ⑦

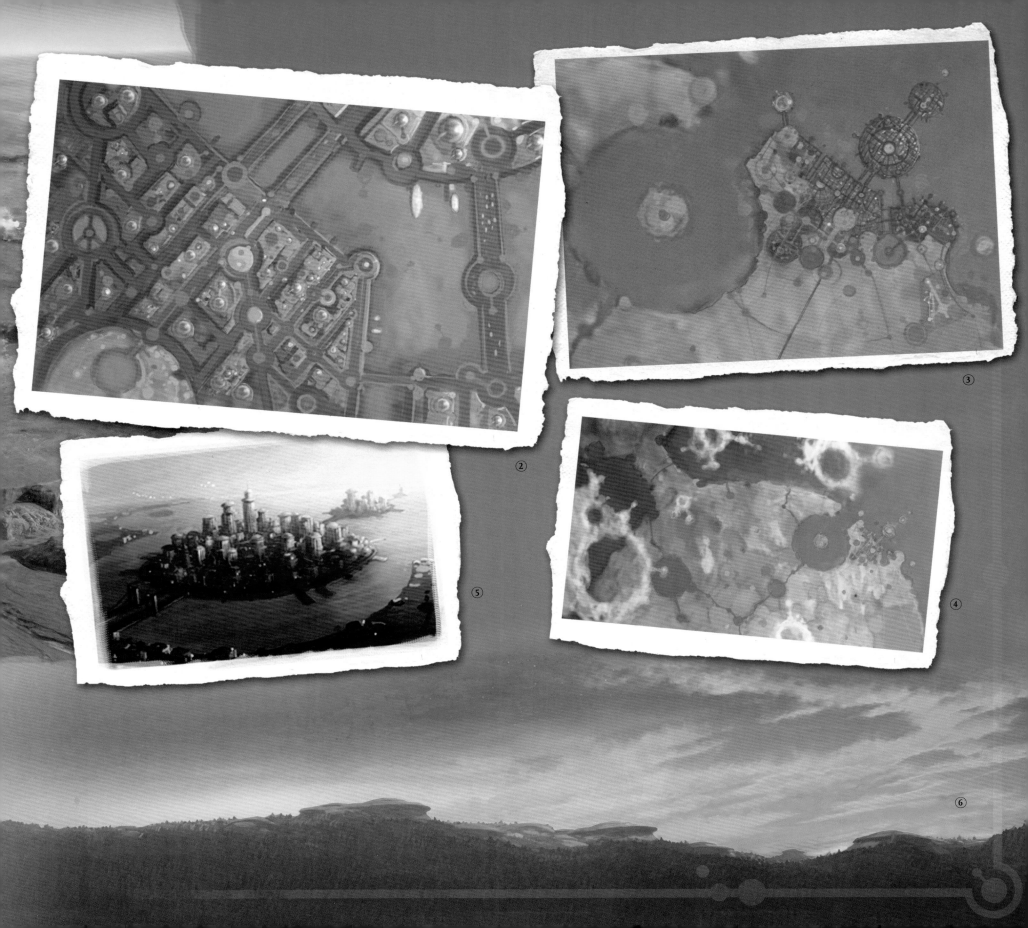

②

③

④

⑤

⑥

Landscapes

①

Planet 51 may be clearly based on America of the 1950s, but an interesting question immediately arises from that: Where in America? By the idyllic looks of Glipforg, a good guess would be Southern California. "Yes, that's one notion," asserts art director Fernando López Juárez. But for the landscapes surrounding Glipforg, the Grand Canyon and Colorado were clear inspirations as well. "Our references were not just '50s movies, but the reality itself—it had to be very recognizable."

Glipforg was anchored in what codirector Marcos Martínez Carvajal labels "a very classic vision of '50s America, even if it's not real—it's the collective image we have of those years. We can see that image of America in a great many things, and that's what we wanted to put in to the film. We looked at all the films that possessed that vision."

The filmmakers' research inevitably led them to some examples of cinema: "*Back to the Future* is very iconic in terms of the way it represented the classic image of '50s Americana and perfect suburban life. The same goes for *Pleasantville*. *Close Encounters of the Third Kind*, of course, was very inspirational in terms of the alien culture. Classic '50s B movies—*The Day the Earth Stood Still*, *Forbidden Planet*—were also hugely inspirational."

Key to developing Planet 51's geography, however, was ensuring that the aesthetic extended to a planetary scale. "I considered what we know about sci-fi film culture," comments visual designer Julián Romero Muñoz, "and the most prominent icons are flying saucers and crop circles. I speculated that with all this technology, the residents of Planet 51 would use these shapes in their basic life. Anything in the landscape would have this pattern of the crop circles. You could find it everywhere, from small stones to big continents."

As such, says Martínez, "Everything is based on the dual motif of the flying saucer and the crop circles. The idea of the circles connected by lines, especially, was the base on which to build everything." This core notion not only provides Planet 51 with a compelling visual hook, but also with no shortage of stunning vistas that accentuate this strange cosmic coincidence.

⑦

1 Vegetation concept • Julián Romero
2, 3, 4, 5, 7 Concept art • Julián Romero
Muñoz 6 Matte painting • Alfonso Blaas

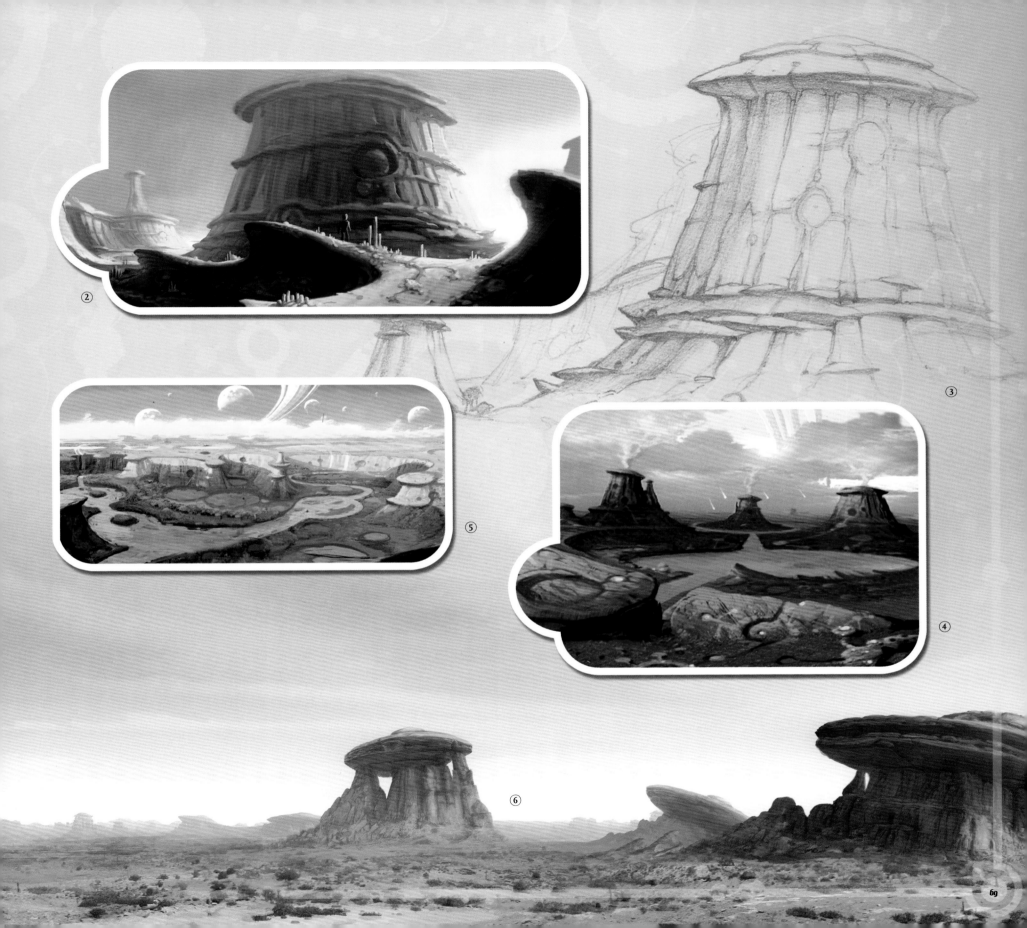

②

③

⑤

④

⑥

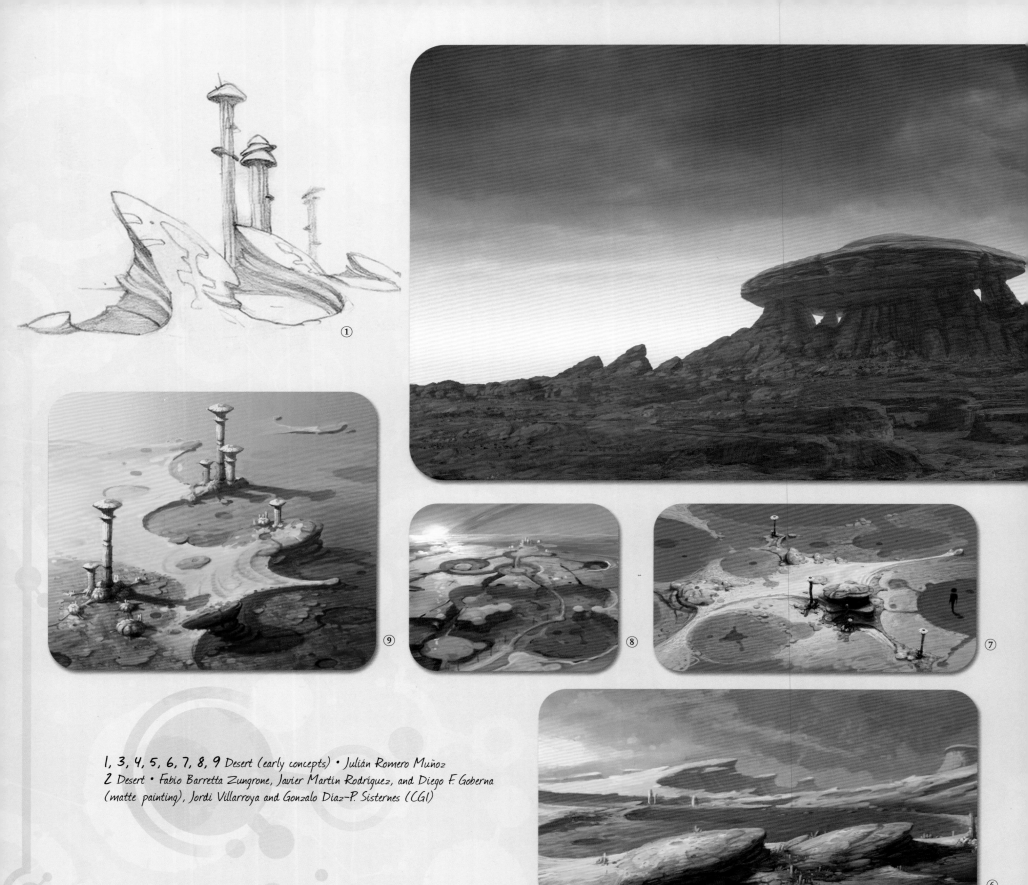

1, 3, 4, 5, 6, 7, 8, 9 Desert (early concepts) • Julián Romero Muñoz
2 Desert • Fabio Barretta Zungrone, Javier Martín Rodríguez, and Diego F. Goberna
(matte painting), Jordi Villarroya and Gonzalo Díaz-P. Sisternes (CGI)

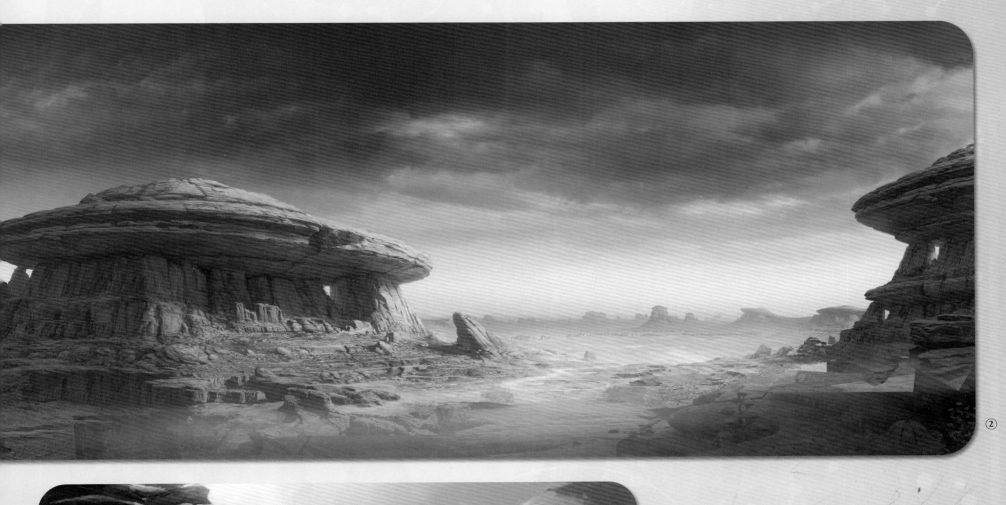

②

④

③

⑤

1 Concept art • Marcos Calo 2, 5, 9 Concept art • Fernando López Juárez 3, 4, 8, 10 Plants concept art • Gracia Artigas 7 Concept art • Gracia Artigas and Fernando López Juárez 6 Matte painting • Jose Manuel Oli 11 The valley from the observatory • Javier Martín Rodríguez (matte painting), Gonzalo Díaz-P Sisternes (CGI)

72

③

④

⑤

⑥

⑦

①

⑥

⑤

④

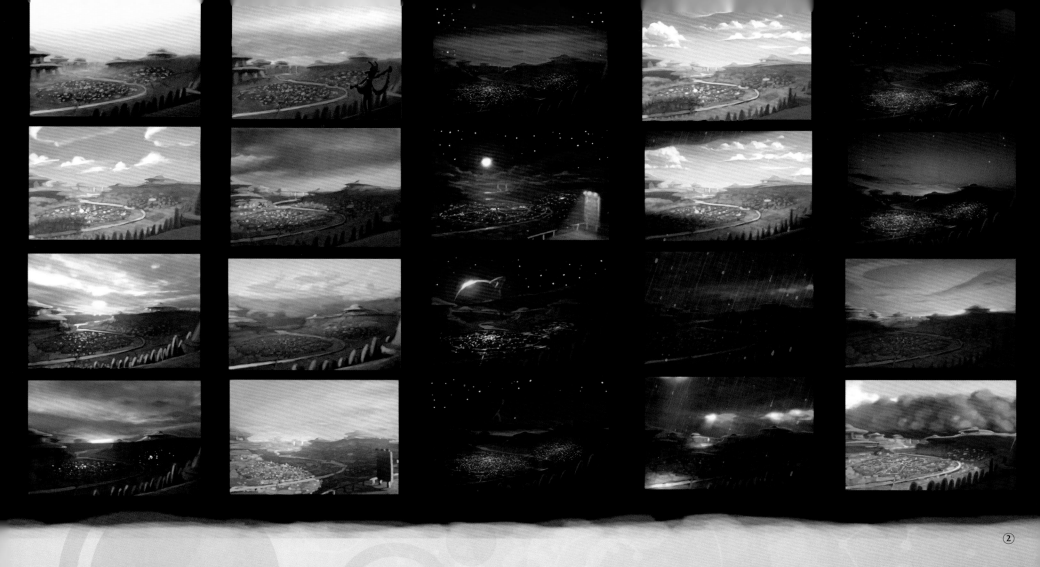

1 Evening • Alfonso Blaas (matte painting) 2 Weather study • Fernando López Juárez
3 Landscape • Javier Martín Rodríguez (matte painting), Jordi Villarroya (CGI)
4, 5, 6 Concept art • Julián Romero Muñoz

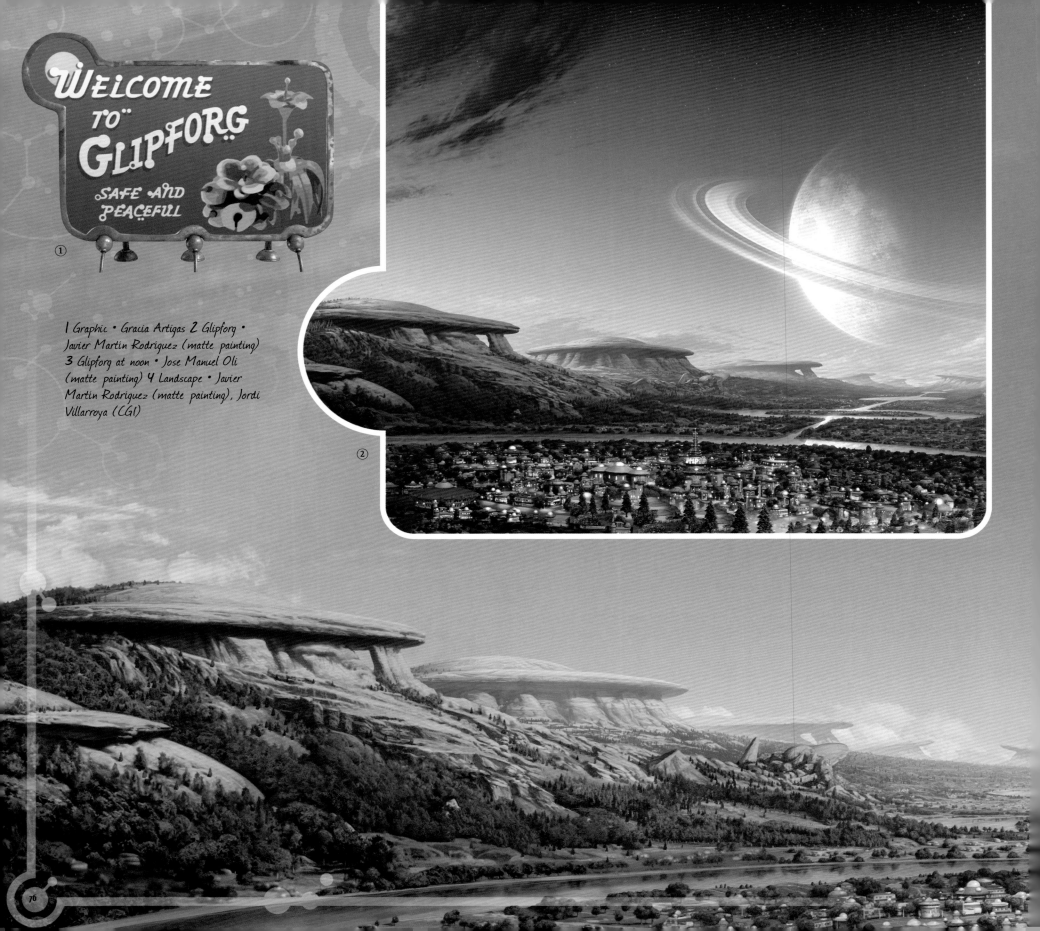

WELCOME TO GLIPFORG
SAFE AND PEACEFULL

①

1 Graphic • Gracia Artigas 2 Glipforg •
Javier Martin Rodriguez (matte painting)
3 Glipforg at noon • Jose Manuel Oli
(matte painting) 4 Landscape • Javier
Martin Rodriguez (matte painting), Jordi
Villarroya (CGI)

②

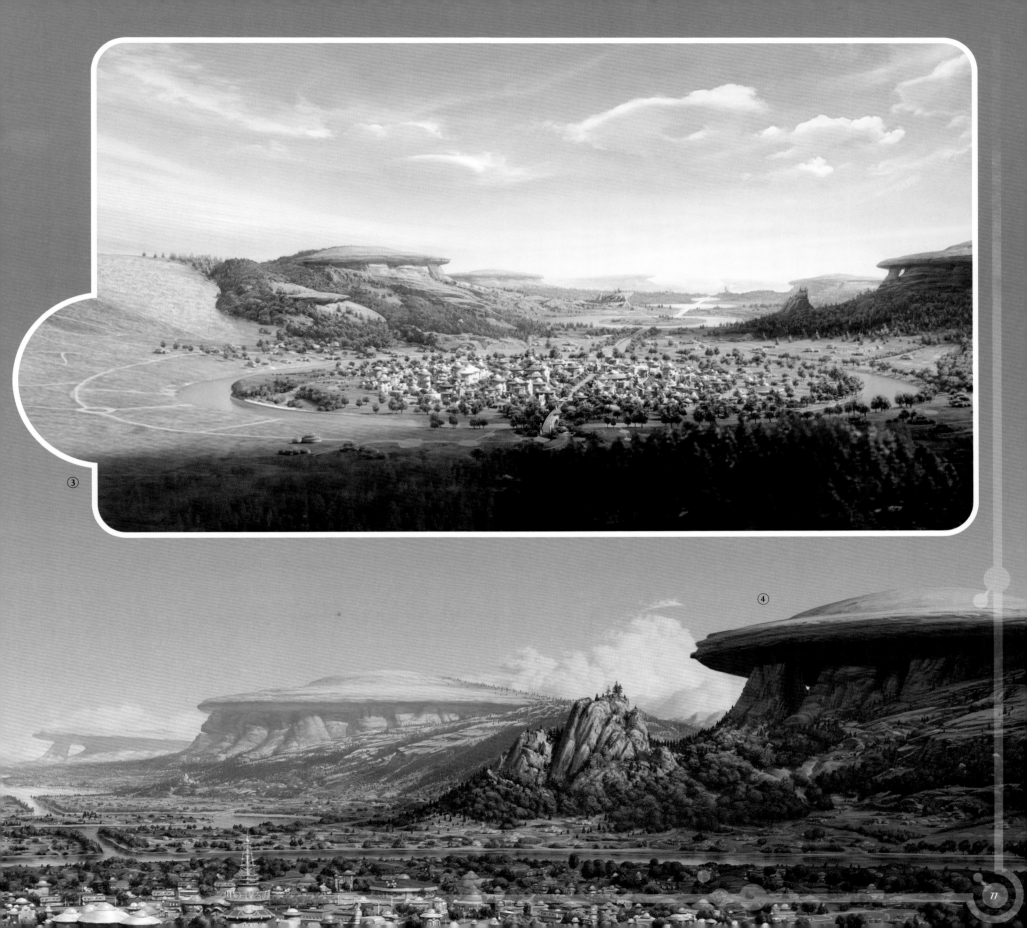

③

④

The Observatory

Situated on the tree-covered tabletop mountain nearest to Glipforg, with an unobstructed view of the limitless cosmos beyond, the observatory is a particularly important place for Lem. Not only is it where the young alien is able to indulge his passion for astronomy, it's also his place of work, where he proudly holds the position of Junior Assistant Curator.

A grandiose location with a dual staircase that allows visitors to ascend either side of the main atrium to a balcony that overlooks a vast mobile of Planet 51's clearly small solar system, the observatory features in two key scenes in the film: It's where Lem first meets Chuck—and where the hapless astronaut manages to get tangled in the wires holding the model planets; it's also where, later on, the mismatched pair finally open up to one another and affirm their friendship, in spite of their vast differences.

While the design of Glipforg's various locations drew from a wide variety of sources, Planet 51's primary scientific arena—barring the clandestine Base 9, obviously—was based on the world-famous Griffith Observatory in Los Angeles. The distinctive art deco facility, which opened in 1935, provided precisely the kind of visual inspiration the design team was seeking. "Everything in the movie has a reference, and this particular location came quicker than we anticipated because of the Griffith Observatory, which features these big windows," says visual designer Julián Romero Muñoz.

"It looks very close to the kinds of observatories that you can find everywhere these days," adds sets and props supervisor Fernando Huélamo García. "The only real difference here is that the building is shaped like a flying saucer." Notably—and suitably—the central section of the observatory, which houses the main telescope, adds to the flying saucer aesthetic by possessing a planetary shape with a central, ringlike rim. "It's not designed to look exactly like [Griffith Observatory], but the hall, the entrance, and the placement in the side of the hill make it clear that the Griffith Observatory was our point of departure," says Romero.

1 Observatory logos • Olga Gridina (graphic design) 2 Observatory design • Julián Romero Muñoz 3 Graphic • Olga Gridina 4 Observatory concept art • Marcos Calo 5 The observatory at night • Jose Manuel Oli and Julián Romero Muñoz (matte painting) 6 Concept art • Julián Romero Muñoz 7 Color key • Fernando López Juárez 8 Observatory • Marcos Calo (concept), David Jaraiz (color study)

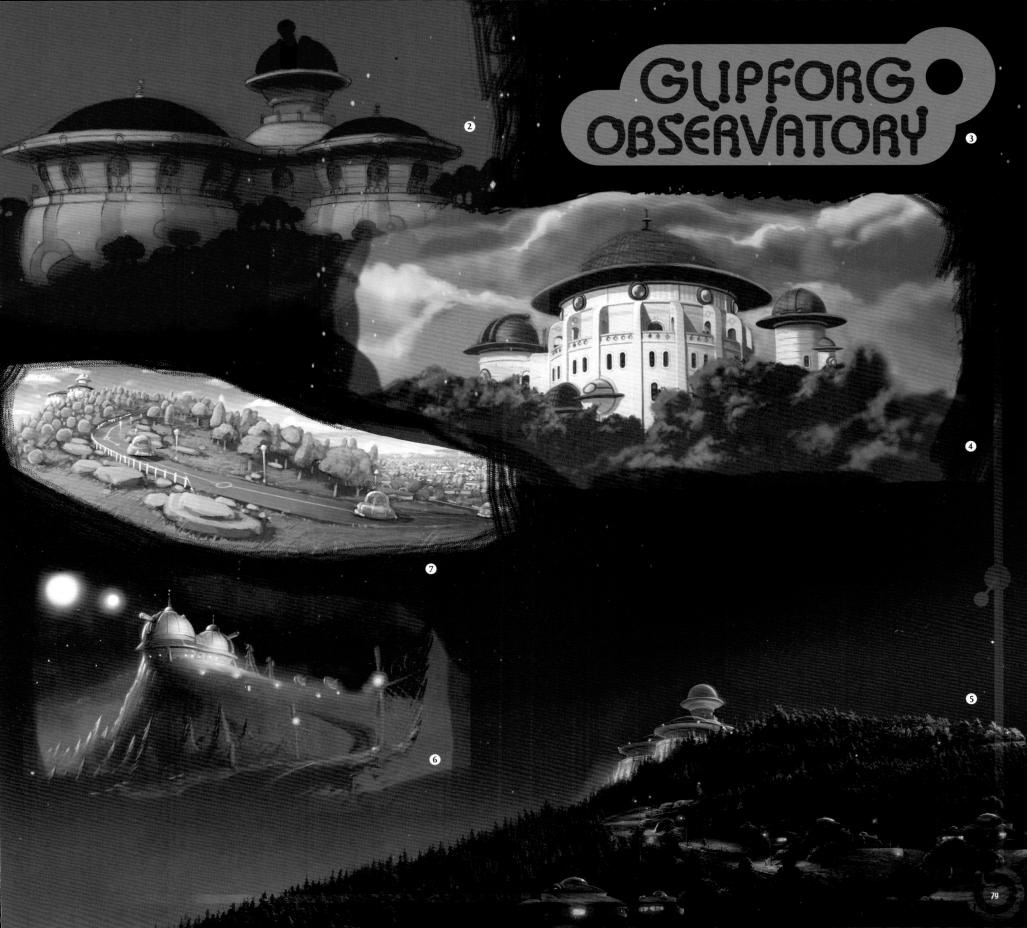

GLIPFORG
OBSERVATORY

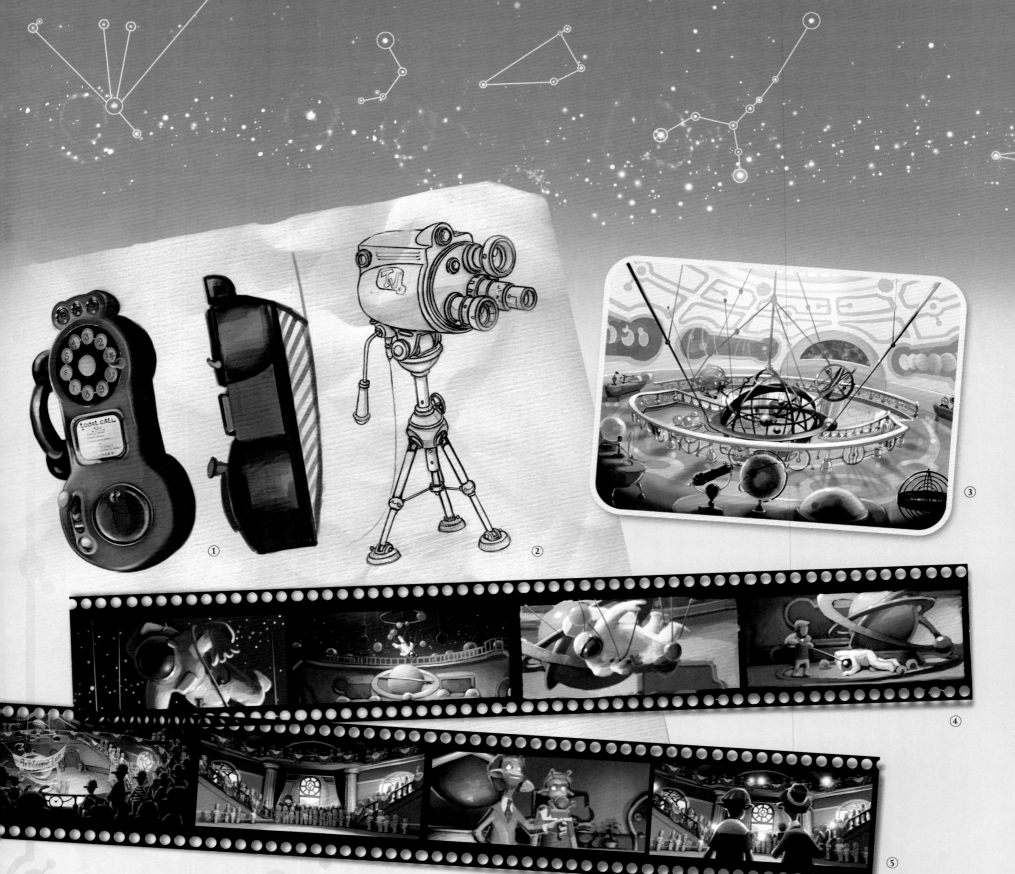

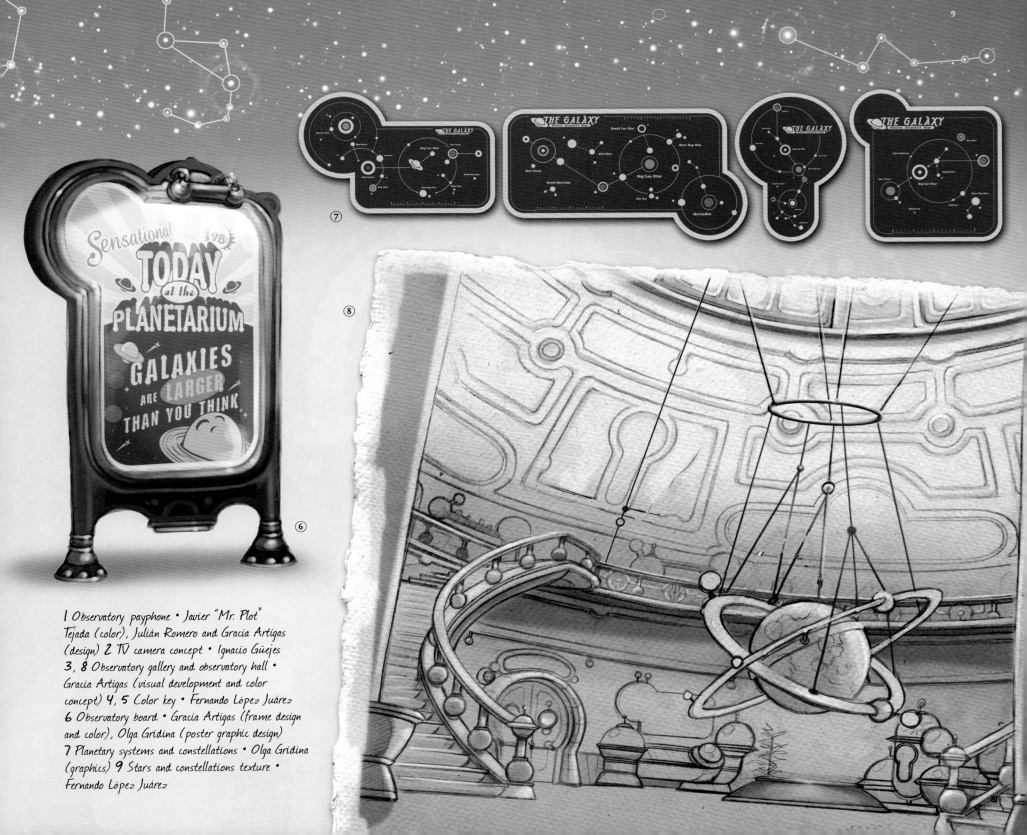

1 Observatory payphone • Javier "Mr. Plot" Tejada (color), Julián Romero and Gracia Artigas (design) 2 TV camera concept • Ignacio Güejes 3, 8 Observatory gallery and observatory hall • Gracia Artigas (visual development and color concept) 4, 5 Color key • Fernando López Juárez 6 Observatory board • Gracia Artigas (frame design and color), Olga Gridina (poster graphic design) 7 Planetary systems and constellations • Olga Gridina (graphics) 9 Stars and constellations texture • Fernando López Juárez

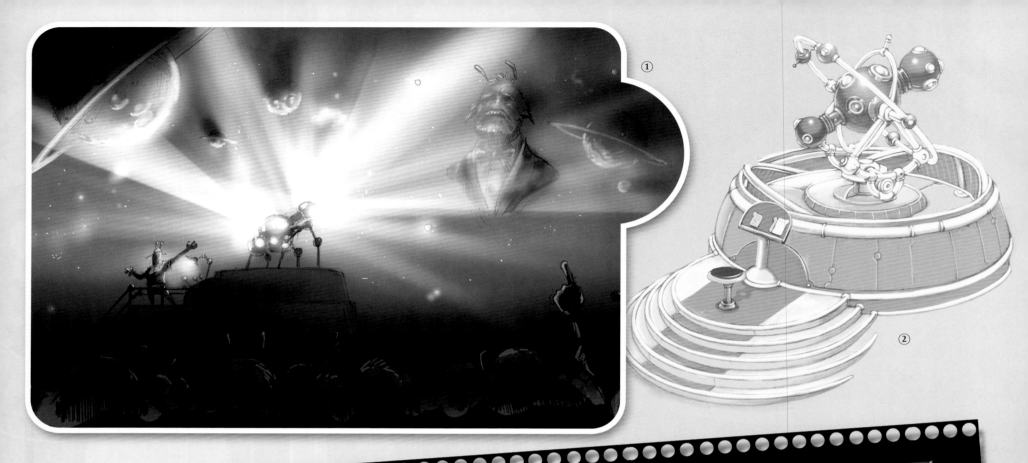

1 Concept art • Guillaume Bonamy 2 Production design and proxy •
Javier "Mr. Plot" Tejada 3, 4 Concept art • Marcos Calo 5 Graphics •
Gracia Artigas 6 Lighting study • Fernando López Juárez 7 Telescope •
Marcos Calo (design), Carlos "Qstom" Nieto (color) 8 Concept art •
Julián Romero Muñoz 9 Color key • Fernando López Juárez

Following pages: 1 Lighting studies • Fernando López Juárez
2 Lighting studies • Javier Martín Rodríguez

③

④

⑦

⑥

⑤

Haglog Comics

ocated in the leisure center adjacent to Glipforg's bowling alley and hot dog restaurant, Haglog Comics is a veritable geek nirvana: a haven of comics, books, toys, and all manner of sci-fi ephemera. So it's just as well that Skiff is an employee there, because he'd otherwise be a constant inhabitant anyway.

One of *Planet 51's* most densely detailed sets, Haglog Comics was a target of particular enthusiasm by the design teams: "The comic book shop set was a particularly important issue for [director] Jorge Blanco García," claims sets and props supervisor Fernando Huélamo García. "He's a very big fan of comics and put a lot of effort into the final design of the interior. It was certainly one of the most interesting sets for people to work on, because so much of the crew were comics fans themselves."

The exterior of the Haglog Comics is a particularly effective expression of the flying saucer aesthetic that permeates *Planet 51's* Glipforg locations, with the trio of glass domes housed on the roof looking exactly like flying saucers from '50s sci-fi B movies, rather than just appropriating the shape like other buildings. The shop sign is also striking, with a 3-D humaniac lurching malevolently over entering customers, perfectly capturing the location's tone.

Inside is an almost overwhelming amount of material, yet it was specifically designed to be this way: "Everything you can imagine about Planet 51 is in that shop," says Huélamo. "It's a world inside a world. We put such an effort into it that it feels that the entirety of the tone of *Planet 51* is essentially condensed into that one location, via the posters and the books, the small toys, tables, and lamps."

Such is the level of detail on display that it provides the eagle-eyed with some gorgeously designed artifacts, notably a chair with a humaniac figure framing the back, its arms outstretched and seemingly ready to strike! Yet, the team also embraced the opportunity to imbue the location with hints of *Planet 51's* long development. "It's incredibly detailed: All the magazines feature the primary art concepts," says Huélamo.

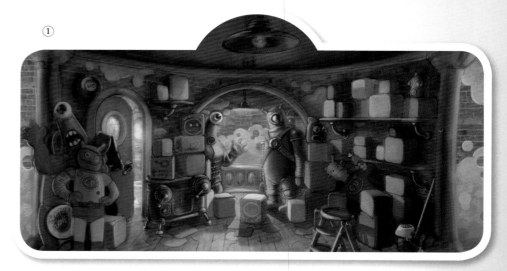

1 Backroom • Gracia Artigas (color), Marcos Calo (drawing) 2 Color key • Fernando López Juárez 3 Color concept art • Julián Romero Muñoz 4 Concept art • Marcos Calo 5 Color concept art • Julián Romero Muñoz 6 Houses line up • Julián Romero Muñoz 7 Comic shop • Marcos Calo, David Jaráiz, Gracia Artigas, and Olga Gridina 8 Comics • Olga Gridina, Gracia Artigas, and David Jaráiz

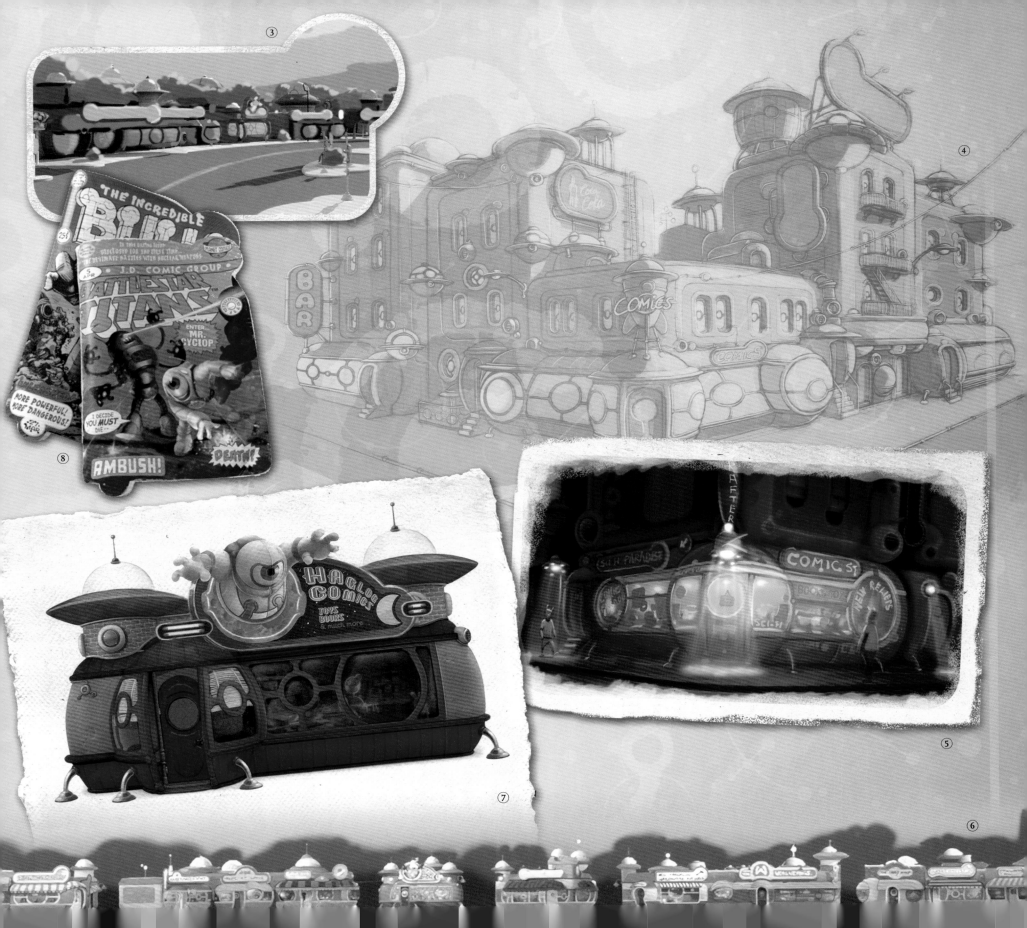

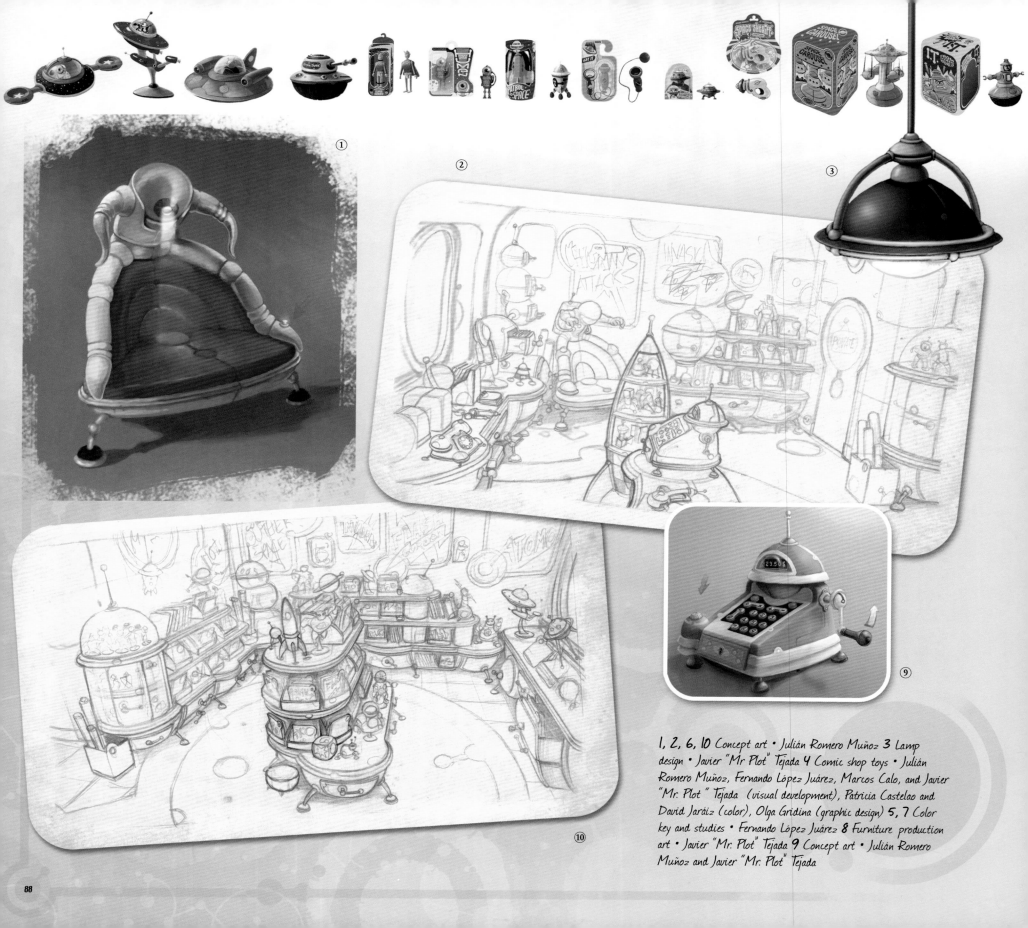

1, 2, 6, 10 Concept art • Julián Romero Muñoz 3 Lamp design • Javier "Mr Plot" Tejada 4 Comic shop toys • Julián Romero Muñoz, Fernando López Juárez, Marcos Calo, and Javier "Mr. Plot" Tejada (visual development), Patricia Castelao and David Jaráiz (color), Olga Gridina (graphic design) 5, 7 Color key and studies • Fernando López Juárez 8 Furniture production art • Javier "Mr. Plot" Tejada 9 Concept art • Julián Romero Muñoz and Javier "Mr. Plot" Tejada

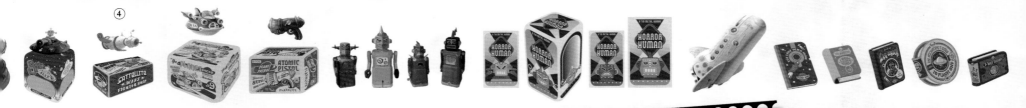

④

⑤

⑥

⑧

⑦

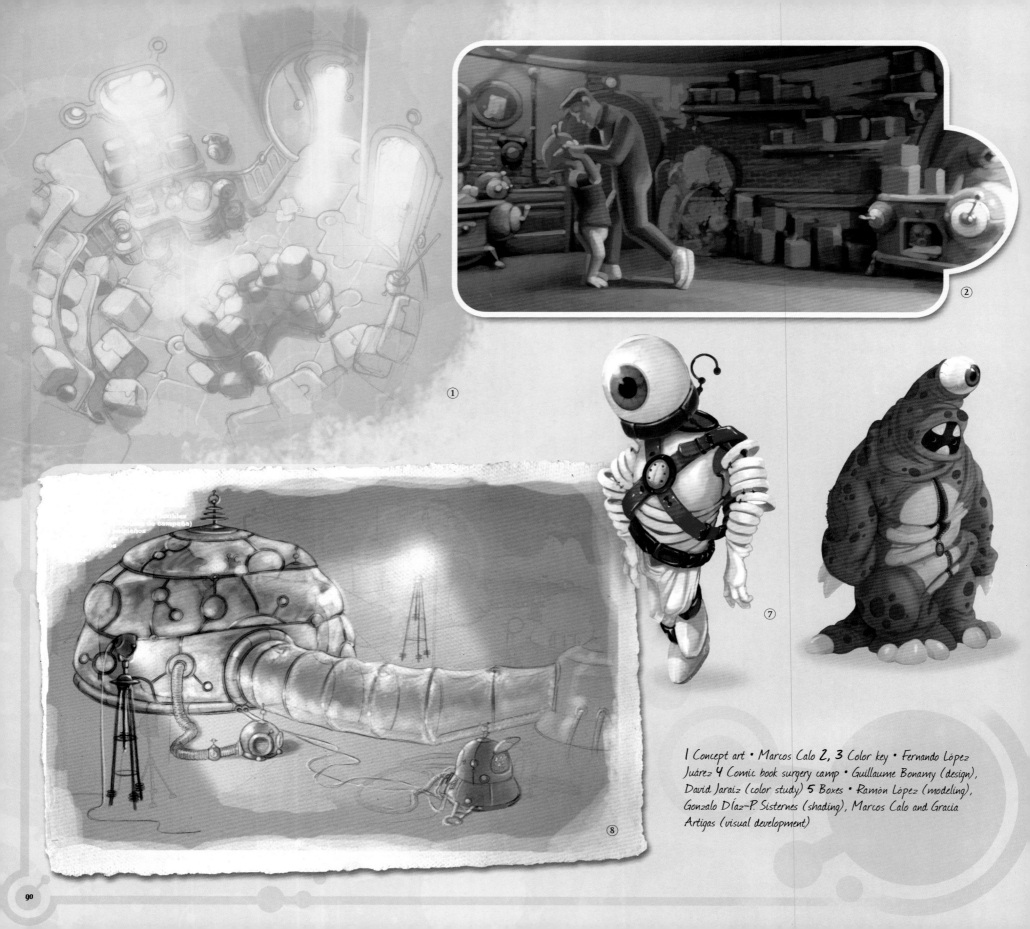

①

②

⑦

⑧

1 Concept art • Marcos Calo 2, 3 Color key • Fernando López
Juárez 4 Comic book surgery camp • Guillaume Bonamy (design),
David Jaraiz (color study) 5 Boxes • Ramón López (modeling),
Gonzalo Díaz-P. Sisternes (shading), Marcos Calo and Gracia
Artigas (visual development)

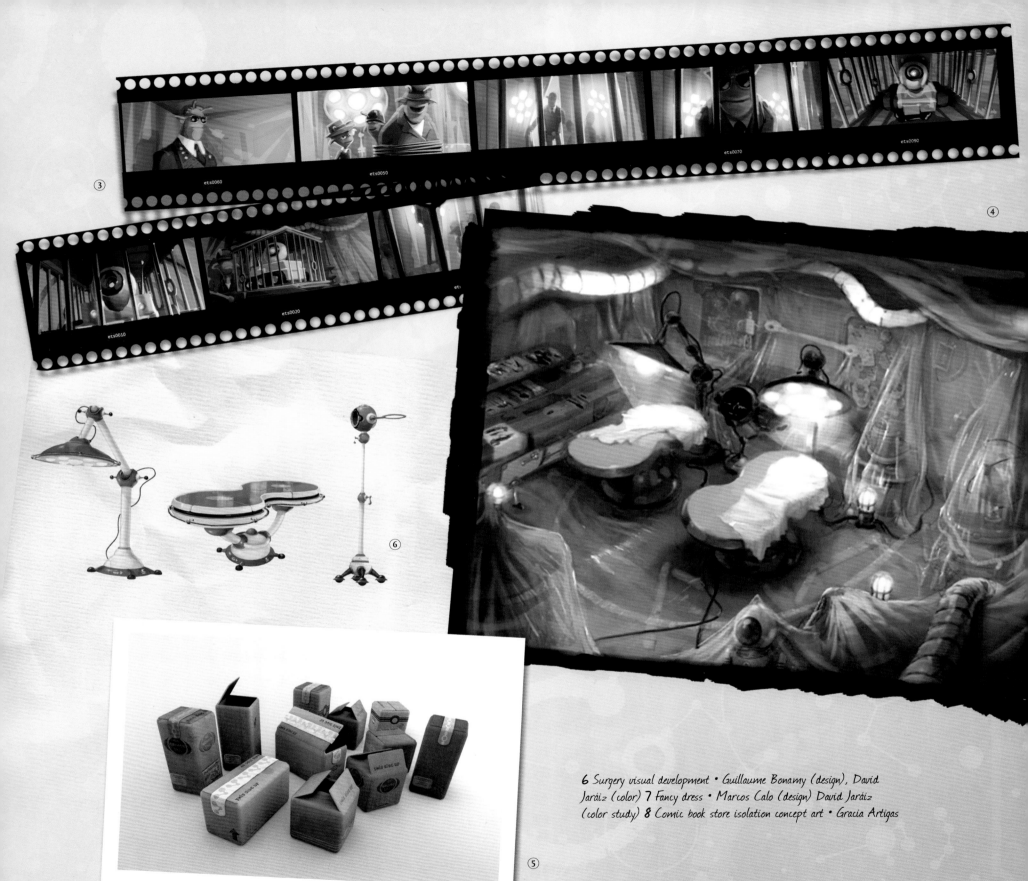

6 Surgery visual development • Guillaume Bonamy (design), David
Jaráiz (color) 7 Fancy dress • Marcos Calo (design) David Jaráiz
(color study) 8 Comic book store isolation concept art • Gracia Artigas

Entertainment Locations

The entertainment locales that feature in *Planet 51* showcase some of the most beautiful and detailed of the film's designs—no mean feat in such a vividly rendered world.

The film opens in Glipforg's cinema—once it becomes clear that the alien invasion of the small town is in fact from the film *Humaniacs! III*—the exterior of which is an effusive example of Glipforg's flying saucer architecture. Teeming with spires and antennae, the building possesses a massive central dome over the main auditorium and a suitably space age radio mast perched atop the main entrance. The interior, however, is a glorious expression of art deco and other retro stylings, the screen oval shaped and surrounded by lavish, dark red drapes.

Yet a location that looks positively tame compared to Glipforg's bowling alley. While all of the other buildings in Glipforg openly utilize the flying saucer motif, the bowling alley is the only one that unabashedly looks like one, appearing every inch the mother ship. The interior is splendidly garish, from the checkered floors to the bowling balls that are shaped like ringed planets.

Although gorgeous to look at, the location posed significant problems for the filmmakers in the early stages of animation, explains layout supervisor Charlie Ramos. "The bowling alley was a difficult location to previsualize because the design is so strange," says Ramos. "In the first version of the film, the bowling alley was a pretty inherent part of the story, and then, progressively, as the script changed, we didn't know what to do with it. However, the design was so beautiful that we wanted to use it some way, so it became a backdrop for an action sequence."

Yet, even in the comparatively smaller role that the alley ultimately plays in the film, the location does play host to one of the film's best homages, according to director Jorge Blanco García. "We've used certain gags that will undoubtedly appeal to fans of older sci-fi, the best example being the jukebox in the bowling alley based on Robby the Robot from *Forbidden Planet*."

1 Food and drinks • Gracia Artigas (visual development) 2 Drawing • Gracia Artigas 3 Burger drive-in design • Marcos Calo 4 Burger interior concept art • Julián Romero Muñoz 5, 6, 7 Leisure center, movie theater, and bowling alley color concept art • Fernando López Juárez 8 Movie theater concepts • Julián Romero Muñoz and Marcos Calo

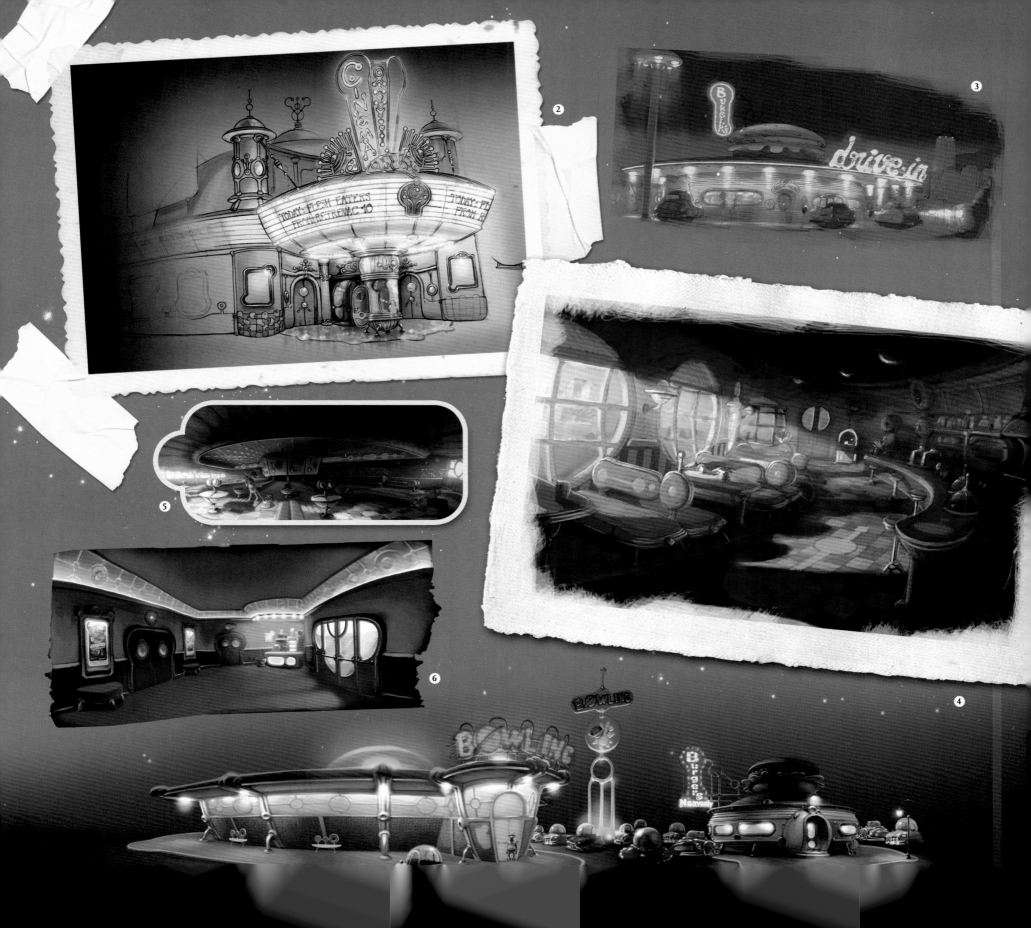

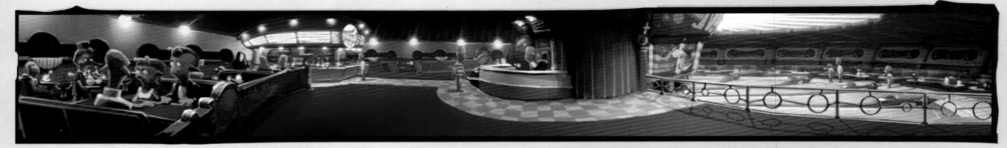

①

⑦

1 Bowling alley lighting study • Fernando López Juárez 2 Graphic • Olga Gridina 3, 4 Bowling alley bar •
Marcos Calo (design), David Jaráiz (color study) 5 Color study • David Jaráiz 6 Pinball machine •
Javier "Mr. Plot" Tejada (design), David Jaráiz (color) 7 Concept art • Marcos Calo

⑥

ENJOY THE GAME

BOWLING

FOR SPORTS FANS

STRIKES, SPARES, FOULS, SPLITS, TURKEYS

②

③

④

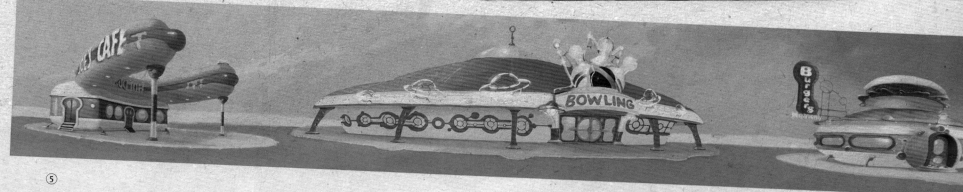

⑤

Residential Locations

Nestled serenely in the outskirts of Glipforg, the residential area—defined, like the rest of the town, by streets of concentric circles that are filled with saucer-shaped buildings—most clearly references the white-picket-fenced suburban nirvana of 1950s America that *Planet 51* draws upon so fulsomely.

The film has two locations here, amidst the immaculately kept lawns and litter-free roads: the family homes of Lem and Neera, which are next door to each other. It's particularly suitable that when Chuck's space module pierces the clouds above the quiet town and comes to land, it's in a place that represents Glipforg's air of a cozy, trouble-free existence: Neera's back garden. Her family, enjoying a barbeque, stare open-mouthed in utter disbelief at the newly arrived visitor before fleeing in abject terror.

The production's use of the flying saucer motif in the architecture of Glipforg receives its most pastoral iteration with the family homes. Giving the impression of a cluster of flying saucers, the resulting houses still adhere very closely to the design of the actual homes of the period, with porches, large bay windows, and attached garages. Neera's home, however, is a little more overt with the motif, with the addition of "landing legs" surrounding the house and an array of antennae emanating from the roof. The interiors of the houses provide an exquisite glimpse of the retro feel that was applied to every household object.

"The aerial view of flying saucers hovering over the rooftops of a city, an image that recurs in sci-fi B movies, informed a major expression of the saucer motif of *Planet 51*," explains visual designer Julián Romero Muñoz. "What we did was make the roofs themselves flying saucers, so there is a constant reminder of an invasion," he says. This image is particularly effective when applied to the residential areas, where Glipforg's citizens are supposed to feel their safest and most secure. "We could have gone more complex with it," says Romero, "but we didn't want to lose that coherence of the basic concept. If we went for more complex shapes, it just wouldn't work."

①

1 High school exterior • Fernando López Juárez 2 Glipforg surroundings concept art • Julián Romero Muñoz
3 Billboard • Gracia Artigas, Carolina Cuenca (drawing) 4 High school design • Marcos Calo

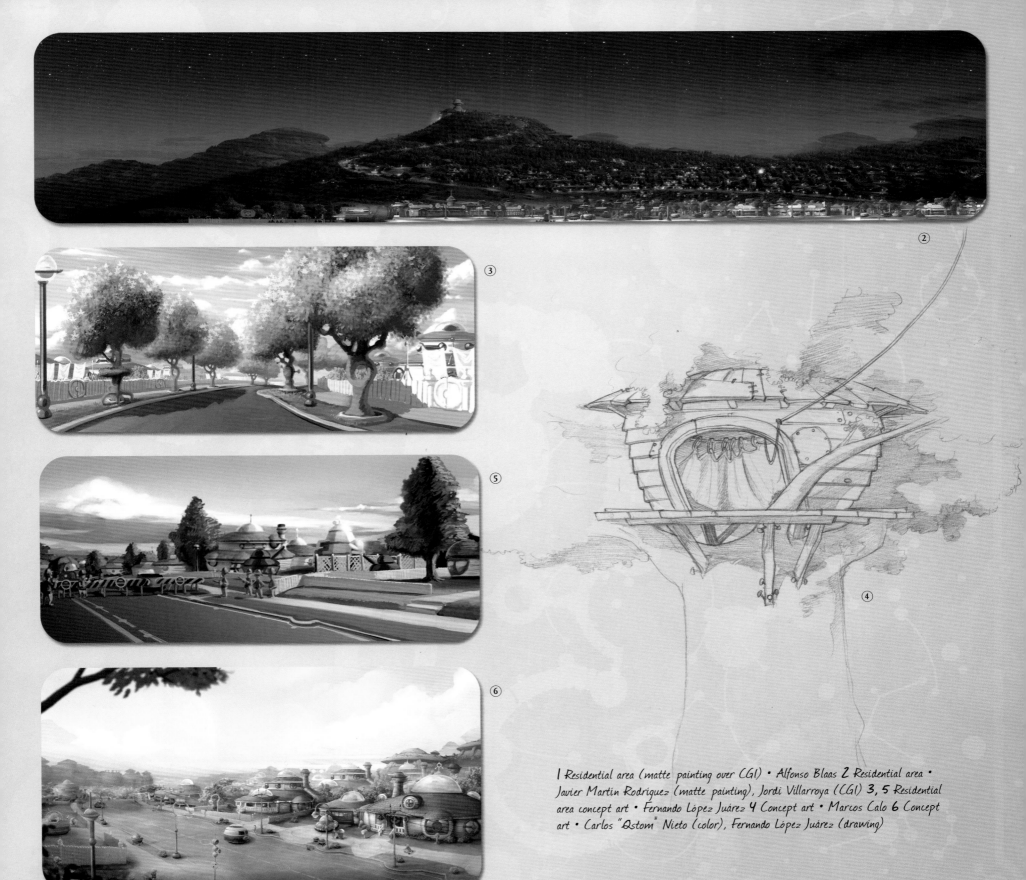

②

③

⑤

④

⑥

1 Residential area (matte painting over CGI) • Alfonso Blaas 2 Residential area • Javier Martín Rodríguez (matte painting), Jordi Villarroya (CGI) 3, 5 Residential area concept art • Fernando López Juárez 4 Concept art • Marcos Calo 6 Concept art • Carlos "Qstom" Nieto (color), Fernando López Juárez (drawing)

① ② ⑧

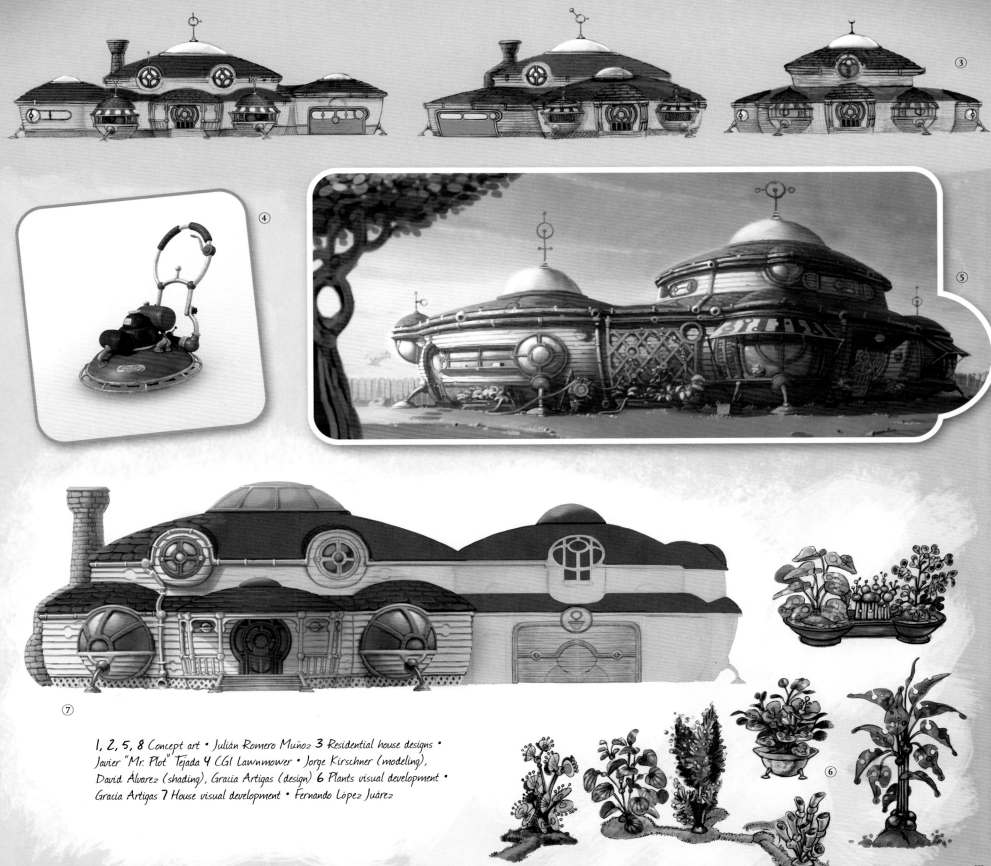

1, 2, 5, 8 Concept art • Julián Romero Muñoz 3 Residential house designs •
Javier "Mr. Plot" Tejada 4 CGI Lawnmower • Jorge Kirschner (modeling),
David Álvarez (shading), Gracia Artigas (design) 6 Plants visual development •
Gracia Artigas 7 House visual development • Fernando López Juárez

101

Whiter and Brighter Wash than you've ever seen before!! With the new Orbi'Tornado Action System

NEW!

Venus'Matic

IT'S A MIRACLE!

Automatic Washer..

①

②

⑥

⑦

102

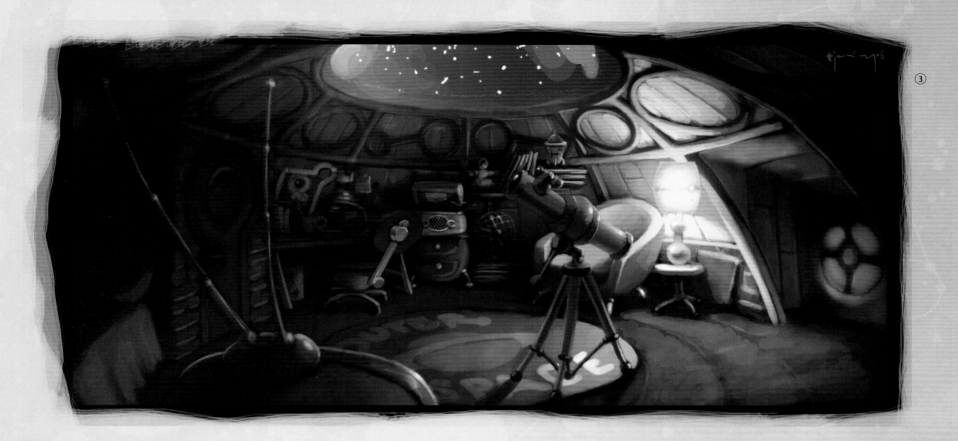

③

⑤

④

1 Advertising poster • Gracia Artigas 2, 5 Visual development • Gracia Artigas 3 Concept art • Fernando López Juárez 4, 6 Visual development • Javier "Mr. Plot" Tejada 7 Color key • Fernando López Juárez

Midtown Buildings

The center of Glipforg provides the best opportunity to view the sheer diversity of buildings that adopt the flying saucer motif—all to entirely successful effect. "We never lost the vision so much that someone watching the film wouldn't recognize what they are looking at. Even though it was a saucer shape, you could easily identify a building and the type of building it was," explains director Jorge Blanco García.

Main Street hosts Glipforg's largest municipal buildings, including the suitably imperious Town Hall, which, composed of white stone and with a grand central facade bolstered by thick pillars, bears more than a passing resemblance to the White House in Washington DC. The roof, of course, is defined by an imposing trio of flying saucers, the larger central one flanked by two smaller ones.

Equally grand is Glipforg's high school, replete with a statue outside the entrance of Glipforg's founder, Pacifier Glipp. Of all the building designs in Glipforg, this is the most sedate, indeed one that could fitmost comfortably on Earth—consider London's Royal Albert Hall, for example.

The town center's gas station, however, employs the flying-saucer motif in a particularly innovative fashion, providing the overhead cover of the station's forecourt, the area lit by fluorescent lighting located on the underside of the saucer. Unlike many of Glipforg's buildings that employ the general shape, the gas station features an extraneous saucer section that looks like it was plucked from a '50s B movie!

Interestingly, the hot dog restaurant is the only building in Glipforg that doesn't utilize the flying-saucer motif. Instead, it's a curved, trailerlike building with the edge of a giant U-shaped hot dog resting on the roof while the two ends jut out on either side. It certainly fits in with the novelty architecture of Googie, but surely it's some mistake? Not at all, confirms visual designer Julián Romero Muñoz, who says the curved hot dog is, in fact, one of Planet 51's less-obvious homages. It is a reference, he says, to a derelict ship in a favorite sci-fi movie.

①

1 Visual development • Gracia Artigas 2 Midtown visual development • Guillaume Bonamy 3, 5 Midtown visual development • Marcos Calo (design), David Jaraiz (color study) 4 Town center concept art • Julián Romero Muñoz 6 Row of houses • Julián Romero Muñoz

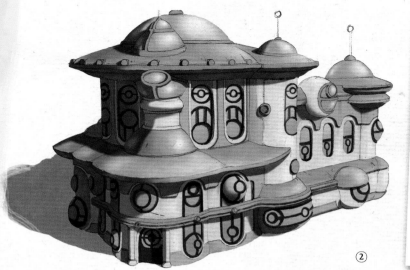

②

③

⑤

④

⑥

105

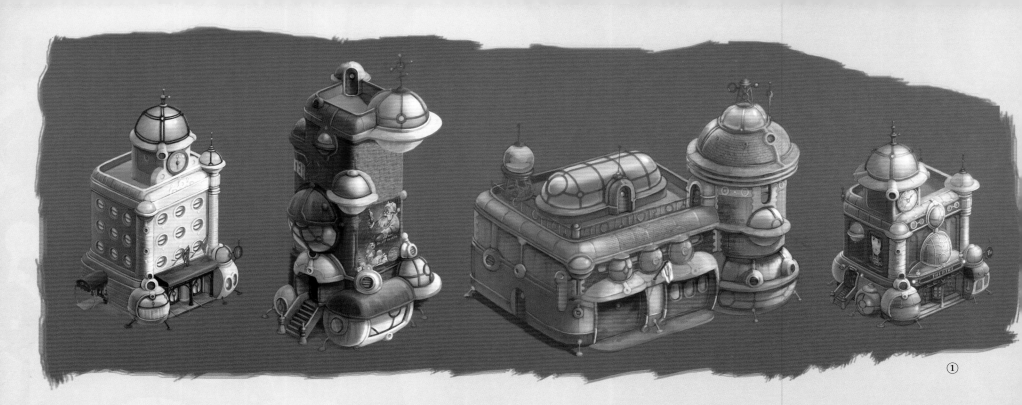

①

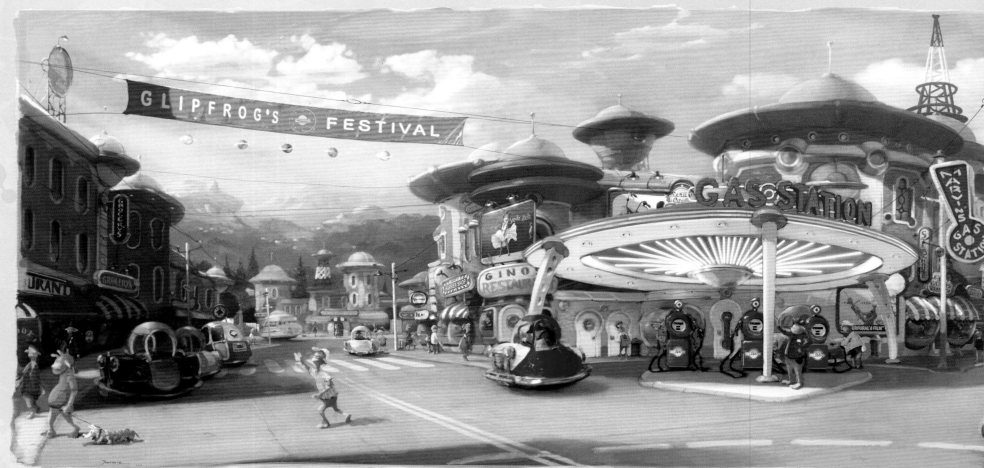

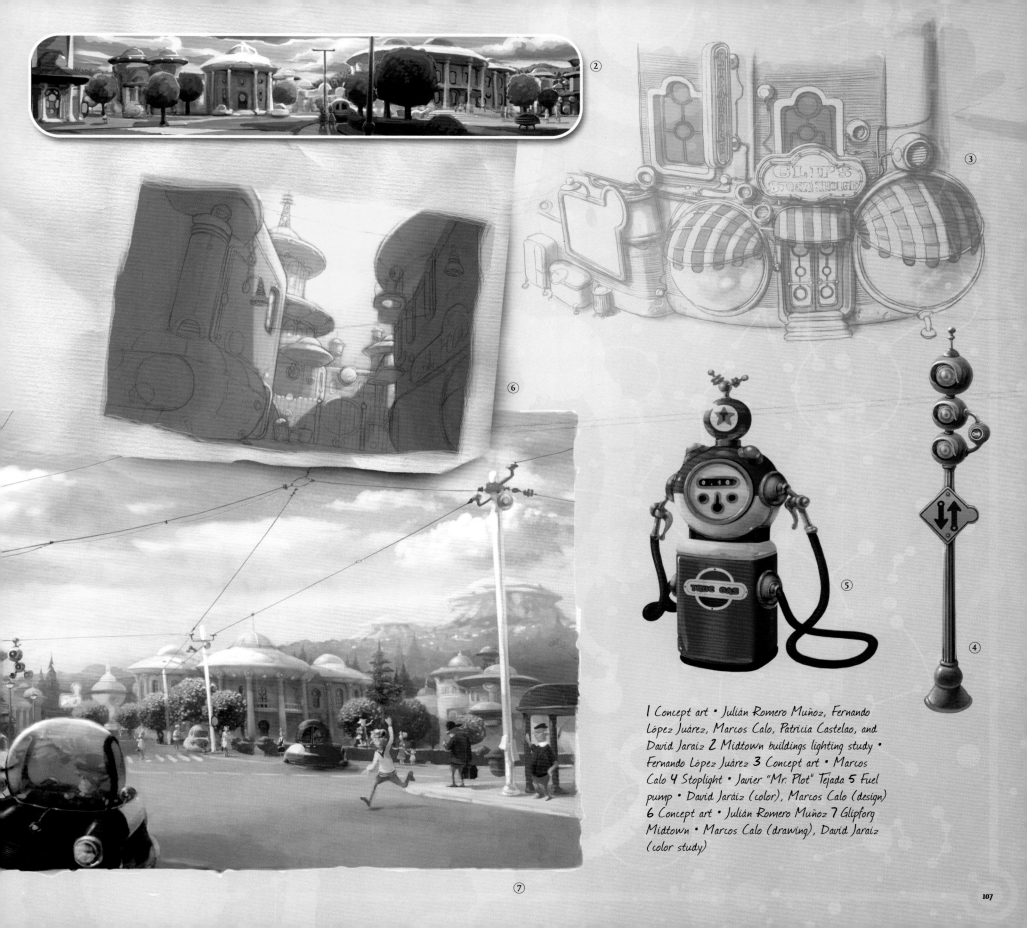

1 Concept art • Julián Romero Muñoz, Fernando López Juárez, Marcos Calo, Patricia Castelao, and David Jaraiz 2 Midtown buildings lighting study • Fernando López Juárez 3 Concept art • Marcos Calo 4 Stoplight • Javier "Mr. Plot" Tejada 5 Fuel pump • David Jaráiz (color), Marcos Calo (design) 6 Concept art • Julián Romero Muñoz 7 Glipforg Midtown • Marcos Calo (drawing), David Jaraiz (color study)

GLIP'S STEAKHOUSE

TUBE GAS

①

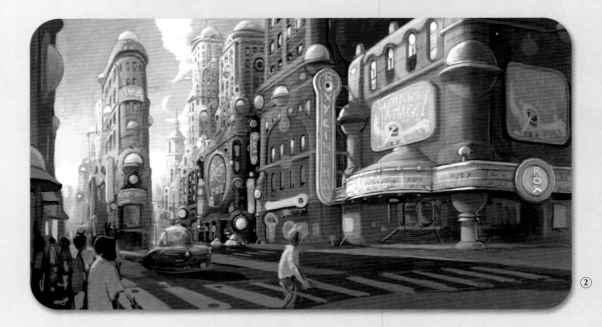

②

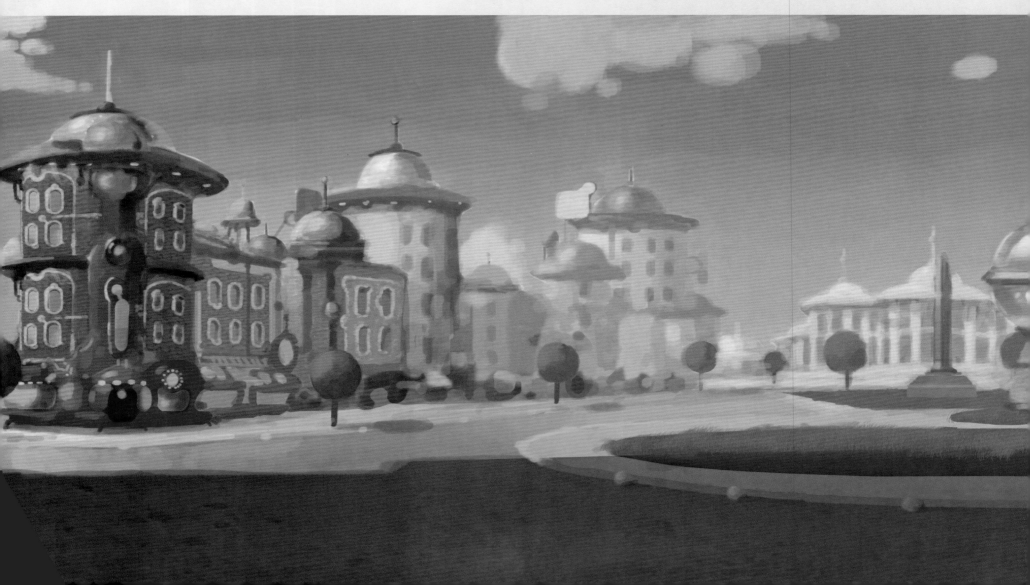

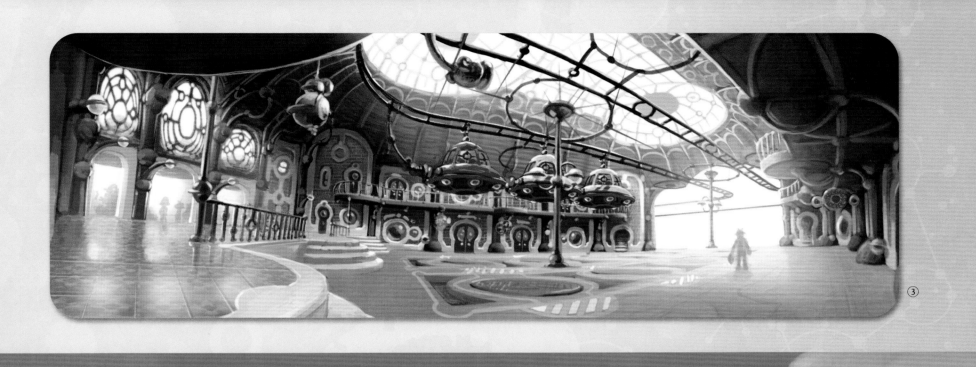

③

1, 2 City concept art • Julián Romero Muñoz 3 Central station
visual development • Fernando López Juárez 4 Early city concept art •
Julián Romero Muñoz (concepts), David Jaraiz (color study)

④

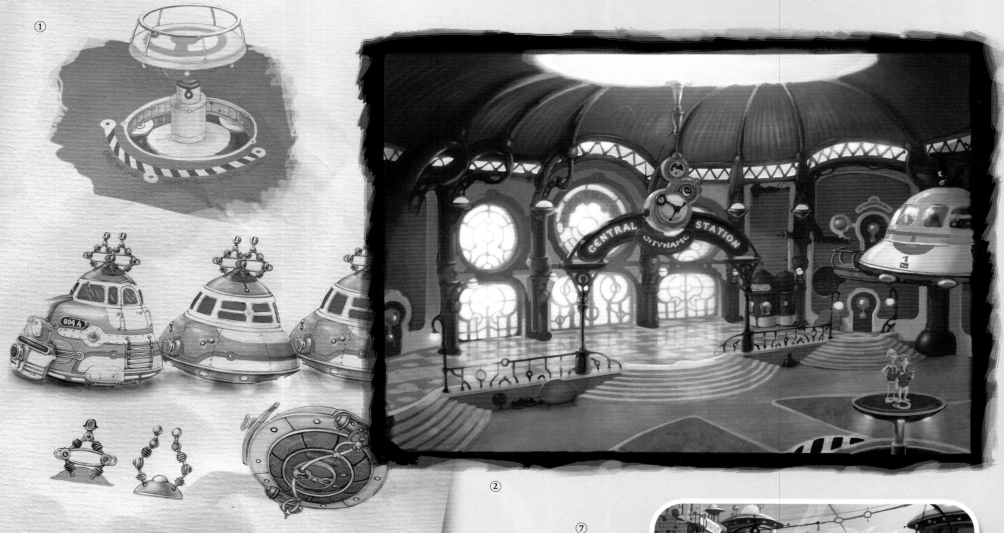

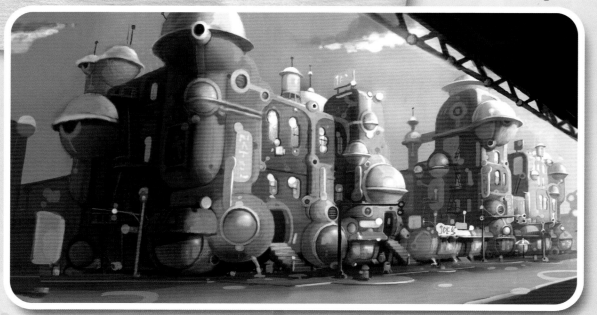

1 Train wagons and platform design • Javier "Mr. Plot" Tejada
2 Central station • Gracia Artigas (design), David Jaraiz (color study) 3 Concept art • Marcos Calo (design), David Jaraiz (color study) 4 Concept art • Fernando López Juárez 5 Train rails and stop platform visual development • Javier "Mr. Plot" Tejada
6, 7 City concept art • Julián Romero Muñoz

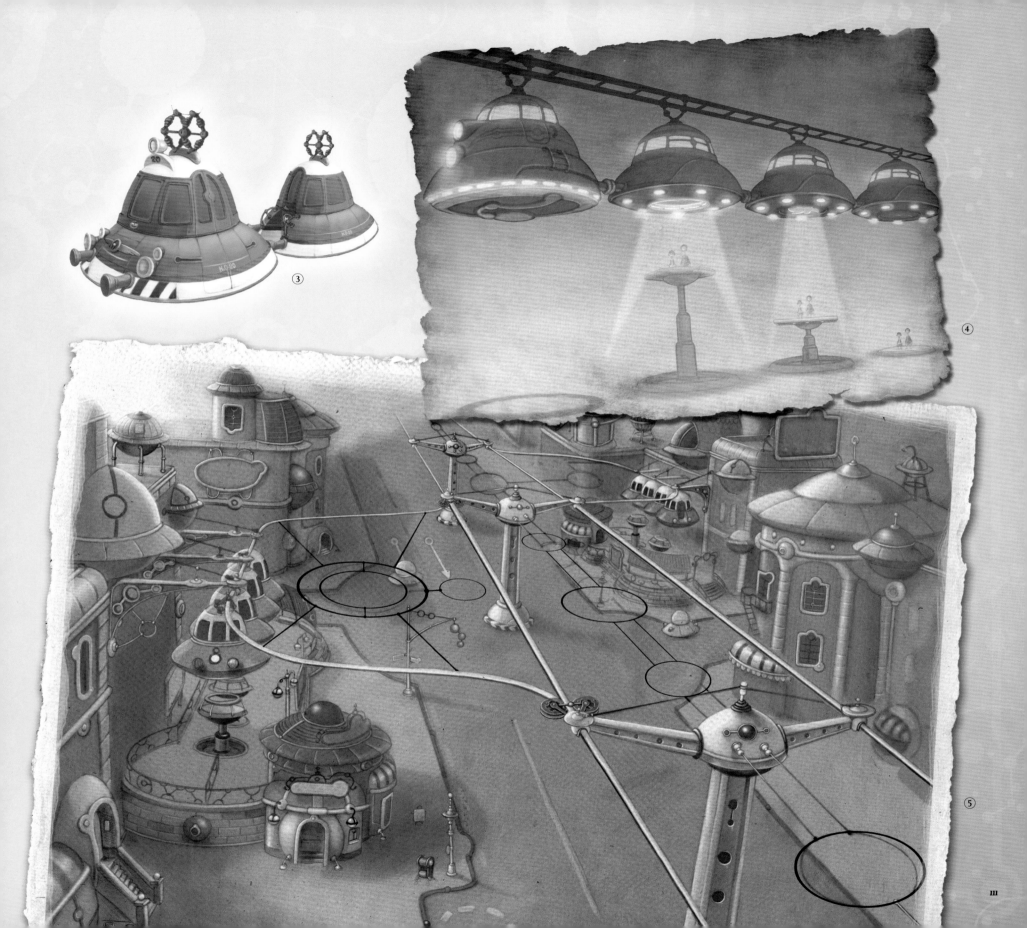

3

4

5

III

Base 9

Planet 51's key—and most complex—location is the secret underground base located in the desert beneath what appears to be an isolated gas station and which is swiftly exposed in all its vast and mysterious grandeur at the pull of a secret lever. Controlled by the military, Base 9's express mission is to keep the citizens of Glipforg ignorant about the true nature of space and extraterrestrial visits—as well as to store the evidence of such visits, such as crashed satellites.

The direct inspiration for Base 9 came from a real-life source: "We were always very clear that there would be a secret underground facility featured in *Planet 51*, and ours was very much based on Area 51 in Nevada," says codirector Javier Abad Moreno, referring to the legendary and ferociously secretive U.S. Air Force base that has long been rumored to horde alien materials. "We liked the idea of a big base hiding in the desert," claims Base 9's designer Julián Romero Muñoz. "Inside, there would be all the satellites and Rover trapped in egglike prisons, very much like in the film *Alien*."

The concept of the secret underground base is a familiar one in sci-fi cinema, and Base 9 acts as direct homage to an array of films. "The art department did an incredible job with this design," enthuses sets and props supervisor Fernando Huélamo García, "allowing us to put in a lot of references to many different movies, like the areas of hidden dangers reminiscent of the *Indiana Jones* movies."

Given that Base 9 is undoubtedly the most technologically advanced location of *Planet 51*, due care had to be taken to ensure that it did not clash with the film's overall retro feel. "The process was hard," explains art director Fernando López Juárez, "because, at the very beginning, Base 9 was exceedingly technological, much more in line with the technology of today. So it was given a green, military color so as to better capture the necessary retro aesthetic." To enhance the location's mystery, adds Abad, "the art department was very clear on having lots of circular corridors that featured many doors."

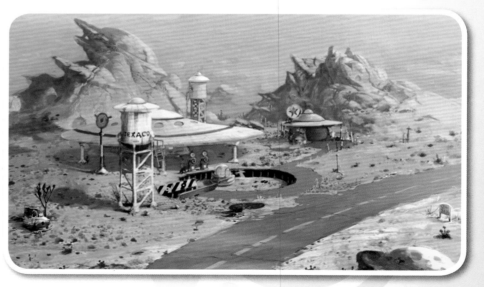

⑤

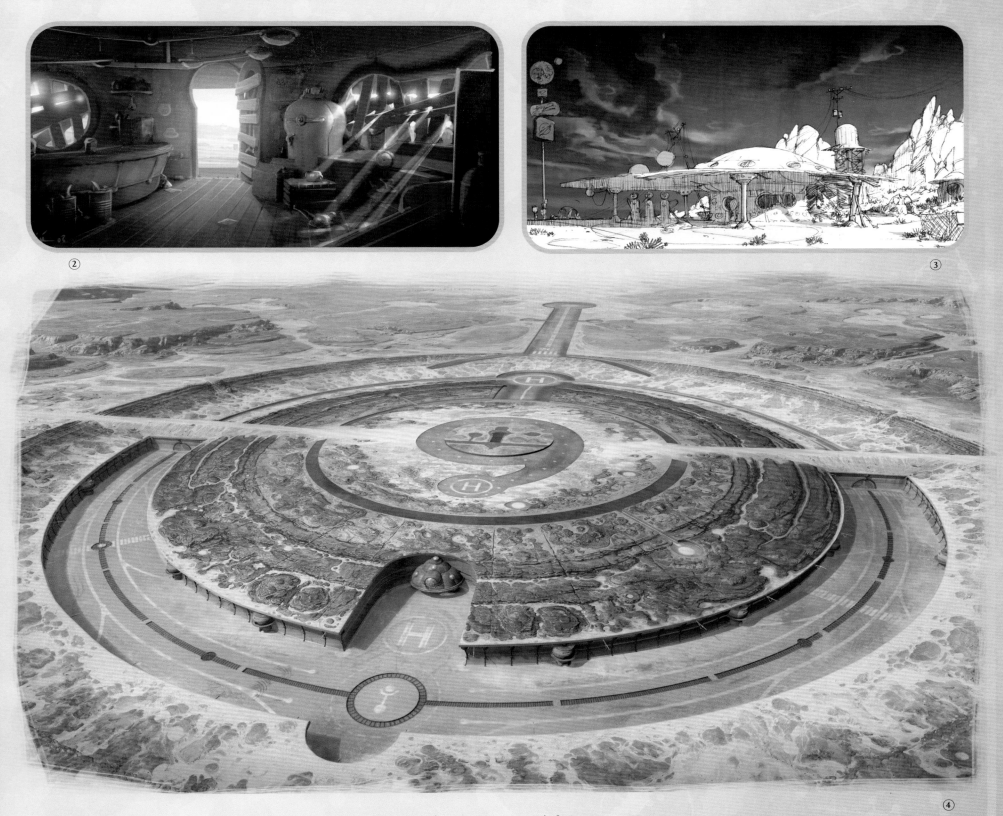

② ③ ④

1 Base 9 hidden gate concept • Guillaume Bonamy (concept and design), David Jaráiz (color) 2 Color key •
Fernando López Juárez 3 Concept art • Guillaume Bonamy 4 Base 9 aerial view • Javier Martín Rodríguez
and Alberto Ruiz (matte painting), Jordi Villarroya (CGI) 5 Gas station color concept • Julián Romero Muñoz

113

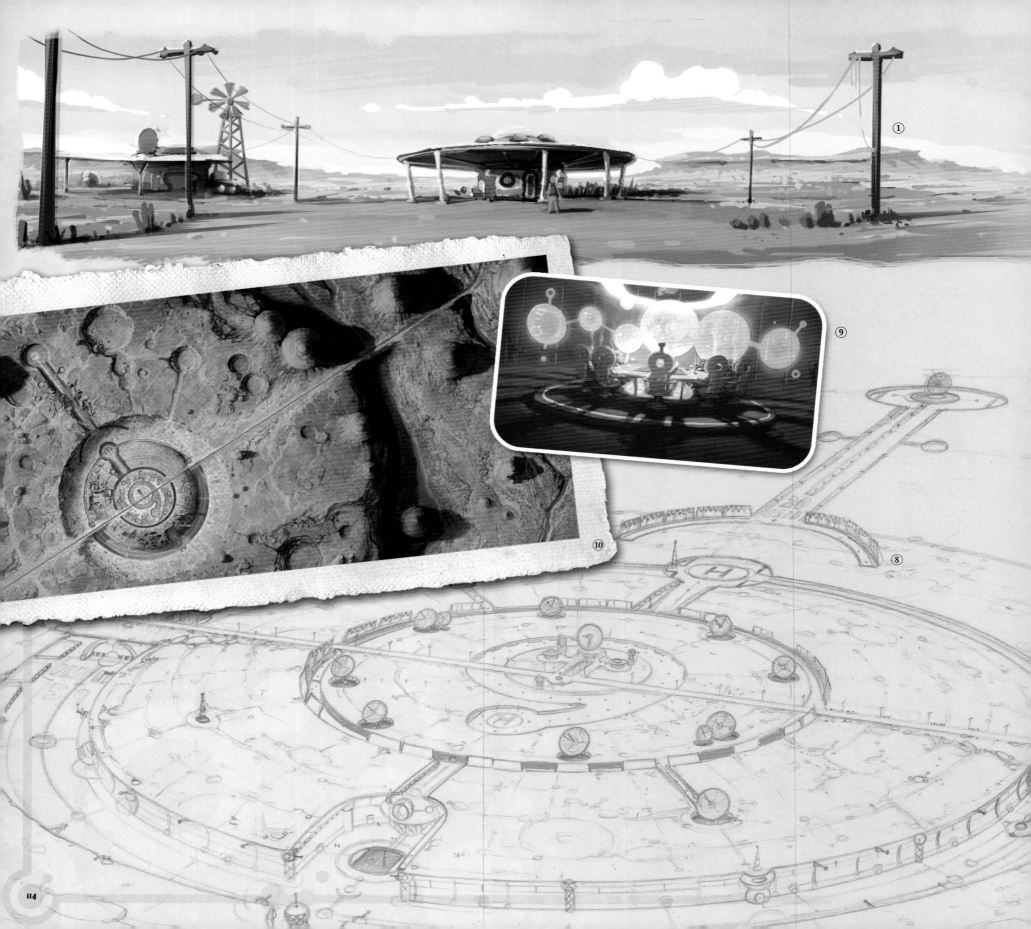

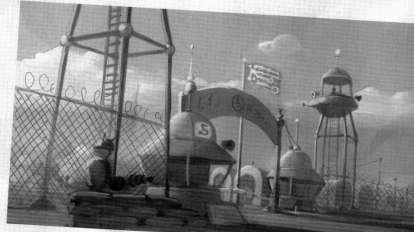

1 Color key • Fernando López Juárez 2, 3, 4, 7 Early concept art •
Julián Romero Muñoz 5 Terminal design • Javier "Mr. Plot" Tejada
6 Color key • Fernando López Juárez 8, 9 Concept art • Julián
Romero Muñoz 10 Base 9 zenital view • Scott McInnes (matte
painting), Jordi Villarroya (CGI)

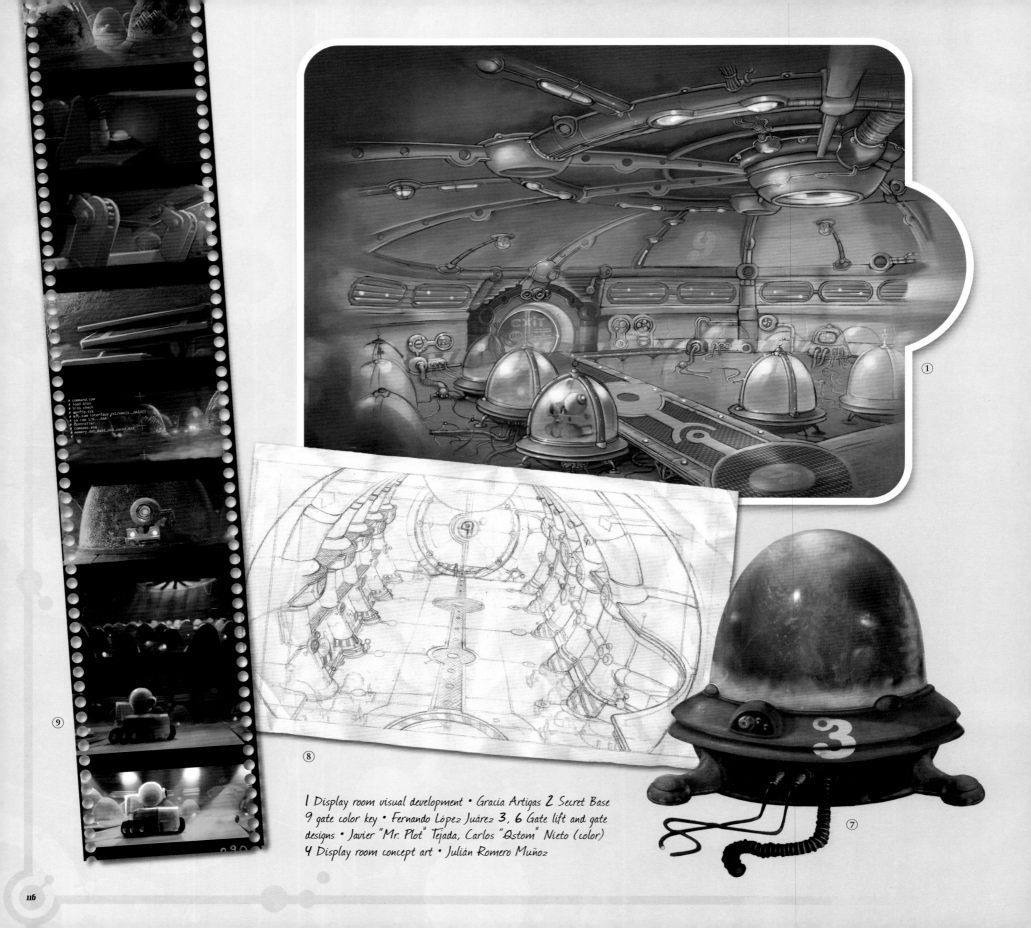

1 Display room visual development • Gracia Artigas 2 Secret Base
9 gate color key • Fernando López Juárez 3, 6 Gate lift and gate
designs • Javier "Mr. Plot" Tejada, Carlos "Qstom" Nieto (color)
4 Display room concept art • Julián Romero Muñoz

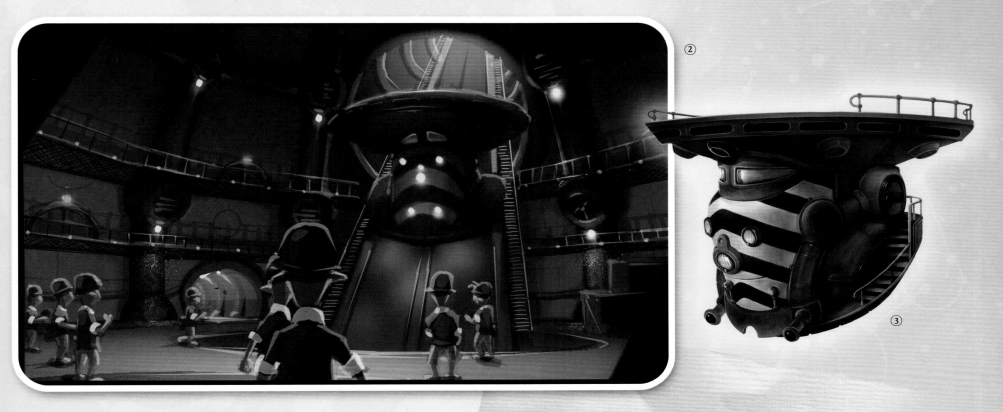

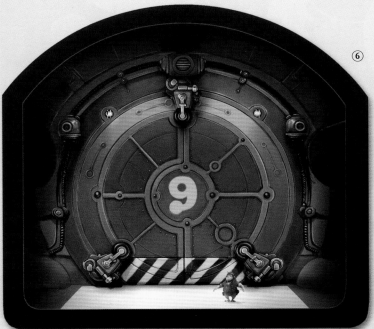

5 Color key • Gracia Artigas 7 Display container • David Jaráiz
(color and shading study), Javier "Mr. Plot" Tejada and Gracia
Artigas (design) 8 Concept pencil drawing • Julián Romero Muñoz
9 Color key • Julián Romero Muñoz

①

⑤

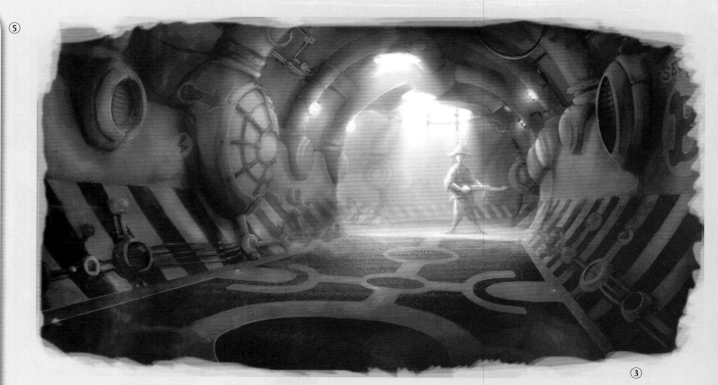

③

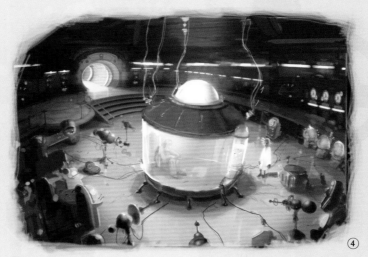

④

1 Corridors • Guillaume Bonamy 2 Containment room design • Marcos Calo 3 Corridors • Guillaume Bonamy (design), Carlos "Qstom" Nieto (lighting study) 4 Containment room • Guillaume Bonamy (concept), David Jaraiz (lighting study) 5 Concept art • Julián Romero Muñoz

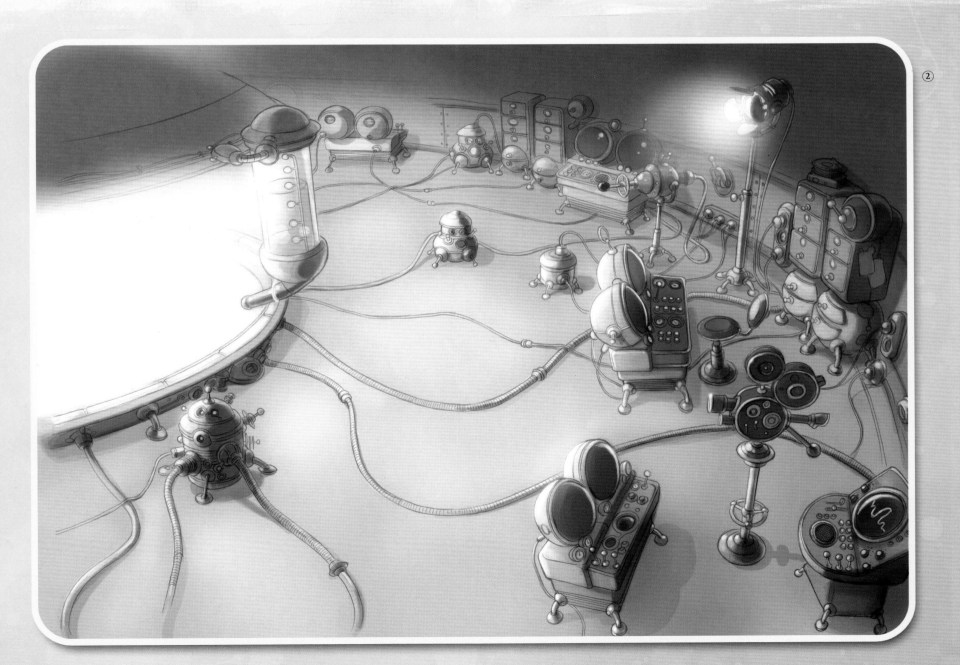

②

1 Base 9 logistics vehicle • Javier "Mr. Plot" Tejada
(designs) 2, 4 Secure room color key • Fernando
López Juárez 3 Concept art • Guillaume Bonamy
5 Secure room concept art • Julián Romero Muñoz
6 Concept art • Guillaume Bonamy

①

②

⑥

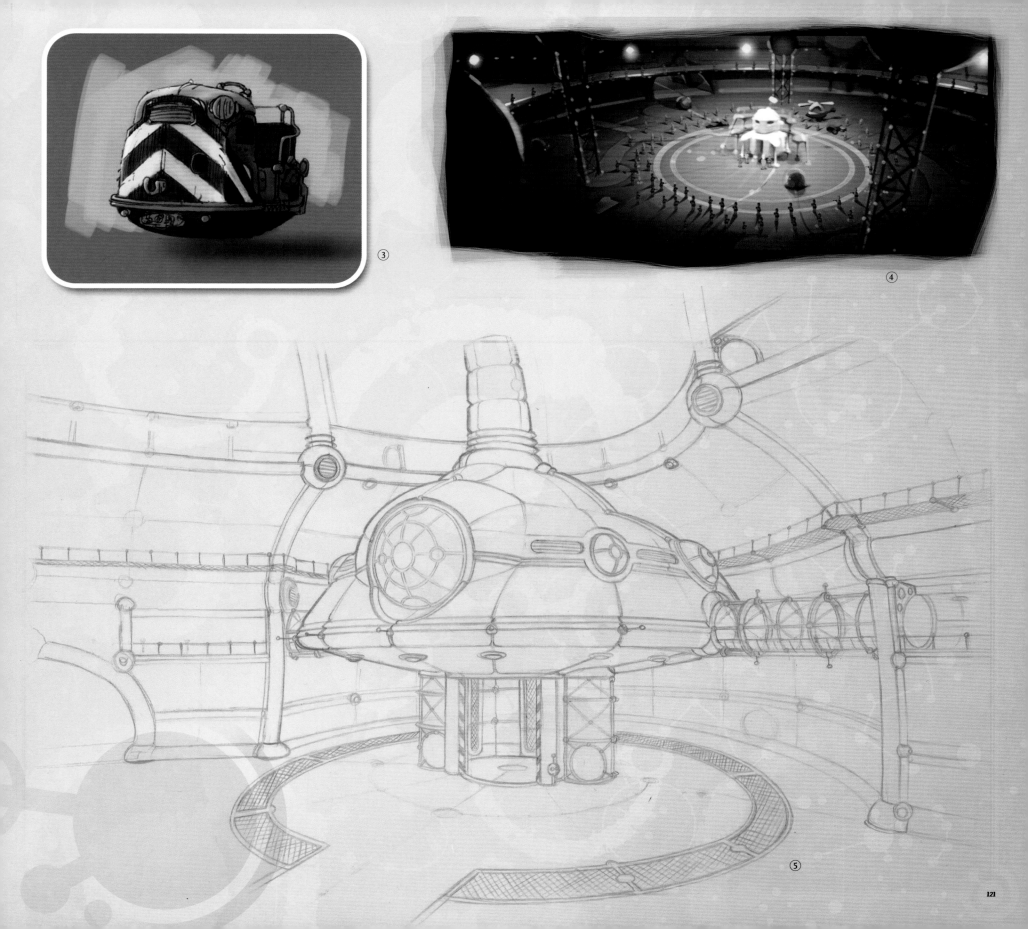

③

④

⑤

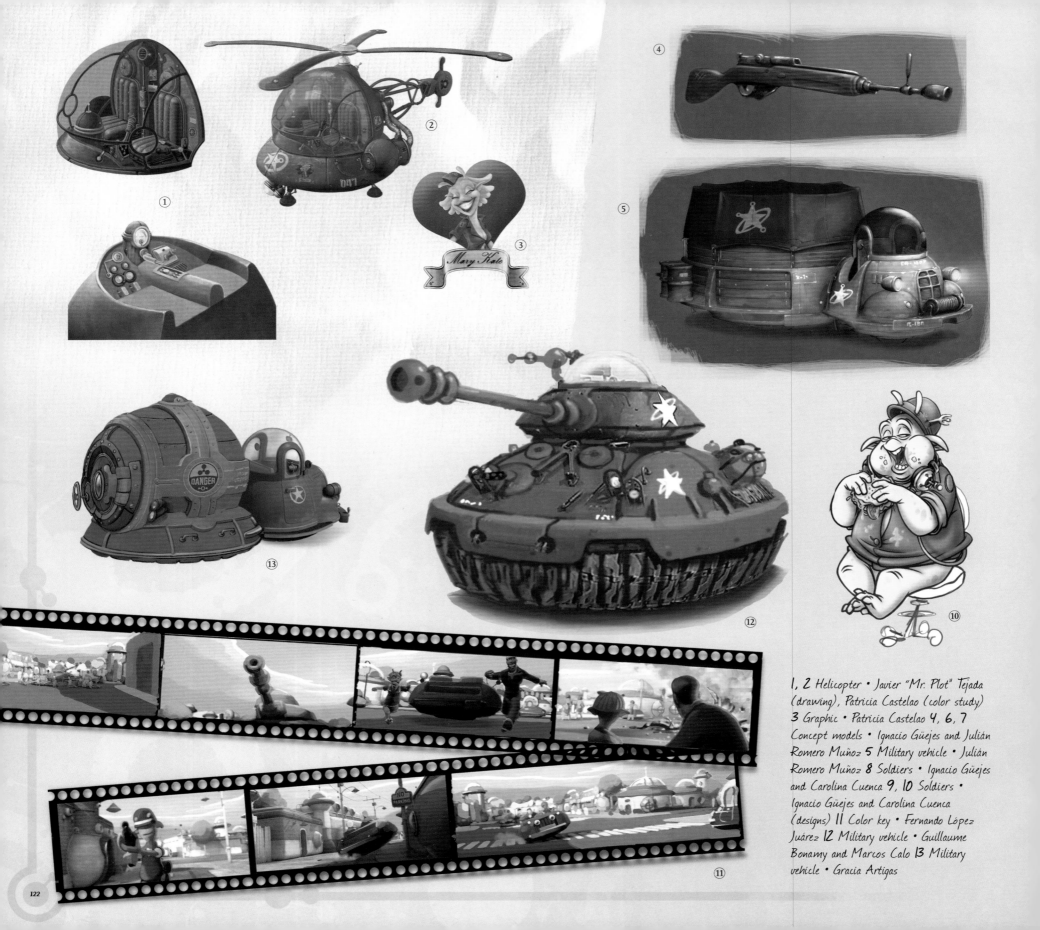

1, 2 Helicopter • Javier "Mr. Plot" Tejada (drawing), Patricia Castelao (color study) 3 Graphic • Patricia Castelao 4, 6, 7 Concept models • Ignacio Güejes and Julián Romero Muñoz 5 Military vehicle • Julián Romero Muñoz 8 Soldiers • Ignacio Güejes and Carolina Cuenca 9, 10 Soldiers • Ignacio Güejes and Carolina Cuenca (designs) 11 Color key • Fernando López Juárez 12 Military vehicle • Guillaume Bonamy and Marcos Calo 13 Military vehicle • Gracia Artigas

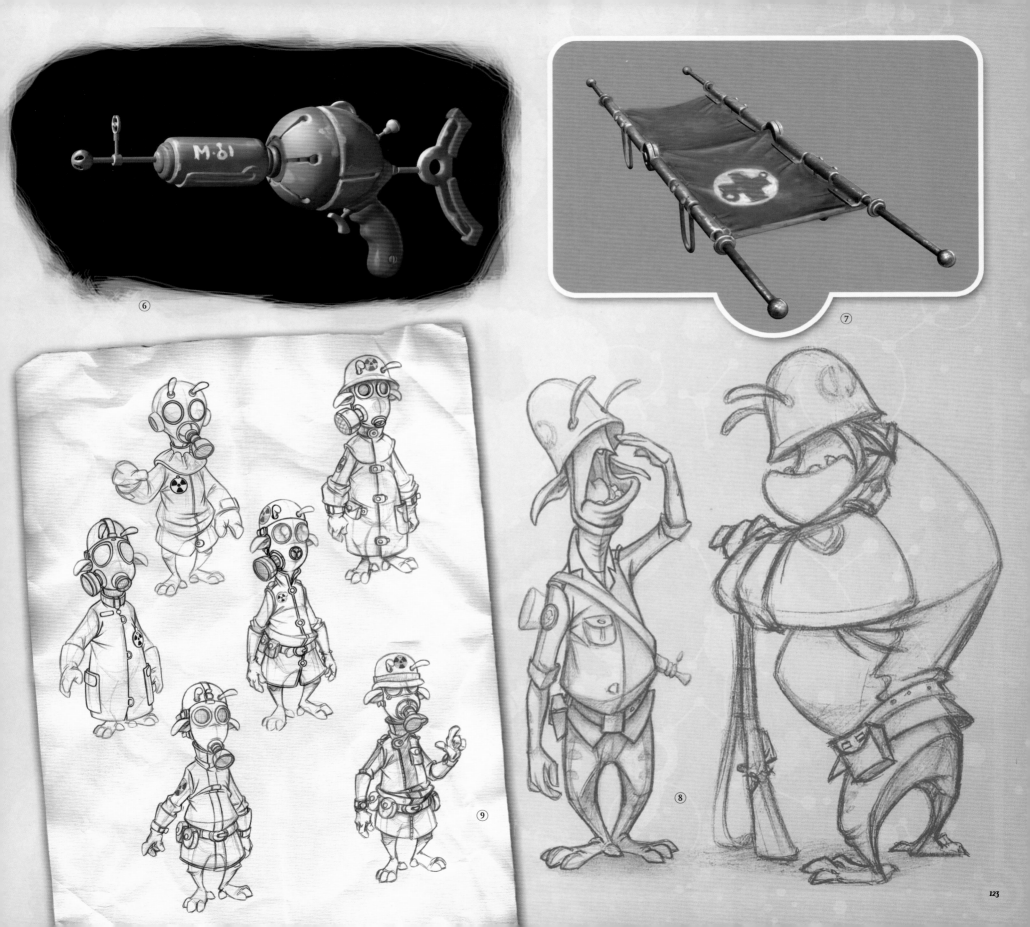

⑥

⑦

⑧

⑨

Vehicles

If the production of *Planet 51* had a "Eureka!" moment, then it surely occurred when the suggestion arose of a flying saucer shaped like a Cadillac. This vivid and highly attractive fusion of fantasy and reality was the catalyst that provided a considerable conceptual boost to the film. "Our turning point was the saucer-shaped '50s cars, and that informed the entire twist of *Planet 51*," says director Jorge Blanco García.

Even better, it was an aesthetic choice that was a dream to design, according to codirector Marcos Martínez Carvajal: "The easiest thing to design was the cars. We had that idea from the very beginning, and that was one of the best things to work on." Hovering (and occasionally swaying vigorously) through the streets of Glipforg are a marvelous array of these hybridized vehicles, all of which are instantly recognizable and fit flawlessly into the film's skewed vision of '50s Americana.

"All the cars are references to actual cars of that period," Martínez keenly notes, adding that the various vehicles have been at the forefront of people's appreciation of the film's look. "I've known people who have looked at the film who have been amazed at what they have seen. They recognize all the vehicles in the movie."

The fact that so many disparate and distinct vehicle designs—from municipal vehicles like the police cars, school and public buses, taxis, and fire trucks to classic brand-name car designs of the period—are successfully converted into the rotund and bubblelike shape of alien craft shows off the sheer malleability of the concept. Likewise for the military vehicles, which convert Sherman tanks, jeeps, trucks, and, memorably, a spider-legged crane with seeming ease.

This quirky element of *Planet 51* is clearly a source of immense satisfaction. The film's producer, Ignacio Pérez Dolset, comments: "The element of cars that are flying saucers is the one that we are most proud of in this production. It is what we enjoyed creating the most, and it's one step beyond what we have seen before."

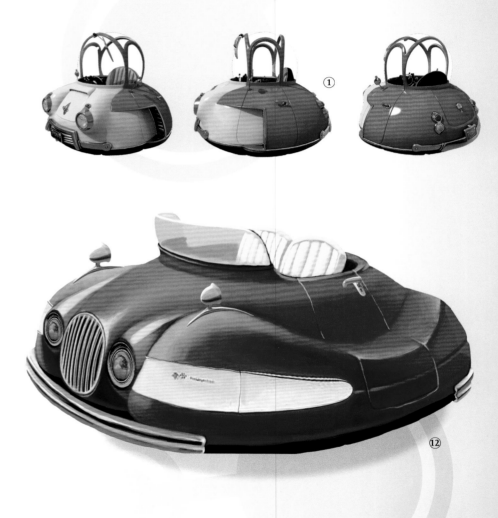

1 Vehicle turnaround • Fernando López (design), Emilio Álvarez (modeling), Gonzalo Diaz-P. Sisternes (shading) 4, 5, 6, 7, 12 Car designs • Fernando López Juárez 2 Early concept art • Ignacio Güejes 3 Car design • Patricia Castelao, Fernando López Juárez (color) 8 Graphic design • Olga Gridina 10 Concept art • Julián Romero Muñoz 11 Poster • Patricia Castelao (color art), Carolina Cuenca (drawing), Olga Gridina (graphic design)

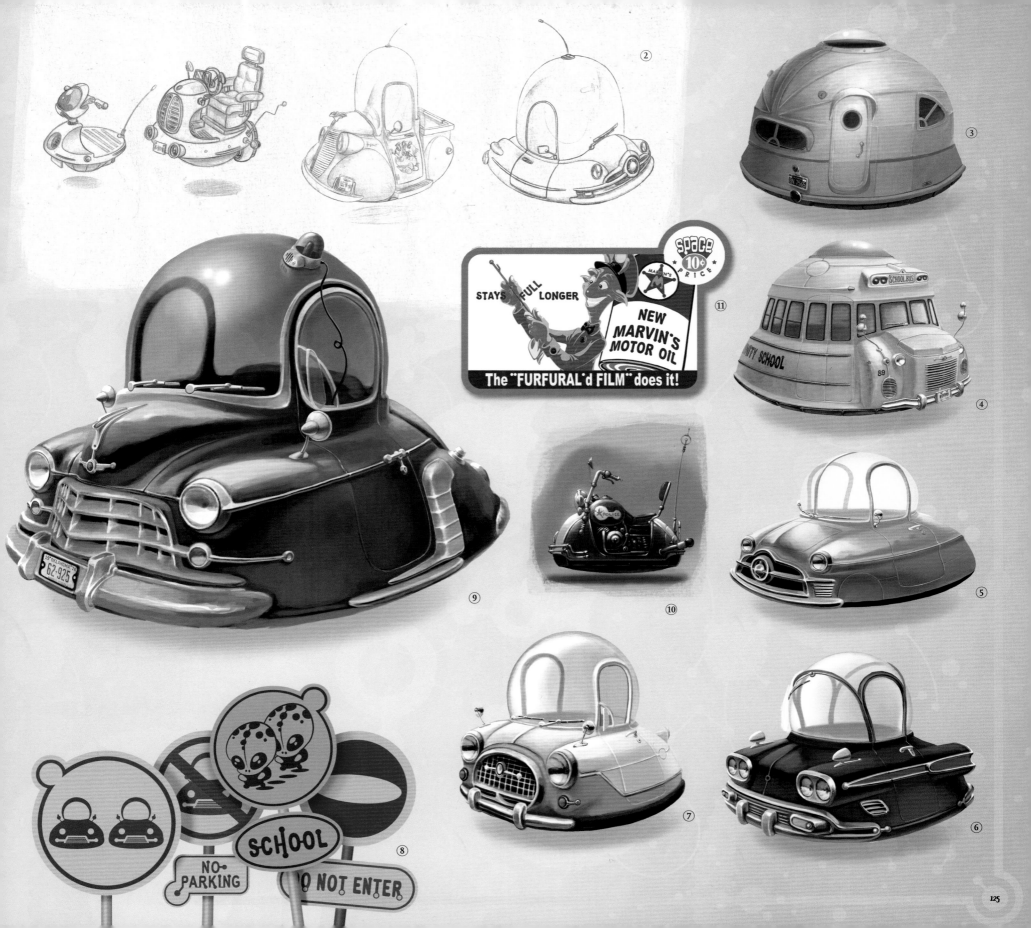

STAYS FULL LONGER

NEW MARVIN'S MOTOR OIL

The "FURFURAL'd FILM" does it!

SPACE 10¢ PRICE

SCHOOL BUS

NO PARKING

SCHOOL

DO NOT ENTER

125

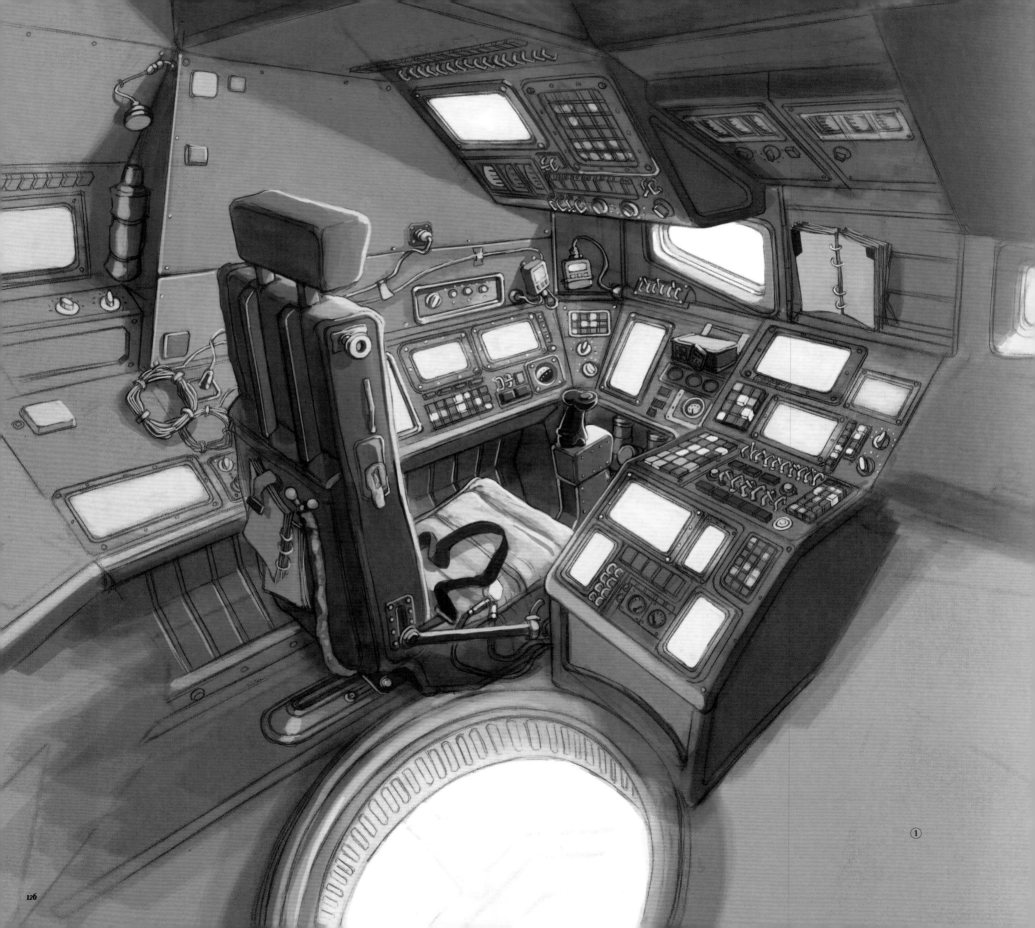

①

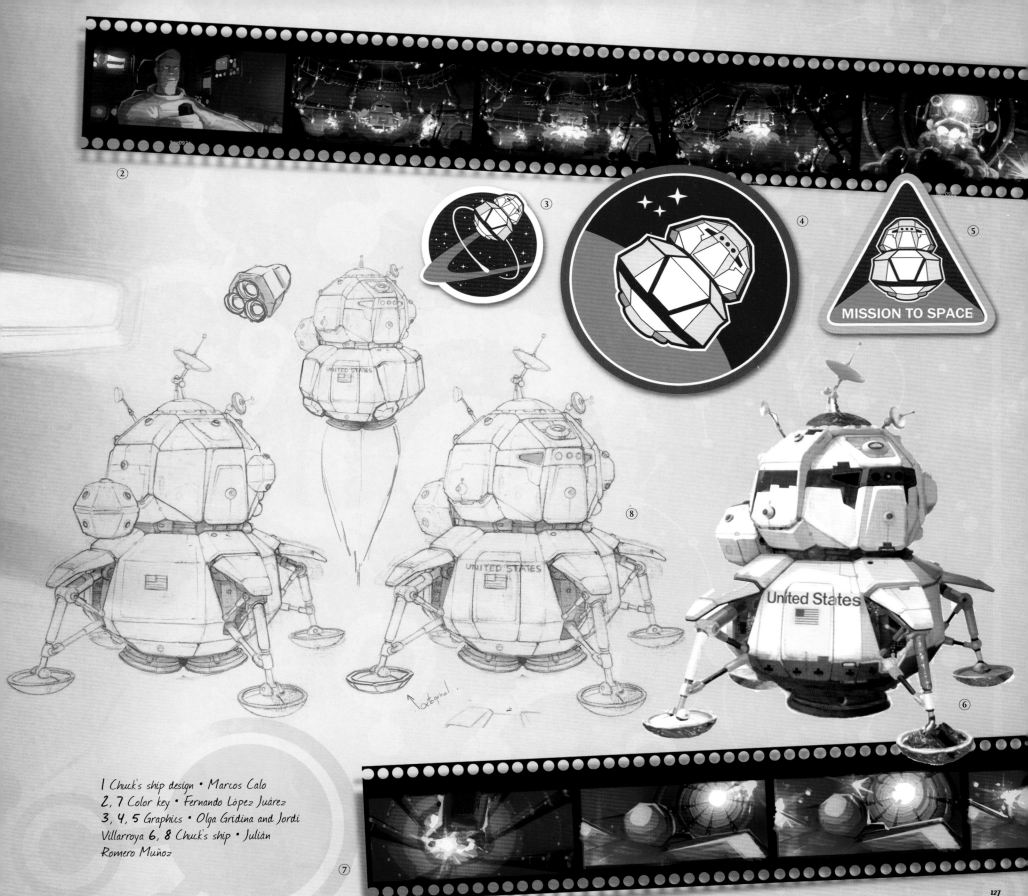

MISSION TO SPACE

1 Chuck's ship design • Marcos Calo
2, 7 Color key • Fernando López Juárez
3, 4, 5 Graphics • Olga Gridina and Jordi
Villarroya 6, 8 Chuck's ship • Julián
Romero Muñoz

127

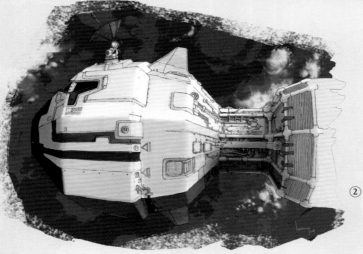

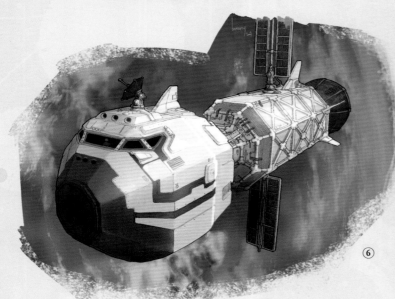

1 Color key • Fernando López Juárez
2, 6 Mothership • Guillaume Bonamy
3, 4 Designs for Chuck's ship • Marcos Calo
5 Graphics • Olga Gridina and Jordi Villarroya

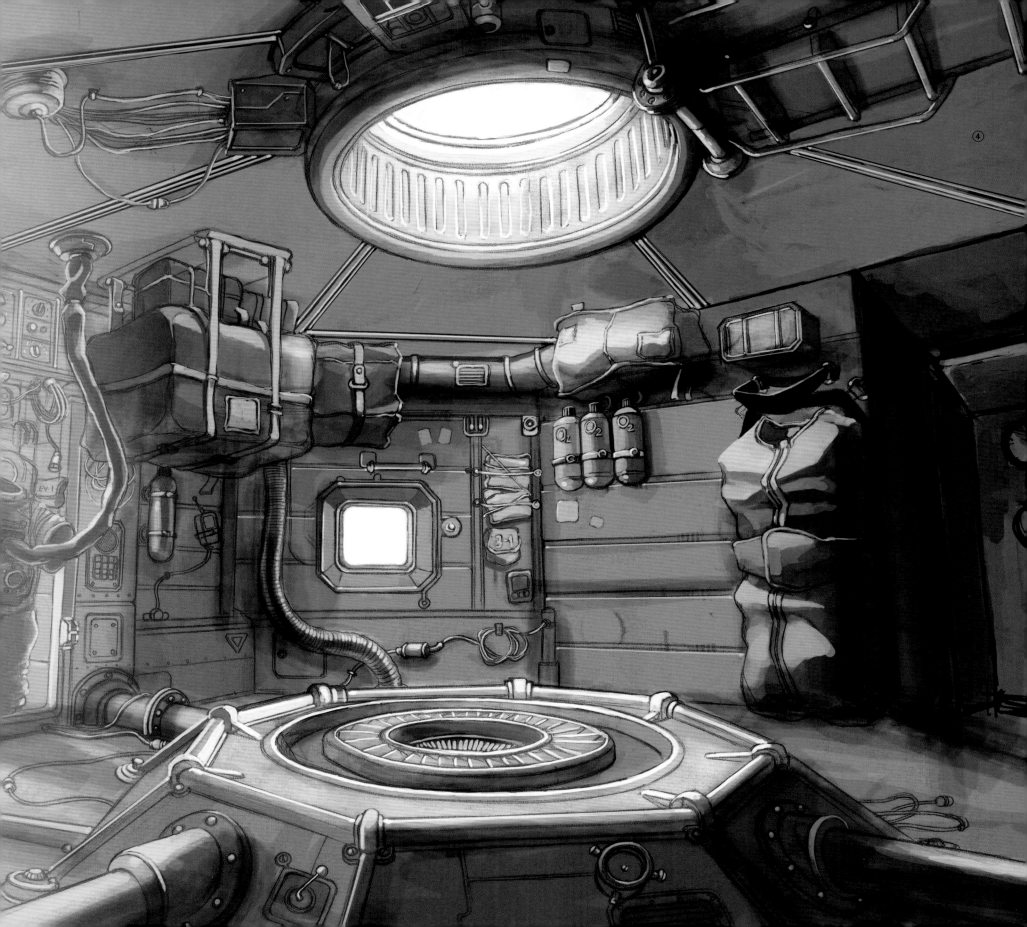

Props & Signs

The most impressive aspect of *Planet 51*'s design is the sheer totality of how the combined aesthetic was implemented. This is best seen in the incredible diversity of props that feature in the film, all contributing to a compelling world.

"It was a lot of fun to redesign all these things." says codirector Marcos Martínez Carvajal. "If I was an alien and everything in my world was round, how would I design a chair, a telephone, or a gun? When we think of aliens, they have ray guns, they have flying saucers—let's filter those through our world's design. This is a very rich world where nothing is spared that influence."

An element that affects almost all of the props in *Planet 51*—be they street signs, magazines and books, or placemats—is an added circular shape in one corner that disallows symmetry. Says art director Fernando López Juárez: "It was simply to provide a small but pointed difference to Earth signs. If they were perfectly round or square, they would be the same"—a definite no-no on Planet 51.

The food eaten in Glipforg is also distinctly eccentric in that it glows (and, in the case of the flying saucer–shaped hamburgers, floats as well!). The glowing foodstuffs idea found its inspiration in the classic '80s sci-fi movie *Cocoon*, according to visual production designer Julián Romero Muñoz. "In that particular film, the aliens have an inner energy, immediately indicating they are more advanced. So I thought that all the food would have this element too, and it would make them glow!"

There is one considerable irony in the film's sci-fi-influenced prop design: While the design elements of ray guns are utilized, none actually appear. The military weaponry looks very much like its '50s Earth counterpart, and this was entirely intentional. "In all the '50s movies where the military are persecuting the aliens," notes sets and props supervisor Fernando Huélamo García, "these kinds of weapons are the most prevalent, so you have to keep that in mind. We didn't want to have it appear different from those films."

①

1 Garden furniture concept • Julián Romero Muñoz 2 Drink machine and newspaper dispenser • Gracia Artigas (design), Jorge Kirschner (modeling), Jorge Costas (shading) 3 Ball pen • Marcos Calo (design), Eduardo Berazaluce (modeling), Anna Sitja (shading) 4, 5 Dog hut and dog plate • Marcos Calo (design), Ramón López Seco de Herrera (modeling), Jordi Villarroya (shading) 6 Hammer • Javier "Mr. Plot" Tejada (design), Juan Gracia (modeling), Javier Borrego (shading) 7, 10 Billboards • Gracia Artigas (graphics) 8 Oil can • Gracia Artigas (design), Jorge Kirschner (modeling), Jordi Villarroya (shading) 9 Dustbin • Marcos Calo (design), Gonzalo Díaz-P. Sisternes (CGI) 11 Toothpaste and toothbrush • Julián Romero Muñoz and Gracia Artigas (design), Juan Gracia and Eduardo Berazaluce (modeling), Xuan Prada and Eva de Prado (shading) 12 Radio • Julián Romero Muñoz (design), Jesús Orillán (modeling), Jordi Villarroya (shading) 13 Mugs • Gracia Artigas (design), Xuan Prada (CGI) 14 TV camera • Marcos Calo (design), Eva de Prado (shading) 15, 16, 17 Magazine covers • Ignacio Güejes and Carolina Cuenca (drawings), David Jaráiz and Patricia Castelao (color painting), Olga Gridina (graphics and lettering) 18 Records and record player set • Gracia Artigas (design and graphics), Jorge Kirschner (modeling), Anna Sitja (shading) 19 TV set • Julián Romero Muñoz (design) 20 TV remote control • Marcos Calo (design), Jesús Orillán (modeling), Eva de Prado (shading)

⑳

⑲

⑱

Cole Cola
Planet Pizza

BallPen

RIPLEY

③
④
⑤

Lwig's TOOLS

⑥
⑦
⑧
⑨
⑩

MY LIFE is GREENER

I SEE GREEN PEOPLE

World's Greenest DAD

⑬

Dental Pro

⑪

⑫

Aunty Raachl's ICE CREAM
Man, it's real cool!
*The smoothest!
Giant scoops!

Picturegoer
with Disk Parade

THE BEST ★ QUALITY
5 APR 02152

⑰

10¢

The Picturegoer Summer ANNUAL
6ᴰ 100 PAGES

The Best of the Isolith
BLAST WHITE

CURT JURGENS
new album

Carol Lombard
most popular ich pop idol!

⑯

Big Sensational BASEBALL STORIES 10¢

MUTINY ON THE WIND
Smash Hatchman Novel
by Leslie Turner

HOME RUNS DON'T COUNT
Great Novel
by Duane Döcket

Service News
written by
COSMO BENNETT

GET IT IN

B Affair Mr. DOC McGEE

THE ASH-CAN GANG
WILLAM P. HOK

⑮

TV

⑭

131

1, 7, 9 Graphics • Olga Gridina 2 Magnifying glass • Javier "Mr. Plot" Tejada 3 Early concept art • Julián Romero Muñoz 4 CGI Coins • Gonzalo Díaz-P. Sisternes (modeling and shading) 5 Concept art • Gracia Artigas 6, 12 Grill and food • Juan Carlos Gracia (modeling), Jordi Villarroya (shading) 8 Burger • Marcos Calo (design), Carlos "Qstom" Nieto (color study) 10 Skate concepts • Gracia Artigas 11 Suitcases • Julián Romero Muñoz 13 Food • Gracia Artigas (visual development)

15¢ HAMBURGERS Best in Town!

① ② ⑤

220

Seq 070BBQ

HUMAN ATTACK

NICE PRICE

"Surrender or die!"

SQ 180ESC

Appendices

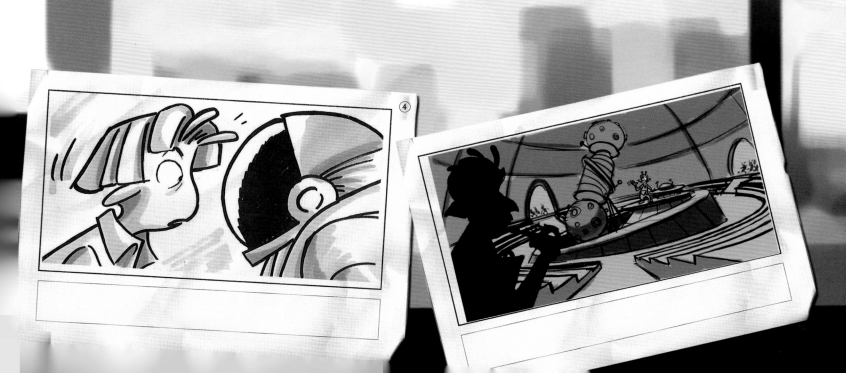

Appendix A

The Storyboards of *Planet 51*

A series of hand-drawn illustrations set in graphical sequence, storyboards are used to explore how best to tell the story. They enable experimentation with the film's narrative, action, potential camera movements, and character development. As supervisor of storyboards Paco Sáez says, "Storyboards give us the opportunity to take risks with the visual narrative and put them to the test. It's the time when we see if things work!"

①

Overleaf: 1 Color keys • Fernando López Juárez and Gracia Artigas 2 Color script • Fernando López Juárez 3, 4, 5 Storyboard images • Jorge Blanco, Javier Abad Moreno, Marcos Martínez, Pedro Pérez Valiente, Pedro Daniel García, Javier Ledesma, and Helios Vicent

1, 2 Storyboard images • Jorge Blanco, Javier Abad Moreno, Marcos Martínez, Pedro Pérez Valiente, Pedro Daniel García, Javier Ledesma, Helios Vicent, Lydia Fernández, and Angel S. Trigo

①

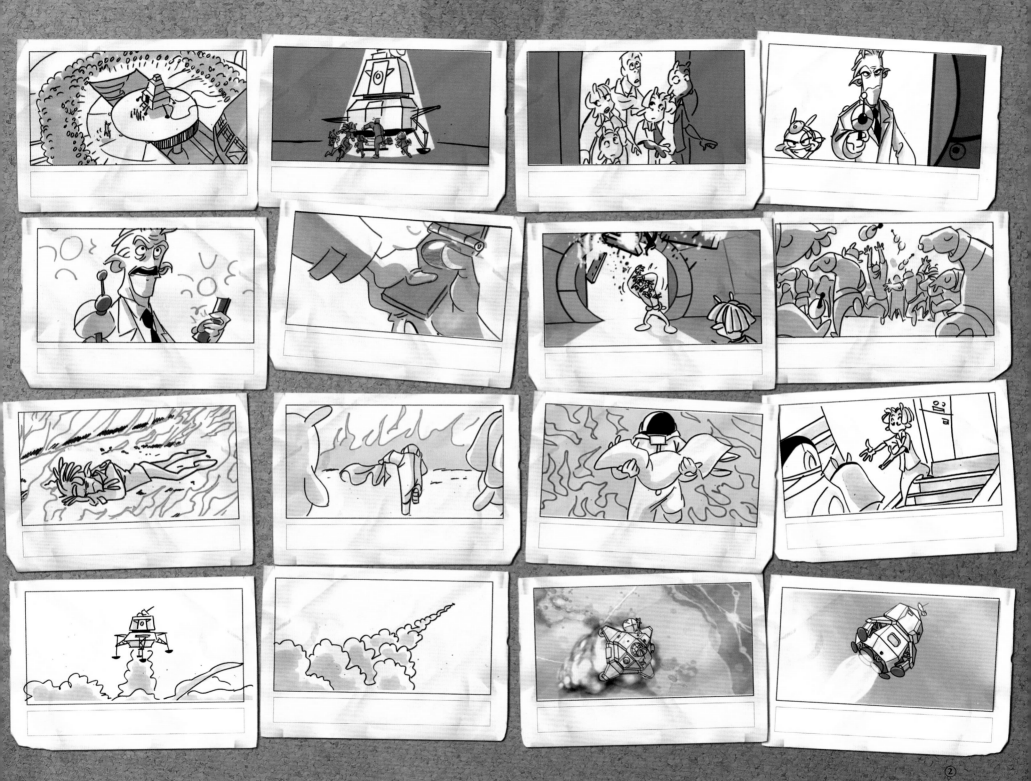

1, 2 Storyboard images • Jorge Blanco, Javier Abad Moreno, Marcos Martínez, Pedro Pérez Valiente, Pedro Daniel García, Javier Ledesma, Helios Vicent, Lydia Fernández, and Angel S. Trigo

Appendix B

The Color Scripts of *Planet 51*

"Color will depend on the time of day, location, action, and emotion of a scene," says art director Fernando López Juárez. "Color scripts reflect the entire development of the film, with its emotional ups and downs."

1°DAY
010MVI 00:00:00 020CIT 00:02:15 030LSK 00:04:19 041NRG 00:08:58 060RAD 090 ROV 070BBK 00:14:1
00:11:48 00:12:39

160BED 171BWA 181BKN 3°DAY
00:32:44 00:34:13 00:35:42 121MLK 191KPP 210ABD 00:39:24 213PRT 216ALW 221CMC 00:
00:37:29 00:38:04 00:42:58 00:44:10

4°DAY
310VDC 01:08:03 320KSS 01:10:15 330HLP 330KOL 01:16:25 350GAS 01:18:
01:14:16

140

Additionally, color scripts create an efficient overview of the film's color palette, which is instrumental in expressing the narrative's emotions and are especially helpful when lighting and compositing a scene.

Color script • Fernando López Juárez

Acknowledgements

I'd like to thank the immensely talented and dedicated crew of *Planet 51* at Ilion Animation Studios in Madrid, who welcomed me into their world and provided a splendid view of an enormously fascinating creative process. Thank you to the following for donating their very precious, deadline-addled time to talk to me:

Ignacio Pérez Dolset	*Producer and CEO, Ilion*
Jorge Blanco García	*Director*
Marcos Martínez Carvajal	*Codirector*
Javier Abad Moreno	*Codirector and Animation Director*
Julián Romero Muñoz	*Visual Designer*
Fernando López Juárez	*Art Director*
Juan Solís García	*Characters Supervisor*
Ignacio Güejes	*Head of Character Design*
Miguel Angel Jimenez Rosado	*Rigging and Skinning Supervisor*
Fernando Huélamo García	*Sets and Props Supervisor*
Charlie Ramos	*Layout Supervisor*
Fernando Moro	*Animation Supervisor*
Carine Gillet	*Final Layout Supervisor*
Barbara Meyers	*Lighting Supervisor*
Javier Romero	*Visual FX Supervisor*
Miguel Pablos	*Compositing Supervisor*

An especially fulsome thank you to Elena García Bou and Ignacio Cajigas, who saw to my every need and ensured that I confidently departed Spain with a mass of material for this book.

At Palace Press, I extend Jake Gerli much gratitude for providing me with this exquisite (and long-desired) opportunity; my editor (and fellow comics fan, to boot!) Kevin Toyama for guiding the project with a steady hand and a very friendly, helpful manner; designer Scott Erwert for crafting this book's beautiful and engaging look; production director Leslie Ann Cohen for ensuring that Ilion's art shines the way it should on the page; and last but by no means least, copyeditor Mikayla Butchart, for giving my text that added gleam. It's been an absolute pleasure working with you all!

This book is dedicated to my elite cadre of fellow geeks—Lee Medcalf, Dave King, Richard Brookes, and James Fox—who routinely and hilariously remind me of the sheer pleasures of a (massively) extended childhood—and, equally, to my wonderful sister Laura Graydon: Making you laugh is a task that never grows old. Like everything else I do, this is also for my dad, who would have loved the gag of the alien dog. Finally, for little Milo, a beloved feline companion who suddenly died the day I finished this book and was by my side (or on my lap) almost constantly as I wrote it—and for five enriching years beforehand. An angel on my shoulder, you left me much too soon—but I'll never forget you.

—Danny Graydon

1 Humaniacs comic • Ignacio Guejes, Marcos Calo (design), Carlos "Qstom" Nieto, Gracia Artigas (color painting and graphic) 2 Planet 51 newspapers • Gracia Artigas and Olga Gridina

Ilion Animation Studios would like to thank the special *Art of Planet 51* crew who made this project possible. If you are looking for the ones to blame, look no further: A very special thank you to producer Raquel Gómez Pla, who dedicated hours and hours to gathering *Planet 51*'s artwork and coordinating the teams of image selection, as well as preparing and organizing a mass of material and documentation for the book, making sure that no good image went astray and that all credits were correct.

Thank you to visual development artist Gracia Artigas Sandoval for creating the art and design concept of the pages of the book so they could show the essence of *Planet 51*, providing all sorts of additional artistic and graphic material and any other support that was required, including concept art for this book cover.

Many thanks to the international coordination manager Elena García Bou. She has been the "un-missing" link with the exceptional editing team at Insight Editions. She made sure all communication was fluent and that they would get all the support they needed in the most efficient way. Working with her, wonders happen.

We would also like to extend our gratitude to Carlos Astorqui, marketing vice-president, for making sure that the whole project would happen.

Our additional thank you to Ignacio Güejes, Julián Romero Muñoz, Fernando López Juárez, and Lorena Hueso for their help selecting the best artwork for this project; Julián Romero Muñoz and Jose Manuel Oli for the concept art of the book cover; and Ramón López Seco de Herrera for taking and compositing the picture of the studio's crew.

And last but not least, we would like to thank Danny Graydon for giving another dimension to the *Planet 51* artwork with such well chosen words; Gary Oldman for writing the foreword; and the communication, coordination, design, and editorial teams at Insight Editions, especially Jake Gerli and Kevin Toyama, who have done such a great job and have been so professional (and patient), taking care of all our requirements and turning this book into a beautiful work of art.

We hope you enjoy reading it as much as we enjoyed making it.

Colophon

Library of Congress Cataloging-in-Publication Data available.

ISBN: 978-1-933784-97-7

ROOTS of PEACE REPLANTED PAPER

Palace Press International, in association with Roots of Peace, will plant two trees for each tree used in the manufacturing of this book. Roots of Peace is an internationally renowned humanitarian organization dedicated to eradicating land mines worldwide and converting war-torn lands into productive farms and wildlife habitats. Together, we will plant two million fruit and nut trees in Afghanistan and provide farmers there with the skills and support necessary for sustainable land use.

Manufactured in China by Palace Press International
www.palacepress.com

10 9 8 7 6 5 4 3 2 1

INSIGHT EDITIONS
3160 Kerner Blvd., Unit 108
San Rafael, CA 94901
www.insighteditions.com

INSIGHT EDITIONS

Publisher: Raoul Goff
Creative Director: Iain R. Morris
Design Assistants: Dagmar Trojanek, Gabe Ely
Project Editor: Kevin Toyama
Production Director: Leslie Cohen

Insight Editions would like to thank Jake Gerli, Lucy Kee, and Barbara Genetin, and especially Elena García Bou, Raquel Gómez Pla, and Gracia Artégas Sandoval at Ilion Animation Studios, for all their help and management of this wonderful book.

Book designed by Scott Erwert • www.erwert.com

1 Alien Stickers • Olga Gridina (graphic design)
2 Concept art • Marcos Calo